Italian Art Ceramics 1900–1950

Valerio Terraroli

Italian Art Ceramics
1900–1950

with the collaboration of Paola Franceschini

Front cover
Gio Ponti, *'My Women: Donatella' bowl*, 1924 (cat. 154)

Back cover
Francesco Nonni, *Andalusian woman*, 1923-25 (cat. 65)

Design
Marcello Francone

Editing
Maria Conconi

Layout
Eliana Gelati

Translation
Cristopher "Shanti" Evans for Language Consulting Congressi

First published in Italy in 2007 by Skira Editore S.p.A.
Palazzo Casati Stampa
via Torino 61
20123 Milano
Italy

© Archivio Cambellotti
© Giacomo Balla, Tommaso Cascella, Lucien Achille Mauzan by SIAE 2007
© Fondazione Lucio Fontana, Milan
© 2007 by Skira editore Milan

All rights reserved under international copyright conventions. No part of this book may be reproduced or utilized in any form or by any means, electronic or mechanical, including phocopying, recording, or any information storage and retrieval system, without permission in writing from the publisher.

Printed and bound in Italy.
First edition

ISBN-13: 978-7624-686-9
ISBN-10: 88-7624-686-X

Distributed in North America by Rizzoli International Publications, Inc., 300 Park Avenue South, New York, NY 10010.
Distributed elsewhere in the world by Thames and Hudson Ltd., 181A High Holborn, London, WC1V 7QX, United Kingdom.

Photographic credits

All the pictures of the Antonello Collection belong to the collection's archives. The pictures of the Gilli and Levis Collections are the property of Foto Saporetti, Milan, and Mauro Magliani, Padua, respectively. For all the rest, the publisher is at the disposal of any copyright holders who have not been cited.

Contents

7 Foreword

9 European and Italian Ceramics 1900-1950: the Ways of Modernity
 Valerio Terraroli

21 Plates

151 Catalogue
 *edited by Valerio Terraroli
 and Roberta D'Adda*

Appendix

219 Marks of the Main Italian Ceramics Factories and Artists
 edited by Roberta D'Adda

229 Glossary
 compiled by Roberta D'Adda

233 Description of the Ceramics Factories and Biographies of the Artists
 compiled by Paola Franceschini

281 Bibliography
 edited by Paola Franceschini

Acknowledgements

The conception and publication of this volume has been made possible by the generosity of Guido Antonello, who has placed his outstanding collection at the disposal of the authors and supplied colour transparencies of the pieces chosen. We would like to express our gratitude to him and to the curator of the collection, Anna Wagner, always thorough and precise in the information and specifications she has provided.
Among the other people whom we must thank for having been kind enough to make their collections available are Luigi Gilli, Prof Angelo Levis and Dr Enrico Camponi, but we are also grateful to the Archivio delle Arti Applicate in Nuoro, the Civica Raccolta di Terraglia in Laveno Mombello, the Museo Internazionale della Ceramica in Faenza, the Museo della Manifattura Richard-Ginori in Doccia, and the Collezione Wolfson in Genoa Nervi.
For the precious information and advice they have provided we would like to thank Elisabetta Alpi (Museo Internazionale della Ceramica in Faenza), Silvia Barisione (Collezione Wolfson in Genoa Nervi), Giovanni Corrieri (Teramo), Daniela De Vicentis (Museo della Ceramica in Grottaglie), Anty Pansera (Milan), Anna Maria Ruta (Palermo), Gaia Salvatori (Naples), Lino Signaroldi (Milan) and Nadir Stringa (Nove).
Particular thanks go to Luciano Colantonio (Brescia) for the generosity, cooperation and warmth he has displayed all through these years in following the work on the book and its realization.
We are also particularly grateful to Roberta D'Adda for her active and painstaking collaboration, and to Cristopher "Shanti" Evans for his accurate translation.
Finally, we must thank the publishers for the faith they have placed in the project and to Eliana Gelati, Clelia Ginetti and Massimo Zanella for having given this work its concrete form.

Foreword

For some years now considerable effort has been going into tracking down critical and documentary sources on the subject of Italian art ceramics, together with the preparation of a first inventory of emblematic pieces and the gathering of reliable information on the history of the ceramic factories and the artists engaged in the activity of design. Now a substantial part of the fruits of that work, in which I have been engaged alongside Paola Franceschini and Roberta D'Adda, has found its way into this book. The objective of the volume is to present a clear picture of the creative dynamics, stylistic evolution and compositional innovations of ceramic production in Italy over a period stretching approximately from the end of the 19th century to the beginning of the 1950s, a time in which a happy combination of technical traditions and artistic personalities produced results that were in many cases exceptional and unique.

In addition, the period of time selected covers the most significant shifts in taste in the modern era, and the repercussions that these had on the development of stylistic systems. The starting point in this process was the figure of Galileo Chini, who was responsible for a personal and yet emblematic elaboration of the stylistic features of Art Nouveau that led to the diffusion of elegantly modernist forms and decorative models all over Italy in the first two decades of the century: from Laveno to Faenza and from Florence to Rome, in this last city with the group of ceramists gathered around the innovative figure of an artist like Duilio Cambellotti.

In fact it was in the field of ceramics that the first significant signs of a change in taste began to emerge toward the end of the second decade of the century, with the introduction of segmented lines, schematically two-dimensional figures and a rhythmic and elegant modelling. This heralded the Deco style that was to be consolidated at the Biennial Exhibitions of Decorative Arts in Monza (1923, 1925, 1927, 1930), at the Venice Biennali and at the Paris Exposition of 1925, where Richard-Ginori triumphed with the incomparable and cosmopolitan inventions of Gio Ponti. In addition to the magnetic personality of the Milanese architect, however, other figures were emerging, such as Guido Andlovitz, the highly active artistic director of the Società Ceramica Italiana at Laveno. Then there were Angelo Biancini, the potters Francesco Nonni, Pietro Melandri, Ercole Drei and Riccardo Gatti in Faenza, the Milanese Giovanni Gariboldi, Duilio Cambellotti in Rome and the sculptors Alfredo Biagini and Arturo Martini. In the thirties Italian ceramics set out to tackle the genre of monumental sculpture, and to find a modern solution to the problems of architectural decoration. But it also paid great attention to the linguistic developments of the so-called second wave of Futurism with the extraordinary creations of the factories at Albisola, produced by designers like Torido Mazzotti, Tullio, Diulgheroff, Farfa and the young Bruno Munari. The experiments of the avant-garde movements, the revival of themes and values of the popular tradition and the search for new means of expression in ceramics, with a rejection of a hackneyed reproduction of traditional models in favour of a more contemporary aproach, emerged with force in the mid-thirties, partly under the impetus of Cambellotti's *buccheri*, the colony of German artists at Vietri sul Mare and the emblematic figures of Melkiorre Melis and Cosimo Fancello in Sardinia. We have chosen to conclude this extensive survey of masterpieces with a number of inventions, dating from the late forties, by Leoncillo Leonardi, Lucio Fontana and Fausto Melotti. Here the figurative and creative trends of the first half of the century are metamorphosed into an impetuous move in the direction of the abstract and non-representational, demonstrating once again the experimental character and high level of creativity displayed by Italian ceramics, now fully abreast of contemporary developments.

Valerio Terraroli
January 2007

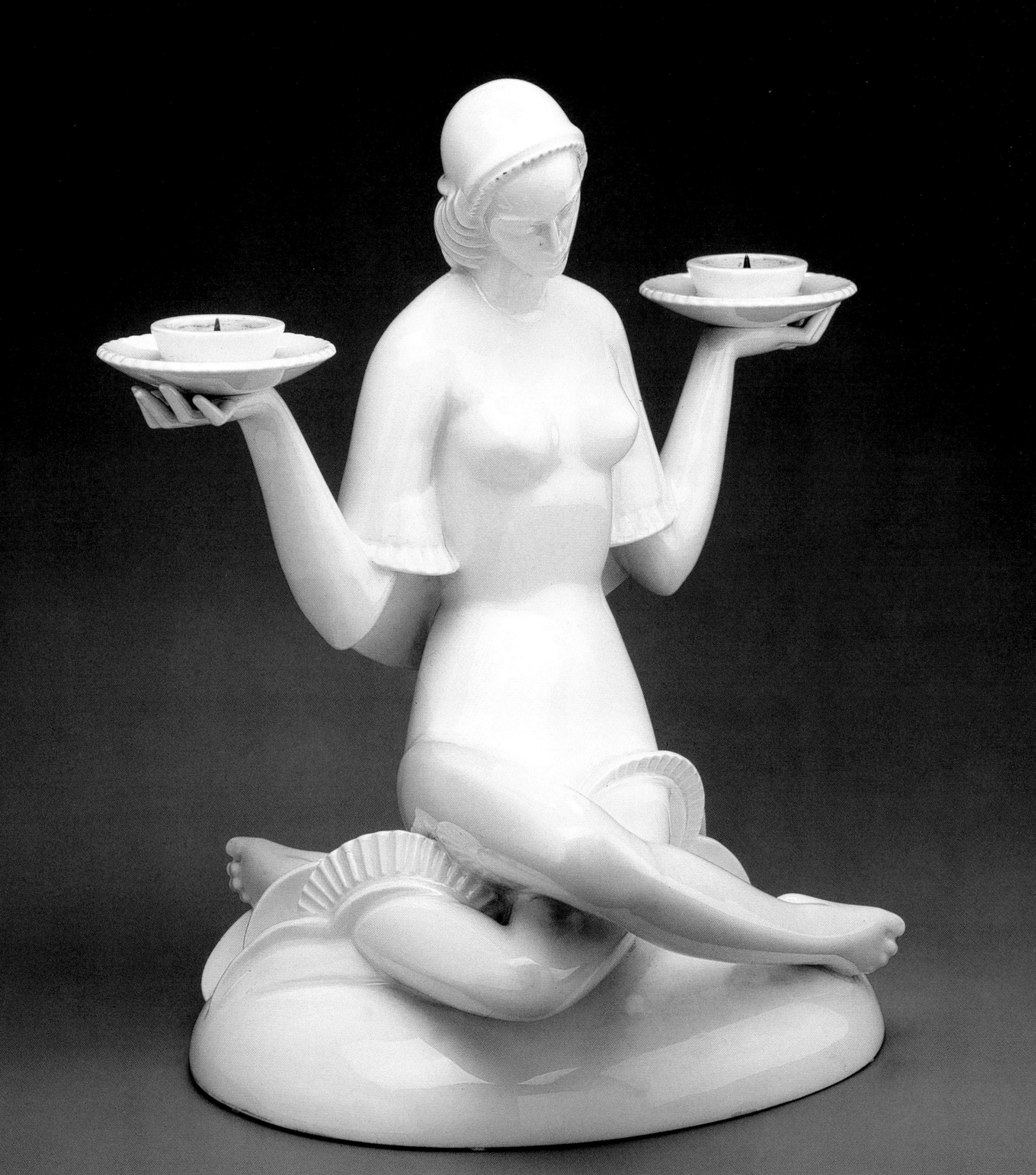

Valerio Terraroli

European and Italian Ceramics 1900-1950: the Ways of Modernity

Gerhard Schliepstein, *Candelabrum in the form of a seated female figure*, 1927-30, Rosenthal Factory. Private collection.

'It would be dangerous, for an industry based on art like that of ceramics, to believe only what is seen at the Exhibitions. True modern art has certainly never been surrounded, at any time, by a stockade. The Exhibition, a sort of congestion of representation, is a dubious phenomenon when it comes to judging the production that determines the contemporary style. It does not just include the results, the reliable testimonies of our technique, our usage and our custom. It contains everything; the true and the false, the real and the fictitious, in arbitrary and accidental proportions.'[1] These statements, as relevant as ever, were made by the architect Gio Ponti, at that time artistic director and designer at the Richard-Ginori factories, in an article devoted to the production of ceramics on the occasion of the Italian participation in the Paris Expo of 1925, an event that defined the stylistic features of Art Deco at a world-wide level. In his critical essay, Ponti set out at least three basic concepts of the relationship between the decorative arts and industrial production at the beginning of the last century: the pressing need to move the plane of production and commerce from an essentially craft basis to an industrial one; the fundamental function of exhibitions for the propagation and broadening of public acceptance; and the concept of style, which is expressed at the different levels of the object of everyday use but is almost never truly represented by expository events, instead participating profoundly in everyday life and feeding on it. Thus ceramics was taken as a litmus test for evaluating on the one hand, and promoting on the other, the modernity of artistic language or rather style, as an ensemble of aesthetic choices, practicality of function and uniformity of models. The road to attaining an autonomy, first productive and commercial and then conceptual, of the *objet d'art*, and of artistic ceramics in particular, has been a long and rocky one. At the outset the approach was fairly timid and did not really get going until the beginning of the 19th century, when types of porcelain made in Great Britain from mixtures of various materials (in particular Parian ware, jasperware and black basaltes ware) undermined the age-old popularity of majolica throughout Europe, although they did not affect the demand for cheaper painted terracotta: in other words the beginning of industrialization in Great Britain led to a search for less costly formulas of composition of the ceramic product to meet the demands of an inevitable broadening of the market with respect to the narrow circle of customers for the porcelain produced by royal and national factories.

The progress in technology that took place over the course of the 1830s, through the introduction into the manufacturing process of many European factories of plaster moulds for the mass production of pieces by casting, along with hydraulic presses, steam engines and the use of the transfer method for the application of pictorial decorations, resulted in a saturation of the market with products of low or appalling quality, and above all characterized by a chaotic and superficial utilization of noble models. The combination of an ever growing demand from the public and an increasingly disorderly range of 'period' products led to a need felt by the shrewder factory owners, and in the debate over art in general, on the one hand to maintain a close link between product and technical innovations, and on the other for a new sensitivity to the history of taste, and thus a precise understanding of styles. The intention was to give rise to a production of high material and aesthetic quality so that pottery of everyday use could become a vehicle for the communication of modern taste. It was certainly thanks to the ingenuity of Henry Cole that these requirements were encapsulated in the invention of a series of ceramic articles, and in particular a tea service manufactured around 1840 at Minton's pottery works in Stoke-upon-Trent in which form, function and decoration appeared so consistent that it proved a commercial success. Cole went on, with a group of friends, to set up Felix Summerly's Art Man-

[1] G. Ponti, 'Le ceramiche. Le ragioni dello stile moderno,' in *L'Italia alla Esposizione Internazionale di arti decorative e industriali moderne Parigi MCMXXV*, Rome 1925, p. 70.

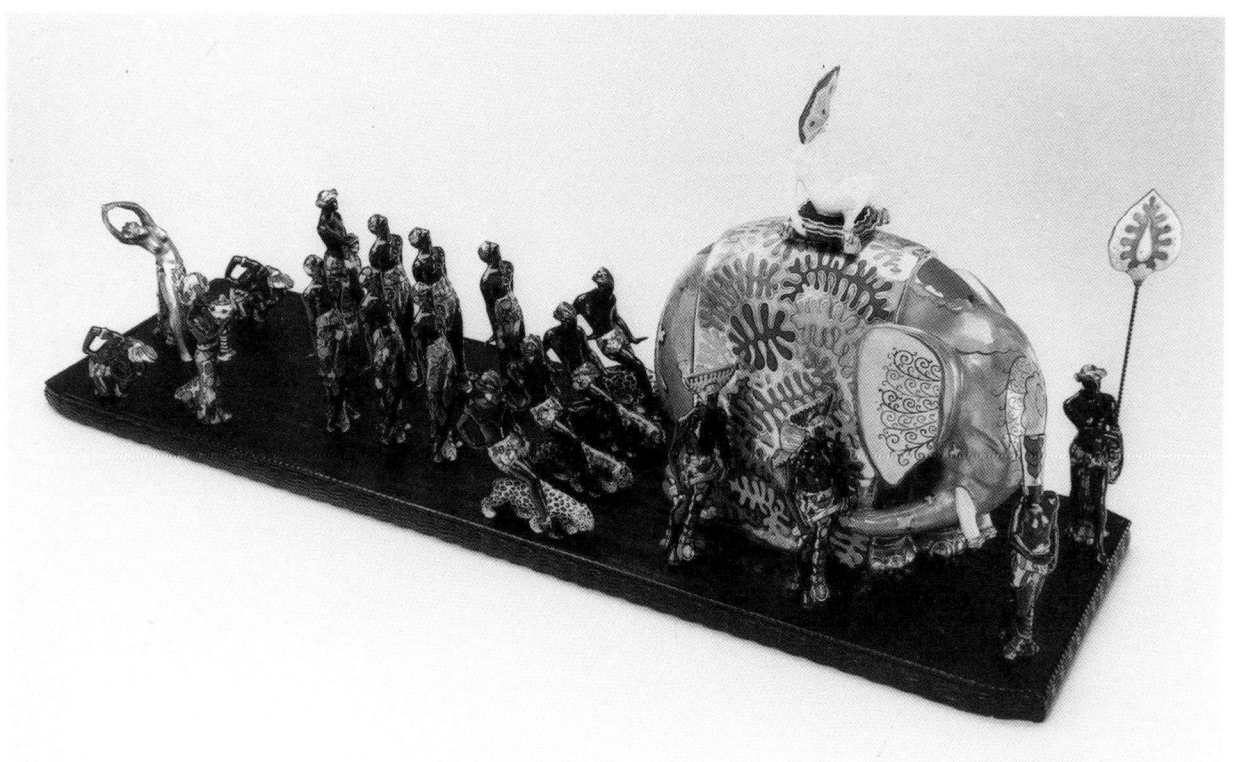

Francesco Nonni and Anselmo Bucci, *Oriental Procession* for the Paris Expo on its original wooden base, 1925

Berlin Porcelain Factory, *Europa on the Bull*, 1912, Kunstgewerbemuseum, Berlin

ufactures for the production of modern articles of everyday use.[2] Thus the need to develop and stimulate the 'taste' of manufacturers was promoted through journals, printed repertories and national expositions and exhibitions of objects from the past to be used as models: an impetus from the bottom up that found its clearest expression in the first major universal exhibition (London 1851). Amidst the vast quantity of products presented to an equally vast and diverse public, there were two ceramic factories that stood out, winning the diploma of honour: Minton's and Sèvres, the only ones that had developed means for the mass production of an extremely varied range of articles, using largely industrialized methods for objects of everyday use, but open to experimentation with new mixtures of clays and new decorations. French taste held sway not just in Paris but in Britain too, as many master potters who had fled France after the revolts of 1848 worked at Minton's, including Albert Carrier Belleuse. Thus the dominant styles were those of the Renaissance and neoclassicism, in line with the models of 'Second Empire' taste. The comparison with other European factories, to a great extent disappointing, led an ever greater number of architects and craftsmen in the sector to call loudly for a serious reform of artistic education and the setting up of museums of decorative arts with collections of ancient and modern objects to be backed up by lectures and workshops. These were the ideas put forward by the German Gottfried Semper, partly as a consequence of his own experience as a designer of porcelain at the Meissen factory, and by the Englishman Owen Jones, which immediately found concrete expression in the commission to acquire at the Crystal Palace a series of new objects to be added to the old ones that the Crown had placed at the disposal of the South Kensington Museum (later to become the Victoria & Albert Museum). This was flanked by the new School of Design, run by Henry Cole, with the assistance from time to time of professionals working in the factories, who agreed to hold specific series of lectures and workshops. The objective was to teach young potters how to study forms, models and decorations of the past, not in order to imitate them in a blinkered way, but to master techniques and systems of decoration that could be reworked in the light of modern taste. Notwithstanding Cole's lead, indicating the industrial development of ceramic production as the way ahead, but without any decline in the quality of the forms and the beauty of the decoration, the majority of European factories catering to the broad popular market do not appear to have been influenced by the aesthetic debate and the innovation in styles. On the contrary, they limited themselves to a tired repetition of eclectic models derived from the Wedgwood tradition, but decorated exclusively by transfer and produced in ever plainer forms and materials of lower and lower quality.

These were purely commercial enterprises, lacking the figures of artistic director and master decorators, but

[2] R. Ausenda, 'Ceramica', in *Storia del disegno industriale. 1851-1918. Il grande emporio del mondo*, Milan 1990, p. 285.
[3] As a source of material on the presence of the decorative arts at the great exhibitions of the 19th and 20th century, cf. *Les arts décoratifs de 1851-1900 à travers les expositions universelles*, Fribourg 1988; see also *Europäische Keramik 1880-1930*, Darmstadt 1986, *La création céramique du Seconde Empire à l'Art Nouveau*, Lille 1986, and the entry in *Skira Dictionary of Modern Decorative Arts,* ed. by V. Terraroli, Milan 2001.

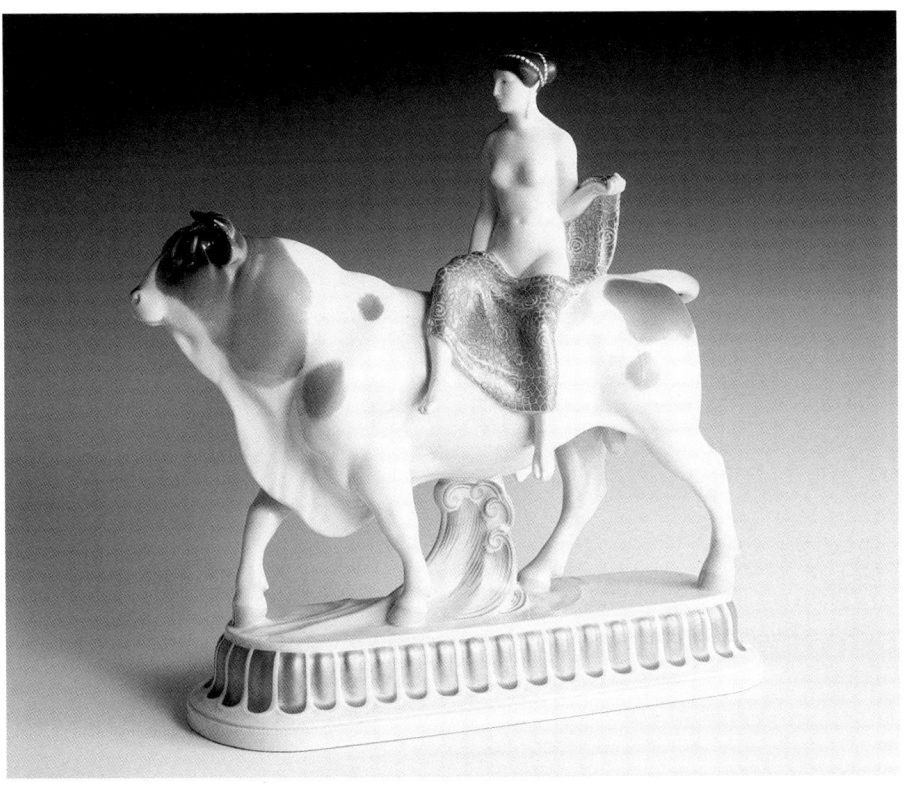

[4] On the role played by Christopher Dresser in the birth of modern design see M. Whiteway, *Christopher Dresser 1834-1904*, Milan 2001, in particular for the ceramics in an Oriental style produced for Minton's between 1862 and 1880 (pp. 50-67) and the ones inspired by Japanese culture and the use of metallic lustres for the Linthorpe Pottery between 1879 and 1882 (pp. 110-45). For an important repertoire of British and American ceramics of the 20th century, see P. Atterbury, E.P. Denker and M. Batkin, *Twentieth-Century Ceramics. A Collector's Guide to British and North American Factory-Produced Ceramics*, London 1999.
[5] The service was named after the man who commissioned it, Eugène Rousseau, a well-known dealer in luxury ceramics.
[6] *Les origines de l'Art Nouveau. La Maison Bing*, exhibition catalogue ed. by G.P. Weisberg, E. Becker and E. Possémé, Amsterdam 2004.

they supplied much of the market and were above all responsible for exports to the United States and Latin America. But while the line of development was the one indicated by the process of industrialization and the need for production on a large scale, even if it could not yet be called mass production, confirmed by the Paris Exhibitions of 1855 and 1867,[3] on the other hand positions emerged that were tinged with a clear contempt for compromises between the artistic product and industry. These voices called for a revival of the artist's imagination, and thus of his leading role, and a return to the production mechanisms of the craft workshops of the past. Yet the two positions, while opposed on a theoretical level, found common ground in the practical application of manufacturing processes: on the one hand the experience of the Arts and Crafts enriched the repertory of the workshops and factories with new ideas and avant-garde experiments, together with an intelligent recovery of historical models; on the other technological advances gradually improved the ability to control individual processes of production, pushing artists towards ever more daring technical experimentation. And it is from this perspective that we should look at the course taken by the ceramist William de Morgan, a pupil of William Morris: just as the Alsatian Joseph Théodore Deck took his inspiration from Iznik ware (London 1862), de Morgan drew on Persian, Turkish and Hispano-Moresque glazed ceramics to create a highly original series of decorative tiles (1863) and dishes characterized by the use of metallic lustres. It was a rediscovery that, alongside a wealth of phytomorphic designs that seemed to foreshadow the world of Art Nouveau, earned him international fame.

The growth of a middle class increasingly anxious to develop aesthetic references of its own not only led to research into and the appreciation and promotion of naturalism in the pictorial sphere, but also to an interest in modes of expression that were remote from the eclecticism and tendency to quote from the past typical of the Romantic tradition and closer to the natural world, evocative of far-off and exotic places. The Japanese products first shown in Europe at the exhibitions held in London in 1862 and in Paris in 1867 proved a great success and had an immediate influence on the extremely modern forms of the metal objects and some of the ceramics made by the brilliant Christopher Dresser[4] and the dinner services made in France by Félix Bracquemond, such as the famous 'Rousseau' (Paris 1867),[5] in which the asymmetry and rigorous naturalism of the Japanese repertoire were inserted into the traditional form of the majolica dinner plates of the 18th century. The interest in this type of product is confirmed by the phenomenon of 'Japonisme', all the rage at the end of the 19th century and not only a decisive element in Symbolist imagery but an endless source of models and ideas for the modernist culture perfectly embodied by Samuel Bing and his Parisian gallery 'L'Art Nouveau'.[6] Japanese pottery, perfectly in step with the explosion in innovations in painting brought about by the Impressionists and Post-Impressionists and the diffusion of woodcuts by Hokusai, Isai, Hiroshige and the Japanese masters of landscape painting, also paved the way for the taste for the 'unfinished', for sketchy colouring, asymmetrical composition and abstract decoration. This led to an appreciation of what had previously been regarded as defects in firing and the application of glazes, as well as to the revival of materials like stoneware, on the tide of the fascination with the raku ware of the Japanese potters. The quest for a new purity of imagination through the use of coarse clay and irregular modelling, embarked on by a potter like Ernest Chaplet, was in keeping with the contemporary ventures into primitivism and popular culture made by Henri Rousseau le Douanier and the Pont-Aven group. In Chaplet's workshop, where the ceramics produced were inspired by the plant world, had forms free of any need for symmetry and a decoration consisting of pure colour, the young Paul Gauguin, in the years 1886-87, modelled around seventy pieces in reddish-brown stoneware based on the primitive world. These objects stirred interest all over the world and at-

Gio Ponti, 'Advertisement for the Società Richard Ginori', in *Domus*, October 1928

tracted faithful followers, but the divide between them and commercial production was evident. It was a gulf that tended to be filled with the worldwide explosion of Art Nouveau following the Paris Exhibition of 1900, when the demands of the new style were reconciled with new materials, new technologies and new markets: the more elegant formal elements were immediately translated into schematized and simplified forms for middling production, where the concept of mass production was taken for granted but complete mechanization was not yet widespread, while on another front people began to debate the question of whether the article of everyday use should have artistic value or not.

As is well-known the modern definition, indeed the very concept, of the decorative arts emerged around the beginning of the 20th century, to a certain extent in connection with the theoretical ideas that sprang out of the modernist style and with the need to classify the creative dynamics involved, which tended, amidst difficulties of various kinds, to completely disengage the decorative object from its ties with craftsmanship and essentially technical and material factors and anchor it to pure artistic creation. In other words the monopoly of the academies of fine arts was essentially broken by the European Secessionist movements: the exponential growth in the number of private galleries and in a middle class with a clear awareness of its own taste and status, together with the systematic elaboration of the concept of the total work of art (*Gesamtkunstwerk*), threw open the doors of the 'temple of art', filled with the stale air of classical models and an eclectic and historicist style now seen as petty bourgeois, not to say Biedermeier, to a sudden and decisive influx of forms, themes and languages that still drew on classical mythology and history but reinterpreted them in light of the necessities, the aesthetic dynamics and the expectations of the contemporary world.

A fundamental means of diffusion of the new languages was provided by the attitudes taken by far-sighted critics like Hermann Bahr in Vienna, who was later to become one of the theorists of the Expressionist movement, Ludwig Hevesi, also in Vienna, and Julius Meier-Graefe in Berlin, who played an important role in spreading the ideas of the French avant-garde in Cen-

Guido Andlovitz, *Amphora on column*, Società Ceramica Italiana Factory in Laveno, in *Domus*, December 1928

tral Europe, as well as by the art magazines, new in their contents and in their graphical presentation of them, like *The Studio* in Great Britain, from 1893, *Emporium* in Italy, from 1895, *Pan* in Berlin, from 1895, *Jugend* in Munich, from 1896, and *Ver Sacrum* in Vienna, from 1898. Then the Secessionist artists and architects themselves were directly involved in training, organizing and running workshops of decorative arts, more or less craft-based or proto-industrial in their approach, like the Vereinigte Werkstätte in Munich and the Wiener Werkstätte in Vienna. Decisive, finally, in the positive evaluation of decoration, in both its architectural and figurative expressions, and of the decorative arts, were the reflections, especially in the German-speaking area, of Adolf Hildebrand and Konrad Fiedler on pure visibility (*Reine Sichtbarkeit*) and Theodor Lipps and August Schmarsow on empathy (*Einfühlung*), as well as the systematic historico-critical revision by Alois Riegl and Franz Wickoff, leading members of the so-called 'School of Vienna', of the division of the history of art into periods, of the close connections between figurative creativity and decorative creativity, of the central role of the decorative arts in the artistic and cultural development and interconnection of different civilizations and of the artistic value attributed to anti-mimetic and purely decorative expressions. A concept taken up by August Endell, an architect and graphic artist from Munich, in a number of articles published for specialist magazines in which he affirmed not only the essential separation between nature and art, but also the need for contemporary art to be characterized by free forms that did not represent anything and that evoked, on the contrary, intensity and empathy of a rhythmic and musical kind. The shift towards basically abstract and rigorously geometric forms, inspired by the natural world, especially that of plants, but reduced to linear expressions handled in a rhythmic way, was reflected in the British Arts and Crafts movement and the Glasgow School in particular, where this mode of expression was developed into a true lexicon that fused archaism and modernity, allusions to the medieval tradition and a willingness to contemplate the industrial production of objects. The diffusion of such ideas commenced in 1893 with the foundation of the magazine *The Studio*, the manual of modernist language in Europe that found an immediate echo in Germany with the graphical inventions of Herman Orbist in Munich and Otto Eckmann in Berlin, inspired on the one hand by the biomorphism of Art Nouveau and on the other by the spatial rigour and asymmetry of Japanese graphics. Around the same time the Belgian Henry van de Velde developed an approach that, drawing on the pictorial experiments of the Pointillists and Nabis, relied on rigorous, two-dimensional and essentially abstract forms. Thus an overturning of positions on the question of the decorative arts took place in the ambit of the Secessions, but thanks to the preceding events described above, commencing with the ideas of Henry Cole, and one which proved more difficult to bring about in painting or sculpture: the total rejection and substantial abandonment of Romantic culture and the overthrowing of an entire formal heritage endorsed by tradition.

The new ornamentation, or if you prefer decoration, stemmed from the awareness that in the modern world, urban life, industrialized society, 'mass' culture and art for all had led to a loss of one own historical position with respect to a consolidated and unbroken tradition, and a return to the indistinct realm of nature and in essence myth, and of biological vitalism. Consequently, in order to overcome the contradiction between the vitality of human beings and the brutal materiality of the objects in their everyday surroundings and of their life in the rigidity of the new architectural spaces, artists turned to ornamentation of an organic character that sprang out of the expressive potentialities inherent in the material employed and that was subject to the function which it had to perform. One of the earliest examples of the organization of production in this sense was provided by the Vereinigte Werkstätte of Munich, which were set up in 1898 by the architects Peter Behrens, Bernhard Pankok and Richard Riemerschmid, together with the aforementioned Obrist and Endell: the objects made by these workshops, despite an essential unity of form, oscillated continually between the use of naturalistic motifs and rigorous and essential structural schemes, in other words between decoration and pure functionality. The objects in stoneware, for instance, were decorated in blue on a grey ground, colours linked to the German craft tradition, but the designs used were new and essentially two-dimensional and geometric. Different from the outset was the attitude adopted by the Viennese Secession, which in the experience of the workshops of the Wiener Werkstätte, founded by Josef Hoffmann and Koloman Moser in 1903, emancipated itself from the typically Art Nouveau, biomorphic repertoire and distanced itself clearly from industrial production, opting instead for a revival of the arts and crafts. At the same time both Hoffmann and Joseph Maria Olbrich, designer of the building in Vienna to house the exhibitions of the Secession (1898) and future moving spirit of the artist's colony at Darmstadt, created a graphic design for the new magazine *Ver Sacrum* that took its inspiration from decorative forms of a pre-classical matrix and from geometric patterns

Gerhard Schliepstein, *Prince and Princess*, 1926, Rosenthal Factory. Bröhan-Museum, Berlin

drawn from Middle Eastern fabrics and carpets: forms that were examined and interpreted by Alois Riegl in *Stilfragen* (*Problems of Style*) published in Vienna in 1893.

The richness and variety of ceramic production at the moment of Art Nouveau's triumph,[7] and with it the problems regarding the relationship with national traditions in the realm of the arts and crafts, the difficulty of reconciling quality with mass production and the desire to utilize a common, immediately recognizable and modern stylistic code, found an important opportunity for verification and comparison at the Exhibition of Decorative and Industrial Arts held in Turin in 1902. That event did not just mark the peak and rapid decline of modernist formulas, but represented the first significant test of the Italian artistic culture with regard to contemporary European production. And if from the viewpoint of the theoretical debate, conducted by people like Thovez, Melani, Reycend and the young Ojetti, the themes were the international ones of style as a means of promoting social and cultural development, of industrial production and of the role of beauty in daily life, in the national reality of production pottery remained effectively anchored to regional traditions, to craft workshops that continued to propose copies of models from the Renaissance and Baroque eras and to a middling production of mediocre quality. On the other hand it was no coincidence that the magazine created in Italy in 1902 as an alternative to the journal *Arte italiana decorativa e industriale*, subsidized by the Ministry of Agriculture, Industry and Trade and edited by Camillo Boito (which, without taking a clear stand against eclecticism, was one of the first to provide graphic designs for industry), was called *Arte decorativa moderna. Rivista d'architettura e decorazione della casa e della vita* ('Modern Decorative Art. Magazine of architecture and decoration of the home and life'). It was founded by the critics Ceragioli, Thovez and Reycend and the master sculptors Calandra and Bistolfi, who were immediately joined by Alfredo Melani, with the explicit aim of moulding the taste of the contemporary public and providing operators in the sector with theoretical instruments and sources of reference. Where ceramics were concerned, two factories excelled in the Italian section at Turin: the Società Ceramica Richard-Ginori of Milan and the Arte della Ceramica of Florence.[8] Milan had boasted a great and rich tradition of majolica during the 18th century,[9] a tradition that had continued into the 19th and gained new impetus through industrialization of the workshops towards the end of the century. In 1883 the Società Ceramica Italiana factory had been founded at Laveno on Lake Maggiore: specializing in ironstone china, it won the gold medal at the Exhibition of Industrial Arts in Turin in 1898 with a series of objects of everyday use in opaque porcelain, decorated in light blue, pink and dark green. At the beginning of the 20th century the firm in Laveno boosted its industrial production (which included insulators for the new grid of electric power lines, as well as sanitary appliances), but combined it with a production of *objets d'art*. Designed by masters from Milan and Varese, including Luigi De Vecchi, Federico Paglia, Luigi Reggiori, Giuseppe Jacopini and Giorgio Spertini, these drew on both the naturalistic repertoire of Art Nouveau, ranging from phytomorphic decorations to insects and wavy and whiplash lines, and themes of Oriental origin or vaguely evocative of Far Eastern imagery. Towards the end of the 19th century the Richard factory[10] also changed its character and production under the expansion-oriented guidance of Augusto Richard. The San Cristoforo factory in Milan had been started up in 1873, while in 1887 the Palme works in Pisa had been acquired and in 1896 the Milanese company merged with the porcelain and majolica factory of Doccia, founded by Marchese Ginori in

[7] Cf. J. Hawkins Opie, *The New Ceramics: Engaging with the Spirit*, in *Art Nouveau 1890-1914*, London 2000, pp. 192-207 (with general bibliography). For Germany useful sources are K.-P. Arnold, *Von Sofakissen zum Städtebau. Die Geschichte der Deutschen Werkstätten und der Gartenstadt Hellerau*, Dresden-Basel 1993; the exhibition catalogue *Jugendstil in Dresden. Aufbruch in die Moderne*, Dresden 1999 an the catalogue of the Bröhan-Museum in Berlin *Porzellan. Kunst und Design 1889 bis 1939 vom Jugendstil zum Funktionalismus*, Berlin 1996, 2 volumes.
[8] On the presence of the Italian ceramic arts at Turin, cf. 'La sezione italiana', ed. by R. Bossaglia, with descriptions of the exhibits compiled by M.F. Giubilei, in *Torino 1902. Le arti decorative internazionali del nuovo secolo*, exhibition catalogue ed. by R. Bossaglia, E. Godoli and M. Rosci, Turin 1994, pp. 411-81.
[9] R. Ausenda, 'Il risorgimento della ceramica lombarda', in *Le arti decorative in Lombardia 1780-1940*, ed. by V. Terraroli, Milan 1998, pp. 225-79, and V. Terraroli, 'Le arti decorative a Milano in età liberty', in *Il Liberty a Milano*, ed. by R. Bossaglia and V. Terraroli, Milan 2003, pp. 86-101. For the coverage in contemporary magazines, see G. Cosi and R. Fiorini, *Ceramica e riviste italiane dal 1895 al 1930*, Faenza 1984.
[10] *Società Ceramica Richard-Ginori 1897-1903*, Milan 1904.

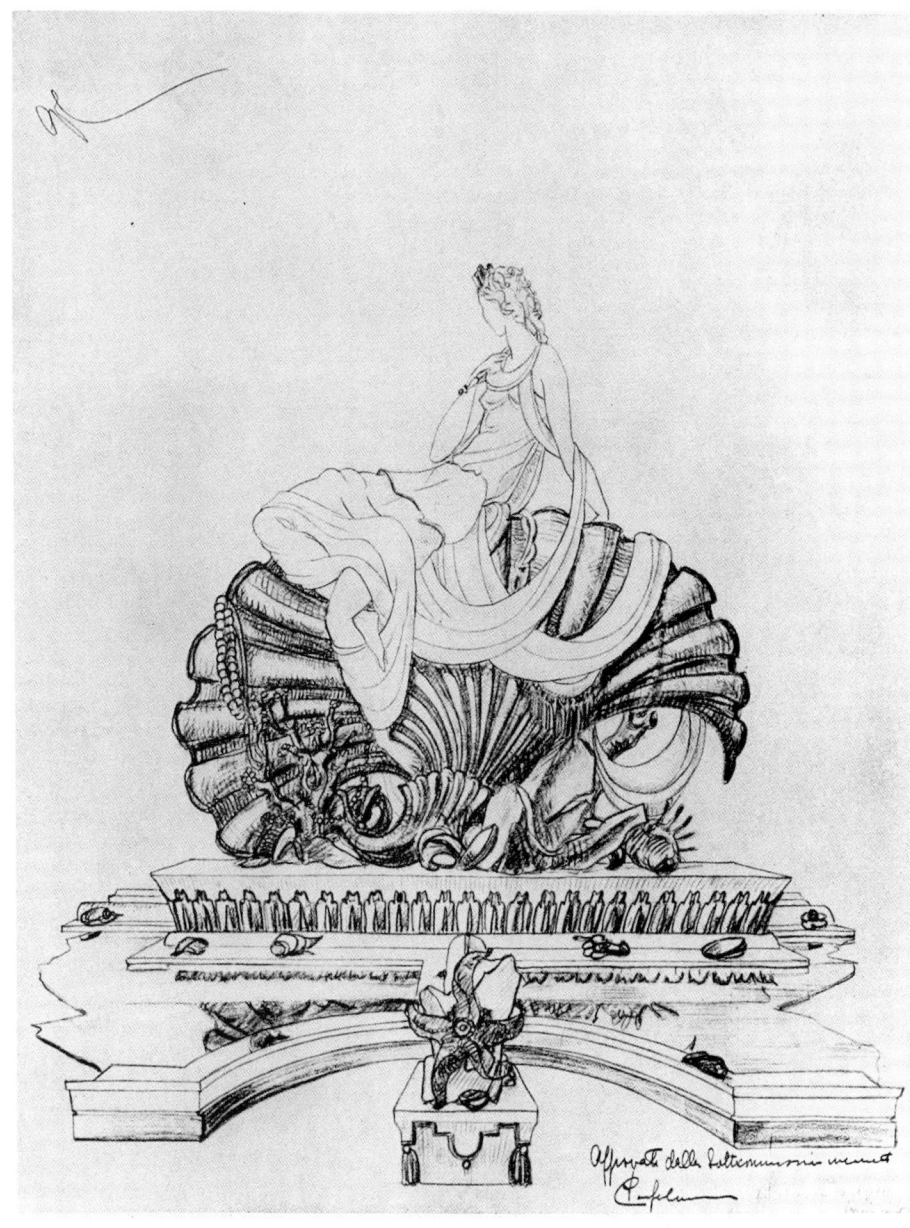

Gio Ponti, Design for the figure of many-towered Italy in the *Centrepiece for the Italian Embassies Abroad*, made in collaboration with Tomaso Buzzi, in *Domus*, December 1928

1735. In 1897 it took over the Musso pottery at Mondovì and in 1900 the production of stoneware by the Frenchman Révol at Vado. The new Società Ceramica Richard-Ginori achieved considerable success at Turin in 1898 and won the gold medal at the Paris Expo of 1900. At Turin, again in 1902, having taken on, like the major European factories, an artistic director, Luigi Tazzini, who was well-acquainted with the stylistic innovations coming out of France and Belgium, it presented a series of decorative objects in white porcelain, some conceived by the Symbolist sculptor Leonardo Bistolfi. They were characterized by flowing forms, softly modelled female figures and heads and plant motifs, reflecting a full adherence to the language of Art Nouveau but without any use of colour. This was an approach that had also been adopted in Germany, at the factory founded by Philip Rosenthal in the Bavarian city of Selb, where a modern industrial and standardized production with geometric characteristics and essential decorations was flanked by a range of moulded white porcelain figures and vases for the decoration of the modern house. Just as had happened in England, where Minton's factories had supported the development of contemporary architecture, in Lombardy the Società Ceramica Italiana of Laveno, with a workforce of four hundred and advanced industrial facilities, devoted itself to the manufacture of facing tiles, an activity in which it was joined by the Milanese Sprangher & C. and Richard-Ginori's San Cristoforo factory, which on the occasion of the exhibition celebrating the completion of the Simplon Tunnel in 1906 covered the outside walls of the Civic Aquarium with painted ceramic tiles in a distinctly Liberty style, the Italian version of Art Nouveau.

The real victor at the Turin Exhibition was, in any case, Galileo Chini, who between 1897 and 1904 held the post of artistic director of the Florentine factory L'Arte della Ceramica, founded in 1896 and renamed Ceramica Fontebuoni in 1902. His creations, ranging from large decorative vases to display plates and from bowls to amphorae, were a clear testimony to the influence of pre-Raphaelite culture and the models of William Morris on Italian decorative art. The craft-based dimension of the work, the indissoluble unity between art and life and the idea of the essential uniqueness of the individual pieces which, although mass-produced, were decorated by hand, shows just how far Italy was at this time from the idea of industrialization and the mechanical production of pieces, as was already happening at the Deutscher Werkbund in Germany. Significant moreover, in 1902, was the presence at the Florentine factory of the painter Adolfo De Carolis, an exponent of symbolist culture and 'd'Annunzian' imagery who was capable of marrying Dante Gabriele Rossetti's models of femininity with the Oriental inspiration and sinuous cadences of Art Nouveau. Chini, for his part, proposed a vast repertoire of forms and techniques of decoration. These ranged from citations of the glorious age of Italian majolica in the Renaissance, like the handles in the form of snakes that formed a continuum with the painted decoration, to the use of metallic lustres, already proposed by the Florentine factory of Ulisse Cantagalli as far back as 1878, and from naturalistic designs of insects, flowers and marsh plants to the stylized motifs of the peacock's tail, thistle and palmette. Finally there were the decorations of a distinctly graphic character or, at most, Graeco-Etruscan inspiration, of the salt-glazed stoneware vases in blue or

green on a pale ground that he continued to produce at the new Fornaci di San Lorenzo factory in Mugello that he ran, with his brothers, until 1927. Other centres of production in Italy attempted to adopt the new style, although belatedly with respect to most of the rest of Europe, but without responding to the underlying wind of linguistic and technical change. This was partly because of the essential separation of ceramic production, except in the rare cases of Cantagalli, Chini and the Milanese factories, from contemporary architectural design.[11] Salvini, Florentia Ars, Conti, Colonnata and Società Ceramica Artistica Fiorentina in Tuscany, Passarini at Bassano del Grappa, Gregorj at Treviso, Fratelli Minardi, Fabbriche Riunite and Domenico Baccarini at Faenza, the illustrious centre of Renaissance majolica, Ruggeri and Molaroni at Pesaro, Castellani and Keramos Ceramiche d'Arte, with the decorations of Renato Bassanelli, and the extraordinary figure of Duilio Cambellotti in Rome[12] and Florio in Palermo all proposed both plastic compositions and painted decorations that in essence did not diverge from the Art Nouveau models of French origin, although they certainly stood out for their very high technical quality and great craftsmanship.

This problem of the contrast between modernity and tradition, epitomized by the personality of Galileo Chini, prompted disputes on the theoretical plane between Agnoldomenico Pica, Alfredo Melani, Enrico Thovez, Roberto Papini, Adolfo Venturi and Ugo Ojetti, although each of them recognized the need for an efficient and modern training for craftsmen, for the staging of national and international exhibitions in order to promote both a taste for beauty and the market, for the creation of repertories of reference, the hiring of an artistic director by factories, including industrial ones, to guarantee the quality and originality of the production, and a substantial fusion of the arts: in other words the rigorous adoption of a modern style with all its implications of social education and the revival of popular traditions and values.[13]

The emergence of the phenomenon of the avant-garde movements in art in the first decade of the new century did not have an immediate effect on the problem of style and the decorative arts, except in the case of Italian Futurism and Russian Cubo-Futurism which, at least theoretically, aimed to put all the relations between individual, city, living spaces and objects on a new footing. The problems of the reproducibility of forms, the industrial production of articles of everyday use and the democratic widening of the market to include less affluent classes remained essentially unresolved, at least from the viewpoint of critical debate,

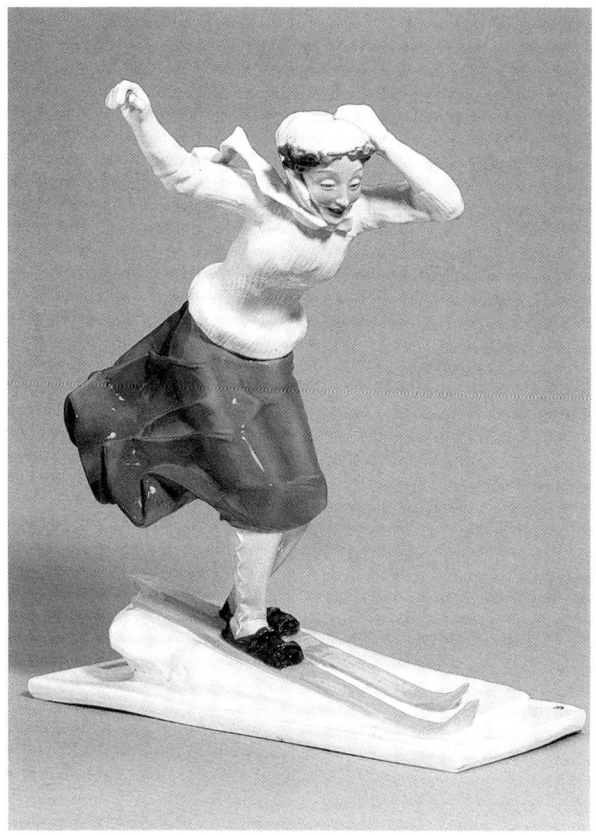

Joseph Wackerle, *Woman Skier*, 1907, Nymphenburg Factory. Bröhan-Museum, Berlin

although they did find pragmatic solutions in the market, which chose from the various proposals banally simplified lines that were most easily accepted by the general public. The grave economic crises faced by the countries of Europe at the end of the First World War, the modification in the taste of the middle class and a spasmodic effort to overcome the hardships and horrors of the war in psychological as well as material terms marked the end of modernist language, in its various national versions, which had already been showing signs of weakness and internal contradictions in the first few years of the 20th century. The question of the choice between an exclusively industrial approach and that of high artistic craftsmanship, between beauty for all or just for an elite, as well as those of the utopia of total art and integrated art and the relations between function, material and aesthetics in the individual object, remained open.

The production of ceramics was a faithful mirror of the radical transformations brought about in artistic language by the avant-gardes: it became an area of experimentation for the Cubists, responded to the propaganda needs of the Bolshevik revolution with the porcelain produced and decorated to designs by Kazimir Malevič and S.V. Chekhonin for the factory in St Petersburg,[14] took on board the Futurist ideas of Balla at the Gatti factory in Faenza, and with the splendid season

[11] G. Gardelli, 'La ceramica e il Liberty', in *Il Liberty in Italia*, cit., pp. 250-67 and the entry in *Ceramica italiana del Novecento*, ed. by F. Bertoni and J. Silvestrini, Milan 2005.
[12] On Duilio Cambellotti's prolific activity as a ceramist, cf. *Duilio Cambellotti e la ceramica a Roma dal 1900 al 1935*, ed. by M. Quesada, Florence 1988.
[13] V. Terraroli, 'Appunti sul dibattito del ruolo delle arti decorative negli anni Venti in Italia: da Ojetti a Papini, da Conti a d'Annunzio, da Sarfatti a Ponti,' in *L'arte nella storia. Contributi di critica e storia dell'arte per Giovanni Sciolla*, ed. by V. Terraroli and F. Varallo, Milan 2000, pp. 131-40.
[14] *Ceramica Sovietica. Fondo Sandretti del '900 russo*, Rovereto 2005.
[15] On the Gatti factory, cf. *Riccardo Gatti (1886-1972). Ceramiche*, ed. by G.C. Bojani, Faenza 1987. On the ceramics of Albisola, cf. G. Chilosi and L. Ughetto, *La ceramica in Liguria*, Genoa 1995.
[16] On the Rometti factory, cf. *Le Ceramiche Rometti*, ed. by E. Mascelloni and M. Caputo, Milan 2005.
[17] A retrospective of the activity of the Wiener Werkstätte was provided by the exhibition marking the centenary of their foundation and its catalogue *Der Preis der Schönheit. 100 Jahre Wiener Werkstätte*, Vienna 2003. The ceramic sector was supervised by Michael Powolny, on whom see E. Frottier, *Michael Powolny. Keramik und Glas aus Wien 1900 bis 1950*, Vienna-Cologne 1990, and then by Dagobert Peche, admired and imitated by Gio Ponti, on whom see *Die Überwindung der Utilität. Dagobert Peche und die Wiener Werkstätte*, Vienna 1998, and Vally Wieselthier, sculptress and designer, on whom see M. Hörmann, *Vally Wieselthier 1895-1945. Wien-Paris-New York*.

Gio Ponti and Giovanni Gariboldi, 'Advertisement for the Società Richard Ginori', in *Domus*, April 1928

Gio Ponti and Giovanni Gariboldi, 'Advertisement for the Società Richard Ginori', in *Domus*, June 1928

Keramik-Skulptur-Design der zwanziger und dreißiger Jahre, Vienna-Cologne-Weimar 1999.
[18] The bibliography on Gio Ponti is extensive, but the reader is referred in particular to the following works: *Gio Ponti. Ceramiche 1923-1930. Le opere del Museo Ginori di Doccia*, exhibition catalogue ed. by S. Salvi and G. Papalini, Florence 1983; *Gio Ponti. Ceramica e architettura*, exhibition catalogue ed. by G.C. Bojani, C. Piersanti and R. Rava, Faenza 1987; V. Terraroli, 'Milano déco: le arti decorative e industriali tra il 1920 e il 1930', in *Milano déco. La fisionomia della città negli anni Venti*, ed. by R. Bossaglia and V. Terraroli, Milan 1999, pp. 29-127; V. Terraroli, 'Le arti decorative in *Domus* 1928', in *Le arti decorative in Lombardia 1789-1940*, ed. by V. Terraroli, Milan 1998, pp. 345-69; L. Manna, *Gio Ponti. Le maioliche*, Milan 2000.
[19] On Guido Andlovitz, cf. M. Munari, *Guido Andlovitz. Ceramiche di Laveno 1923-1942*, Rome 1990.
[20] On Francesco Nonni, see *Francesco Nonni. Ceramiche degli anni Venti*, ed. by G.C. Bojani, Faenza 1986.
[21] On Pietro Melandri, cf. E. Gaudenzi, *Pietro Melandri (1885-1976)*, Faenza 2002.
[22] On the phenomenology of Art Deco there is now a rich but heterogeneous bibliography, but of particular interest are the catalogues of the recent exhibitions in London: *Art Déco 1910-1939*, ed. by C. Benton, T. Benton and G. Wood, London 2003, and *Modernism: Designing a New World 1914-1939*, ed. by C. Wilk, London 2006; for Italy, in addition to *Milano déco. La fisionomia della città negli anni Venti*, cit., see *Il Déco in Italia*, ed. by F. Benzi, Rome 2004; while on the ceramics of the Deco period, cf. K. McCready, *Art Deco and Modernist Ceramics*, London 1995. Still

at Albisola,[15] through the inventions of the aeropainters, from Farfa to Tullio d'Albisola and from Crali to Diulgheroff and the young Munari, the Rometti factory at Umbertide,[16] with the decorations devised by Corrado Cagli and Dante Baldelli, and the Galvani workshops at Pordenone.

The extraordinary production of the Wiener Werkstätte,[17] which set the standard for the taste of the European upper middle class, had put itself forward as an idealistic alternative, in the rigorous and elaborate training of its craftsmen, to the reality of machinery and production on an industrial scale, resuscitating, once again before the explosion of the phenomenon of the artistic avant-gardes, the utopia of art as a means of reshaping and transforming everyday life. The affirmation of the Viennese Secessionist credo, in open contrast to the more thoroughly industrialized situation in Germany, where simplicity of form was introduced as an *a priori* necessity of industrial reproduction rather than as an aesthetic choice of the emerging discipline of design, found direct parallels in Italy in Ponti's activity at Richard-Ginori, from 1923 on,[18] in the figure of Guido Andlovitz, artistic director at the Laveno factory[19] and very close to the Viennese style, and in the potteries of Faenza with Francesco Nonni[20] and Pietro Melandri[21] and his school, giving rise to the Italian version of the international Art Deco: supple figures in syncopated attitudes, based on Futurist models, stylized naturalistic if not clearly abstract decorations, references to the Mannerist repertoire (Ponti) and the Pompadour style (Ponti, Andlovitz and Nonni), a melting pot of Orientalism, allusions to classical culture, folk traditions and the languages of the Viennese Secession (Andlovitz, Melandri, Ponti).

But once again it was Paris, with the Expo of 1925, that marked a turning point in taste: that event represented the climax of the Deco style[22] and not its beginning, revealing the substantial internal contradictions in the never resolved conflict between functional art and decorative art, and showing itself to be the heir to a certain way of understanding Art Nouveau. Once again the idea of the beauty of the superfluous was accentuated in order to feed a market perennially hungry for novelty, and this also led to a total renewal of the design and modalities of advertising. The task of Art Deco seems to have been that of winning over the broadest possible section of the public to a modern and characteristic style, as an alternative to the still very popular reproduction object. At the same time, however, the utopian desire to create total art and to bring about a radical change of society through beauty appears to have been eclipsed by an accommodation that was more commercial than aesthetic, borrowing from incipient rationalism and the Futurist and Constructivist redrafting of the

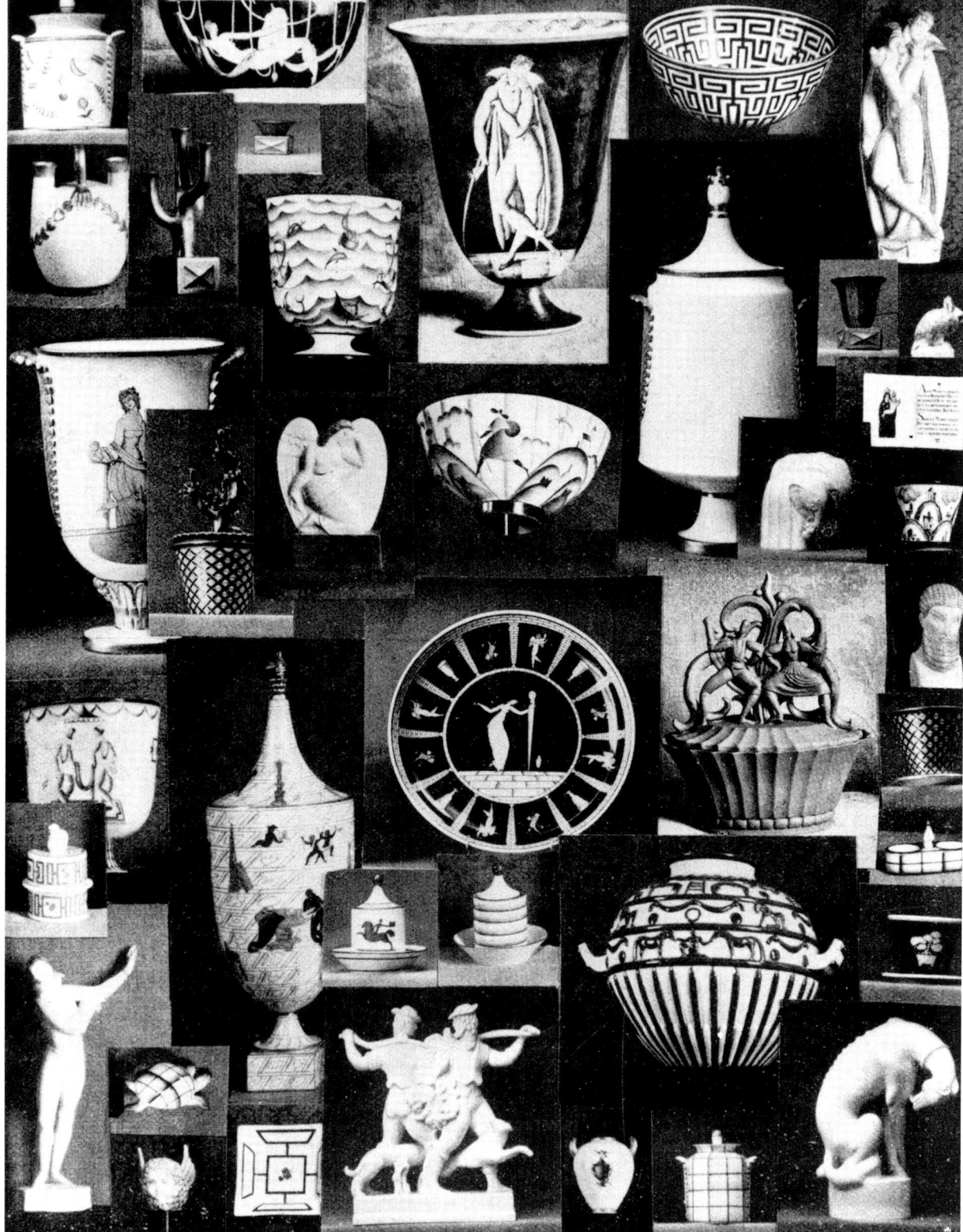

Gio Ponti, 'Advertisement for the Società Richard Ginori', in *Domus*, December 1928

indispensable are the numerous magazines, exhibition catalogues, catalogues of the production of individual factories and repertories, in particular R. Papini, *Le arti d'oggi. Architettura e arti decorative in Europe*, Milan-Rome 1930; *Les Arts décoratifs modernes. France*, ed. by G. Quénioux, Paris n.d. (but 1928); and *Encyclopédie des arts décoratifs et industriels modernes au XXème siècle*, 12 volumes, Paris n.d. (*circa* 1930).

[23] The sumptuous *Centrepiece for the Italian Embassies* was produced in limited numbers between 1926 and 1927 and is an example of an effective collaboration between the architects Gio Ponti and Tomaso Buzzi, while the models were made by the Tuscan sculptor Italo Griselli and the gilding executed with an agate-tipped stylus on the white porcelain by Elena Diana.

[24] On the exhibitions at Monza, cf. V. Terraroli, *Milano déco: le arti decorative e industriali tra il 1920 e il 1930*, cit., Milan 1999, pp. 29-127, and *1923-1930 Monza. Verso l'unità delle arti. Oggetti d'eccezione delle Esposizioni internazionali di arti decorative*, ed. by A. Pansera and M.T. Chirico, Cinisello Balsamo 2004.

[25] On the history of the I.S.I.A. at the Villa Reale in Monza, see *L'I.S.I.A. a Monza. Una scuola d'arte europea*, ed. by R. Bossaglia, Monza 1986, and V. Terraroli, 'Appunti sul dibattito del ruolo delle arti decorative negli anni Venti in Italia: da Ojetti a Papini, da Conti a d'Annunzio, da Sarfatti a Ponti', cit.

Nikolaj Sujetin,
Ink-pot and pen holder, 1922-23,
Porcelain Factory, St Petersburg.
Bröhan-Museum, Berlin

spaces of daily life the grating and nimble, geometric and essential cadences that distinguished it. On the other hand it was evident at the Paris Expo, and at other exhibitions of the kind, that a harmonious and indissoluble relationship between everyday environmental and decoration, which had been the linchpin of the modernist utopia, had been sidestepped, not because the terms of the question, debated on many occasions, were not known, but because preference was given to the individuality and refined preciosity of the object, its isolation with respect to a context into which it fitted, but which it could happily do without, and, when all is said and done, its absolute gratuitousness, and this greatly increased people's desire to possess it.

The fact that Deco production in the decorative arts, but also in ornamental painting and sculpture, which continued essentially unchanged up until the end of the thirties, was aimed at a niche market is indubitable, but it is equally true that the glittering world of spangles and gilding, of beguiling boudoirs and lavish residences, of the at once old-fashioned and modern ambiences that could be seen in films, in plays, on transatlantic liners, in hotels and in cafés, penetrated deeply into the collective consciousness and common feelings, fuelling a desire for identification with that exclusive and glossy setting. Out of this came a widespread production of vulgar and second-rate forms of the 'twenties' style, which contrasted with an output that, while mass-produced, retained a high quality of invention and decoration, such as the majolica ware and porcelain designed by Gio Ponti for Richard-Ginori. It suffices to think of the stunning and unrivalled Centrepiece for the Italian Embassies of 1926-27[23] and the large majolica ware and stylized and extremely modern figures modelled by Gerhard Schliepstein, artistic director at the factory in Rosenthal in the twenties. At the same time Deco became a way of recovering for contemporaneity ethical and aesthetic values considered lost, such as craft traditions and national and regional roots, as happened, for instance, in Italy, by seeking to marry rural culture and metropolitan elegance, pride in one's own history and openings to an international style.

The series of exhibitions specifically devoted to the decorative arts, held every two years at the Villa Reale in Monza from 1923 to 1927 and then again in 1930,[24] before being transferred to Milan where it became a triennial event, demonstrates the desire for Italian artistic production to be a success at the European level, for the updating of its style and its never forgotten relationship with tradition and for the forging of a close link between the decorative arts and the figurative arts, which led to the foundation of the I.S.I.A. (Istituto Superiore per le Industrie Artistiche) in 1925.[25] It is significant, besides, that at the Paris Expo in 1925 Italy achieved an extraordinary success with the majolica and porcelain designed by the architect Gio Ponti for Richard-Ginori: objects of extreme refinement, cultured and modern, the product of a combined effort of the designer and artists and craftsmen of matchless skill (from Italo Griselli to Libero Andreotti) in which formal structure and decoration, indebted to the experiences of the Viennese Secession, they represented the swansong of artistic ceramics. The speeding up of production, the demands of an ever expanding market and the parenthesis of the war and subsequent reconstruction increasingly widened the gap between the artistic ceramic product and commercial production. And while the birth of contemporary design ushered in a new period of inventiveness, stimulating new concepts of style and new fashions, ceramics too found renewed creativity as an artistic medium through the original work of Leoncillo Leonardi, Lucio Fontana and Fausto Melotti.

Plates

Note

The plates are arranged in
chronological order and accompanied
by captions giving the author and title
of the piece, the date, the factory and
a reference to the relevant section
of the catalogue.
The catalogue contains all the
technical descriptions, along with
small format reproductions in black
and white, of all the works selected
for analysis. The sections are
arranged chronologically and divided
up into twenty-year periods
(1890-1910; 1910-1930; 1930-1950).
Within each twenty-year period
the pieces are grouped by factory
and according to their geographical
location (from north to south),
each factory by author in alphabetical
order and the individual pieces
by each author are arranged
in chronological order.
The descriptions are purely technical.

Galileo Chini
Amphora with handles in the form of snakes, 1896-98
(cat. 1)

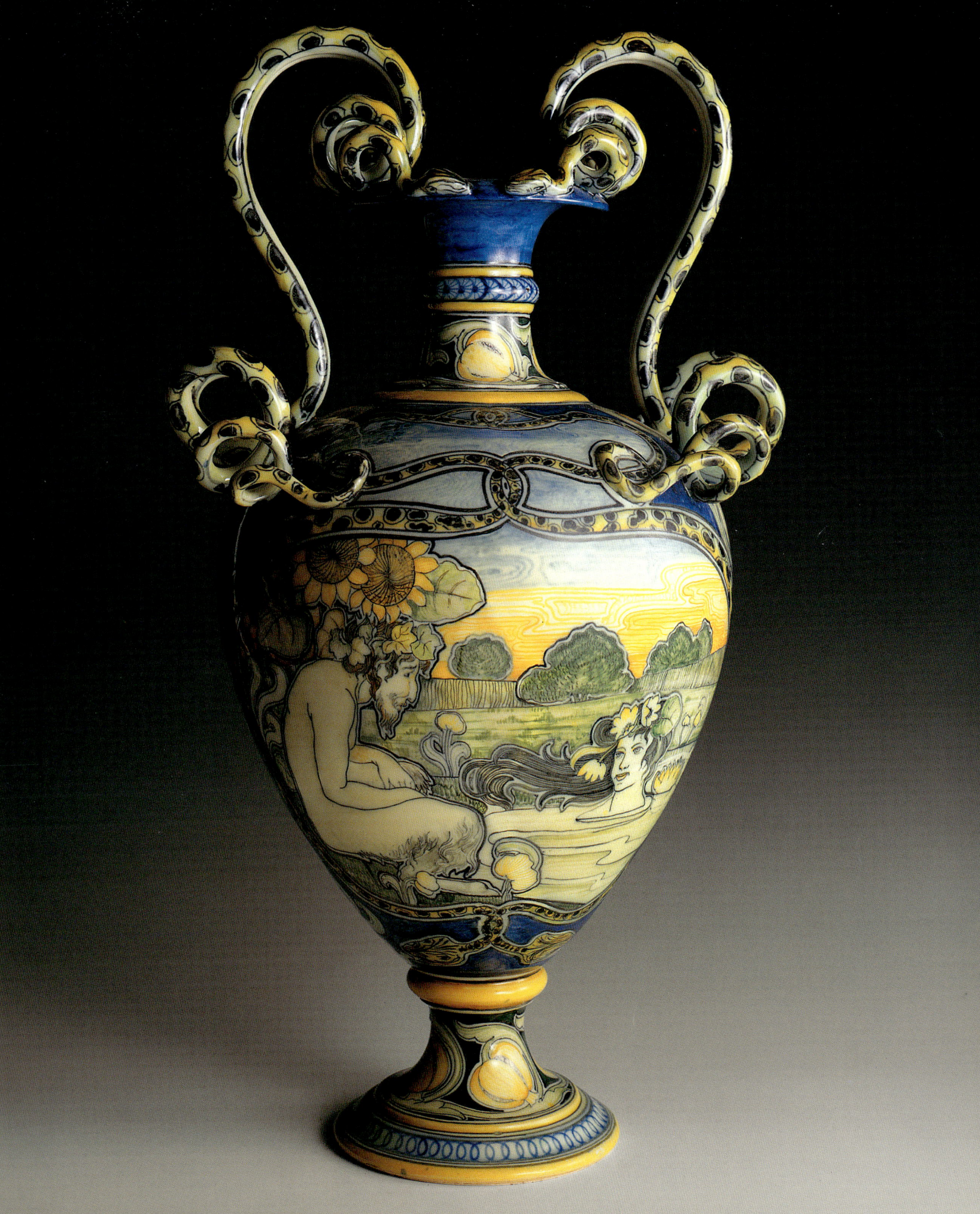

Galileo Chini
Vase with woman's profile,
1896–1900
(cat. 4)

Galileo Chini
Plate with woman's profile,
1898–1900
(cat. 6)

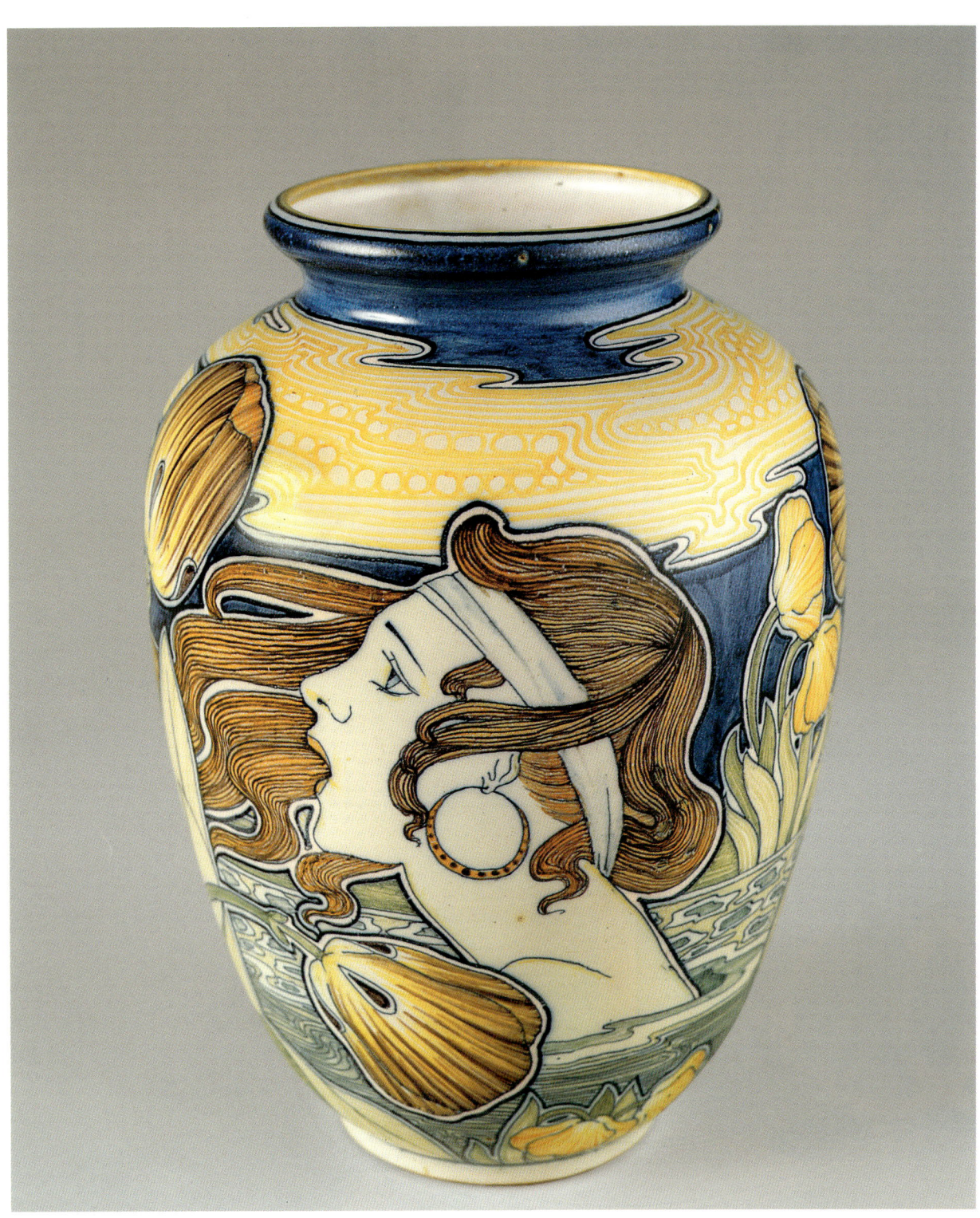

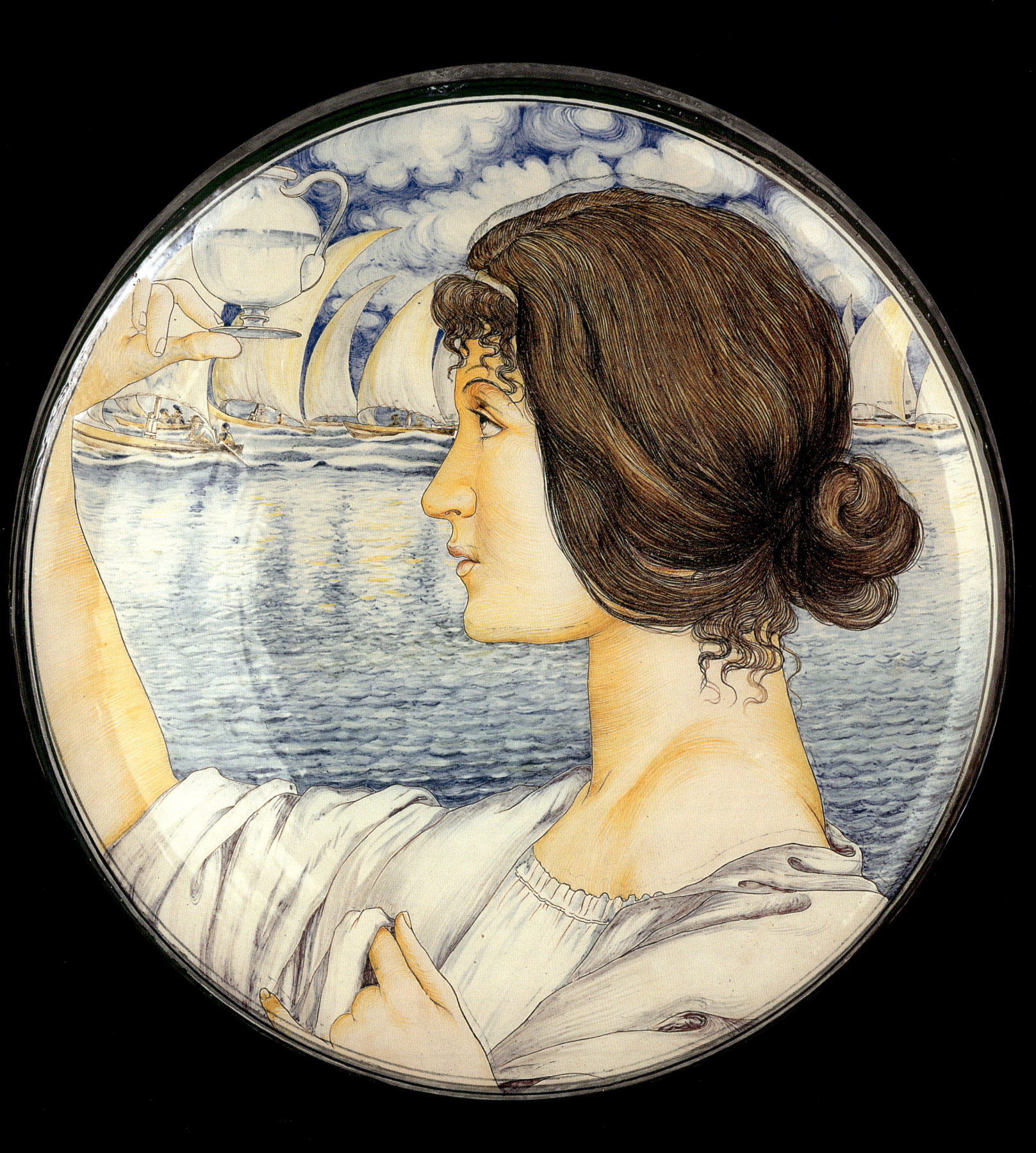

Domenico Baccarini
Vase with carnations, 1908
(cat. 37)

Vase with garlic flowers, 1908
(cat. 39)

26

Galileo Chini
Large vase with floral motifs, 1910
(cat. 15)

Plate with eagle, circa 1900
(cat. 41)

Galileo Chini
Vase with salamanders, 1898–1902
(cat. 11)

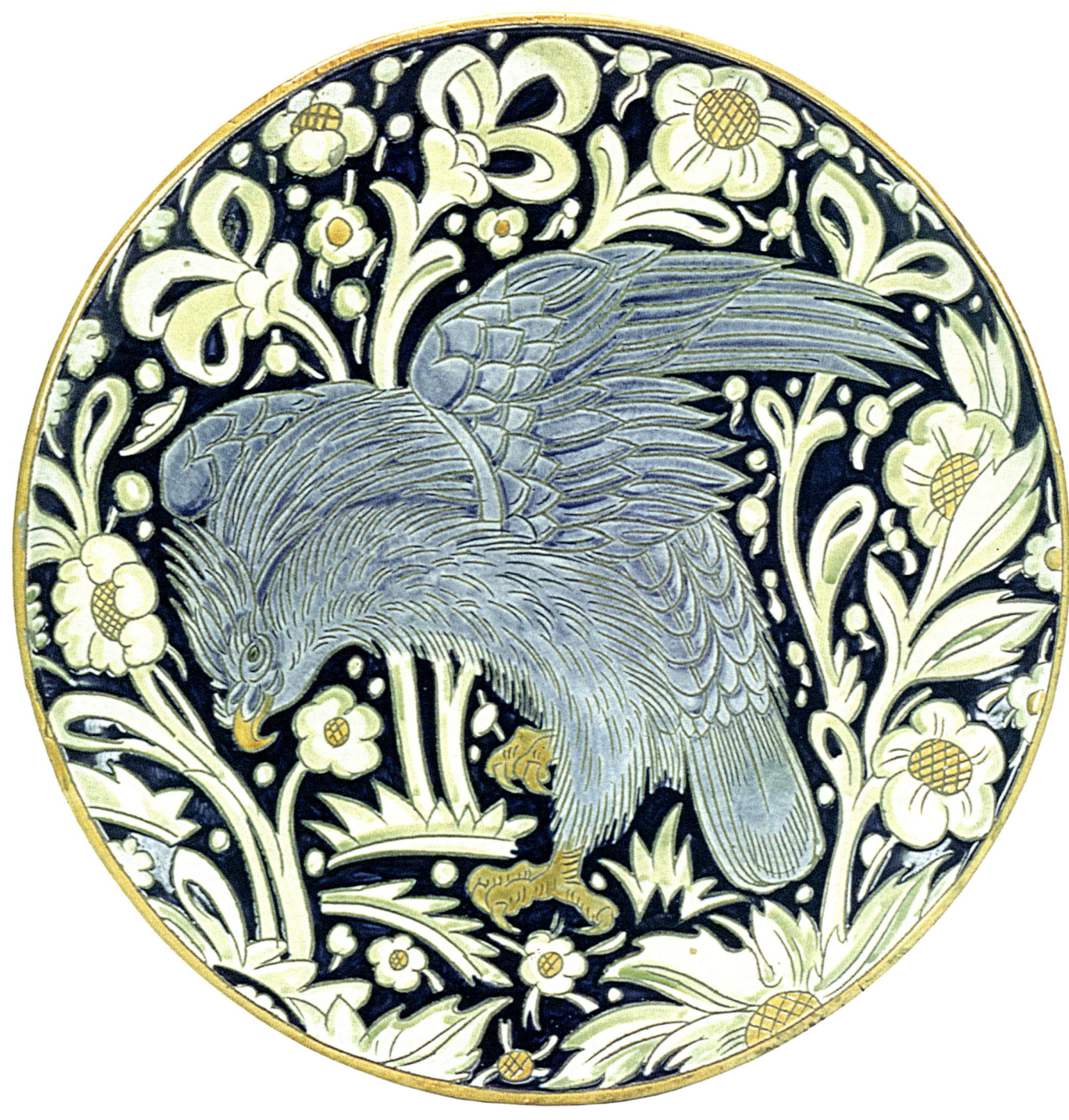

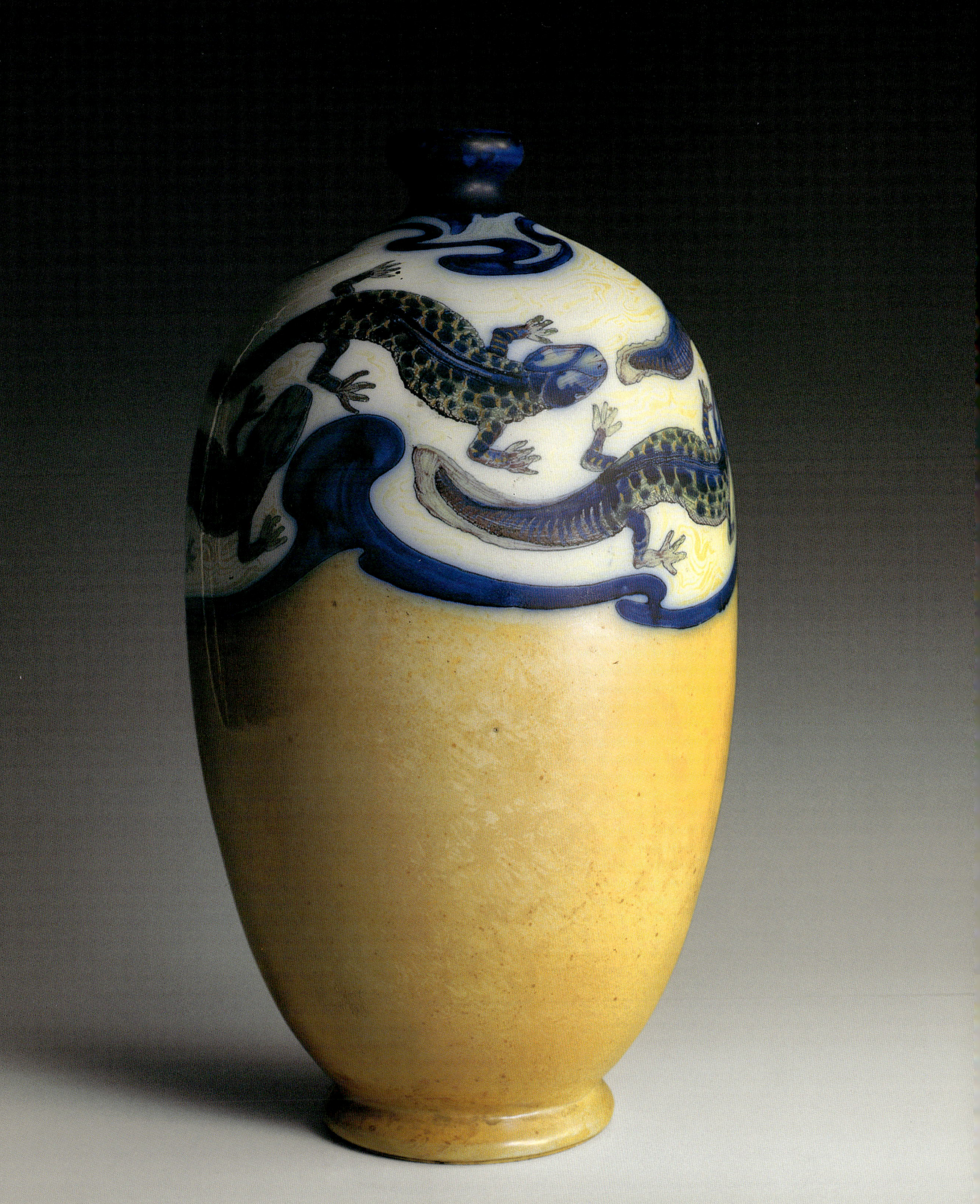

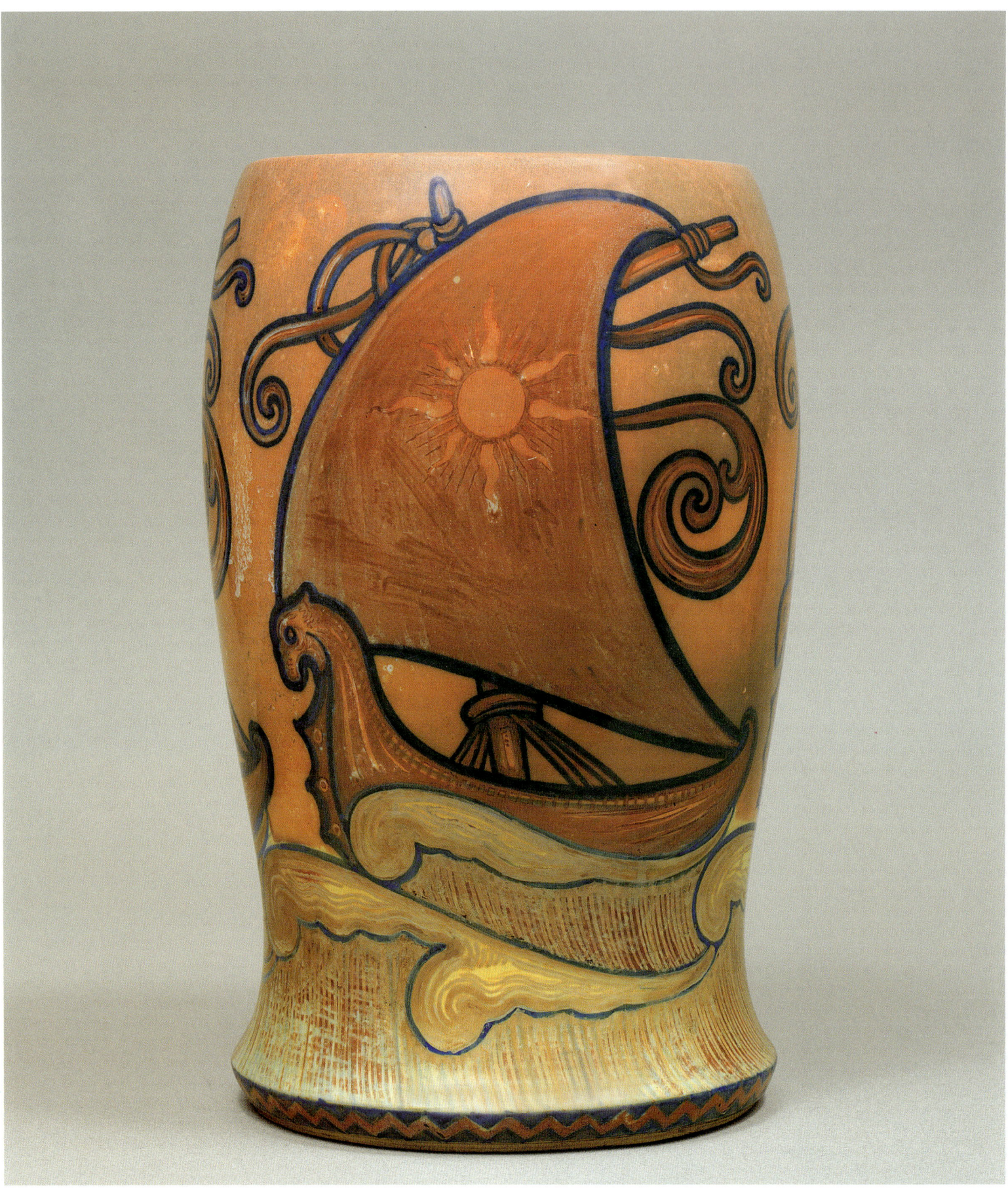

Galileo Chini
Vase with ship, 1906–10
(cat. 17)

Galileo Chini
Vase with laurel trees and waterscape, 1898–1900
(cat. 8)

Galileo Chini
Vase with birds of prey and decoration of stylized peacock feathers, 1898–1902
(cat. 10)

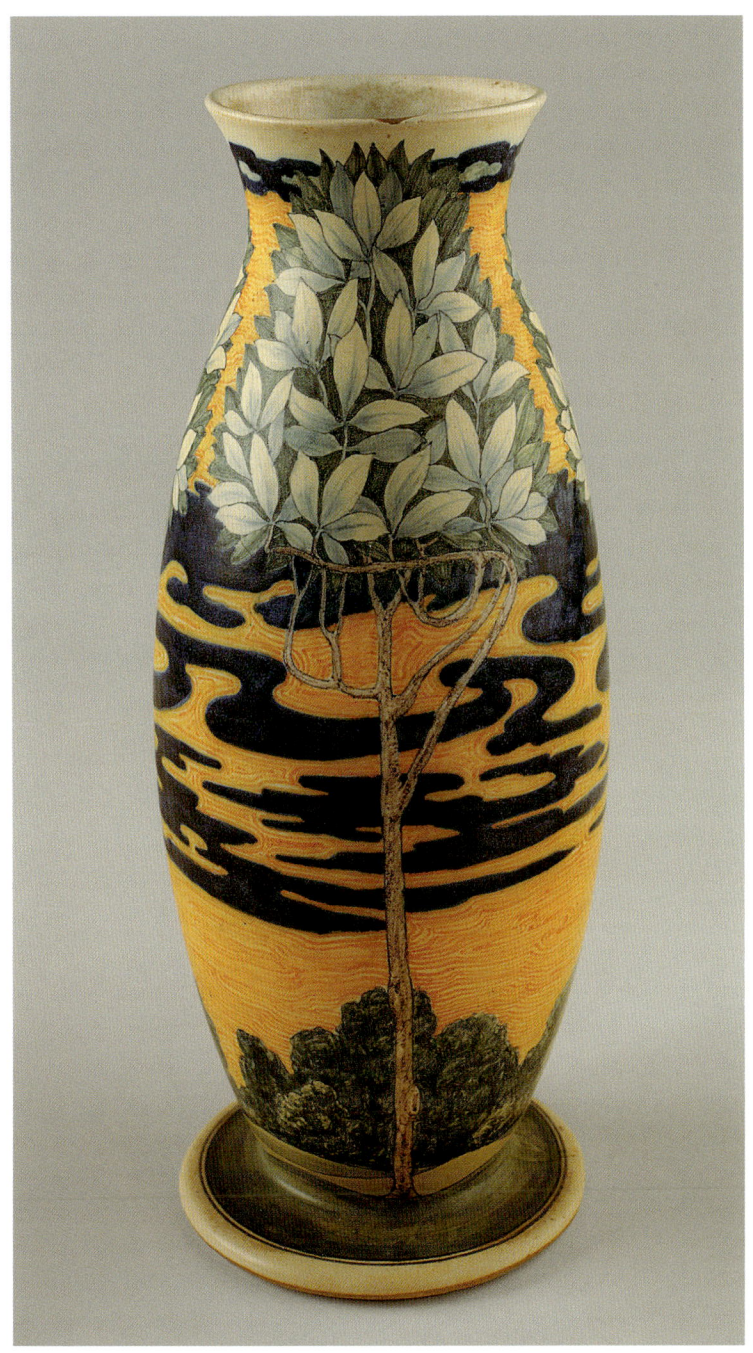
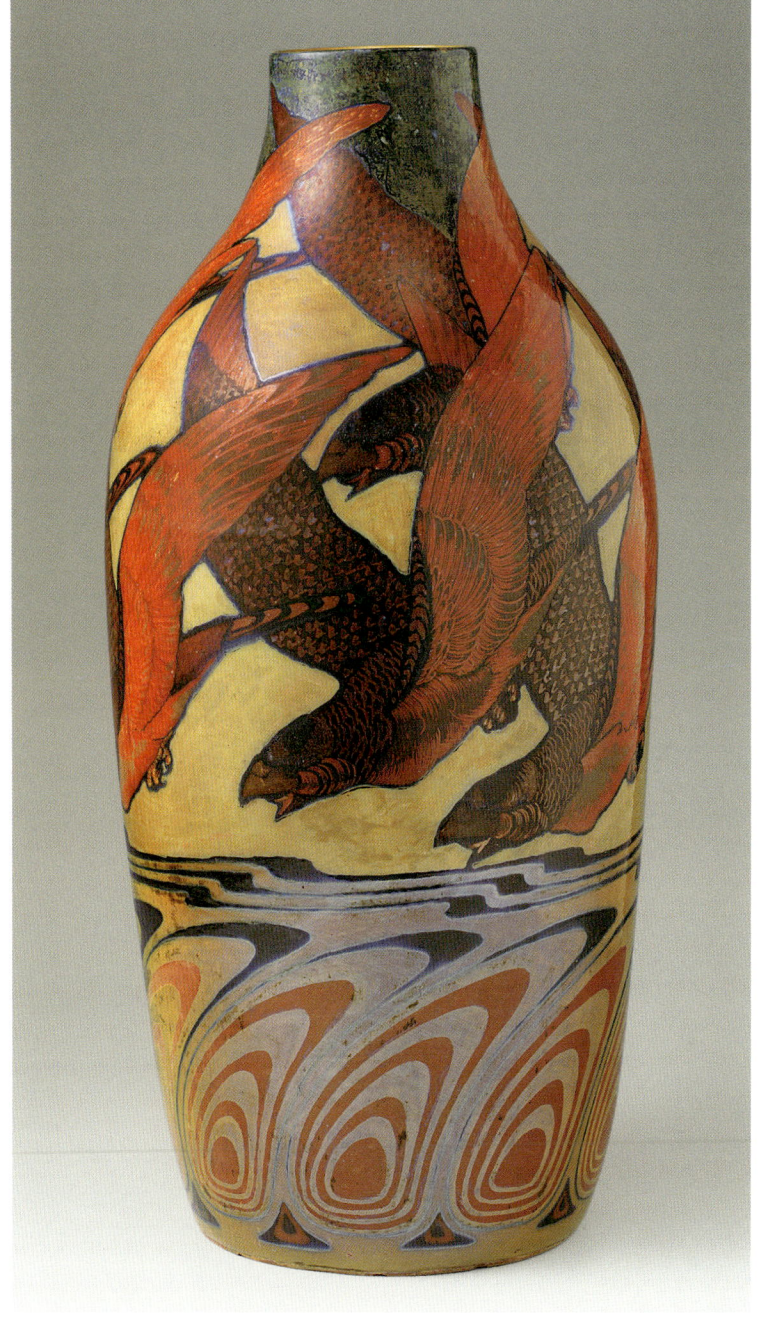

Galileo Chini
Vase with trees and butterflies,
1903–04
(cat. 14)

Galileo Chini
*Jar with geometric decorations
and three medallions with pairs
of stylized hawks, circa* 1919
(cat. 22)

Galileo Chini
*Vase with water arum flowers
and leaves,* 1906
(cat. 20)

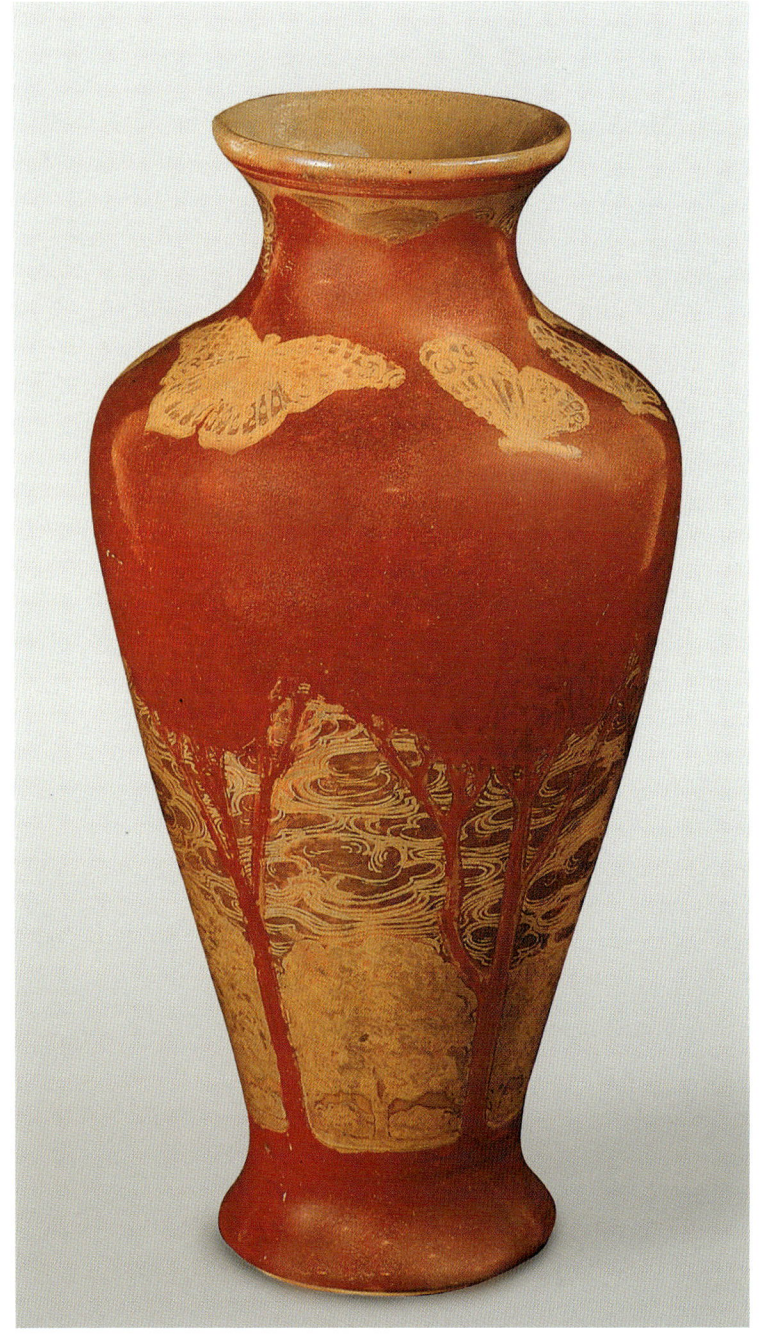
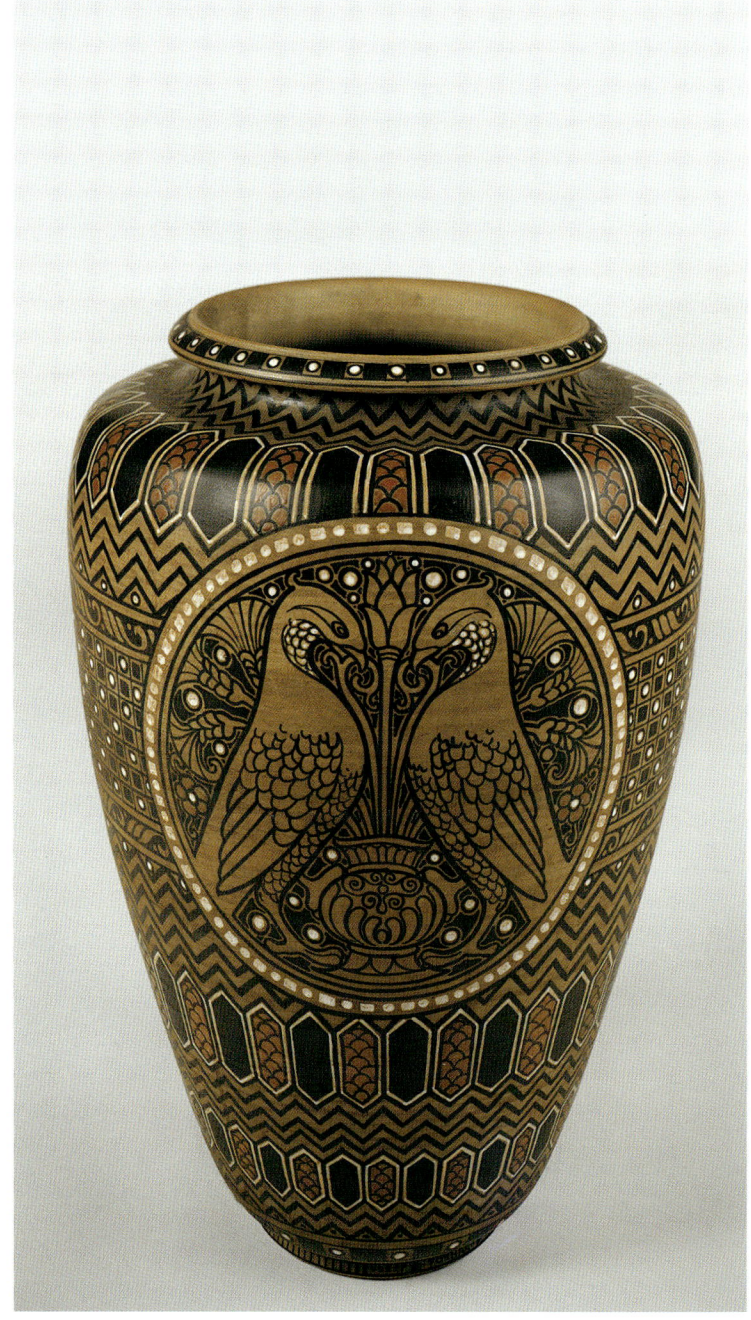

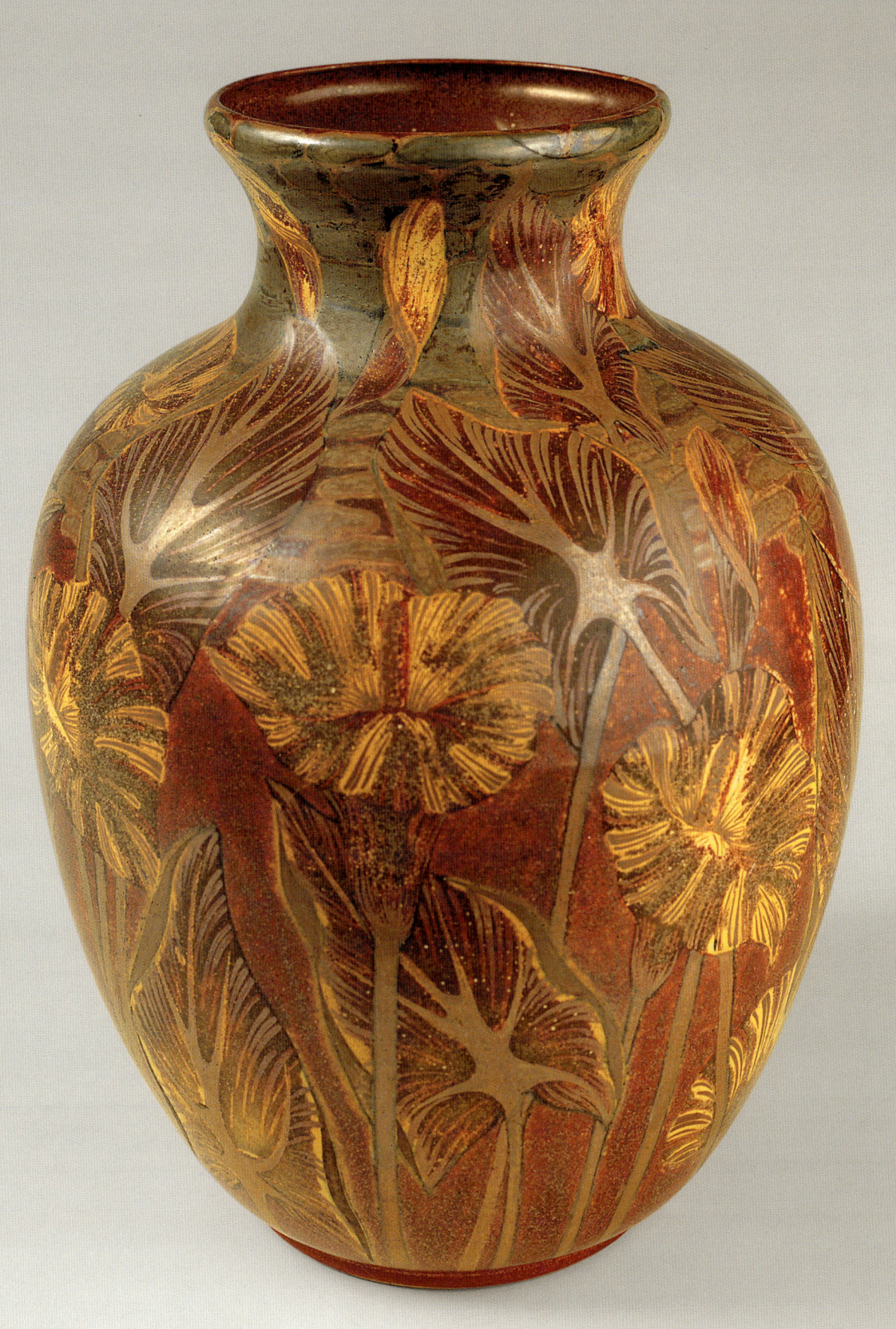

Galileo Chini
Vase with cicadas, 1906–10
(cat. 18)

Galileo Chini
Goblet with waves and sea birds,
1906–10
(cat. 19)

Giorgio Spertini
Vase with gilded metal mount, 1903
(cat. 29)

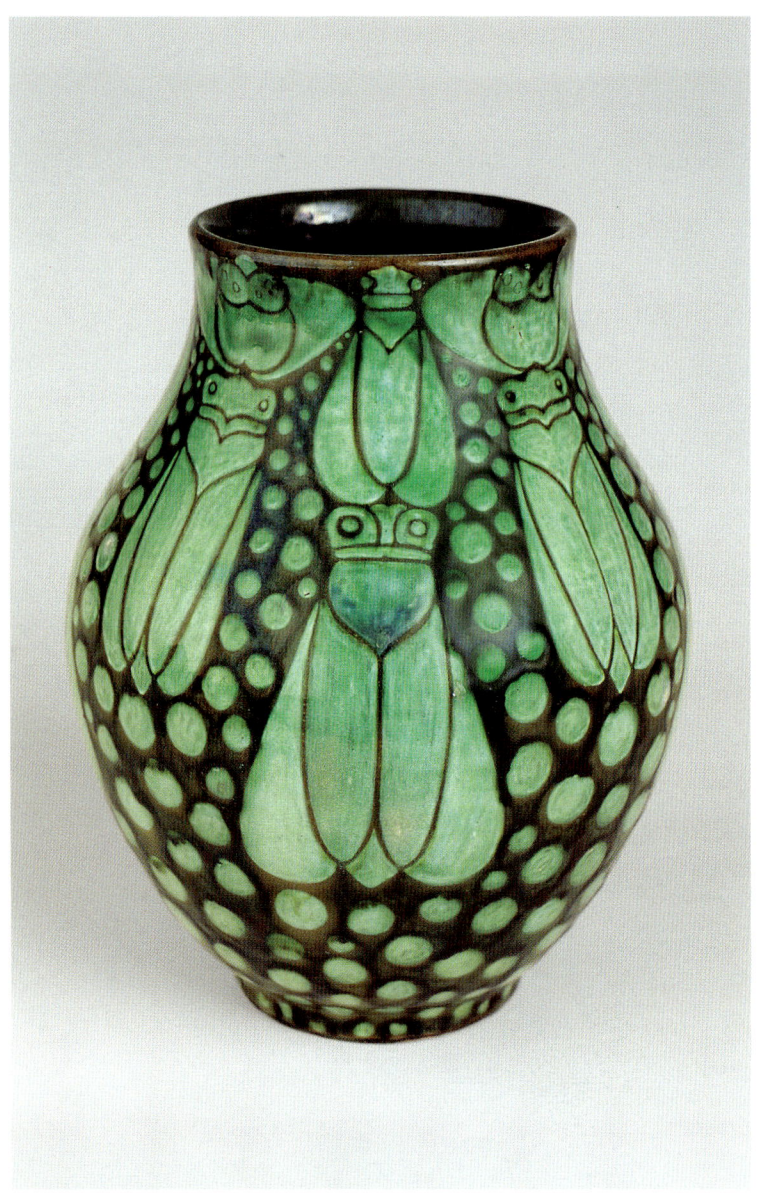

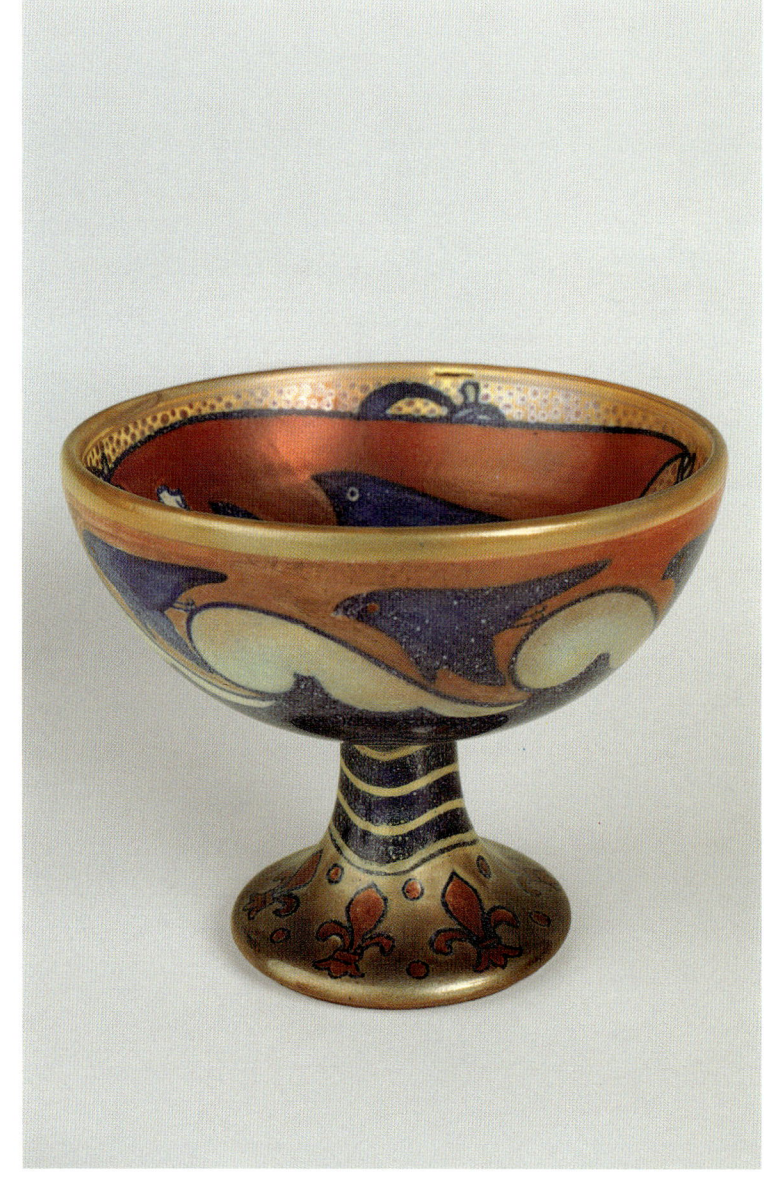

Quaglino Poggi
Anthropomorphic bowl with face and hair of a girl, 1912–15
(cat. 35)

Achille Calzi, attributed to
Display plate with Gorgon's head, circa 1916
(cat. 40)

38

Alfredo Biagini
Small faun, circa 1920
(cat. 242)

Romeo Berardi
Plate with marine fantasy, 1923
(cat. 240)

Renato Bassanelli
Vase with faun perched in a tree,
circa 1922
(cat. 237)

Renato Bassanelli
Vase with putti and garlands
of flowers, 1925–30
(cat. 238)

Duilio Cambellotti
Vase of the Zodiac, 1923
(cat. 248)

40

Giulio Rufa
Vase with putti carrying baskets of fruit, circa 1925
(cat. 261)

Alfredo Biagini, attributed to
Egg-shaped vase with female nudes and garlands of flowers in a wood, circa 1925–30
(cat. 245)

Giulio Rufa, attributed to
Vase with women carrying baskets, 1926
(cat. 262)

Duilio Cambellotti
Fountain of the Jugs, 1910–14
(cat. 49)

Duilio Cambellotti
Vase with crows, 1927
(cat. 252)

45

Enzo Ceccherini
Vase with four handles in the form of ears of wheat and rural scenes, 1922
(cat. 51)

Pietro Melandri
Vase with lid decorated with ivy leaves and gilded floral pattern, 1925
(cat. 55)

Pietro Melandri
Small bowl with woman's head in a Byzantinizing style, circa 1926
(cat. 56)

Pietro Melandri
Vase with antelopes, 1924–26
(cat. 54)

Francesco Nonni and Anselmo Bucci
Hindu dancing girl on elephant, 1927
(cat. 71)

Francesco Nonni and Anselmo Bucci
Figure in black-and-silver pyjama-robe (*Portrait of Domenico Silvestrini*), 1923
(cat. 66)

Francesco Nonni and Pietro Melandri
Inkwell with dancing woman and panther, 1923
(cat. 67)

Francesco Nonni
Andalusian woman, 1923–25
(cat. 65)

Francesco Nonni
Pierrot, 1925
(cat. 70)

Francesco Nonni and Pietro Melandri
Container in the form of a lady in 18th-century dress, 1920–22
(cat. 64)

Francesco Nonni
Dancer with flower-patterned dress, 1923
(cat. 68)

Pietro Melandri and Ercole Drei
Tragedy and Comedy, 1928
(cat. 62)

Gio Ponti and Giorgio Supino
Bust of woman with floral shawl, 1923
(cat. 106)

on the following pages:

Gio Ponti
Plate with Euridice, 1923
(cat. 104)

Gio Ponti
Plate with Orfeo, 1923
(cat. 105)

60

Gio Ponti
Ink-pot with figure of dancing master, 1925
(cat. 116)

Gio Ponti
Ink-pot with quill and scroll, 1925
(cat. 117)

Gio Ponti
Sugar bowl with lid decorated with niches holding small urns, 1923–25
(cat. 185)

Gio Ponti
Ink-pot decorated with works of architecture, 1925
(cat. 114)

Gio Ponti
Ink-pot decorated with Eros on red ground, 1925
(cat. 115)

Gio Ponti
Urn with skiers, 1930
(cat. 174)

Gio Ponti
Urn with 'The Classical Conversation',
1925
(cat. 173)

Gio Ponti
Urn with 'The Archaeological Stroll',
1923–25
(cat. 172)

63

Gio Ponti
Urn with grotesque decorations, 1925
(cat. 169)

Gio Ponti
Urn with Mannerist architectural decorations, 1925–30
(cat. 171)

66

Gio Ponti
Urn with a representation of the chariot of Cupid and the chariot of Fortuna, 1925
(cat. 170)

Gio Ponti and Libero Andreotti
'The Triumph of Love and Death' cista, 1927–30
(cat. 125)

Gio Ponti and Libero Andreotti
'The Archaeological Stroll' cista,
1924–25
(cat. 124)

Gio Ponti and Libero Andreotti
'The Migration of the Mermaids'
cista, 1927–30
(cat. 126)

on the following pages:

Gio Ponti
Pair of 'Hunting' plates: the Stag Hunt; Carrying the Quarry, 1927–30
(cat. 167, 168)

69

Gio Ponti
Vase of Flowers and Women, 1924
(cat. 161)

Gio Ponti
'My Women: Agata' plate, 1925
(cat. 159)

Gio Ponti
'My Women: Isabella' plate, 1925
(cat. 160)

Gio Ponti
'My Women: Donatella' plate, 1925
(cat. 156)

Gio Ponti
'My Women: Leonia' bowl, 1924
(cat. 153)

Gio Ponti
'My Women: Donatella' bowl, 1924
(cat. 154)

on the following pages:

Gio Ponti
'The Classical Conversation' vase, 1925
(cat. 110)

Gio Ponti
'The House of the Industrious and Indolent Ephebes' vase, 1924
(cat. 109)

77

79

Gio Ponti
Large 'Dance Troupe' bonbonnière,
1927
(cat. 141)

Gio Ponti
'Putto on Dolphin' from the series of the *Large Centrepiece for the Italian Embassies*, 1926
(cat. 140)

Gio Ponti with Italo Griselli, Tomaso Buzzi and Luigi Tazzini
Italy, central part of the *Large Centrepiece for the Italian Embassies*, 1926
(cat. 139)

Gio Ponti and Geminiano Cibau
The Dancing Master, 1927
(cat. 133)

Gio Ponti
'The Dancing Master' goblet, 1927
(cat. 134)

Gio Ponti
'Hospitality' goblet, 1927–28
(cat. 136)

Gio Ponti
Tile with Venus, circa 1927
(cat. 138)

Guido Andlovitz
Plate with Judith and the head of Holofernes, 1923
(cat. 84)

Gio Ponti
'Noble Activities. The Ancestors' plate,
1924–25
(cat. 118)

Gio Ponti
'Perfidious Cammilla' plate, 1924–25
(cat. 122)

Gio Ponti
'The Lovers' plate, 1925
(cat. 120)

Gio Ponti
'The New Love' plate, 1925
(cat. 121)

Gio Ponti
'Mea Lesbia' plate, 1924–25
(cat. 119)

Gio Ponti
'The Archaeological Stroll' plate,
1928
(cat. 129)

Gio Ponti
'The Archaeological Stroll' plate,
1924
(cat. 130)

Gio Ponti
'Prospectica' amphora, 1925
(cat. 188)

94

Guido Andlovitz
Two-handled vase, 1927
(cat. 331)

Guido Andlovitz
Spherical vase with small grips, 1930
(cat. 103)

Guido Andlovitz
Pair of potiche *vases with lids,*
circa 1928
(cat. 96-97)

Guido Andlovitz
*Small vase with lid decorated
with a cactus*, 1926–27
(cat. 95)

Guido Andlovitz
'Monza 83' vase with double leaf-shaped handle and naturalistic decorations in a grid of squares, 1927–30
(cat. 94)

Guido Andlovitz
Vase of the Legions, 1927
(cat. 91)

Guido Andlovitz
Vase with figures of musicians, 1927
(cat. 87)

Guido Andlovitz
Three plates with figurines in neo-18th-century style and candelabrum decorative motifs, 1927
(cat. 88-90)

Guido Balsamo Stella
Bowl of the Ermine, 1923
(cat. 73)

Giacinto Dolcetti
Server with lady in 18th-century costume in a garden with balustrade and arch of greenery, circa 1925
(cat. 76)

101

Rodolfo Ceccaroni
'The Resurrection', 1928
(cat. 276)

Ferruccio Mengaroni
Panel with head of Medusa, 1925
(cat. 273)

Tarcisio Tosin
Prismatic cista *with two small applied female nudes*, 1928
(cat. 355)

Tarcisio Tosin
Cylindrical cista *with two applied female figures in niches. Stepped lid with kneeling female figure*, circa 1930
(cat. 357)

Tarcisio Tosin
Cylindrical urn with two applied female figures in niches. Stepped lid with kneeling female figure, circa 1930
(cat. 358)

105

Giuseppe Piombanti Ammannati
*Woman's bust with hat and fan:
The Fan, circa* 1937
(cat. 441)

Arturo Martini
Judith, 1927
(cat. 218)

Arturo Martini
Bathers, 1929–30
(cat. 220)

Arturo Martini
Flamingo, 1929–30
(cat. 221)

Tarcisio Tosin
Reclining female nude, circa 1930
(cat. 359)

Giovanni Grande
Pollux, 1929
(cat. 198)

109

Mario Sturani
Vase representing three masks, 1929
(cat. 212)

Mario Sturani
Bowl with family group, 1930
(cat. 213)

Mario Sturani
Bowl with group of young people dancing, 1930
(cat. 214)

Corrado Cagli
Urn with lid, representing a decorator of pottery, 1929
(cat. 415)

Corrado Cagli
Urn with lid and grip in the form of a fruit, decorated with images of peasant women with baskets of fruit, 1930
(cat. 417)

Corrado Cagli
'The Glebe' vase, 1930
(cat. 419)

Corrado Cagli
'The Graces' vase, 1930
(cat. 420)

114

Dante Baldelli and Corrado Cagli
Urn with lid and grip in the form of a cockerel, decorated with images of two peasant women, 1930
(cat. 416)

Dante Baldelli
Vase with lid, representing the theme of labour, 1931–33
(cat. 421)

115

Corrado Cagli
Vase with lid and grip in the form of ibexes, representing archers, 1931–33
(cat. 423)

Corrado Cagli
Pair of vases with lid and grip in the form of a wing, decorated with winged figures, 1930–31
(cat. 424)

Plate with the Crucifixion and angels, circa 1930
(cat. 426)

Corrado Cagli
Large 'Horse-breaker' plate, 1930–32
(cat. 427)

Dante Baldelli
Panel with five tiles: 'Believing, Obeying, Fighting'; 'The March on Rome'; head of Benito Mussolini; 'Silence is Tough Discipline'; 'Combat', 1931–32
(cat. 413)

119

Dante Baldelli
Two large 'Hunters' plates, 1935
(cat. 430, 431)

Dante Baldelli
Large 'Mermaids' plate, 1935
(cat. 429)

Dante Baldelli
*Vase with allegories of Architecture,
Painting and Sculpture*, 1935
(cat. 428)

Corrado Cagli
Vase representing the theme of motherhood, circa 1935
(cat. 425)

Dante Baldelli
Vase with archers, 1930–35
(cat. 422)

Dante Baldelli, attributed to
Vase with angels in flight, 1930–35
(cat. 432)

Eagle, 1935–40
(cat. 400)

125

Tullio d'Albisola
Futurist cylindrical vase, 1930–32
(cat. 389)

Tullio d'Albisola
'Anti-imitative Phobia' polycentric conical vase, 1929–30
(cat. 228)

Tullio d'Albisola
'Anti-imitative Phobia' jug, 1929
(cat. 226)

Riccardo Gatti
and Mario Guido Dal Monte
Plate with dancing masked figure,
1928–29
(cat. 231)

Tullio d'Albisola
Jug, 1929–30
(cat. 390)

on the following pages:

Anteater vase with aero-Futurist decorations, 1930–35
(cat. 385)

Tullio d'Albisola
'Anti-imitative Phobia' plate: the Destructive Bee, 1929
(cat. 225)

Tullio d'Albisola
Box with lid with the Magi, 1930–32
(cat. 388)

Bruno Munari
Bulldog, 1934
(cat. 402)

Torido Mazzotti
Bowl with three flat circles in relief,
1930–32
(cat. 395)

Fillia (Luigi Colombo)
Geometric vase, 1932
(cat. 396)

Nicolaj Diulgheroff
Destructured fruitstand with Futurist decoration, 1930–31
(cat. 382)

Giovanni Gariboldi
Four tiles representing the Seasons,
1939–40
(cat. 319-322)

Giovanni Gariboldi
Drinking vessel with centaur,
1930–35
(cat. 312)

133

Guido Andlovitz
Bowl in 'crackled green' glaze with cylindrical feet, 1930–38
(cat. 329)

Guido Andlovitz
Centrepiece bowl, 1930
(cat. 335)

Guido Andlovitz
Triangular candelabrum for four candles, circa 1938
(cat. 337)

Guido Andlovitz
Double-circle candelabrum for four candles, circa 1938
(cat. 336)

Cubic box with lid and grip in the form of an antelope, circa 1935
(cat. 363)

Vase of the Seals, 1935–40
(cat. 373)

Rectangular vase with two fencers, 1930–35
(cat. 366)

Federico Melis
Urn with Sardinian horsemen and anthropomorphic lid, 1927–31
(cat. 284)

Melkiorre Melis
African water carrier, 1928–30
(cat. 288)

Melkiorre Melis
Centrepiece: Bedouin woman, 1930–35
(cat. 455)

Salvatore Fancello
Lions and wild boars, circa 1938
(cat. 462)

Salvatore Fancello
Goat, 1934–37
(cat. 459)

Salvatore Fancello
Wild boar, 1936
(cat. 456)

Salvatore Fancello
Woman's head, circa 1938
(cat. 463)

Salvatore Fancello
Woman's head, circa 1938
(cat. 464)

Angelo Biancini
Faith, 1937
(cat. 339)

Angelo Biancini
Woman's head with vase: Canephore,
circa 1938
(cat. 344)

Arturo Martini
Fascist Victory, 1936–37
(cat. 409)

Angelo Biancini
Putto with goose, 1937–38
(cat. 345)

Angelo Biancini
Duck and ducklings, circa 1938
(cat. 341)

145

Angelo Biancini
Garden cache-pot with decorations in bas-relief, 1937
(cat. 343)

Angelo Biancini
Green vase with zoomorphic and anthropomorphic figures in relief, 1937
(cat. 349)

Angelo Biancini
Actaeon Attacked by the Dogs,
1939–40
(cat. 351)

Angelo Biancini
Diana the Huntress, 1939–40
(cat. 352)

Leoncillo
Caryatid-candlestick,
1940–45
(cat. 471)

Catalogue

1896–1919

1
Galileo Chini
Amphora with handles in the form of snakes, 1896–98
Arte della Ceramica factory, Florence
Majolica turned on the wheel, with the serpentine handles applied subsequently, and decorated with underglaze polychrome enamels; h 49 x 28.5 x Ø 23.5
Inscriptions: 'ADCF' and marks in relief (pomegranate) and in blue glaze (clasped hands)
Antonello Collection, Milan

2
Galileo Chini
Amphora with square handles and floral decorations, 1896–98
Arte della Ceramica factory, Florence
Majolica turned on the wheel and decorated with underglaze polychrome enamels; h 14.5 x Ø 13.5
Inscriptions: 'ADCF' and marks in relief (pomegranate) and in blue glaze (clasped hands); "144/6"
Antonello Collection, Milan

3
Galileo Chini
Vase with woman's profile and floral motifs, 1896–98
Arte della Ceramica factory, Florence
Majolica turned on the wheel and decorated with underglaze polychrome enamels; h 26.5 x Ø 15
Inscriptions: 'ADCF' and marks in relief (pomegranate) and in blue glaze (clasped hands)
Antonello Collection, Milan

4
Galileo Chini
Vase with woman's profile, 1896–1900
Arte della Ceramica factory, Florence
Majolica turned on the wheel and decorated with underglaze polychrome enamels; h 27 x Ø 19.5
Inscriptions: 'ADCF' and mark in relief (pomegranate)
Antonello Collection, Milan

5
Galileo Chini
Vase with three medallions adorned with women's profiles and floral motifs, 1896–1900
Arte della Ceramica factory, Florence
Majolica turned on the wheel and decorated with underglaze polychrome enamels; h 20 x Ø 12.5
Inscriptions: 'ADCF' and mark in relief (pomegranate), '162/a' and 'c'
Antonello Collection, Milan

6
Galileo Chini
Plate with woman's profile, 1898–1900
Arte della Ceramica factory, Florence
Majolica turned on the wheel and decorated with underglaze polychrome enamels; Ø 48
Inscriptions: 'ADCF' and mark (pomegranate), 'Firenze', '261' in blue
Antonello Collection, Milan

7
Galileo Chini
Plate with female figure among waves, 1898–1900
Arte della Ceramica factory, Florence
Majolica turned on the wheel and decorated with underglaze polychrome enamels; Ø 30
Inscriptions: 'ADCF Florence', '304' and mark (pomegranate) in blue
Antonello Collection, Milan

8
Galileo Chini
Vase with laurel trees and waterscape, 1898–1900
Arte della Ceramica factory, Florence
Majolica turned on the wheel and decorated with underglaze polychrome enamels; h 32 x Ø 19
Inscriptions: 'ADCF', 'Florence', '260' and mark (pomegranate) in blue
Antonello Collection, Milan

9
Galileo Chini
Vase with tulips, circa 1900
Arte della Ceramica factory, Florence
Majolica turned on the wheel and decorated with underglaze polychrome enamels; h 32 x Ø 20
Inscriptions: 'ADCF' 'Firenze', '867' and mark (pomegranate) in blue
Antonello Collection, Milan

10
Galileo Chini
Vase with birds of prey and decoration of stylized peacock feathers, 1898–1902
Arte della Ceramica factory, Florence
Majolica turned on the wheel and with polychrome lustre decorations; h 46 x Ø 23
Inscriptions: 'ADCF' and 'Firenze' in blue; '126XX'; 'G.B.7.F.' and mark (pomegranate) in ochre
Antonello Collection, Milan

11
Galileo Chini
Vase with salamanders, 1898–1902
Arte della Ceramica factory, Florence
Majolica turned on the wheel and decorated with underglaze polychrome enamels; h 30 x Ø 17
Inscriptions: 'ADCF' 'Firenze' in blue; '530'; 'LS' (inside a rectangle) and mark (pomegranate) in red
Antonello Collection, Milan

12
Galileo Chini
Vase with stylized peacock feathers, 1898–1902
Arte della Ceramica factory, Florence
Majolica turned on the wheel and decorated with underglaze polychrome enamels and lustres; h 44.5 x Ø 24
Inscriptions: 'ADCF' and mark (pomegranate), 'Firenze' in blue; '1002. G-D-7' in red
Antonello Collection, Milan

152

13
Galileo Chini
Small vase with applications representing a salamander, a snail and an insect, 1898–1902
Arte della Ceramica factory, Florence
Stoneware turned on the wheel with applications in relief and decorated with lustres; h 5.5 x Ø 12.5
Inscriptions: 'ADCF' scratched in the paste and mark (pomegranate), '165'
Antonello Collection, Milan

14
Galileo Chini
Vase with trees and butterflies, 1903–04
Factory of Fontebuoni (Arte della Ceramica), Florence
Majolica turned on the wheel and decorated with lustres; h 26 x Ø 8.5
Inscriptions: stamped in red with the mark (pomegranate) and the initials 'ADCF'; 'FIRENZE FONTEBUONI' and '7245'
Private collection

15
Galileo Chini
Large vase with floral motifs, 1910
Factory of Fontebuoni (Arte della Ceramica), Florence
Majolica turned on the wheel and decorated with underglaze polychrome enamels; h 42 x Ø 30
Inscriptions: mark (pomegranate) and initials 'ADCF' in the paste; 'Manifattura di Fontebuoni Firenze 1910' in red; 'M' inscribed in the leafwork in blue;
'114-2119'
Antonello Collection, Milan

16
Galileo Chini
Vase with stylized trees, 1903–09
Factory of Fontebuoni (Arte della Ceramica), Florence
Majolica turned on the wheel and decorated with lustres; h 44.5 x Ø 33
Inscriptions: 'Fontebuoni', mark (pomegranate) and initials 'ADCF, FIRENZE' stamped in blue; '(RP) ROC' in red; 'M' inscribed in the leafwork; 'Sag.: 598 Dec.: 4001/05 39' engraved in the paste
Antonello Collection, Milan

17
Galileo Chini
Vase with ship, 1906–10
Fornaci di San Lorenzo factory, Borgo San Lorenzo
Majolica turned on the wheel and decorated with underglaze polychrome enamels; h 31 x Ø 20
Inscriptions: 'Fornace di San Lorenzo Mugello'; '80/2049' and gridiron mark without inscription in the circle
Gilli Collection, Milan

9

12

15

10

13

16

11

14

17

153

18
Galileo Chini
Vase with cicadas, 1906–10
Fornaci di San Lorenzo factory, Borgo San Lorenzo
Majolica turned on the wheel and decorated with polychrome enamels; h 19 x Ø 16
Inscriptions: grill mark with stylized lily ('Mugello') and circled dot in blue
Antonello Collection, Milan

19
Galileo Chini
Goblet with waves and sea birds, 1906–10
Fornaci di San Lorenzo factory, Borgo San Lorenzo
Majolica turned on the wheel and decorated with lustres; h 14 x Ø 18.5
Inscriptions: grill mark with stylized lily ('Mugello') and circled dot, '2054' in blue; circled 'M' in red
Antonello Collection, Milan

20
Galileo Chini
Vase with water arum flowers and leaves, 1906
Fornaci di San Lorenzo factory, Borgo San Lorenzo
Majolica turned on the wheel and decorated with underglaze polychrome enamels; h 98 x Ø circa 44
Inscriptions: grill mark with stylized lily ('Mugello'), '2119', circled dot and MCMVIII in blue
Antonello Collection, Milan

21
Galileo Chini
Cache-pot decorated with running lions among plant shoots, 1906–19
Fornaci factory di San Lorenzo, Borgo San Lorenzo
Salt-glazed stoneware decorated with polychrome enamels; h 31 x Ø 43
Inscriptions: grill mark with stylized lily ('Mugello'), circled dot and '2016' in blue
Antonello Collection, Milan

22
Galileo Chini
Jar with geometric decorations and three medallions with pairs of stylized hawks, circa 1919
Fornaci di San Lorenzo factory, Borgo San Lorenzo
Salt-glazed stoneware decorated with polychrome glaze; h 71 x Ø 45.5
Inscriptions: '2257' on the base with, in blue, grill mark with stylized lily and 'FORNACI-S./LORENZO/CHINI & C/BORGO-S.-LORENZO-MUGELLO-ITALIA'
Antonello Collection, Milan

18

21

24

19

25

22

26

20

23

27

154

23
Galileo Chini
Vase with two doves and a stylized palm,
1919–20
Fornaci di San Lorenzo factory, Borgo San Lorenzo
Salt-glazed stoneware decorated with blue enamels; h 28 x Ø 15
Inscriptions: stamped in black with the grill mark in a circle and 'Fornaci S. Lorenzo, Chini and Co (Mugello)'; engraved in the paste: '6075' / '2214', circled dot, 'Chini & Co Mugello, 16' and 'B'
Antonello Collection, Milan

24, 25
Pair of majolica plates with woman's profile and floral decorations modelled on the rim, 1900–10
Società Ceramica Colonnata factory, Sesto Fiorentino
Majolica turned on the wheel and decorated with underglaze polychrome enamels
(the rim is in relief); Ø 59
Inscriptions: 'Colonnata SCI / 84 / P bis' in black
Antonello Collection, Milan

26
Ink-pot with lizard, 1902
Richard-Ginori factory, Doccia, Florence
White porcelain; h 10 x Ø 19
Inscriptions: 'Ginori' (in green)
Museo di Doccia, Sesto Fiorentino, Florence
Shown at Turin in 1902

27
Flower vase, 1902
Richard-Ginori factory, Doccia, Florence
White porcelain; h 40 x Ø base 15 x Ø mouth 22
Inscriptions: 'Ginori' (in green)
Museo di Doccia, Sesto Fiorentino, Florence
Shown at Turin in 1902

28
Quadrangular vase, 1902
Richard-Ginori factory, Doccia, Florence
White porcelain; 31.5 x 8.5 x 8.5
Inscriptions: 'Ginori' (in green)
Museo di Doccia, Sesto Fiorentino, Florence
Shown at Turin in 1902

29
Giorgio Spertini
Vase with gilded metal mount, 1903
Società Ceramica Italiana factory, Laveno
Ironstone china cast in mould and decorated with monochrome green glaze; gilded mount of Art Nouveau inspiration attributed to Ceragioli; h 40.5 x Ø 15
Antonello Collection, Milan

30
Amphora with handles and floral decoration set on column, 1901
Società Ceramica Italiana factory, Laveno
Ironstone china cast in mould, decorated with underglaze enamel and highlights in gold on third firing; amphora h 38 x Ø 43; column h 99.5 x Ø 26;
Inscriptions: 47/S.C.I./01
Civica Raccolta di Terraglia, Cerro di Laveno Mombello

31
Marco Reggiani
Large amphora with decorations on an Oriental theme, 1906
Società Ceramica Italiana factory, Laveno
Ironstone china cast in mould and decorated in overglaze and gold finishes on third firing; h 145 x Ø 53
Civica Raccolta di Terraglia, Cerro di Laveno Mombello

32, 33
Giancarlo Iacopini
Pair of decorative plates with landscapes, 1906
Società Ceramica Italiana factory, Laveno
Soft earthenware shaped in mould and decorated with underglaze polychrome enamels; Ø 60
Civica Raccolta di Terraglia, Cerro di Laveno Mombello

28

29

30

31

32

33

155

34
Giuseppe Bellorini
Vase with decorations and peacock feathers, 1919
Società Ceramica Italiana factory, Laveno
Ironstone china cast in mould and decorated with underglaze polychrome enamels; h 59.3 x Ø 32
Inscriptions: '76/S.C.I./19/3'
Civica Raccolta di Terraglia, Cerro di Laveno Mombello

35
Quaglino Poggi
Anthropomorphic bowl with face and hair of a girl, 1912–15
Albisola
Majolica shaped in mould, finished by hand and decorated with glaze; h 14 x Ø 46
Inscriptions: 'P. A. ALBISOLA' in black
Antonello Collection, Milan

36
Domenico Baccarini, attributed to
Cache-pot with small female heads and flowers, 1906–07
Società Ceramiche Faentine factory, Faenza
Majolica shaped in mould in relief and decorated with underglaze polychrome enamels
Antonello Collection, Milan

37
Domenico Baccarini
Vase with carnations, 1908
Società Ceramiche Faentine factory, Faenza
Majolica turned on the wheel and decorated with underglaze polychrome enamels; h 29.5 x Ø 12
Inscriptions: 'FCR FAENZA' in black
Museo Internazionale della Ceramica, Faenza, inv. no. 9734

38
Domenico Baccarini
Vase with six female figures cloaked in drapery, 1909
Società Ceramiche Faentine factory, Faenza
Majolica turned on the wheel with applications in relief and partially decorated in white glaze; h 79 x Ø 23
Inscriptions: 'SCF' with the C framed and 'FAENZA' in blue
Museo Internazionale della Ceramica, Faenza, inv. no. 22670

39
Vase with garlic flowers, 1908
Fratelli Minardi factory, Faenza
Majolica turned on the wheel and decorated with underglaze polychrome enamels; h 64 x Ø 32
Inscriptions: 'M' inside 'Q' and 'F.lli Minardi Faenza' in brown
Museo Internazionale della Ceramica, Faenza, inv. no. 20634

34

38

39

35

40

36

41

37

42

43

44

40
Achille Calzi, attributed to
Display plate with Gorgon's head, circa 1916
Società Ceramiche Faentine factory, Faenza (?)
Majolica shaped in mould and decorated with underglaze polychrome enamels;
Inscriptions: 'FC' in blue
Antonello Collection, Milan

41
Plate with eagle, circa 1900
Gregorj factory, Treviso
Majolica shaped in mould, coated with slip and decorated with underglaze polychrome enamels; h 5.2 x Ø 47
Inscriptions: 'CERAMICA G. GREGORJ TREVISO' with punch and brush in brown
Museo Internazionale della Ceramica, Faenza, inv. no. 30797

42
Arturo Martini
Cache-pot with lions and Egyptian figure, 1911
Gregorj factory, Treviso
Ironstone china cast in mould and decorated with underglaze polychrome enamels; h 29.8 x Ø 33.8
Inscriptions: 'CERAMICA G. GREGORJ TREVISO' with punch on bottom
Museo Internazionale della Ceramica, Faenza, inv. no. 30798

43
Achille Tamburlini and Raffaele Carbonaro
Vase with allegorical figures, 1910–12
Tamburlini factory, Venice
Terracotta shaped in mould, finished by hand and coated with copper; h 27.5 x Ø 15
Inscriptions: 'Tamburlini/Venezia' in the paste; 'AT-RC' in a circle
Private collection

44
Olga Modigliani
Bowl with antelopes, 1910
Rome
Terracotta turned on the wheel and decorated with underglaze polychrome enamels; h 9 x Ø 18
Private collection

45
Romeo Berardi
Vase with pigeons, 1912
Rome
Terracotta turned on the wheel and decorated with underglaze polychrome enamels;
h 23 x Ø 17.7
Inscriptions: 'R. BERARDI / 1912 / ROME' under the base
Private collection

46
Romeo Berardi
Vase with owls, 1914
Rome
Terracotta turned on the wheel and decorated with underglaze polychrome enamels;
h 24.5 x Ø 21
Private collection

47
Paolo Stamaty Rodocanachi
Large plate with dancing female figure, 1912
Rome
Terracotta turned on the wheel and decorated with underglaze polychrome enamels; Ø 22
Inscriptions: signed 'Cian 5; 11.6.912' under the base
Private collection

48
Torquato Castellani
Plate with cock, 1917
Rome
Terracotta turned on the wheel and decorated with underglaze polychrome enamels; Ø 53.5
Inscriptions: signed and dated 'TCastellani 1917 Roma' on the back
Private collection

49
Duilio Cambellotti
Fountain of the Jugs, 1910–14
Rome
Terracotta modelled on the wheel, coated with slip and decorated with underglaze polychrome enamels; h 26 x 133
Inscriptions: 'CD' engraved in the paste
Museo Internazionale della Ceramica, Faenza, inv. no. 24826
Panel made up of thirteen elements: the central one represents a Nymph in high relief surrounded by jugs, while the twelve tiles are painted with figures of grazing horses

50
Romeo Berardi
Vase of the Garfish, 1919
Rome
Terracotta turned on the wheel and decorated with underglaze polychrome enamels;
h 9 x Ø 19.3
Inscriptions: 'R. Berardi / 1919 Roma' under the base
Private collection

45

46

47

48

49

50

1920–30

51
Enzo Ceccherini
Vase with four handles in the form of ears of wheat and rural scenes, 1922
Maioliche Artistiche Ernesto Conti factory, Sesto Fiorentino, Florence
Majolica turned on the wheel with applied handles and decorated with underglaze polychrome enamels in the Divisionist style
Private collection

52
Pietro Melandri
Plate with grotesque decorations, circa 1923
Fratelli Minardi di Focaccia e Melandri factory, Faenza
Majolica turned on the wheel and decorated with underglaze polychrome enamels; h 4 x Ø 61
Inscriptions: 'FAENZA / MELANDRI' in brown and mark (goshawk inside a circle); 'Melandri Faenza' in brown
Antonello Collection, Milan

53
Pietro Melandri
Vase in a neo-15th century style with floral decorations and a horseman at the centre, 1922–24
Fratelli Minardi di Focaccia e Melandri factory, Faenza
Majolica turned on the wheel and decorated with underglaze polychrome enamels (attributable to Francesco Nonni); h 55.5 x Ø 40
Inscriptions: 'FOCACCIA / MELANDRI / FAENZA / M' in blue and mark (goshawk in a circle)
Antonello Collection, Milan

54
Pietro Melandri
Vase with antelopes, 1924–26
Fratelli Minardi di Focaccia e Melandri factory, Faenza
Majolica turned on the wheel and decorated with underglaze polychrome enamels and lustres; h 19.2 x Ø 16
Inscriptions: 'MELANDRI' in black; goshawk mark; 'FOCACCIA/FAENZA/MF'
Private collection

55
Pietro Melandri
Vase with lid decorated with ivy leaves and gilded floral pattern, 1925
Fratelli Minardi di Focaccia e Melandri factory, Faenza
Majolica turned on the wheel and decorated with underglaze polychrome enamels, lustres and gilding; h 26 x Ø 25
Inscriptions: 'M F' under the foot and goshawk mark
Gilli Collection, Milan
Shown at the 2nd Monza Biennale (1925)

56
Pietro Melandri
Small bowl with woman's head in a Byzantinizing style, circa 1926
Fratelli Minardi di Focaccia e Melandri factory, Faenza
Majolica shaped in mould and decorated with lustres; Ø 12.5
Inscriptions: 'M' in black; goshawk mark; 'F / FAENZA / MF'
Private collection

57
Pietro Melandri
Vase with three handles in the shape of suns, 1925–31
Fratelli Minardi di Focaccia e Melandri factory, Faenza
Majolica turned on the wheel and decorated with polychrome enamels and in lustre; h 40 x Ø 27
Inscriptions: 'MF' and goshawk mark under the foot
Museo Internazionale della Ceramica, Faenza, inv. no. 23813

58
Pietro Melandri
Olla with fish and seaweed, 1927–30
Fratelli Minardi di Focaccia e Melandri factory, Faenza
Majolica turned on the wheel and decorated with underglaze polychrome enamels, lustres and gilding; h 22 x Ø 16
Inscriptions: 'FM; goshawk mark; FAENZA/MF/MELANDRI/FOCACCIA' in black
Private collection

59
Pietro Melandri
Bowl with antelope, 1927–30
Fratelli Minardi di Focaccia e Melandri factory, Faenza
Majolica shaped in mould with underglaze polychrome enamels and gilding; h 7 x Ø 23
Inscriptions: 'FOCACCIA'; goshawk mark; MELANDRI/FAENZA/MF' in black
Private collection

60
Pietro Melandri
Peacock Bowl, 1927–30
Fratelli Minardi di Focaccia e Melandri factory, Faenza
Majolica shaped in mould with underglaze polychrome enamels and gilding; h 7 x Ø 23
Inscriptions: in black 'FOCACCIA; goshawk mark; MELANDRI/FAENZA/MF'
Private collection

61
Pietro Melandri
'Tauromachia' vase representing the capture of a wild bull, 1928–30
Fratelli Minardi di Focaccia e Melandri factory, Faenza
Majolica shaped in mould and in relief and decorated with monochrome green glaze; h 29 x Ø 24
Inscriptions: 'FAENZA / MELANDRI' in yellow
Antonello Collection, Milan

62
Pietro Melandri and Ercole Drei
Tragedy and Comedy, 1928
Fratelli Minardi di Focaccia e Melandri factory, Faenza
Majolica shaped in mould and decorated with underglaze polychrome enamels;
h 44 x 22.5 x 14.5
Inscriptions: 'MF/MELANDRI' and goshawk mark
Museo Internazionale della Ceramica, Faenza

63
Francesco Nonni and Pietro Melandri
Container in the form of a lady in 18th-century dress, 1920–22
Fratelli Minardi di Focaccia e Melandri factory, Faenza
Majolica shaped in mould and decorated with underglaze polychrome enamels; h 23 x 20 x 7
Inscriptions: 'FAENZA MF' in brown
Antonello Collection, Milan

64
Francesco Nonni and Pietro Melandri
Container in the form of a lady in 18th-century dress, 1920–22
La Faïence factory, Faenza
Majolica shaped in mould and decorated with underglaze polychrome enamels and lustres;
h 23 x 20 x 7
Inscriptions: 'Z (in a circle with four tongues of flame) / Faenza' in blue
Antonello Collection, Milan

65
Francesco Nonni
Andalusian woman, 1923–25
Fratelli Minardi di Focaccia e Melandri factory, Faenza
Majolica shaped in mould and decorated underglaze; h 32 x 20 x 7
Inscriptions: 'F', goshawk mark, 'M' 'FAENZA MF' in brown
Antonello Collection, Milan

57

58

59

60

61

62

63

64

65

159

66
Francesco Nonni and Anselmo Bucci
*Figure in black-and-silver pyjama-robe
(Portrait of Domenico Silvestrini)*, 1923
Fratelli Minardi di Focaccia e Melandri factory,
Faenza
Majolica shaped in mould and finished by hand,
glazed in black with patches of silver outlined
in gold, face and hands in terracotta;
h 33 x 11 x Ø 12 at base
Museo Internazionale della Ceramica, Faenza,
inv. no. 30486

67
Francesco Nonni and Pietro Melandri
Inkwell with dancing woman and panther, 1923
Fratelli Minardi di Focaccia e Melandri factory,
Faenza
Majolica shaped in mould and decorated with
underglaze polychrome enamels; h 37.5 x 29 x 29
Inscriptions: 'MF' with goshawk mark under
the foot
Private collection
Shown at the 1st Monza Biennale (1923)

68
Francesco Nonni
Dancer with flower-patterned dress, 1923
Fratelli Minardi di Focaccia e Melandri factory,
Faenza
Majolica shaped in mould and decorated with
underglaze polychrome enamels; h 28 x 23
Inscriptions: 'MF' and goshawk mark in brown
Gilli Collection, Milan

69
Francesco Nonni
*Soup tureen with floral decorations and grip
in the form of an Oriental dancer*, 1925
Fratelli Minardi di Focaccia e Melandri factory,
Faenza
Majolica shaped in mould and decorated with
underglaze polychrome enamels; h 26 x Ø 22
Inscriptions: 'MF' and goshawk mark in black
Private collection

70
Francesco Nonni
Pierrot, 1925
Fratelli Minardi di Focaccia e Melandri factory,
Faenza
Majolica shaped in mould and decorated with
underglaze polychrome enamels; h 26 x 16.5 x 5
Inscriptions: 'MF' in black and the mark (goshawk
inside a circle)
Shown at the 2nd Monza Biennale (1925);
there are many variations in the decorations,
usually executed by Pietro Melandri
Antonello Collection, Milan

71
Francesco Nonni and Anselmo Bucci
Hindu dancing girl on elephant, 1927
Fratelli Minardi di Focaccia e Melandri factory,
Faenza
Majolica shaped in mould and decorated
with underglaze polychrome enamels; h 32 x 24
Inscriptions: 'F', goshawk mark, 'M' 'FAENZA MF'
in brown.
Antonello Collection, Milan
Central part of the *Oriental Procession*
centrepiece, made for the Paris International
Exhibition of 1925 and produced again in 1927
with 25 figures

72
Galileo Chini
Vase with decoration of holly leaves, 1920–25
Fornaci di San Lorenzo factory, Borgo San Lorenzo
Majolica turned on the wheel and decorated with
underglaze polychrome enamels
Inscriptions: grill mark with stylized lily and
'FORNACI S.LORENZO, CHINI E CO. (MUGELLO)' in blue
Gilli Collection, Milan

73
Guido Balsamo Stella
Bowl of the Ermine, 1923
Cantagalli factory, Florence
Majolica shaped in mould and in relief
and decorated in red glaze; h 15 x 47 x 30.5
Gilli Collection, Milan
Shown at the 1st Monza Biennale (1923)

74
*Pierrot playing the violin embraced by a lady
in 18th-century dress*, 1926
Società Cooperativa Ceramica di Imola factory,
Imola
Majolica shaped in mould and decorated with
underglaze polychrome enamels; h 36 x 30 x 10
Inscriptions: 'Imola'
Antonello Collection, Milan

75
*Vase with lid decorated with flowers, butterflies
and birds*, 1920–25
Cantagalli factory, Florence
Majolica turned on the wheel and decorated
in grey glaze and polychrome lustres; h 36 x Ø 21
Inscriptions: mark (cock) and 'ITALIA' in red lustre
Museo Internazionale della Ceramica, Faenza,
inv. no. 18123

76
Giacomo Dolcetti
Server with lady in 18th-century costume in a garden with balustrade and arch of greenery, circa 1925
La Bottega del Vasaio, Venice
Majolica shaped in mould and decorated with underglaze polychrome enamels; h 36.5 x 28
Inscriptions: 'Bottega del Vasaio di Giacinto Dolcetti in Venezia', mark (gondola)
Private collection

77
Giacomo Dolcetti
Serving dish with lady in 18th-century costume in a garden, circa 1925
La Bottega del Vasaio, Venice
Majolica shaped in mould and decorated with underglaze polychrome enamels; h 36.5 x 28
Inscriptions: 'Bottega del Vasaio di Giacinto Dolcetti in Venezia', mark (gondola)
Private collection

78
Federico Paglia
Vase with asters, 1922
Società Ceramica Italiana factory, Laveno
Ironstone china cast in mould and decorated overglaze; gold on third firing; 59 x Ø 32
Inscriptions: '76 / S.C.I. / 22/ 3', 'S.C. ITALIANA LAVENO' stamped in gold
Civica Raccolta di Terraglia, Cerro di Laveno Mombello

79
Giorgio Spertini
Large vase with falcons in heraldic position, 1922
Società Ceramica Italiana factory, Laveno
Ironstone china cast in mould and decorated with underglaze polychrome enamels; 59 x Ø 32
Inscriptions: 'S.C.I LAVENO'
Civica Raccolta di Terraglia, Cerro di Laveno Mombello

80-82
Giuseppe Bellorini
Three plates with heads of Renaissance warriors, 1923
Società Ceramica Italiana factory, Laveno
Earthenware shaped in mould in relief and decorated with underglaze polychrome enamels; Ø 61
Inscriptions: '62/S.C.I./21/x/24/VERBANUM STONE/S.C.I./LAVENO'
Civica Raccolta di Terraglia, Cerro di Laveno Mombello

83
Piero Portaluppi
Vase with lid and stylized floral decoration, 1923
Società Ceramica Italiana factory, Laveno
Earthenware cast in mould, glazed in cobalt blue, decorated overglaze with gold and silver on third firing; 60 x Ø 15
Inscriptions: mark 'VERBANUM/STONE/LAVENO' – 'MANIF. S.C.I. LAVENO'
Civica Raccolta di Terraglia, Cerro di Laveno Mombello

84
Guido Andlovitz
Plate with Judith and the head of Holofernes, 1923
Società Ceramica Italiana factory, Laveno
Earthenware shaped in mould and decorated with underglaze polychrome enamels, gold and platinum; Ø 17
Inscriptions: Lavenia with mountains mark in blue
Private collection

85
Guido Andlovitz
Urn with lid decorated with rural scenes, circa 1925
Società Ceramica Italiana factory, Laveno
Ironstone china cast in mould and decorated with underglaze yellow and brown; h 43 x Ø 25
Inscriptions: 'SCI' with heart-shaped mark and 'Figure Vecchio Milano, Laveno'; mark (mountains above lake), 'Lavenia' and, almost illegible, 'Made in Italy' (in the panel).
Antonello Collection, Milan

86
Guido Andlovitz and Giuseppe Bellorini
'Monza' vase, 1925
Società Ceramica Italiana factory, Laveno
Ironstone china cast in mould and decorated with underglaze polychrome enamels; h 43.5 x max Ø 25
Inscriptions: mark (three mountains above lake), 'Lavenia/s74'
Antonello Collection, Milan

87
Guido Andlovitz
Vase with figures of musicians, 1927
Società Ceramica Italiana factory, Laveno
Ironstone china cast in mould and decorated with underglaze polychrome enamels; h 54
Inscriptions: 'Lavenia / 1297', mark (three mountains above lake)
Antonello Collection, Milan

88-90
Guido Andlovitz
Three plates with figurines in neo-18th-century style and candelabrum decorative motifs, 1927
Società Ceramica Italiana factory, Laveno
Earthenware shaped in mould and decorated with underglaze polychrome enamels; Ø 60
Inscriptions: 'VERBANUM STONE/S.C.I./LAVENO'
Civica Raccolta di Terraglia, Cerro di Laveno Mombello

91
Guido Andlovitz
Vase of the Legions, 1927
Società Ceramica Italiana factory, Laveno
Ironstone china cast in mould and decorated with underglaze polychrome enamels and lustre (on the foot); h 36 x Ø 34
Inscriptions: 'Lavenia / Made in Italy', mark (three mountains above lake);
Antonello Collection, Milan

92, 93
Guido Andlovitz
Large amphorae on cylindrical pedestals with floral decorations in relief, 1927–29
Società Ceramica Italiana factory, Laveno
Ironstone china cast in mould, decorated in underglaze white and gold on third firing; column: h 125 x Ø 33.5; vase: h 36.7 x Ø 47.5
Inscriptions: 'LAVENIA' and mark (three mountains above lake)
Civica Raccolta di Terraglia, Cerro di Laveno Mombello

94
Guido Andlovitz
'Monza 83' vase with double leaf-shaped handle and naturalistic decorations in a grid of squares, 1927–30
Società Ceramica Italiana factory, Laveno
Ironstone china cast in mould and decorated with underglaze polychrome enamels and gilding on third firing; leaves added subsequently; h 25.5 x Ø max 20
Inscriptions: 'Lavenia / Made in Italy / Teresyta Papini', mark (three mountains above lake)
Antonello Collection, Milan

95
Guido Andlovitz
Small vase with lid decorated with a cactus, 1926–27
Società Ceramica Italiana factory, Laveno
Ironstone china cast in mould and decorated overglaze and gilded on third firing; h 11 x Ø 10
Inscriptions: mark (mountains above lake): 'Lavenia' and 'Made in Italy'
Antonello Collection, Milan

96, 97
Guido Andlovitz
Pair of potiche *vases with lids, circa* 1928
Società Ceramica Italiana factory, Laveno
Ironstone china shaped in mould and airbrushed with red glaze; one of the vases has been decorated with a motif of tulips by transfer on third firing; h 28 x Ø 24
Inscriptions: mark (mountains above lake): 'Lavenia, Made in Italy' and '8280'
Antonello Collection, Milan

88-90

91 92,93 94

95 96,97

98
Guido Andlovitz
Vase with lady in 18th-century dress, circa 1928–30
Società Ceramica Italiana factory, Laveno
Ironstone china cast in mould and decorated overglaze on third firing; 16 x Ø 10
Inscriptions: 'SOCIETA / CERAMICA ITALIANA'; 'VERBANUM STONE /S.C.I. /LAVENO'; 'R. MARIA'
Civica Raccolta di Terraglia, Cerro di Laveno Mombello

99
Guido Andlovitz
Hexagonal vase decorated with stylized succulents and fabrics, 1928–30
Società Ceramica Italiana factory, Laveno
Ironstone china cast in mould and decorated with underglaze polychrome enamels; h 22.5 x 17
Inscriptions: 'Lavenia / Made in Italy', mark (three mountains above lake)
Antonello Collection, Milan

100
Guido Andlovitz
Cista with lid, 1928–30
Società Ceramica Italiana factory, Laveno
Ironstone china cast in mould and decorated with black glaze; gold on third firing; h 26
Antonello Collection, Milan

101
Guido Andlovitz
Vase with marine fauna, 1930
Società Ceramica Italiana factory, Laveno
Ironstone china cast in mould and decorated with black glaze; gold on third firing; h 37 x max Ø 32.5
Inscriptions: 'Lavenia' under the base
Civiche Raccolte d'Arti Applicate del Castello Sforzesco, Milan, inv. no. 1543

102
Guido Andlovitz
Large amphora of classical inspiration with figures playing music, circa 1930
Società Ceramica Italiana factory, Laveno
Ironstone china cast in mould (handles applied subsequently) decorated with underglaze polychrome enamels; h 46.5 x Ø 27
Civica Raccolta di Terraglia, Cerro di Laveno Mombello

103
Guido Andlovitz
Spherical vase with small grips, 1930
Società Ceramica Italiana factory, Laveno
Ironstone china cast in mould and decorated in streaked monochrome lobster red glaze; h 33.5
Antonello Collection, Milan

98

99

100

101

102

103

104

105

106

164

104
Gio Ponti
Plate with Euridice, 1923
Richard-Ginori factory, Doccia, Florence
Majolica turned on the wheel and decorated with underglaze polychrome enamels; Ø 49
Inscriptions: 'Ginori' in blue; nel cartiglio 'In cosi dura/sorte/lasiata'
Private collection

105
Gio Ponti
Plate with Orfeo, 1923
Richard-Ginori factory, Doccia, Florence
Majolica shaped in mould and decorated with underglaze polychrome enamels; Ø 49
Inscriptions: '1923' and mark (crown)
Private collection

106
Gio Ponti and Giorgio Supino
Bust of woman with floral shawl, 1923
Richard-Ginori factory, San Cristoforo, Milan
Ironstone china cast in mould and decorated with underglaze polychrome enamels; h 48.5 x 44 x 22
Inscriptions: engraved with the name of the modeller, 'Supino', on the right side; 'S. C. Richard' under the base in green, surmounted by lion with banner, a 'T' and a 'V' superimposed and the words 'CSNSP / S. Cristoforo / 1923'
Civiche Raccolte d'Arti Applicate del Castello Sforzesco, Milan, inv. no. 3309
Shown at the 1st Monza Biennale (1923)

107
Gio Ponti
Two-handled vase decorated in relief with a circus theme, 1924
Richard-Ginori factory, Doccia, Florence
Majolica shaped in mould and decorated with underglaze polychrome enamels; 26 x max Ø 32
Inscriptions: 'Ginori 1923' in black and mark (crown)
Antonello Collection, Milan

108
Gio Ponti
Bowl with two horizontal handles and lid, 1923
Richard-Ginori factory, Doccia, Florence
Majolica shaped in mould and decorated with underglaze polychrome enamels; h 17.5 x Ø 30
Inscriptions: 'Ginori 1923' in black; mark (crown) and 'Ω'
Antonello Collection, Milan

109
Gio Ponti
'The House of the Industrious and Indolent Ephebes' vase, 1925
Richard-Ginori factory, Doccia, Florence
Majolica shaped in mould and decorated with underglaze polychrome enamels; h 78 x Ø 74
Inscriptions: 'Gio Ponti/MCMXXV' on the handles and 'Conversazione classica' 'Ginori'; 'Ω'
Museo della Fabbrica, Doccia, Sesto Fiorentino
Shown at the 2nd Monza Biennale (1925) and in Paris (1925)

110
Gio Ponti
'The Classical Conversation' vase, 1925
Richard-Ginori factory, Doccia, Florence
Majolica shaped in mould and decorated with underglaze polychrome enamels; h 80 x Ø 74
Inscriptions: mark (crown) 'Ω' 'Gio Ponti / MCM XXV' on the handle
and 'La Conversazione Classica'
Museo della Fabbrica, Doccia, Sesto Fiorentino
Shown at the 2nd Monza Biennale (1925) and in Paris (1925)

107

108

109

110

111
Gio Ponti and Salvatore Saponaro
Plenty, 1927
Società Ceramica Italiana factory, Laveno
Ironstone china cast in mould and decorated in green glaze; h 62 x Ø 24
Civica Raccolta di Terraglia, Cerro di Laveno Mombello
Sculpture for wall-mounted drinking fountain, shown at the 3rd Monza Biennale

112
Gio Ponti
Bowl of Minerva, 1924–25
Richard-Ginori factory, Doccia, Florence
Porcelain shaped in mould and decorated with underglaze polychrome enamels and gilded with agate burnisher; h 11 x Ø 21
Inscriptions: in black in the gilded scroll, 'Richard-Ginori / Pittoria di Doccia / Ginori (in green)'; in the blue scroll, 'Dai freschi di B. Peruzzi nel castello di Belcaro'
Antonello Collection, Milan

113
Gio Ponti
Bottle, 1929
Richard-Ginori factory, Doccia, Florence
Majolica shaped in mould and decorated with underglaze polychrome enamels; h 20 x 20 x 20
Inscriptions: 'Gio Ponti / Made in Italy / 12 19-378 E / Ginori' in blue and mark (crown)
Antonello Collection, Milan

114
Gio Ponti
Ink-pot decorated with works of architecture, 1925
Richard-Ginori factory, Doccia, Florence
Porcelain shaped in mould and decorated with underglaze polychrome enamels; h 11.5 x Ø 12
Inscriptions: 'Richard-Ginori / Pittoria di Doccia / 1925' in black in the gilded scroll; 'Richard-Ginori / 27=10' in green; 'Gio Ponti 1925' in gold; paper label 'Vetri Soffiati Muranesi / Venini & C.'
Antonello Collection, Milan

115
Gio Ponti
Ink-pot decorated with Eros on red ground, 1925
Richard-Ginori factory, Doccia, Florence
Porcelain shaped in mould and decorated with underglaze polychrome enamels; h 11.5 x Ø 12
Inscriptions: 'Richard-Ginori / Pittoria di Doccia / 1925' in black in the gilded scroll
Private collection

116
Gio Ponti
Ink-pot with figure of dancing master, 1925
Richard-Ginori factory, Doccia, Florence
Porcelain shaped in mould and decorated with underglaze polychrome enamels; gold applied with agate burnisher; h 11.5 x Ø 12
Inscriptions: 'Richard-Ginori / Pittoria di Doccia / 1925' in black in the gilded scroll
Private collection

117
Gio Ponti
Ink-pot with quill and scroll, 1925
Richard-Ginori factory, Doccia, Florence
Porcelain shaped in mould and decorated with underglaze black; gold applied with agate burnisher; h 11.5 x Ø 12
Inscriptions: 'Richard-Ginori / Pittoria di Doccia / 1925' in black in the gilded scroll
Private collection

118
Gio Ponti
'Noble Activities. The Ancestors' plate, 1924–25
Richard-Ginori factory, Doccia, Florence
Porcelain shaped in mould, decorated with blue glaze and gilded with agate burnisher; Ø 32.6
Inscriptions: 'Richard-Ginori / Pittoria di Doccia / 1924' marks in gold; 'Le attività gentili / 1925' in light blue; 'Richard-Ginori' in green
Private collection

119
Gio Ponti
'Mea Lesbia' plate, 1924–25
Richard-Ginori factory, Doccia, Florence
Porcelain shaped in mould and decorated with blue glaze and gilded with agate burnisher; Ø 33
Inscriptions: 'Richard-Ginori / Pittoria di Doccia' marks in gold; 'Mea Lesbia/ 1925' in blue; 'Richard-Ginori' in green
Private collection

120
Gio Ponti
'The Lovers' plate, 1925
Richard-Ginori factory, Doccia, Florence
Porcelain shaped in mould and decorated with blue glaze; gold applied with agate burnisher; Ø 32.3
Inscriptions: 'Richard-Ginori / Pittoria di Doccia / 1924' marks in gold; 'Gli amanti / 1925' in blue; 'Richard-Ginori' in green
Private collection

121
Gio Ponti
'The New Love' plate, 1925
Richard-Ginori factory, Doccia, Florence
Porcelain shaped in mould and decorated with polychrome enamels; gold applied with agate burnisher; Ø 32.3
Inscriptions: 'Richard-Ginori / Pittoria di Doccia / 1924' marks in gold; 'L'amor nuovo /1925' in blue; 'Richard-Ginori' in green
Private collection

122
Gio Ponti
'Perfidious Cammilla' plate, 1924–25
Richard-Ginori factory, Doccia, Florence
Porcelain shaped in mould, decorated with blue glaze and gilded with agate burnisher; Ø 33
Inscriptions: 'Richard-Ginori / Pittoria di Doccia' marks in gold; 'Richard-Ginori' in green
Private collection

112

111 113

114 115

116 117

123
Gio Ponti
'Perfidious Cammilla' plate, 1924–25
Richard-Ginori factory, Doccia, Florence
Porcelain shaped in mould and decorated with polychrome enamels; gold applied with agate burnisher; Ø 33
Inscriptions: "Richard-Ginori / Pittoria / di Doccia / 1924' in gold; 'La perfida Cammilla / 1923' in black; Ginori flower mark
Gabriella Salvi Ponti Collection
First version of the previous model in which the colonnade is adorned with a dense floral pattern in violet; decoration prepared for the Paris Expo of 1925

124
Gio Ponti and Libero Andreotti
'The Archaeological Stroll' cista, 1924–25
Richard-Ginori factory, Doccia, Florence
Porcelain shaped in mould and decorated with polychrome enamels; gold applied with agate burnisher; h 59 x 30.5
Inscriptions: 'Richard-Ginori / Pittoria di Doccia' in green; 'La conversazione classica / 1925 / Made in Italy' in gold; 'Gio Ponti / 1924' in black
Private collection

125
Gio Ponti and Libero Andreotti
'The Triumph of Love and Death' cista, 1927–30
Richard-Ginori factory, Doccia, Florence
Porcelain shaped in mould and decorated with blue glaze; gold applied with agate burnisher; h 59 x 30.5
Inscriptions: 'Richard-Ginori / Pittoria di Doccia' in gold; 'Gio Ponti' in black
Civiche Raccolte d'Arte Applicata del Castello Sforzesco, Milan

126
Gio Ponti and Libero Andreotti
'The Migration of the Mermaids' cista, 1927–30
Richard-Ginori factory, Doccia, Florence
Porcelain shaped in mould and decorated with white glaze; gold applied with agate burnisher; h 59 x 31.5
Inscriptions: "Richard-Ginori / Pittoria di Doccia' in gold; 'Gio Ponti' in black
Civiche Raccolte d'Arte Applicata del Castello Sforzesco, Milan

118

119

120

121

122

123

124

125

126

127
Gio Ponti and Libero Andreotti
Cista with 'The Classical Conversation', 1925
Richard-Ginori factory, Doccia, Florence
Porcelain shaped in mould, decorated in polychrome enamels and gilded with agate burnisher; h 59 x Ø 30.5
Inscriptions: 'Richard-Ginori / Pittoria di Doccia / 30=5 / Italia' in black in the gilded scroll; 'La conversazione classica 1925' in black scroll; 'Gio Ponti' in gold, label 'Mod 4588 / dec 624 E'
Antonello Collection, Milan

128
Gio Ponti
Sconces with 'The Classical Conversation', 1927
Richard-Ginori factory, Doccia, Florence
Porcelain shaped in mould and decorated with underglaze polychrome enamels; gold applied with agate burnisher, bronze mount; h 63 x 36
Inscriptions: 'Gio Ponti 1927' in gold
Antonello Collection, Milan
The model dates from 1924 and the sconces were made for Emilio Lancia for the furnishing of Casa Monti in Milan

129
Gio Ponti
'The Archaeological Stroll' plate, 1928
Richard-Ginori factory, Doccia, Florence
Porcelain shaped in mould and decorated in underglaze white and black; gold applied with agate burnisher; Ø 33.5
Inscriptions: 'Richard-Ginori / Pittoria di Doccia' marks in gold; 'La passeggiata archeologica' in blue; 'Richard-Ginori / 28=1' in green; 'Gio Ponti' in black
Private collection

130
Gio Ponti
'The Archaeological Stroll' plate, 1924
Richard-Ginori factory, Doccia, Florence
Porcelain shaped in mould and decorated with underglaze black and white; gold applied with agate burnisher; Ø 31
Inscriptions: 'Richard-Ginori / Pittoria di Doccia' in gold
Private collection

131
Gio Ponti
The Promised Land, 1925–30
Richard-Ginori factory, Doccia, Florence
Porcelain shaped in mould and decorated with white glaze; gold applied with agate burnisher; h 24 x 23.5 x 7.5
Inscriptions: in black in the gilded scroll 'Richard-Ginori / Pittoria di Doccia / Italia'
Antonello Collection, Milan

132
Gio Ponti
'Domus Amoris' centrepiece, 1927
Richard-Ginori factory, Doccia, Florence
Porcelain shaped in mould and decorated with white glaze; gold applied with agate burnisher; h 10.5 x Ø 24.8
Inscriptions: 'Richard-Ginori / Pittoria di Doccia / 1927' in the gilded scroll
Private collection

133
Gio Ponti and Geminiano Cibau
The Dancing Master, 1927
Richard-Ginori factory, Doccia, Florence
Porcelain shaped in mould and decorated with white glaze; gold applied with agate burnisher; h 27.5 x max Ø 10
Inscriptions: 'Richard-Ginori' in green; 'Richard-Ginori / Pittoria di Doccia' in yellow
Private collection

134
Gio Ponti
'The Dancing Master' goblet, 1927
Richard-Ginori factory, Doccia, Florence
Porcelain shaped in mould and decorated with white glaze; gold applied with agate burnisher; h 29 x 23.2 x 11.2
Inscriptions: 'Richard-Ginori / Pittoria di Doccia' in gold
Private collection

135
Gio Ponti
'Temperance' goblet, 1927–28
Richard-Ginori factory, Doccia, Florence
Porcelain shaped in mould and decorated with white glaze; gold applied with agate burnisher; h 29 x 23.2 x 11.2
Inscriptions: 'Richard-Ginori / Pittoria di Doccia' in gold
Private collection

136
Gio Ponti
'Hospitality' goblet, 1927–28
Richard-Ginori factory, Doccia, Florence
Porcelain shaped in mould and decorated with white glaze; gold applied with agate burnisher; h 29 x 23.5 x 11
Inscriptions: 'Richard-Ginori / Pittoria di Doccia' in gold; 'Italia' in black
Private collection

137
Gio Ponti
'Plenty' goblet, 1927–28
Richard-Ginori factory, Doccia, Florence
Porcelain shaped in mould and decorated with blue glaze; gold applied with agate burnisher; h 29.5 x 23 x 11
Inscriptions: in black in the gilded scroll, 'Richard-Ginori / Pittoria di Doccia / 27=10 / Italia' (in green)
Antonello Collection, Milan

127

128

129

130

131

132

138
Gio Ponti
Tile with Venus, circa 1927
Richard-Ginori factory, San Cristoforo, Milan
Ironstone china cast in mould and decorated
with underglaze polychrome enamels; h 44 x 28
Inscriptions: 'Richard-Ginori / S. Cristoforo /
Milano / Made in Italy' in brown and mark
(San Cristoforo); 'M 2155 / D 267 Taranto'
in a black scroll; 'Gio Ponti / VENUS' on the front
Antonello Collection, Milan

139
Gio Ponti with Italo Griselli, Tomaso Buzzi
and Luigi Tazzini
Italy, central part of the *Large Centrepiece
for the Italian Embassies*, 1926
Richard-Ginori factory, Doccia, Florence
Porcelain shaped in mould and decorated with
white glaze; gold applied with agate burnisher;
h 36 x 27 x 10
Inscriptions: 'Richard-Ginori' in green;
'Richard-Ginori / Pittoria di Doccia' in gold
Museo della Fabbrica Richard-Ginori, Doccia,
Sesto Fiorentino

140
Gio Ponti
'Putto on Dolphin' from the series of the *Large
Centrepiece for the Italian Embassies*, 1926
Richard-Ginori factory, Doccia, Florence
Porcelain shaped in mould and decorated with
white glaze; gold applied with agate burnisher;
h 21 x 21 x 8.5
Inscriptions: 'Richard-Ginori / Pittoria di Doccia'
in black in the gilded scroll; 'Richard-Ginori /
29=4' in green; 'H' in green; black rectangle
with '29-5'
Antonello Collection, Milan

141
Gio Ponti
Large 'Dance Troupe' bonbonnière, 1927
Richard-Ginori factory, Doccia, Florence
Porcelain shaped in mould and decorated with
white glaze; gold applied with agate burnisher;
h 27 x 23 x 14.5
Inscriptions: 'Richard-Ginori / Pittoria di Doccia'
in black in the gilded scroll; 'Richard-Ginori /
27=5' in black; 'Made in Italy' in green
Antonello Collection, Milan

133

134

135

136

137

138

139

140

141

169

142
Gio Ponti and Salvatore Saponaro
The Tired Pilgrim, 1926–28
Richard-Ginori factory, San Cristoforo, Milan
Earthenware cast in mould and decorated with underglaze polychrome enamels; h 25.5 x 21 x 16
Inscriptions: 'Richard-Ginori / S. Cristoforo / Made in Italy / 363' in brown and mark (San Cristoforo)
Antonello Collection, Milan

143
Gio Ponti
Bottle from the 'Tired' series: The Tired Smoker, 1929
Richard-Ginori factory, San Cristoforo, Milan
Earthenware cast in mould and decorated with underglaze polychrome enamels; h 17 x 14.4 x 7
Inscriptions: 'Richard-Ginori / S. Cristoforo / Milano / Made in Italy' in brown, mark (San Cristoforo); '249' in black; 'il fumatore stanco / 1929 / Gio Ponti' on the front
Antonello Collection, Milan

144
Gio Ponti
Bottle from the 'Tired' series: The Tired Gardener, 1929
Richard-Ginori factory, San Cristoforo, Milan
Earthenware cast in mould and decorated with underglaze polychrome enamels; h 17 x 14.4 x 7
Inscriptions: 'Richard-Ginori / S. Cristoforo / Milano / Made in Italy' in brown; 'il giardiniere stanco / Gio Ponti' on the front
Museo Internazionale della Ceramica, Faenza, inv. no. 1461

145
Gio Ponti
'Alato' goblet, 1927–30
Richard-Ginori factory, Doccia, Florence
Porcelain shaped in mould and decorated with underglaze polychrome enamels, gold applied with agate burnisher; h 19 x Ø 15.4
Inscriptions: 'Richard-Ginori' in green; 'Richard-Ginori / Pittoria di Doccia' in gold
Private collection

146
Gio Ponti
'Triumphal Chariot' goblet, 1927
Richard-Ginori factory, Doccia, Florence
Porcelain shaped in mould and decorated with underglaze blue; gold applied with agate burnisher; h 19 x Ø 15.4
Inscriptions: 'Richard-Ginori' in green; 'Richard-Ginori / Pittoria di Doccia' in gold
Private collection

142

143

144

145

146

147

148

149

150

170

147
Gio Ponti
'Circus' goblet, 1929
Richard-Ginori factory, Doccia, Florence
Porcelain shaped in mould and decorated with underglaze polychrome enamels; gold applied with agate burnisher; h 19 x Ø 15.4
Inscriptions: 'Richard-Ginori' in green; 'Richard-Ginori / Pittoria di Doccia' in gold
Private collection

148
Gio Ponti
'Jungle' goblet, 1930
Richard-Ginori factory, Doccia, Florence
Porcelain shaped in mould and decorated with underglaze polychrome enamels; gold applied with agate burnisher; h 19 x Ø 15.4
Inscriptions: 'Richard-Ginori' in green; 'Richard-Ginori / Pittoria di Doccia' in gold
Private collection

149
Gio Ponti
'The Classical Conversation' goblet, 1927
Richard-Ginori factory, Doccia, Florence
Porcelain shaped in mould and decorated with underglaze polychrome enamels; gold applied with agate burnisher; h 19 x Ø 15.4
Inscriptions: 'Richard-Ginori' in green; 'Richard-Ginori / Pittoria di Doccia' in gold
Private collection

150
Gio Ponti
'Sailing' goblet, 1927
Richard-Ginori factory, Doccia, Florence
Porcelain shaped in mould and decorated with underglaze polychrome enamels; h 19 x 15.4
Inscriptions: 'Richard-Ginori / Pittoria di Doccia / 1927' in black in the gilded scroll; 'Richard-Ginori / 27=3' in green; 'Gio Ponti 1927' in gold; 'Italia' in black
Antonello Collection, Milan

151
Gio Ponti
'The Circus' bowl, 1929
Richard-Ginori factory, Doccia, Florence
Porcelain shaped in mould and decorated with matt green glaze; gold applied with agate burnisher; h 7.4 x Ø 14.6
Inscriptions: 'Richard-Ginori' in green; 'Richard-Ginori / Pittoria di Doccia' in gold
Private collection

152
Gio Ponti
'Putti with Snake' bowl, 1925
Richard-Ginori factory, Doccia, Florence
Majolica shaped in mould and decorated with underglaze polychrome enamels; h 15.4 x 32 x 16
Inscriptions: 'Richard-Ginori' and mark (crown)
Private collection

153
Gio Ponti
'My Women: Leonia' bowl, 1924
Richard-Ginori factory, Doccia, Florence
Majolica shaped in mould and decorated with underglaze polychrome enamels; h 16 x 32 x 15
Inscriptions: mark (crown) and 'Ginori / Gio Ponti'
Private collection

154
Gio Ponti
'My Women: Donatella' bowl, 1924
Richard-Ginori factory, Doccia, Florence
Majolica shaped in mould and decorated with underglaze polychrome enamels; h 15.2 x 32 x 16
Inscriptions: 'Richard - Ginori' in blue, and mark (crown)
signed 'Gio Ponti'/ 'Made in Italy'
Private collection

155
Gio Ponti
'My Women: Domitilla' plate, 1925
Richard-Ginori factory, Doccia, Florence
Majolica shaped in mould and decorated with underglaze polychrome enamels; Ø 49
Inscriptions: 'Ginori / 1018' in blue and mark (crown)
Antonello Collection, Milan

156
Gio Ponti
'My Women: Donatella' plate, 1925
Richard-Ginori factory, Doccia, Florence
Majolica shaped in mould and decorated with underglaze polychrome enamels; Ø 48
Inscriptions: mark (crown), 'Ginori / 334'
Private collection

157
Gio Ponti
'My Women: Emerenziana' plate, 1924
Richard-Ginori factory, Doccia, Florence
Majolica shaped in mould and decorated with underglaze polychrome enamels; Ø 49
Inscriptions: 'Ginori', mark (crown), 'M.334 / M.309 E. / Gio Ponti / Emerenziana' in brown
Antonello Collection, Milan

158
Gio Ponti
'My Women: Donatella' plate, 1927
Richard-Ginori factory, Doccia, Florence
Majolica shaped in mould and decorated with underglaze polychrome enamels; Ø 49
Inscriptions: 'Ginori', mark (crown), 'M.334 / Gio Ponti 1927 / Donatella / Italia' in brown
Antonello Collection, Milan

151

152

153

154

155

156

157

158

159
Gio Ponti
'My Women: Agata' plate, 1925
Richard-Ginori factory, Doccia, Florence
Majolica shaped in mould and decorated
with underglaze polychrome enamels; Ø 48
Inscriptions: mark (crown), 'Ginori-Italy /
334-Gio Ponti / 1925'
Museo della Fabbrica Richard-Ginori, Doccia,
Sesto Fiorentino

160
Gio Ponti
'My Women: Isabella' plate, 1925
Richard-Ginori factory, Doccia, Florence
Majolica shaped in mould and decorated with
underglaze polychrome enamels; Ø 48
Inscriptions: mark (crown), 'Ginori-Italy /
334-Gio Ponti / 1925'
Museo della Fabbrica Richard-Ginori, Doccia,
Sesto Fiorentino

161
Gio Ponti
Vase of Flowers and Women, 1924
Richard-Ginori factory, Doccia, Florence
Majolica shaped in mould and decorated with
underglaze polychrome enamels; h 47 x Ø 40
Inscriptions: mark (crown); 'Ginori-1036-206'
Museo della Fabbrica Richard-Ginori, Doccia,
Sesto Fiorentino

162
Gio Ponti
'Hunting' vase, 1927–30
Richard-Ginori factory, Doccia, Florence
Majolica shaped in mould and decorated with
underglaze polychrome enamels; h 50 x max Ø 135
Inscriptions: 'Ginori 1036-393 E / Gio Ponti /
Made in Italy' in black and mark (crown)
Antonello Collection, Milan
Shown at the 1st Monza Triennale (1930)

163, 164
Gio Ponti
*Pair of 'Hunting' plates on green ground:
the Triumph of the Amazons*, circa 1930
Richard-Ginori factory, Doccia, Florence
Majolica shaped in mould and decorated
with underglaze polychrome enamels; Ø 36
Inscriptions: 'Ginori 229-368 E / Gio Ponti /
Made in Italy' in black and mark (crown)
Antonello Collection, Milan

165, 166
Gio Ponti
*Pair of 'Hunting' plates on red ground: Carrying
the Deer; the Amazon's Rest*, 1927 circa
Richard-Ginori factory, Doccia, Florence
Majolica shaped in mould and decorated
with underglaze polychrome enamels; Ø 35.8
Inscriptions: 'Ginori M.229 / 368-E / Gio Ponti'
in black and mark (crown)
Antonello Collection, Milan

167, 168
Gio Ponti
*Pair of 'Hunting' plates: the Stag Hunt; Carrying
the Quarry*, 1927-30
Richard-Ginori factory, Doccia, Florence
Porcelain shaped in mould and decorated with
white glaze; gold applied with agate burnisher;
Ø 33.4
Inscriptions: 'Richard-Ginori / Pittoria di Doccia'
in black on yellow ground; 'Richard-Ginori-40'
in green
Private collection

169
Gio Ponti
Urn with grotesque decorations, 1925
Richard-Ginori factory, Doccia, Florence
Porcelain shaped in mould and decorated with
blue and white glaze; gold applied with agate
burnisher; h 50 x Ø 16.5
Inscriptions: 'Richard-Ginori / Pittoria di Doccia'
in gold; 'Richard-Ginori' in green
Private collection

170
Gio Ponti
*Urn with a representation of the chariot of Cupid
and the chariot of Fortuna*, 1925
Richard-Ginori factory, Doccia, Florence
Porcelain shaped in mould and decorated with
underglaze blue glaze; gold applied with agate
burnisher; h 50 x Ø 16.5
Inscriptions: 'Richard-Ginori / Pittoria di Doccia'
in gold; 'Richard-Ginori' in green
Private collection

159

160

161

162

163

164

165

166

171
Gio Ponti
Urn with Mannerist architectural decorations, 1925–30
Richard-Ginori factory, Doccia, Florence
Porcelain shaped in mould and decorated with underglaze white and blue; gold applied with agate burnisher; h 50 x Ø 16.5
Inscriptions: 'Richard-Ginori / Pittoria di Doccia' in gold; 'Richard-Ginori' in green
Private collection

172
Gio Ponti
'The Archaeological Stroll' urn, 1923–25
Richard-Ginori factory, Doccia, Florence
Porcelain shaped in mould and decorated with underglaze polychrome enamels; gold applied with agate burnisher; h 50 x Ø 16.5
Inscriptions: 'Richard-Ginori / Pittoria di Doccia' in gold; 'Richard-Ginori' in green
Private collection

173
Gio Ponti
Urn with 'The Classical Conversation', 1925
Richard-Ginori factory, Doccia, Florence
Porcelain shaped in mould and decorated with underglaze polychrome enamels; gold applied with agate burnisher; h 50 x Ø 16.5
Inscriptions: 'Richard-Ginori / Pittoria di Doccia / 1925' in black in the gilded scroll; 'Richard-Ginori / 27=6' in green; 'Gio Ponti 1925' in gold; 'La conversazione classica' in the scroll in blue.
Antonello Collection, Milan

174
Gio Ponti
Urn with skiers, 1930
Richard-Ginori factory, Doccia, Florence
Porcelain shaped in mould and decorated with underglaze polychrome enamels; gold applied with agate burnisher; h 50 x Ø 16.5
Inscriptions: 'Richard-Ginori / Pittoria di Doccia' in gold; 'Richard-Ginori' in green
Antonello Collection, Milan

167

168

169

170

170

171

172

173

174

175-178
Gio Ponti
Mermaids/Seasons, 1929–30
Richard-Ginori factory, Doccia, Florence
Porcelain shaped in mould and decorated with underglaze polychrome enamels; Ø 23.3
Inscriptions: 'Richard-Ginori / Pittoria di Doccia' in gold; 'Ginori' in green
Antonello Collection, Milan

179-182
Gio Ponti
The Four Seasons, 1929–30
Richard-Ginori factory, Doccia, Florence
Porcelain shaped in mould and decorated with underglaze polychrome enamels; Ø 23.3
Inscriptions: 'Richard-Ginori' in green
Antonello Collection, Milan

183, 184
Gio Ponti
Two plates with the motifs of the ace of batons and the ace of cups, 1929–30
Richard-Ginori factory, Doccia, Florence
Porcelain shaped in mould and decorated with underglaze polychrome enamels; Ø 23
Inscriptions: 'Richard-Ginori / Pittoria di Doccia' in gold; 'Ginori' in green
Antonello Collection, Milan

185
Gio Ponti
Sugar bowl with lid decorated with niches holding small urns, 1923–25
Richard-Ginori factory, Doccia, Florence
Majolica shaped in mould and decorated with underglaze polychrome enamels; h 19 x Ø 12
Inscriptions: 'Ginori' in green
Private collection

186
Gio Ponti
Small vase with putti, 1928
Richard-Ginori factory, Doccia, Florence
Porcelain shaped in mould and decorated with underglaze polychrome enamels; gold applied with agate burnisher; h 11 x Ø 6.5
Inscriptions: 'Richard-Ginori / Pittoria di Doccia' under the foot, 'Richard-Ginori' in green, 'Italia' in black
Private collection

187
Gio Ponti
'Prospectica' bowl, 1927–28
Richard-Ginori factory, Doccia, Florence
Porcelain shaped in mould and decorated with underglaze polychrome enamels; h 11 x Ø 21
Inscriptions: 'Richard-Ginori / Pittoria di Doccia' in black in the gilded scroll
Private collection

175-178

183

184

179-182

188
Gio Ponti
'Prospectica' amphora, 1925
Richard-Ginori factory, Doccia, Florence
Majolica shaped in mould and decorated
with underglaze polychrome enamels;
h 52.5 x max Ø 132.5
Inscriptions: mark (crown); 'Ginori / 1925'
Museo della Fabbrica Richard-Ginori, Doccia,
Sesto Fiorentino

189
Gio Ponti
Vase with figure of siren, circa 1925
Richard-Ginori factory, San Cristoforo, Milan
Stoneware decorated with red glaze; h 62 x Ø 41
Inscriptions: 'Ginori 52 / 1314 S' in black
and mark (crown)
Antonello Collection, Milan

190
Giovanni Garibodi
Vase with floral decoration in gold, 1928
Richard-Ginori factory, San Cristoforo, Milan
Earthenware cast in mould and decorated with
white glaze; gold applied with agate burnisher;
h 21.5 x Ø 20.5
Inscriptions: 'Richard-Ginori / S. Cristoforo /
Made in Italy / 5911 / 3307' in brown and mark
(San Cristoforo)
Antonello Collection, Milan

191
Gio Ponti
Plate with figure of an angel holding an anchor,
1930
Richard-Ginori factory, Doccia, Florence
Majolica shaped in mould and decorated with
underglaze polychrome enamels; h 26 x 32 x Ø 25.5
Inscriptions: 'Ginori 119 / Gio Ponti' in black
and mark (crown)
Antonello Collection, Milan

185

186

187

188

189

190

191

175

192
Enrico Mazzolani
The Canticle of the Sun, circa 1925
Milan
Majolica shaped in mould and decorated with underglaze polychrome enamels; h 65 x 52 x 15
Inscriptions: 'E. Mazzolani' on the base
Antonello Collection, Milan

193
Enrico Mazzolani
Centaur and nymph (The Dream), 1927
Milan
Majolica shaped in mould and decorated with two underglaze colours;
h 74 x 35 x 30
Inscriptions: 'E. Mazzolani' on the base;
'EM / Milano 1927' on the bottom
Galleria d'Arte Moderna 'Carlo Rizzarda', Feltre

194
Enrico Mazzolani
Tragic mask (The Drama), 1927–28
Milan
Majolica shaped in mould and decorated with two underglaze colours; h 63 x 18 x 18
Inscriptions: 'E. Mazzolani' on the back;
'EM' on the bottom
Galleria d'Arte Moderna 'Carlo Rizzarda', Feltre

195
Enrico Mazzolani
Caresses, 1928
Milan
Majolica shaped in mould and decorated with two underglaze colours; h 62 x 14 x 13
Inscriptions: 'E. Mazzolani' on the base;
'EM / Milano 928' on the bottom
Galleria d'Arte Moderna 'Carlo Rizzarda', Feltre

196
Golia (Eugenio Colmo)
Plate with floral decorations, 1925
Golia factory, Turin
Earthenware cast in mould and decorated with underglaze polychrome enamels; silver; Ø 30.8
Inscriptions: 'Golia Torino 29/7/1925' and, over drawing of a flower, '711';
Museo Internazionale della Ceramica, Faenza, inv. no. 25442

197
Golia (Eugenio Colmo)
'Grandmother and Granddaughter' plate, 1927
Golia factory, Turin
Earthenware cast in mould and decorated with underglaze polychrome enamels; silver; Ø 31.5
Inscriptions: '1542' 'Golia Torino 16/1/1927'
Museo Internazionale della Ceramica, Faenza, inv. no. 25438

198
Giovanni Grande
Pollux, 1929
Lenci factory, Turin
Earthenware cast in mould and decorated with underglaze polychrome enamels; h 38 x 41.5 x 26
Inscriptions: 'Lenci, Made in Italy, 10-4-29' - Lenci and figurine (engraved in the paste). Lenci label with 134 and 'Polluce' written by hand
Antonello Collection, Milan

199
Giovanni Grande
Drunken Bacchus, 1929
Lenci factory, Turin
Earthenware cast in mould and decorated with white glaze; h 38 x 41.5 x 26
Inscriptions: 'Lenci, Italia, 11-6-29'; signed 'Grande' on the edge and 'Bacco ubriaco' 'Trionfo di Bacco' engraved in the paste
Antonello Collection, Milan

200
Giovanni Grande
Faun uncovering a nymph, circa 1930
Lenci factory, Turin
Earthenware cast in mould and decorated with underglaze polychrome enamels and partially by airbrush; h 25 x 46 x 33
Inscriptions: 'Lenci, Made in Italy' and executor's mark; signed 'Grande' on the base and 'Fauno e nudo dormiente' 'fauno e ninfa' engraved in the paste
Antonello Collection, Milan

192

193

194

195

196

197

201
Giovanni Grande
First Kiss, 1932
Lenci factory, Turin
Earthenware cast in mould and decorated with underglaze polychrome enamels and partially by airbrush; h 28 x 23.5 x 17.5
Inscriptions: 'Lenci Made in Italy, 5-2-32' and executor's mark 'Primo bacio'
Antonello Collection, Milan

202
Giovanni Grande
Don Quixote astride Rocinante, 1930 *circa*
Lenci factory, Turin
Earthenware cast in mould and decorated with underglaze polychrome enamels;
h 38 x 41.5 x 26; h 45.5 x 38.5 x 17
Inscriptions: 'Lenci, Made in Italy' and 'K' with dash (executor's mark), circled 66 (with blue felt-tip pen) 'Don Chisciotte'
Antonello Collection, Milan

203
Giovanni Grande
The Bride and Groom, 1929–30
Lenci factory, Turin
Earthenware cast in mould and decorated with underglaze polychrome enamels; h 38 x 36 x 22
Inscriptions: 'Lenci, Made in italy', initials 'LR' (executor's mark) and '24' in the paste
Lenci label with '24'
Antonello Collection, Milan

198

199

200

201

202

203

177

204
Helen König Scavini
Female nude with apple, 1929
Lenci factory, Turin
Earthenware cast in mould and decorated with white glaze; h 51.5 x 15 x 17.5
Inscriptions: 'Lenci, Made in Italy, 18-XII-'29' and executor's mark 'Nuda con mela'
Antonello Collection, Milan

205
Sandro Vacchetti
The Two Tigers, 1930
Lenci factory, Turin
Earthenware cast in mould and decorated with underglaze polychrome enamels; h 43 x 25 x 12
Inscriptions: 'Le due tigri'
Private collection

206
Dancer in kimono, 1920–30
Bigi factory, Turin
Earthenware cast in mould and decorated with underglaze polychrome enamels; h 43 x 28.5 x 14
Inscriptions: 'Bigi / Torino'
Antonello Collection, Milan

207
Abele Jacopi, attributed to
The Four Elements: Water, 1930–35
Lenci factory, Turin
Earthenware cast in mould and decorated with underglaze polychrome enamels; h 28.5 x 38 x 18
Inscriptions: 'Lenci / Made in Italy / Torino' and decorator's mark; label '762'
Antonello Collection, Milan

208
Abele Jacopi, attributed to
The Four Elements: Air and Earth, 1930–35
Lenci factory, Turin
Earthenware cast in mould and decorated with underglaze polychrome enamels; h 50 x 31 x 18.5
Inscriptions: 'Lenci / Made in Italy / Torino' and 'B' (initial of the decorator, perhaps Maria Balossi)
Antonello Collection, Milan

209
Abele Jacopi, attributed to
The Four Elements: Fire, 1930–35
Lenci factory, Turin
Earthenware cast in mould and decorated with underglaze polychrome enamels; h 32 x 37.5 x 18
Inscriptions: 'Lenci / Made in Italy / Torino' and decorator's mark; label '761'
Antonello Collection, Milan

210
Mario Sturani
Lamp with three lights in the form of a woman's head, 1929
Lenci factory, Turin
Earthenware cast in mould and decorated with undergreen glaze; h 33 x 24.5 x 13
Inscriptions: 'Lenci, Made in Italy, 11-9-29' and '39' engraved in the paste; 'Sturani' 'Maschera per lampada elettrica' engraved in the paste on the edge
Antonello Collection, Milan

211
Mario Sturani
Ashtray representing Harlequin mask, 1929
Lenci factory, Turin
Earthenware cast in mould and decorated with underglaze polychrome enamels and partially by airbrush; h 15 x 16 x 15
Inscriptions: 'Lenci Made in Italy, 21-VIII-'29'; '41', 'Lenci' 'Maschera Arlecchino' engraved in the paste
Antonello Collection, Milan

212
Mario Sturani
Vase representing three masks, 1929
Lenci factory, Turin
Earthenware cast in mould and decorated with underglaze polychrome enamels; h 15 x 22 x 17
Inscriptions: 'Lenci, Made in Italy, 16-7-29' and executor's mark – '36' 'Maschere' engraved in the paste
Antonello Collection, Milan

213
Mario Sturani
Bowl with family group, 1930
Lenci factory, Turin
Earthenware cast in mould and decorated with underglaze polychrome enamels; h 32 x Ø 30
Inscriptions: 'Lenci, Made in Italy, 26-8-930' and mark 'Scodella'
Antonello Collection, Milan

214
Mario Sturani
Bowl with group of young people dancing, 1930
Lenci factory, Turin
Earthenware cast in mould and decorated with underglaze polychrome enamels; h 23 x Ø 27
Inscriptions: 'Lenci, Made in Italy, 14-5-930' and mark 'Scodella - Il ponte' or 'Contadini danzanti'
Antonello Collection, Milan

215
Mario Sturani
Vase with arum lilies and fruit: The Table, 1929–30
Lenci factory, Turin
Earthenware cast in mould and partially modelled and applied; decoration with underglaze polychrome enamels; h 35.5 x 27.5 x 24.5
Inscriptions: 'Lenci, Made in Italy, Torino' and executor's mark. Lenci label with 14, 'Vaso - La tavola'
Antonello Collection, Milan

216
Arturo Martini
Judith, 1927
Industria Ligure Ceramiche Artistiche (I.L.C.A.), Nervi
Majolica shaped in mould and decorated with underglaze polychrome enamels (attributable to Manlio Trucco); h 30 x Ø 28
Inscriptions: 'ILCA NERVI' under the base
Private collection

217
Arturo Martini
Orpheus, 1927
Industria Ligure Ceramiche Artistiche (I.L.C.A.), Nervi
Majolica shaped in mould and decorated with underglaze polychrome enamels (attributable to Manlio Trucco); h 32.5 x Ø 28
Inscriptions: 'ILCA NERVI' under the base
Private collection

218
Arturo Martini
Judith, 1927
Savona, factory Savona Nuova
Majolica shaped in mould and decorated with underglaze polychrome enamels (attributable to Manlio Trucco); h 30 x Ø 28; h 33.5 x Ø 28
Inscriptions: 'Savona Nuova' and mark (phoenix on a towered castle)
Antonello Collection, Milan

213

214

215

216

217

218

219
Arturo Martini
Visitation, 1929–30
Industria Ligure Ceramiche Artistiche (I.L.C.A.), Nervi
Majolica shaped in mould and decorated with underglaze polychrome enamels; h 30 x Ø 24
Inscriptions: 'Ilca Nervi' and mark (two-faced crowned head)
Private collection

220
Arturo Martini
Bathers, 1929–30
Industria Ligure Ceramiche Artistiche (I.L.C.A.), Nervi
Majolica shaped in mould and decorated with underglaze polychrome enamels; h 30 x Ø 24
Inscriptions: 'Ilca Nervi' and mark (two-faced crowned head)
Antonello Collection, Milan

221
Arturo Martini
Flamingo, 1929–30
Industria Ligure Ceramiche Artistiche (I.L.C.A.), Nervi
Majolica shaped in mould and decorated with underglaze polychrome enamels; h 40 x Ø base 8
Inscriptions: 'Ilca Nervi' and mark (two-faced crowned head)
Antonello Collection, Milan
Shown at the 4th Monza Triennale (1930)

222
Francesco Messina
The Generative Flame, 1924–25
La Fenice factory, Albisola Capo
Majolica shaped in mould and decorated with underglaze polychrome enamels; h 32.3 x 30 x 2.8
Raccolte Civiche di Palazzo Rosso, Genoa

223
Manlio Trucco
Jar with lid and two handles, circa 1927
La Fenice factory, Albisola Capo
Majolica shaped in mould and decorated with metal lustres; h 17.8 x 15.8
Inscriptions: 'Albisola / Trucco' and symbol of La Fenice under the base
Civiche Raccolte d'Arti Applicate del Castello Sforzesco, Milan, inv. no. 119

219

220

221

222

223

224

225

226

227

180

224
Tullio d'Albisola
'The Passion for GG di Tullio' two-handled vase, circa 1926-28
Giuseppe Mazzotti factory, Albisola Marina
Majolica shaped in mould and decorated with underglaze polychrome enamels; h 28
Inscriptions: 'MGA Albissola Marina' under the base
Private collection

225
Tullio d'Albisola
'Anti-imitative Phobia' plate: the Destructive Bee, 1929
Giuseppe Mazzotti factory, Albisola Marina
Majolica shaped in mould and decorated with underglaze polychrome enamels; h 3 x Ø 37
Inscriptions: 'Fobia anti-imitativa Tullio' and 'M.G.A.' under the foot
Private collection

226
Tullio d'Albisola
'Anti-imitative Phobia' jug, 1929
Giuseppe Mazzotti factory, Albisola Marina
Majolica shaped in mould and decorated with underglaze polychrome enamels; h 15 x 24 x 10
Inscriptions: 'Fobia anti-imitativa Tullio' and 'M.G.A.' under the foot
Gilli Collection, Milan

227
Tullio d'Albisola
'Flowers of My Gardens' vase, circa 1929
Giuseppe Mazzotti factory, Albisola Marina
Majolica shaped in mould and decorated with underglaze polychrome enamels; h 25.5 x 27
Inscriptions: 'Fobia anti-imitativa Tullio' and 'M.G.A.' under the foot
Museo Internazionale della Ceramica, Faenza, inv. no. 2020

228
Tullio d'Albisola
'Anti-imitative Phobia' polycentric conical vase, 1929–30
Giuseppe Mazzotti factory, Albisola Marina
Majolica shaped in mould and decorated with underglaze polychrome enamels; h 21 x 17
Inscriptions: 'Fobia anti-imitativa Tullio' and 'M.G.A.' under the foot
Gilli Collection, Milan

229
Tullio d'Albisola
'Loves - Flowers' vase, 1929
Giuseppe Mazzotti factory, Albisola Marina
Glazed terracotta; h 21.8 x Ø foot 14.5
Inscriptions: 'Fobia anti-imitativa Tullio' and 'M.G.A.' under the foot; mark of the kiln
Civiche Raccolte d'Arti Applicate del Castello Sforzesco, Milan, inv. no. 1779

230
Tullio d'Albisola
'Witches' vase, 1929
Giuseppe Mazzotti factory, Albisola Marina
Glazed terracotta; h 19 x Ø base 13 x Ø mouth 6
Inscriptions: 'Fobia / anti-imitativa / di / Tullio / MGA' under the foot
Civiche Raccolte d'Arti Applicate del Castello Sforzesco, Milan, inv. no. 3294

231
Riccardo Gatti and Mario Guido Dal Monte
Plate with dancing masked figure, 1928–29
Gatti & C. factory, Faenza
Majolica shaped in mould and decorated with underglaze polychrome enamels; Ø 14.5
Inscriptions: mark (stylized head of cat) and 'FAENZA R. GATTI' under the base
Gilli Collection, Milan

232
Riccardo Gatti
Futurist vase with storks, 1928
Gatti & C. factory, Faenza
Majolica shaped in mould and decorated with underglaze polychrome enamels; h 30 x Ø 22
Inscriptions: mark (stylized head of cat) and 'FAENZA R. GATTI' under the foot
Museo Internazionale della Ceramica, Faenza, inv. no. 18745

233
Riccardo Gatti
Ovoid vase with female figures and chromatic interpenetrations, 1928–29
Gatti & C. factory, Faenza
Majolica shaped in mould and decorated with underglaze polychrome enamels; h 33
Inscriptions: (stylized head of cat) and 'R. GATTI FAENZA' in black under the base mark
Private collection

228

229

230

231

232

233

234
Leonardo Castellani
Cache-pot with plant motifs, 1920–25
Castellani factory, Cesena
Terracotta turned on the wheel and decorated with underglaze polychrome enamels; h 26.5 x Ø 33
Inscriptions: stamped 'CESENAE' and mark (stylized house)
Gilli Collection, Milan

235
Enea Antonelli
Tortoise, 1922–24
Terracotta modelled, decorated with dark blue/light blue and glazed; h 8.5 x 10
Private collection

236
Renato Bassanelli
Plate with sleeping Venus and Pan, circa 1922
Keramos factory, Rome
Terracotta modelled, decorated with polychrome enamels and glazed; h 6.5 x Ø 32.3
Inscriptions: under the base, 'R. BASSANELLI' and 'KERAMOS' in the paste
Private collection

237
Renato Bassanelli
Vase with faun perched in a tree, circa 1922
Keramos factory, Rome
Terracotta modelled, decorated with polychrome enamels and glazed; h 29
Inscriptions: under the base 'R. BASSANELLI / KERAMOS / ROMA', in the paste
Antonello Collection, Milan

238
Renato Bassanelli, attributed to
Vase with putti and garlands of flowers, 1925–30
Keramos factory, Rome
Terracotta modelled, decorated with polychrome enamels and glazed; h 34.5
Antonello Collection, Milan

239
Renato Bassanelli
Container with lid decorated with sprays of roses, 1923–25
Keramos factory, Rome
Terracotta modelled on the wheel, decorated with polychrome enamels and glazed; h 7 x Ø 9.30
Private collection

240
Romeo Berardi
Plate with marine fantasy, 1923
Terracotta modelled, decorated with polychrome enamels and glazed; Ø 15
Inscriptions: 'R. BERARDI', mark '1923 Roma'
Antonello Collection, Milan

241
Alfredo Biagini
Jug of the Satyrs, 1915–20
Fratelli Minardi di Focaccia e Melandri factory, Faenza
Majolica shaped in mould and decorated with underglaze polychrome enamels; h 26 x max Ø 17
Inscriptions: 'ADO/BIAGINI/BNI/AMM/MF/FAENZA/S.' under the base
Private collection

242
Alfredo Biagini
Small faun, circa 1920
Sindacato Industrie Artistiche Italiane (S.I.A.I.) factory, Rome
Majolica shaped in mould and decorated with underglaze polychrome enamels; h 21 x 13 x Ø 10 of base
Inscriptions: under the base in the two rettangoli engraved in the paste is indicato 'Piece Unico' and 'siai - Roma'
Antonello Collection, Milan

243
Alfredo Biagini
Lioness, 1920–21
Sindacato Industrie Artistiche Italiane (S.I.A.I.) factory, Rome
Majolica shaped in mould and decorated with high-fired polychrome enamels; h 23 x 79 x 21
Private collection

244
Alfredo Biagini
Hamadryas (or sacred baboon), 1921–23
Sindacato Industrie Artistiche Italiane (S.I.A.I.) factory, Rome
Majolica shaped in mould and decorated with high-fired polychrome enamels; h 38 x 29 x 18
Inscriptions: 'S.I.A.I. – ROMA' on the base
Museo Internazionale della Ceramica, Faenza, inv. no. 1087

245
Alfredo Biagini, attributed to
Egg-shaped vase with female nudes and garlands of flowers in a wood, circa 1925–30
Sindacato Industrie Artistiche Italiane (S.I.A.I.) factory, Rome
Majolica shaped in mould and decorated with underglaze polychrome enamels; h 25 x max Ø 14.2
Antonello Collection, Milan

246
Duilio Cambellotti
Bowl with bowed female figure, 1920
Regio Istituto Nazionale per l'Istruzione Professionale (R.I.N.I.P.) factory, Rome
Majolica shaped in mould and decorated with black glaze (*bucchero* technique); h 6.5 x 17
Private collection

247
Duilio Cambellotti
Vase of the Zodiac, 1924
Regio Istituto Nazionale per l'Istruzione Professionale (R.I.N.I.P.) factory, Rome
Majolica shaped in mould and decorated with underglaze polychrome enamels; h 27 x Ø 30.7
Inscriptions: 'DC', mark (ear of wheat) and 'R.I.N.I.P. Roma / F. Frigiotti' engraved under the base
Antonello Collection, Milan

248
Duilio Cambellotti
Vase of the Zodiac, 1923
Regio Istituto Nazionale per l'Istruzione Professionale (R.I.N.I.P.) factory, Rome
Majolica turned on the wheel and decorated with black glaze (*bucchero* technique); h 32 x Ø 29
Antonello Collection, Milan

243

244

245

246

248

247

249
Duilio Cambellotti
Maremma cowherd in horseback, 1924
Regio Istituto Nazionale per l'Istruzione
Professionale (R.I.N.I.P.) factory, Rome
Majolica shaped in mould and decorated
with black glaze (*bucchero* technique); h 28
Inscriptions: 'DC', mark (ear of wheat) and the title
'Buttero R.I.N.I.P.-Roma' engraved under the base
Antonello Collection, Milan

250
Duilio Cambellotti
Vase of the Fishing Smacks, 1924
Regio Istituto Nazionale per l'Istruzione
Professionale (R.I.N.I.P.) factory, Rome
Majolica shaped in mould and decorated with
underglaze blue and green; h 19.5 x Ø 18
Inscriptions: 'DC' and 'R.I.N.I.P.-Roma'
under the base
Private collection

251
Duilio Cambellotti
Bowl of the Violets, 1925
Regio Istituto Nazionale per l'Istruzione
Professionale (R.I.N.I.P.) factory, Rome
Terracotta modelled and decorated with lustres
underglaze; h 10 x Ø 31
Inscriptions: 'DC' and mark (ear of wheat)
under the base
Private collection

252
Duilio Cambellotti
Vase with crows, 1927
Majolica shaped in mould, finished by hand and
decorated with black glaze (*bucchero* technique);
h 20 x Ø 17
Inscriptions: stamped 'CD' and mark
(ear of wheat)
Gilli Collection, Milan

253
Achille Luciano Mauzan
*Woman squatting with her hands folded
(Nostalgia)*, circa 1920
Laboratorio Nuova Ceramica factory, Rome
Terracotta modelled, coated with slip and
decorated with dripped underglaze enamels;
h 16 x 18 x 18
Antonello Collection, Milan

254
Achille Luciano Mauzan
Jug, 1920–21
Laboratorio Nuova Ceramica factory, Rome
Terracotta modelled and decorated
with underglaze polychrome enamels;
h 13.5 x max Ø 7.7
Inscriptions: 'L N C R / M' (the 'm' is traversed
by an oblique line) under the base
Private collection

255
Roberto Rosati
Fawn, 1922
Ceramiche Palazzi factory, Rome
Majolica shaped in mould and decorated with
underglaze red and green; h 36 x 8 x 6
Private collection

256
Roberto Rosati
Cache-pot with tigers, 1925
Fiamma factory, Rome
Terracotta modelled and decorated with underglaze polychrome enamels; h 20 x Ø circa 30
Private collection

257
Roberto Rosati
Plate with gazelle, 1926
Fiamma factory, Rome
Terracotta modelled on the wheel and decorated with underglaze polychrome enamels; Ø 24.7
Inscriptions: 'ROSATI / X-V-26' marking on the back
Private collection

258
Ferruccio Palazzi
Vase with squirrels, 1920
Palatino Ars factory, Rome
Terracotta modelled and decorated with underglaze polychrome enamels; h 19 x max Ø 17
Inscriptions: 'PALATINO ARS Roma'
Private collection

259
Mary Pandolfi de Rinaldis
Vase with budgerigars, 1923
S.I.P.L.A. factory, Rome
Terracotta modelled with applications in relief decorated with underglaze polychrome enamels; h 17.3 x max Ø 21.5
Inscriptions: 'PANDOLFI / SIPLA / ROMA' on the bottom
Civiche Raccolte d'Arti Applicate del Castello Sforzesco, Milan, inv. no. 1547

260
Mary Pandolfi de Rinaldis
Tiles with women's heads, 1921
Terracotta shaped in mould and decorated with underglaze polychrome enamels; h 47 x 47
Inscriptions: 'MARY / PANDOLFI / CORSO UMBERTO I N. 504 / INDIRIZZO DI RINVIO' on the back
Private collection

261
Giulio Rufa
Vase with putti carrying baskets of fruit, circa 1925
Palazzi factory, Rome
Terracotta turned on the wheel and decorated with underglaze polychrome enamels; h 38.5 x max Ø 29
Inscriptions: 'G. Rufa' under the base
Private collection

262
Giulio Rufa, attributed to
Vase with women carrying baskets, 1926
Palazzi factory, Rome
Terracotta turned on the wheel and decorated with underglaze polychrome enamels; h 32 x Ø 17
Inscriptions: 'Palazzi / Roma' under the base
Antonello Collection, Milan

263
Giovanni Prini
The Swallow, 1921
Rome
Majolica modelled and decorated with
underglaze polychrome enamels; h 16 x 22 x 20
Private collection

264
Ferruccio Palazzi Olivieri
Leda and the Swan, 1924–26
Palazzi factory, Rome
Terracotta turned on the wheel and decorated
with underglaze polychrome enamels; Ø 40
Inscriptions: 'PALAZZI ROMA' under the base in black
Private collection

265
Ferruccio Palazzi Olivieri and Roberto Rosati
Plate with girl from the Roman Campagna with a copper vessel on her head, circa 1926
Palazzi factory, Rome
Terracotta turned on the wheel and decorated
with underglaze polychrome enamels; Ø 40.5
Inscriptions: 'Olivieri' under the head
Private collection, Rome

266
Spherical container with lid and figurine in fancy dress, 1925–30
La Salamandra factory, Perugia
Terracotta shaped in mould and decorated with
underglaze polychrome enamels; h 26 x Ø 18
Inscriptions: 'Salamandra Perugia Italy 229' in black
Antonello Collection, Milan

267
Female figurine with fan, 1925–30
La Salamandra factory, Perugia
Terracotta shaped in mould and decorated
with underglaze polychrome enamels; h 29
Inscriptions: 'Salamandra Perugia' in black
Antonello Collection, Milan

268
Box with lid in the form of lady in 18th-century dress, circa 1925
La Salamandra factory, Perugia
Terracotta shaped in mould and decorated with
underglaze polychrome enamels; h 30 x 27 x 17.5
Inscriptions: 'Salamandra Perugia Italy 1' in black
Antonello Collection, Milan

269
Basilio Cascella
Plate with woman's head, 1922–23
Bozzelli factory, Rapino
Terracotta shaped in mould and decorated
with underglaze polychrome enamels; Ø 47.4
Inscriptions: 'B. Cascella' on the rim
Civiche Raccolte d'Arti Applicate del Castello
Sforzesco, Milan, inv. no. 1909
Shown at the 1st Monza Biennale (1923)

270
Giuseppe Forestiere and Reggi
Vase with deer, 1924–25
Reale Istituto d'Arte factory, Naples
Majolica shaped in mould with applications
in relief and decorated with underglaze

263

264

265

266

267

268

269

270

polychrome enamels; h 65 x 30.5
Civiche Raccolte d'Arti Applicate del Castello Sforzesco, Milan, inv. no. 3359

271
Ferruccio Mengaroni
Crab, 1924–25
Maioliche Artistiche Pesaresi Ferruccio Mengaroni A.M. and C. (M.A.P.) factory, Pesaro
Majolica decorated with underglaze polychrome enamels; h 28.3 x 87 x 87
Civiche Raccolte d'Arti Applicate del Castello Sforzesco, Milan, inv. no. 3361
Shown at the 2nd Monza Biennale (1925)

272
Ferruccio Mengaroni
Dory, 1924–25
Maioliche Artistiche Pesaresi Ferruccio Mengaroni A.M. and C. (M.A.P.) factory, Pesaro
Majolica decorated with underglaze polychrome enamels; h 17 x 80 x 10
Inscriptions: 'M.A.P. / Italy / Pesaro' inside
Galleria d'Arte Moderna 'Carlo Rizzarda', Feltre, inv. no. 517

273
Ferruccio Mengaroni
Panel with head of Medusa, 1925
Maioliche Artistiche Pesaresi Ferruccio Mengaroni A.M. and C. (M.A.P.) factory, Pesaro
Majolica decorated with underglaze polychrome enamels; Ø 240
Inscriptions: 'M. A. P. Ferruccio Mengaroni fece Pesaro 1925'
Museo Civico, Pesaro
Shown at the 2nd Monza Biennale (1925)

274
Eliseo Bertozzini and Vincenzo Molaroni
Large neo-Renaissance vase, 1925–30
Molaroni factory, Pesaro
Majolica shaped in mould with applications in relief and decorated with underglaze polychrome enamels; h 79.5 x max Ø 26 x Ø foot 18.5
Civiche Raccolte d'Arti Applicate del Castello Sforzesco, Milan, inv. no. 4056

275
Giovanni Spinaci
Serving dish with portrait of Cimabue inside ornamental design of grotesques, circa 1930
Giovanni Spinaci and Compagni factory, Gubbio
Majolica in various shades of blue, gold lustre and red lustre, Ø 32.8
Inscriptions: at the centre, inside a tondo, above the male profile with a beard and hood, 'Cimabue'
Museo Comunale, Gubbio, inv. no. 483

276
Rodolfo Ceccaroni
'The Resurrection', 1928
Recanati
Majolica shaped in mould and decorated with underglaze polychrome enamels; Ø 35.7
Inscriptions: 'Tura mirum spargens sonum for sepulcra regionum' in the scroll on the front; 'AD. MCMXXVIII II febbraio R. Ceccaroni da Recanati – La Resurrezione' on the back
Museo Internazionale della Ceramica, Faenza, inv. no. 20405

271

272

273

274

275

276

187

277
David Zipirovič
Plate with portrait of Beatrice d'Este, 1923–27
Società Anonima Maioliche Deruta factory, Deruta
Majolica shaped in mould and decorated with underglaze polychrome enamels; Ø 48
Inscriptions: 'Deruta' on the back and 'D.Z.' inside a shield
Museo Regionale delle Ceramiche di Deruta, Deruta, inv. no. 4014

278
Gian Carlo Polidori
Plate with woman carrying basket and dolphins, 1925–26
Matricardi factory, Ascoli Piceno
Majolica shaped in mould and decorated with underglaze polychrome enamels; Ø 25.2
Inscriptions: '1046 / GC POLIDORI / MATRICARDI / ASCOLI PICENO' on the base of the foot
Civiche Raccolte d'Arti Applicate del Castello Sforzesco, Milan, inv. no. 3286

279
Francesco Ciusa
Box with lid representing mother with laughing child, 1919–21
Società per Industria Ceramiche Artistiche (S.P.I.C.A.) factory, Albisola
Terracotta shaped in mould and decorated with polychrome enamels; h 17.5
Inscriptions: 'SPICA'
Archivio per le Arti Applicate, Nuoro

280
Francesco Ciusa
Young bride from Nuoro, circa 1922
Società per Industria Ceramiche Artistiche (S.P.I.C.A.) factory, Albisola Terracotta shaped in mould and decorated with polychrome enamels; h 35.2
Inscriptions: 'SPICA' on the bottom
Private collection

281
Francesco Ciusa
Container with lid: CANTU PRUS MANNU EST S'AMORE TANTU PRUS TRISTA EST SA BIDA, 1919–21
Società per Industria Ceramiche Artistiche (S.P.I.C.A.) factory, Albisola Terracotta shaped in mould and decorated with polychrome enamels; h 28.5
Inscriptions: 'SPICA'
Archivio per le Arti Applicate, Nuoro

282
Federico Melis
Woman from Barbagia, 1927–30
Bottega d'Arte Ceramica di Federico Melis factory at the Società Ceramica Industriale (S.C.I.C.), Cagliari
Terracotta shaped in mould and decorated with polychrome enamels; h 43.5
Inscriptions: 'Bottega d'arte ceramica Cagliari'
Camera di Commercio, Sassari

283
Federico Melis
Sardinian urn, 1927–31
Bottega d'Arte Ceramica di Federico Melis factory at the Società Ceramica Industriale (S.C.I.C.), Cagliari
Terracotta shaped in mould with applications in relief and decorated in relief with underglaze white and black; h 54
Inscriptions: 'Melis Sardinia' painted on the bottom
Private collection

284
Federico Melis
Urn with Sardinian horsemen and anthropomorphic lid, 1927–31
Bottega d'Arte Ceramica di Federico Melis factory at the Società Ceramica Industriale (S.C.I.C.), Cagliari
Terracotta shaped in mould and decorated in relief with underglaze white and black; h 52
Inscriptions: 'Melis Sardinia'
Private collection

285
Federico Melis
Vase with horsemen, 1929–31
Bottega d'Arte Ceramica di Federico Melis factory at the Società Ceramica Industriale (S.C.I.C.), Cagliari
Terracotta shaped in mould and decorated with underglaze white and black; h 24.5
Inscriptions: 'SCIC Cagliari Melis' on the bottom
Private collection

277

278

279

280

281

282

286
Federico Melis
Small head of girl from Desulo, 1928–30
Bottega d'Arte Ceramica di Federico Melis
factory at the Società Ceramica Industriale
(S.C.I.C.), Cagliari
Terracotta shaped in mould and decorated
with underglaze polychrome enamels; h 14
Inscriptions: 'SCIC Cagliari Sardinia Melis'
painted on the bottom
Private collection

287
Federico Melis
Ashtray in the form of a woman with a basket making an offering, 1929–31
Bottega d'Arte Ceramica di Federico Melis
factory at the Società Ceramica Industriale
(S.C.I.C.), Cagliari
Terracotta shaped in mould and decorated with underglaze polychrome enamels; h 23.5 x Ø 13.5
Inscriptions: 'SCIC Cagliari Sardinia Melis' painted on the bottom
Archivio per le Arti Applicate, Nuoro

288
Melkiorre Melis
African water carrier, 1928–30
C.A.M.M. factory, Rome
Terracotta shaped in mould and decorated with underglaze polychrome enamels; h 26.4
Inscriptions: 'Roma C.A.M.M.' stamped on the bottom
Archivio per le Arti Applicate, Nuoro

283

284

285

286

287

288

1930–50

289
Anselmo Bucci
Speckled spherical vase with lid, 1932–36
Faenza
Majolica shaped in mould with applications in relief (the two handles) and decorated with polychrome lustres on third firing: h 33 x max Ø 27
Inscriptions: under the base 'FAENZA' and 'A Bucci'
Civiche Raccolte d'Arti Applicate del Castello Sforzesco, Milan, inv. no. 120

290
Anselmo Bucci
Large vase with popular festival, 1930–35
Faenza
Majolica shaped in mould with elements in relief and incisions in the paste decorated with underglaze polychrome enamels; h 69.5 x 24.3
Inscriptions: under the base 'FAENZA / BUCCI / MODEL - EMAPI' and mark (vase)
Museo Internazionale della Ceramica, Faenza, inv. no. 31712

291
Anselmo Bucci
Spherical vase with lattice decoration, 1947
Faenza
Majolica shaped in mould and decorated with underglaze polychrome enamels; h 22 x max Ø 27
Inscriptions: mark (vase)
Museo Internazionale della Ceramica, Faenza, inv. no. 1718

292
Riccardo Gatti
Oval vase with abstract decorations, circa 1935
Gatti & C. factory, Faenza
Majolica shaped in mould and decorated with polychrome lustres on third firing; h 32 x Ø 20.5
Inscriptions: 'R. GATTI / FAENZA / E' in black
Antonello Collection, Milan

293, 294
Riccardo Gatti
Pair of plates: Grape-picking and Country Festival, 1935–38
Gatti & C. factory, Faenza
Majolica shaped in mould and decorated with black and white glaze and gilding; Ø 36
Inscriptions: 'R. GATTI / FAENZA' in black
Antonello Collection, Milan

295
Pietro Melandri and Ercole Drei
Goblet with figure of Pegasus, 1930–35
Pietro Melandri factory, Faenza
Majolica turned on the wheel with modelling in relief and decorated with polychrome glazes and lustres on third firing; h 41.5 x 37 x 30
Museo Internazionale della Ceramica, Faenza, inv. no. 24156

289

291

292

290

293

294

295

296

297

296
Pietro Melandri
Face of satyr, 1932
Pietro Melandri factory, Faenza
Majolica modelled and decorated with
underglaze polychrome enamels; h 47 x 24 x 19
Inscriptions: 'Melandri' engraved on the back
Museo Internazionale della Ceramica, Faenza,
inv. no. 2719

297
Pietro Melandri
Woman's head with hat, 1934
Pietro Melandri factory, Faenza
Majolica modelled and decorated with lustres
on third firing; h 18 x 24 x 21
Inscriptions: 'Melandri / 34' in black
Antonello Collection, Milan

298
Pietro Melandri
Panel in high relief with the myth of Orpheus,
1935–40
Pietro Melandri factory, Faenza
Majolica modelled and decorated with
underglaze polychrome enamels; h 30 x 40
Inscriptions: 'M' and mark (goshawk inside
a circle) on the edge
Antonello Collection, Milan

299
Pietro Melandri
Large plate with marine fauna, circa 1935
Pietro Melandri factory, Faenza
Majolica modelled and decorated with
polychrome glazes and lustres on third firing; Ø 47
Inscriptions: 'MELANDRI / FAENZA' in black and mark
(goshawk inside a circle)
Antonello Collection, Milan

300
Pietro Melandri
Saint Sebastian, 1940
Pietro Melandri factory, Faenza
Majolica modelled with mould and decorated
with underglaze polychrome enamels;
reassembled on a surface of glass and metal
cramps;
h 230 x *circa* 110
Civica Raccolta di Terraglia, Cerro di Laveno
Mombello

301
Dante Morozzi
Etruscan nude, 1931
Majolica modelled and decorated with
polychrome enamels
underglaze with cavillatura; h 48 x 23
Museo Internazionale della Ceramica, Faenza,
inv. no. 1092

302
Leo Ravazzi
Mercury, 1935
Sesto Fiorentino
Majolica shaped in mould with finishing touches
and decorated with underglaze red; h 36
Inscriptions: 'Leo Ravazzi A. XIII'
Museo Internazionale della Ceramica, Faenza,
inv. no. 1465

303
Gio Ponti
Woman's head, circa 1930
Richard-Ginori factory, San Cristoforo, Milan
Earthenware cast in mould and decorated with green glaze; h 19.5
Inscriptions: mark (San Cristoforo) and 'RICHARD-GINORI / FABBRICATO IN ITALIA / MADE IN ITALY / 6279 / 502 T' in green
Museo Internazionale della Ceramica, Faenza, inv. no. 1391

304
Gio Ponti
'The Hands' plate, 1930
Richard-Ginori factory, Doccia, Florence
Majolica shaped in mould and decorated with underglaze polychrome enamels; Ø 36
Inscriptions: Ginori crown mark, 'Ginori/Gio Ponti 250' on the back
Antonello Collection, Milan

305
Gio Ponti
'La Pontesca' plate, 1930
Richard-Ginori factory, Doccia, Florence
Majolica shaped in mould and decorated with underglaze polychrome enamels; Ø 46
Inscriptions: Ginori crown, 'Ginori/Gio Ponti' on the back
Private collection

306
Gio Ponti
'The Concert' plate, 1933
Richard-Ginori factory, Doccia, Florence
Porcelain decorated with underglaze polychrome enamels and gilded with agate burnisher; Ø 33
Inscriptions: in black in the gilded scroll, 'Richard-Ginori / Pittoria di Doccia / 33=7' (in green)
Antonello Collection, Milan

307
Gio Ponti
Bookend in the form of elephants with garland of flowers, 1933
Richard-Ginori factory, Doccia, Florence
Porcelain decorated with underglaze polychrome enamels and gilded with agate burnisher; h 10.2 x 8.5 x 10.5
Inscriptions: in black in the gilded scroll, 'Richard-Ginori / Pittoria di Doccia / 33=10' (in green)
Antonello Collection, Milan

308
Gio Ponti
Vase with angel, 1930–35
Richard-Ginori factory, Doccia, Florence
Majolica shaped in mould and decorated with underglaze polychrome enamels; h 35 x max Ø 19
Inscriptions: mark (crown) and 'Gio Ponti'
Private collection

303

304

305

305

307

308

309

310

311

192

309
Gio Ponti and Pietro Melandri
Pair of angels riding a bicycle, 1936
Pietro Melandri factory, Faenza
Majolica modelled and decorated with high-fired polychrome glazes and lustres; h 23 x 27 x 18
Inscriptions: 'PONTI MELANDRI' under the base in black
Antonello Collection, Milan

310
Gio Ponti and Pietro Melandri
Bird-shaped vase, 1940
Pietro Melandri factory, Faenza
Majolica shaped in mould and decorated with underglaze polychrome enamels; h 62 x max Ø 42
Private collection

311
Enrico Mazzolani
Leda and the Swan, 1932
Milan
Majolica shaped in mould and decorated with white glaze; h 52 x 14 x 12
Inscriptions: 'Enrico Mazzolani 1932' under the base
Antonello Collection, Milan

312
Giovanni Gariboldi
Drinking vessel with centaur, 1930–35
Richard-Ginori factory, San Cristoforo, Milan
Earthenware cast in mould and partially incised and decorated with red glaze and gilding on third firing; h 35 x 32
Inscriptions: mark (San Cristoforo) under the base
Private collection, Padua

313
Giovanni Gariboldi
Vase with Chinese-style lid, circa 1930
Richard-Ginori factory, San Cristoforo, Milan
Earthenware cast in mould with applications in relief and decorated with grey and white glaze; h 35.5 x 26 x Ø 25
Inscriptions: 'Richard-Ginori / Made in Italy /896' in green and mark (San Cristoforo)
Antonello Collection, Milan

314
Giovanni Gariboldi
Vase with floral decoration in bas-relief, 1930–35
Richard-Ginori factory, San Cristoforo, Milan
Earthenware cast in mould and decorated with green and white glaze; h 74 x Ø 32.5
Inscriptions: 'N. O. / 6598' in green and mark (San Cristoforo)
Antonello Collection, Milan

315
Giovanni Gariboldi
Dolphin-shaped paperweights, circa 1933
Richard-Ginori factory, San Cristoforo, Milan
Earthenware cast in mould and decorated with white glaze; h 20 x 19 x 5.5
Inscriptions: 'Richard-Ginori / S. Cristoforo / Milano / Made in Italy / 6277 / 345-T' and mark (San Cristoforo) in brown
Antonello Collection, Milan

316
Giovanni Gariboldi
Panel representing Venus on a shell drawn by two dolphins and a sail, 1932
Richard-Ginori factory, San Cristoforo, Milan
Stoneware shaped in mould and decorated with black glaze and gold on third firing; h 25 x 25
Inscriptions: 'Richard-Ginori / S. Cristoforo / Milano / Made in Italy / 2142 / 468-T' in brown and mark (San Cristoforo)
Antonello Collection, Milan

317
Giovanni Gariboldi
Shell-shaped vase, 1936
Richard-Ginori factory, San Cristoforo, Milan
Earthenware cast in mould and decorated with 'Chinese green' glaze; h 17 x 18 x 6
Inscriptions: 'Richard-Ginori / Made in Italy / 2-50-10' in brown and mark (San Cristoforo)
Antonello Collection, Milan

312

313

314

315

316

317

318
Giovanni Gariboldi
Vase with horizontal ribbing, 1930–35
Richard-Ginori factory, San Cristoforo, Milan
Ironstone china cast in mould and decorated with red glaze and gilding on third firing; h 30 x Ø 13
Inscriptions: mark (San Cristoforo) under the base
Civica Raccolta di Terraglia, Cerro di Laveno Mombello

319-322
Giovanni Gariboldi
Four tiles representing the Seasons, 1939–40
Richard-Ginori factory, San Cristoforo, Milan
Earthenware cast in mould and decorated with underglaze polychrome enamels; h 24 x 24
Inscriptions: signed 'Giovanni Gariboldi' at bottom right, mark (San Cristoforo) on the back
Colantonio Collection, Brescia

323
Giovanni Gariboldi
Large vase with floral decoration in relief, 1947
Richard-Ginori factory, San Cristoforo, Milan
Earthenware cast in mould and decorated with grey and white glaze; 64.5 x Ø 31
Inscriptions: 'Richard-Ginori / fabbricato in italia / 8-47-8 / 896 / 7474' and mark (San Cristoforo) in green
Antonello Collection, Milan

324
Giuseppe Sciolli
Cache-pot representing the theme of motherhood, circa 1930
Richard-Ginori factory, Mondovì
Soft earthenware turned on the wheel and decorated with underglaze polychrome enamels; h 18.5 x 21 x 19
Inscriptions: 'x / Manifattura Richard-Ginori di Mondovì x' and mark (crowned m) in black
Antonello Collection, Milan

325
Giuseppe Sciolli
Vase representing a farmer in the fields, circa 1930
Richard-Ginori factory, Mondovì
Soft earthenware shaped in mould and decorated with underglaze polychrome enamels; h 24 x Ø 23.5
Antonello Collection, Milan

326
Giuseppe Sciolli
Large plate with floral decoration and woman crouching to pick meadow flowers, 1932
Richard-Ginori factory, Mondovì
Soft earthenware shaped in mould and decorated with underglaze polychrome enamels; h 4 x Ø 37
Inscriptions: 'x / Manifattura Richard-Ginori di Mondovì x' and mark (crowned m) in black
Antonello Collection, Milan

327
Guido Andlovitz
Monumental amphora on conical base and decorated with geometric thunderbolt motifs, circa 1932
Società Ceramica Italiana factory, Laveno
Ironstone china cast in mould with polychrome

overglaze decorations and metal lustres;
h 81 x max Ø 45
Civica Raccolta di Terraglia, Cerro di Laveno Mombello

328
Guido Andlovitz
Vase with horizontal mouldings, 1930–35
Società Ceramica Italiana factory, Laveno
Ironstone china cast in mould and decorated with semi-matt monochrome black glaze; h 20 x Ø 27
Inscriptions: 'Lavenia / 52 35 6', mark
(three mountains above lake)
Antonello Collection, Milan

329
Guido Andlovitz
Bowl in 'crackled green' graze with cylindrical feet, 1930–38
Società Ceramica Italiana factory, Laveno
Ironstone china cast in mould with applications in relief and decorated with crackled green glaze;
h 4.7 x Ø 14.5
Inscriptions: mark (three mountains above lake): 'Lavenia' and '10-38'
Antonello Collection, Milan

330
Guido Andlovitz
Squashed spherical vase, 1936–38
Società Ceramica Italiana factory, Laveno
Ironstone china cast in mould and decorated with underglaze monochrome enamel; h 21.5
Inscriptions: 'Lavenia' and mark
(three mountains above lake)
Antonello Collection, Milan

331
Guido Andlovitz
Two-handled vase, 1927
Società Ceramica Italiana factory, Laveno
Ironstone china cast in mould and decorated with underglaze monochrome Vesuvius red; h 42
Inscriptions: 'Lavenia / 9/49', mark (three mountains above lake)
Antonello Collection, Milan

332
Guido Andlovitz
Spherical vase with narrow mouth, 1930–35
Società Ceramica Italiana factory, Laveno
Ironstone china cast in mould and decorated with high-fired red glaze; h 22 x Ø 13
Inscriptions: 'Lavenia' and mark
(three mountains above lake)
Private collection

333
Guido Andlovitz
Spherical vase with wide mouth, 1930–35
Società Ceramica Italiana factory, Laveno
Ironstone china cast in mould and decorated with high-fired red glaze; h 22 x Ø 13
Inscriptions: 'Lavenia' and mark
(three mountains above lake)
Private collection

327

328

329

330

331

332

333

334
Guido Andlovitz
Container with lid and conical grip, 1930–35
Società Ceramica Italiana factory, Laveno
Ironstone china shaped in mould and decorated with light-blue glaze; h 11 x Ø 15
Inscriptions: 'Lavenia' and mark (three mountains above lake)
Antonello Collection, Milan

335
Guido Andlovitz
Centrepiece bowl, 1930
Società Ceramica Italiana factory, Laveno
Ironstone china cast in mould with assembled parts in relief and decorated with red glaze;
h 11 x 30 x *circa* 17
Antonello Collection, Milan

336
Guido Andlovitz
Double-circle candelabrum for four candles, circa 1938
Società Ceramica Italiana factory, Laveno
Ironstone china cast in mould and decorated with red glaze on third firing; h 21.5 x 33 x 6.5
Inscriptions: mark (mountains above lake); 'Lavenia' and '2-38'
Antonello Collection, Milan

337
Guido Andlovitz
Triangular candelabrum for four candles, circa 1938
Società Ceramica Italiana factory, Laveno
Ironstone china cast in mould and decorated with monochrome green glaze; h 17 x 27.5 x 8.5
Inscriptions: 'Laveno 4-53' and mark (three mountains above lake)
Antonello Collection, Milan

338
Angelo Biancini
Container with lid and grip in the form of an elephant, circa 1937
Società Ceramica Italiana factory, Laveno
Ironstone china shaped in mould and decorated with yellow glaze; h 9 x Ø 15
Inscriptions: 'Lavenia' and mark (three mountains above lake)
Antonello Collection, Milan

339
Angelo Biancini
Faith, 1937
Società Ceramica Italiana factory, Laveno
Ironstone china cast in mould and decorated with high-fired green glaze; h 30
Museo Internazionale della Ceramica, Faenza, inv. no. 2701

334

335

336

337

338

339

340

341

342

343

344

196

340
Angelo Biancini
Crèche, circa 1937
Società Ceramica Italiana factory, Laveno
Ironstone china cast in mould and decorated
with black glaze; h 60 x 64 x 18
Inscriptions: 'Lavenia'
Private collection

341
Angelo Biancini
Duck and ducklings, circa 1938
Società Ceramica Italiana factory, Laveno
Ironstone china cast in mould and decorated
with high-fired red glaze; h 36 x 25 x 22
Private collection

342
Angelo Biancini
Horse, circa 1938
Società Ceramica Italiana factory, Laveno
Ironstone china cast in mould and decorated
with red glaze; h 27 x 22 x 13
Inscriptions: 'Lavenia'
Private collection

343
Angelo Biancini
Garden cache-pot with decorations in bas-relief,
1937
Società Ceramica Italiana factory, Laveno
Ironstone china cast in mould (slab-built)
and decorated with shiny green glaze; h 71
Inscriptions: mark (three mountains above lake)
and 'Lavenia, NC'
Antonello Collection, Milan

344
Angelo Biancini
Woman's head with vase: Canephore, circa 1938
Società Ceramica Italiana factory, Laveno
Ironstone china cast in mould and decorated
with grey/light blue glaze; h 51
Antonello Collection, Milan
Shown at the 7th Milan Triennale in 1940

345
Angelo Biancini
Putto with goose, 1937–38
Società Ceramica Italiana factory, Laveno
Ironstone china cast in mould and decorated with
green glaze with crystallizations; h 53 x 32 x 23
Inscriptions: signed 'BIANCINI' and 'PUTTO CON OCA'
in capital letters in the paste on the base
Antonello Collection, Milan

346
Angelo Biancini
Mermaid carrying a vase, circa 1939
Società Ceramica Italiana factory, Laveno
Ironstone china cast in mould and decorated with
crackled dark sepia glaze; h 102 x 33 x 23
Inscriptions: 'Lavenia'
Private collection

347
Angelo Biancini
Box with lid with plant and animal motifs, 1938
(version made in 1943)
Società Ceramica Italiana factory, Laveno
Ironstone china cast in mould and decorated
with green glaze; h 10.5 x 15.5
Inscriptions: 'Lavenia', '43' and mark
(three mountains above lake)
Antonello Collection, Milan

348
Angelo Biancini
*Large vase with animals and human figures
in relief*, 1938
Società Ceramica Italiana factory, Laveno
Ironstone china cast in mould (slab-built)
and decorated with grey glaze, crystallizations
and drips; h 41.5 x Ø 29
Inscriptions: 'Lavenia', '9-52' and mark
(three mountains above lake)
Antonello Collection, Milan

349
Angelo Biancini
*Green vase with zoomorphic and
anthropomorphic figures in relief*, 1937
Società Ceramica Italiana factory, Laveno
Ironstone china cast in mould (slab-built) and
decorated with crackled green glaze; h 43 x Ø 31.5
Inscriptions: 'Lavenia, Made in Italy', '12-55'
and mark (three mountains above lake)
Slab-built
Antonello Collection, Milan

350
Angelo Biancini
*Large high relief with Orpheus encountering
the animals*, 1939–40
Società Ceramica Italiana factory, Laveno
Ironstone china cast in mould and decorated
with green glaze; h 310 x 190
Inscriptions: 'Lavenia'
Civica Raccolta di Terraglia, Cerro di Laveno
Mombello

345

348

346

349

347

350

197

351
Angelo Biancini
Actaeon Attacked by the Dogs, 1939–40
Società Ceramica Italiana factory, Laveno
Ironstone china cast in mould and decorated with white glaze; h 93.5 x 63 x 22
Inscriptions: 'Lavenia', mark (three mountains above lake) and 'Atteone'
Antonello Collection, Milan
Shown at the 7th Milan Triennale in 1940

352
Angelo Biancini
Diana the Huntress, 1939–40
Società Ceramica Italiana factory, Laveno
Ironstone china cast in mould and decorated with dripped green glaze; h 88 x 64 x 25
Antonello Collection, Milan
Shown at the 7th Milan Triennale in 1940

353
Sirio Tofanari
She-bear and cub, 1948
Società Ceramica Italiana factory, Laveno
Earthenware decorated with underglaze pigment; 22.5 x 15.5 x 37
Inscriptions: 'Lavenia, 7-48' and mark (three mountains above lake) in green
Museo Internazionale della Ceramica, Faenza, inv. no. 2703

354
Bear, 1948–50
Piccinelli factory, Bergamo
Stone china (klinker) cast in mould; h 40 x 71
Museo Internazionale della Ceramica, Faenza, inv. no. 2237/2

355
Tarcisio Tosin
Prismatic urn with two small applied female nudes, 1928
La Freccia factory, Vicenza
Mauve-coloured ironstone china cast in mould and decorated by airbrush; h 45
Inscriptions: signed 'Tosin' in black under the base
Antonello Collection, Milan

356
Tarcisio Tosin
Cylindrical urn with two applied female figures in niches. Stepped lid with kneeling female figure, circa 1930
La Freccia factory, Vicenza
Ironstone china cast in mould with assembled elements in relief decorated with underglaze polychrome enamels and by airbrush; h 51
Inscriptions: under the base, the mark (arrow) and the inscription 'L'ospitalità' in black
Antonello Collection, Milan

357
Tarcisio Tosin
Cylindrical urn with two applied female figures in niches. Stepped lid with kneeling female figure, circa 1930
La Freccia factory, Vicenza
Earthenware cast in mould with assembled elements in relief decorated with underglaze polychrome enamels and by airbrush; h 51
Inscriptions: under the base, the mark (arrow) with the signature 'Tosin' and the inscription 'L'ospitalità' in black
Antonello Collection, Milan

358
Tarcisio Tosin
Cylindrical urn with two applied female figures in niches. Stepped lid with kneeling female figure, circa 1930
La Freccia factory, Vicenza (dal 1930)
Earthenware cast in mould with assembled elements in relief decorated with underglaze polychrome enamels and by airbrush; h 50.5
Inscriptions: under the base, the mark (arrow) with 'F S' in black
Antonello Collection, Milan

359
Tarcisio Tosin
Reclining female nude, circa 1930
La Freccia factory, Vicenza
Earthenware shaped in mould with assembled elements in relief and decorated with underglaze polychrome enamels and by airbrush;
h 13 x 23 x 10.5
Inscriptions: signed 'Tosin' in black; under the base, mark (arrow) with 'F S' in black
Antonello Collection, Milan

360
Tarcisio Tosin
Centrepiece with architecture in 18th-century style and classical figures in eight elements, 1930–35
La Freccia factory, Vicenza
Earthenware cast in mould with assembled elements in relief and decorated with underglaze polychrome enamels and by airbrush;
circa h 24 x 90 x 30
Inscriptions: under the base, 'Tosin' and mark (arrow) in black
Antonello Collection, Milan

361
Tarcisio Tosin
Fish, 1935
La Freccia factory, Vicenza
Earthenware cast in mould with assembled elements in relief and decorated with underglaze polychrome enamels and by airbrush;
h 13 x 23 x 10.5
Inscriptions: signed 'Tosin' in black and mark (arrow)
Private collection

362
Box with lid and grip in the form of a donkey,
Galvani factory, Pordenone
Earthenware cast in mould with assembled elements in relief and decorated by airbrush;
h 12 x 14.5 x 14.5
Inscriptions: signed 'galvani' in black and mark (cockerel)
Private collection

363
Cubic box with lid and grip in the form of an antelope, circa 1935
Galvani factory, Pordenone
Earthenware cast in mould with assembled elements in relief and decorated by airbrush;
h 22 x 15 x 15
Inscriptions: 'Galvani Pordenone' under the base, with a punch
Private collection

359

360

361

362 363

364
Plate with antelope, 1930–35
Galvani factory, Pordenone
Earthenware cast in mould and decorated by airbrush; Ø 35.5
Inscriptions: 'Galvani/Pordenone' under the base
Private collection

365
Angelo Simonetto
Cylindrical planter with stylized gazelle, 1930–35
Galvani factory, Pordenone
Earthenware cast in mould and decorated by airbrush; h 11.5, x Ø 15
Inscriptions: in brown: '79 F.to 2206 Dec. 9/23 BL', mark (cockerel with scroll) 'Galvani Pordenone, E'
Antonello Collection, Milan

366
Rectangular vase with two fencers, 1930–35
Galvani factory, Pordenone
Earthenware cast in mould and decorated by airbrush; h 25 x 16.5 x 7.5
Inscriptions: 'Galvani' under the base, with a punch
Private collection

367
Pair of vases with lid and grip in the form of an octopus, 1933–35
Galvani factory, Pordenone
Earthenware cast in mould with assembled elements in relief and decorated by airbrush; h 49 x Ø 26
Inscriptions: 'Galvani' under the base, with a punch
Private collection

368
Vase with lid and grip in the form of an octopus, 1933–35
Galvani factory, Pordenone
Earthenware cast in mould with assembled elements in relief and decorated by airbrush; h 49 x Ø 26
Private collection

369
Vase with lid, 1933–35
Galvani factory, Pordenone
Earthenware cast in mould and decorated by airbrush; 36 x 15.5
Inscriptions: mark (cockerel)
Private collection

370
Vase with trees, circa 1935
Galvani factory, Pordenone
Earthenware cast in mould and decorated by airbrush; 3.5 x Ø 28
Private collection

371
Vase of the Elephant, circa 1935
Galvani factory, Pordenone
Earthenware cast in mould and decorated by airbrush; h 22 x Ø 19
Private collection

372
Plate with woman carrying basket, circa 1935
Galvani factory, Pordenone
Majolica cast in mould and decorated by airbrush; Ø 36
Private collection

373
Vase of the Seals, 1935–40
Galvani factory, Pordenone
Earthenware cast in mould and decorated by airbrush; h 24 x Ø 20
Inscriptions: 'Galvani / Pordenone' and mark (cockerel)
Private collection

374
Mermaid with dolphin, 1934–36
Le Bertetti factory, Turin
Terracotta shaped in mould and decorated with polychrome enamels and by airbrush
Private collection

375
Gigi Chessa and Luigi Maria Giorgio
'Venice' box, 1932
Lenci factory, Turin
Terracotta shaped in mould and with applied grip, decorated with underglaze polychrome enamels; h 18 x 13.3 x 13.3
Inscriptions: 'Lenci, Made in Italy, Turin, 19-7-32' and executor's mark; 'Scatola (Venezia)'
Antonello Collection, Milan

376
Giulio Da Milano
Harlequin and Columbine, 1930–32
Lenci factory, Turin
Matt polychrome ceramic; h 35.5 x Ø 25.22 at base
Inscriptions: 'Lenci, Made in Italy, Torino' and initial 'B' (executor's initial). Lenci label with '69' and 'Arlecchino e Arlecchina' written by hand
Antonello Collection, Milan

377
Abele Jacopi
The Skyscraper, circa 1935
Lenci factory, Turin
Terracotta shaped in mould and decorated with underglaze polychrome enamels and by airbrush; h 44.5 x 10.5 x 13.5
Inscriptions: 'Lenci, Made in Italy, Torino', 'Il grattacielo', 'Ultimo Tocco'
Antonello Collection, Milan

378
Sandro Vacchetti
Nude member of the Italian Fascist Youth Movement with cap and drum, 1935
Essevi di Sandro Vacchetti factory, Turin
Terracotta shaped in mould and decorated with underglaze polychrome enamels and by airbrush; h 32 x 13 x Ø 11
Inscriptions: 'Essevi di Sandro Vacchetti - Torino, Italia'
Antonello Collection, Milan

379
Sandro Vacchetti
Sequoia: female nude with dog and fawn, 1937
Essevi di Sandro Vacchetti factory, Turin
Terracotta shaped in mould and assembled, decorated with underglaze polychrome enamels and by airbrush; h 50 x 25.5 x 36.5
Inscriptions: 'Essevi, Made in Italy, Torino' and no. 162 'Sequoia', entitled and signed 'Sequoia di Sandro Vacchetti'
Antonello Collection, Milan

380
Sandro Vacchetti
Susanna Bathing, 1938
Essevi di Sandro Vacchetti factory, Turin
Terracotta shaped in mould and decorated with underglaze polychrome enamels and by airbrush; h 33 x 33 cm
Inscriptions: 'Essevi Made in Italy' and 'Susanna al bagno'
Antonello Collection, Milan

381
Goblet-shaped vase with warriors and crocodiles, 1936–37
Lenci factory, Turin
Terracotta shaped in mould and decorated with underglaze polychrome enamels; h 27 x Ø 27
Inscriptions: 'Lenci, Made in Italy, XV'
Antonello Collection, Milan

370

371

372

373

374

375

376

377

378

379

380

381

201

382
Nicolaj Diulgheroff
Destructured fruitstand with Futurist decoration, 1930–31
Mazzotti factory, Albisola Marina (MGA)
Ceramica matt turned on the wheel and decorated with polychrome enamels;
h 18.5 x 34 x 42
Inscriptions: in black 'M.G.A.'
Antonello Collection, Milan

383
Nicolaj Diulgheroff
Spherical vase with woman's profile and still life in Futurist style, circa 1930
La Casa dell'Arte factory, Albisola Marina
Matt ceramic shaped in mould and decorated with polychrome enamels and by airbrush;
h 19 x Ø 24
Inscriptions: 'LA CASA DELL'ARTE / ALBISOLA' in black
Antonello Collection, Milan

384
Farfa (Vittorio Osvaldo Tommasini)
and Tullio d'Albisola
Anteater vase, 1931–32
Mazzotti factory (M.G.A.), Albisola Marina
Majolica shaped in mould and decorated with underglaze polychrome enamels; h 26 x 21 x 20.5
Inscriptions: 'Tullio / Farfa' on the outside
Private collection

385
Anteater vase with aero-Futurist decorations, 1930–35
Mazzotti factory (M.G.A.), Albisola Marina
Majolica shaped in mould and decorated with underglaze polychrome enamels; h 32 x Ø 20.5
Antonello Collection, Milan

386
Tullio d'Albisola
'Medusa' loving cup, 1930
Mazzotti factory (M.G.A.), Albisola Marina
Majolica shaped in mould and decorated with underglaze polychrome enamels; 14.5 x 26
Inscriptions: under the base 'Coppa amatoria di Tullio M.G.A. Genova'
Private collection

387
Tullio d'Albisola
Modern Venus, circa 1930
Mazzotti factory (M.G.A.), Albisola Marina
Terracotta coated with chromium-plated aluminium; h 28.5 x 28 x 22
Inscriptions: 'Italia, Albissola Marina' under the base
Private collection

382

383

384

385

386

387

388

389

390

202

388
Tullio d'Albisola
Box with lid with the Magi, 1930–32
Mazzotti factory (M.G.A.), Albisola Marina
Majolica shaped in mould and decorated with underglaze polychrome enamels; h 21 x Ø 19
Inscriptions: 'M.G.A. UNICA' under the box
Gilli Collection, Milan

389
Tullio d'Albisola
Futurist cylindrical vase, 1930–32
Mazzotti factory (M.G.A.), Albisola Marina
Majolica shaped in mould and decorated with underglaze polychrome enamels; h 17 x 13
Inscriptions: 'M.G.A.' under the foot
Gilli Collection, Milan

390
Tullio d'Albisola
Jug, 1929–30
Mazzotti factory (M.G.A.), Albisola Marina
Majolica shaped in mould and decorated with underglaze polychrome enamels; h 29 x 33 x 18
Inscriptions: 'M.G.A.' under the foot
Gilli Collection, Milan

391
Tullio d'Albisola
Futurist jug and cup, 1930–31
Mazzotti factory (M.G.A.), Albisola Marina
Matt ceramic turned on the wheel and decorated with polychrome enamels; h 14.5 x 9 x 14.5
Inscriptions: 'M.G.A.' in black
Antonello Collection, Milan

392
Tullio d'Albisola
Large vase with three circles in relief, 1930–35
Mazzotti factory (M.G.A.), Albisola Marina
Majolica shaped in mould, incised on the surface and decorated with underglaze green and orange; h 17 x 17 x 10
Inscriptions: 'M.G.A.' in black, under the foot
Private collection

393
Tullio d'Albisola
Egg-shaped vase, 1930–31
Mazzotti factory (M.G.A.), Albisola Marina
Majolica shaped in mould and decorated with underglaze polychrome enamels; h 26 x Ø 18
Inscriptions: 'M.G.A.' under the foot
Private collection

394
Torido Mazzotti
Triestine vase, 1930–32
Mazzotti factory (M.G.A.), Albisola Marina
Majolica shaped in mould, incised on the surface and decorated with polychrome enamels underglaze; h 17 x 17 x 10
Inscriptions: 'M.G.A.' in black, under the foot
Private collection

395
Torido Mazzotti
Bowl with three flat circles in relief, 1930–32
Albisola Marina, manifattura Mazzotti (M.G.A.)
Maiolica formata a stampo e decorata a smalti policromi sottovetrina; h 15 x 12 x 6
Inscriptions: 'M.G.A.' in black, under the base
Gilli Collection, Milan

396
Fillia (Luigi Colombo)
Geometric vase, 1932
Mazzotti factory (M.G.A.), Albisola Marina
Majolica shaped in mould and decorated with underglaze polychrome enamels; h 18
Inscriptions: stamped 'M.G.A.'
Museo Internazionale della Ceramica, Faenza, inv. no. 2568

397
Pizzo (Giuseppe Pizzorni)
Dog, 1929
Gatti & C. factory, Faenza
Majolica shaped in mould and decorated with underglaze monochrome enamel; h 20 x 21 x 8
Gilli Collection, Milan
Shown in the exhibition *Trentatré Futuristi* at the Galleria Pesaro in Milan, 1929 (not in catalogue)

398
Pizzo (Giuseppe Pizzorni)
Pelican, 1929–30
Gatti & C. factory, Faenza
Majolica shaped in mould and decorated with underglaze monochrome enamel; h 16 x 14.5
Gilli Collection, Milan

399
Pizzo (Giuseppe Pizzorni)
Bear, 1929–30
Gatti & C. factory, Faenza
Majolica shaped in mould and decorated with underglaze monochrome enamel; h 9 x 12 x 4
Gilli Collection, Milan

400
Eagle, 1935–40
Mazzotti factory (M.G.A.), Albisola Marina
Majolica shaped in mould and decorated with underglaze polychrome enamels; h 24
Antonello Collection, Milan

401
Bruno Munari
Camel, 1934
Mazzotti factory (M.G.A.), Albisola Marina
Majolica shaped in mould and decorated by airbrush; h 16.5 x 16.5
Museo Internazionale della Ceramica, Faenza, inv. no. 2570

402
Bruno Munari
Bulldog, 1934
Mazzotti factory (M.G.A.), Albisola Marina
Majolica shaped in mould and decorated with underglaze monochrome enamel; h 5 x 27 x 16
Inscriptions: 'M.G.A.'
Museo Internazionale della Ceramica, Faenza, inv. no. 2569

397

398

399

400

401

402

403

404

405

406

403
Manlio Trucco
Pair of cache-pots representing swallows in flight, 1930-37
Ceramiche Albisola Spica (C.A.S.) factory, Albisola Capo
Majolica turned on the wheel and decorated with underglaze polychrome enamels; h 18 x 26
Inscriptions: 'C.A.S.' and mark (ear of wheat) in black
Antonello Collection, Milan

404
Giovanni Battista De Salvo
Idol with cat, 1933
La Casa dell'Arte factory, Albisola Marina
Majolica turned on the wheel and decorated with crazed monochrome glaze; h 43 x 38
Inscriptions: signed 'De Salvo' on the base
Private collection

405
Giovanni Battista De Salvo
The Abandoned Woman, 1933
La Casa dell'Arte factory, Albisola Marina
Majolica turned on the wheel and decorated with crazed monochrome glaze; h 30.5 x 27.2 x 21
Inscriptions: paper label under the base: 'Casa dell'Arte / Albisola Capo / Savona 3'
Civiche Raccolte d'Arti Applicate del Castello Sforzesco, Milan, inv. no. 1536

406
Mario Gambetta
The Spirit of Commerce and Speed and *The Sad and the Happy Tale*, 1933
La Casa dell'Arte factory, Albisola Marina
High reliefs in majolica shaped in mould and decorated with underglaze monochrome enamel;
General Post Office (telegram counter room), Savona (formerly)

407, 408
Arturo Martini
Lion and lioness, 1934–35
Stabilimento Mathon factory, Corsico, Milan
Stoneware shaped in mould and decorated with underglaze polychrome enamels; h 53 x 134 x 45
Antonello Collection, Milan

409
Arturo Martini
Fascist Victory, 1936–37
Stabilimento Mathon factory, Corsico, Milan
Majolica shaped in mould and decorated with underglaze monochrome green; h 80 x 25 x 40
Antonello Collection, Milan
The *Victory Walking* or *Fascist Victory* was shown at the Venice Biennale in 1932 (model in terracotta); from 1936 onward, in agreement with the Mathon firm, Martini produced the model in plaster and in 1937 made several versions in ceramic.

410
Dante Baldelli
'Belvedere' plate, circa 1930
Società Anonima Ceramiche Rometti factory, Umbertide
Majolica shaped in mould and decorated with polychrome enamels and by airbrush; Ø 28.5
Antonello Collection, Milan

411
Corrado Cagli
Icarus, 1929
Società Anonima Ceramiche Rometti factory, Umbertide
Majolica shaped in mould and decorated with *nero di Fratta* glaze; h 29 x 39
Private collection

407

408

409

410

411

412
Dante Baldelli and Corrado Cagli
Vase with hunters on horseback, 1928–30
Società Anonima Ceramiche Rometti factory, Umbertide
Majolica turned on the wheel and decorated with underglaze polychrome enamels; h 26.5 x Ø 21
Inscriptions: engraved 'rometti umbertide'
Antonello Collection, Milan

413
Dante Baldelli
Panel with five tiles: 'Believing, Obeying, Fighting'; 'The March on Rome'; head of Benito Mussolini; 'Silence is Tough Discipline'; 'Combat', 1931–32
Società Anonima Ceramiche Rometti factory, Umbertide
Majolica shaped in mould and decorated with underglaze polychrome enamels; Mussolini's head is in *nero di Fratta*; h 20 x 20 (each tile)
Inscriptions: 'rometti umbertide' on the back
Antonello Collection, Milan

414
Mario Di Giacomo
The Batter, 1928–30
Società Anonima Ceramiche Rometti factory, Umbertide
Majolica shaped in mould and decorated with black monochrome glaze; h 39 x 34.5 x 14.5
Antonello Collection, Milan

415
Corrado Cagli
Urn with lid, representing a decorator of pottery, 1929
Società Anonima Ceramiche Rometti factory, Umbertide
Majolica shaped in mould and decorated with underglaze polychrome enamels; h 48.5 x Ø 23
Inscriptions: 'rometti umbertide made in italy'
Antonello Collection, Milan

416
Dante Baldelli and Corrado Cagli
Urn with lid and grip in the form of a cockerel, decorated with images of two peasant women, 1930
Società Anonima Ceramiche Rometti factory, Umbertide
Majolica shaped in mould and decorated with underglaze polychrome enamels; h 57 x Ø 14.5
Inscriptions: 'rometti umbertide/italy'
Antonello Collection, Milan

417
Corrado Cagli
Urn with lid and grip in the form of a fruit, decorated with images of peasant women with baskets of fruit, 1930
Società Anonima Ceramiche Rometti factory, Umbertide
Majolica shaped in mould and decorated with underglaze polychrome enamels; h 43.5 x Ø 17.5
Inscriptions: 'rometti umbertide made in italy'
Antonello Collection, Milan

412

414

413

415

416

417

418
Dante Baldelli and Corrado Cagli
'Cupid' vase, circa 1930
Società Anonima Ceramiche Rometti factory, Umbertide
Majolica shaped in mould with applications in relief and decorated with underglaze polychrome enamels; h 57 x Ø 15
Antonello Collection, Milan

419
Corrado Cagli
'The Glebe' vase, 1930
Società Anonima Ceramiche Rometti factory, Umbertide
Majolica shaped in mould and decorated with underglaze polychrome enamels; h 30 x Ø 17
Inscriptions: 'rometti umbertide made in italy'
Antonello Collection, Milan

420
Corrado Cagli
'The Graces' vase, 1930
Società Anonima Ceramiche Rometti factory, Umbertide
Majolica shaped in mould and decorated with underglaze polychrome enamels; h 36 x Ø 26
Inscriptions: 'rometti umbertide/ italy'
Antonello Collection, Milan

421
Dante Baldelli
Vase with lid, representing the theme of labour, 1931–33
Società Anonima Ceramiche Rometti factory, Umbertide
Majolica shaped in mould with applications in relief and decorated with polychrome enamels underglaze; h 44 x Ø 16
Inscriptions: 'ceramiche rometti umbertide/dbaldelli disegnò/mbaldelli eseguì'
Antonello Collection, Milan

422
Dante Baldelli
Vase with archers, 1930–35
Società Anonima Ceramiche Rometti factory, Umbertide
Majolica shaped in mould and decorated with underglaze polychrome enamels; h 28 x Ø 22
Inscriptions: 'rometti umbertide' in orange
Antonello Collection, Milan

423
Corrado Cagli
Vase with lid and grip in the form of ibexes, representing archers, 1931–33
Società Anonima Ceramiche Rometti factory, Umbertide
Majolica shaped in mould with applications in relief and decorated with underglaze polychrome enamels and by airbrush; h 42 x Ø 27
Inscriptions: 'rometti umbertide' in black
Antonello Collection, Milan

418

419

420

421

422

423

207

424
Corrado Cagli
Pair of vases with lid and grip in the form of a wing, decorated with winged figures, 1930–31
Società Anonima Ceramiche Rometti factory, Umbertide
Majolica shaped in mould and decorated with underglaze polychrome enamels; h 34 x Ø 16
Inscriptions: 'rometti umbertide/made in Italy' in black
Antonello Collection, Milan

425
Corrado Cagli
Vase representing the theme of motherhood, circa 1935
Società Anonima Ceramiche Rometti factory, Umbertide
Majolica shaped in mould and decorated with underglaze polychrome enamels; h 28.5 x Ø 17.5
Inscriptions: in black 'Made in Italy / rometti umbertide'
Antonello Collection, Milan

426
Plate with the Crucifixion and angels, circa 1930
Società Anonima Ceramiche Rometti factory, Umbertide
Majolica shaped in mould and decorated with underglaze polychrome enamels; h 4 x Ø 30.5
Inscriptions: 'rometti umbertide / made in italy'
Antonello Collection, Milan

427
Corrado Cagli
Large 'Horse-breaker' plate, 1930–32
Società Anonima Ceramiche Rometti factory, Umbertide
Majolica shaped in mould and decorated with underglaze polychrome enamels; h 4 x Ø 30
Inscriptions: 'ceramiche rometti umbertide / made in Italy'
Antonello Collection, Milan

428
Dante Baldelli
Vase with allegories of Architecture, Painting and Sculpture, 1935
Società Anonima Ceramiche Rometti factory, Umbertide
Majolica shaped in mould and decorated with underglaze polychrome enamels; h 35.5 x Ø 19
Inscriptions: 'rometti umbertide' in black
Antonello Collection, Milan

429
Dante Baldelli
Large 'Mermaids' plate, 1935
Società Anonima Ceramiche Rometti factory, Umbertide
Majolica shaped in mould and decorated with underglaze polychrome enamels and by airbrush; h 4 x Ø 29
Inscriptions: 'rometti italy' in black
Antonello Collection, Milan

430, 431
Dante Baldelli
Two large 'Hunters' plates, 1935
Società Anonima Ceramiche Rometti factory, Umbertide
Majolica shaped in mould and decorated with underglaze polychrome enamels and by airbrush; respectively: Ø 29 (orange ground); Ø 28 (grey ground)
Inscriptions: 'rometti italy' in black
Antonello Collection, Milan

432
Dante Baldelli, attributed to
Vase with angels in flight, 1930–35
Società Anonima Ceramiche Rometti factory, Umbertide
Majolica shaped in mould and decorated with underglaze polychrome enamels; h 45 x Ø 24
Inscriptions: 'rometti / italy' in black
Antonello Collection, Milan

433
Vase with silver-plated handles, 1935–40
Deruta factory, Deruta
Majolica shaped in mould and decorated with underglaze polychrome enamels and silver; h 50 x Ø 42
Private collection

424

425

426

427

428

429

434
Aldo Zerbi (to a design by Tomaso Buzzi)
Washing the Elephant, 1933
Milan
Terracotta modelled and decorated with underglaze green; h 50.5 x 48 x 37
Inscriptions: label 'Triennale delle Arti Decorative e Industriali / Milano / 1933' and '162'
Civiche Raccolte d'Arti Applicate del Castello Sforzesco, Milan, inv. no. 2181
Shown at the 5th Triennale (1933)

435
Vase with four female figures, 1935
Cantagalli factory, Florence
Majolica shaped in mould and decorated with monochrome green glaze; h 40 x Ø 24
Inscriptions: 'Cantagalli / Firenze / (Italy)'
Antonello Collection, Milan

436
Duilio Cambellotti
Vase with tubular handles and applied oxen in relief, 1935
Rome
Terracotta turned on the wheel with applications in relief decorated with underglaze polychrome enamels; h 28 x Ø 28.3
Inscriptions: 'VETRALLI MCMXXXV', mark (ear of wheat) and 'CD' in reverse
Museo Internazionale della Ceramica, Faenza, inv. no. 24824

437
Ivos Pacetti
Vase with elephants, circa 1935
La Fiamma factory, Rome
Majolica shaped in mould and decorated with underglaze polychrome enamels; h 31 x Ø 17
Private collection

438
Ivos Pacetti
Vase with stylized human figures, circa 1935
La Fiamma factory, Rome
Majolica shaped in mould and decorated with underglaze polychrome enamels; h 16.5 x 13
Private collection

430, 431

434

432

433

435

436

437

438

209

439
Ivos Pacetti
Mask, 1932
La Fiamma factory, Rome
Terracotta decorated with low-fired monochrome bronze glaze; h 22 x 31.5 x 19
Inscriptions: 'IVOS X' at bottom
Private collection

440
Giuseppe Piombanti Ammannati
Venus, turquoise head, circa 1935
Premiata Fabbrica di Maioliche Artistiche Egisto Fantechi factory, Sesto Fiorentino
Majolica modelled, coated with slip and decorated with underglaze turquoise;
h 49.8 x 18.6 x 16.7
Inscriptions: 'GPA' on the back of the statue's neck
Civiche Raccolte d'Arti Applicate del Castello Sforzesco, Milan, inv. no. 4121

441
Giuseppe Piombanti Ammannati
Woman's bust with hat and fan: The Fan,
circa 1937
Premiata Fabbrica di Maioliche Artistiche Egisto Fantechi factory, Sesto Fiorentino
Majolica modelled and decorated with underglaze polychrome enamels; h 54 x 30 x 30
Inscriptions: signed '+ G. PIOMBANTI' in black, 'GPA' monogram (with crossed circle and tongue of flame)
Antonello Collection, Milan

442
Giuseppe Piombanti Ammannati
Ochre woman, circa 1940
Premiata Fabbrica di Maioliche Artistiche Egisto Fantechi factory, Sesto Fiorentino
Majolica modelled and decorated with underglaze polychrome enamels; h 57.5 x Ø 18
Museo Internazionale della Ceramica, Faenza, inv. no. 24111

443
Giuseppe Piombanti Ammannati
Fertility, circa 1940
Premiata Fabbrica di Maioliche Artistiche Egisto Fantechi factory, Sesto Fiorentino
Majolica modelled and decorated with underglaze polychrome enamels; h 35 x Ø 12
Museo Internazionale della Ceramica, Faenza, inv. no. 24112

444
Guido Cacciapuoti
Turbot, 1932–38
Cacciapuoti factory, Milan
Stoneware shaped in mould and decorated in underglaze red; h 50 x 25 x 9
Inscriptions: 'Fabriqué en Italie / G. Cacciapuoti' under the foot
Private collection

445
Guido Cacciapuoti
Wolf, 1928–32
Cacciapuoti factory, Milan
Majolica shaped in mould and decorated with underglaze polychrome enamels; h 20 x 28 x 5
Private collection

439

443

440

441

442

446
Irene Kowaliska
Vase decorated with stylized floral motifs, 1935–38
Industria Ceramica Salernitana (I.C.S.) factory,
Vietri sul Mare
Majolica shaped in mould and decorated with
two underglaze colours; h 24
Private collection

447
Irene Kowaliska
Jug with the fishmonger Pietro, 1930–39
Industria Ceramica Salernitana (I.C.S.) factory,
Vietri sul Mare
Majolica shaped in mould and decorated with
underglaze polychrome enamels; h 22.5
Inscriptions: 'IK'; mark (little bird) and 'ITALIA'
Museo Internazionale della Ceramica, Faenza,
inv. no. 25091

448
Irene Kowaliska
'Rosa' jug, 1935–40
Industria Ceramica Salernitana (I.C.S.) factory,
Vietri sul Mare
Majolica shaped in mould and decorated
with underglaze polychrome enamels; h 23
Private collection

449
Irene Kowaliska
Jug, 1935–40
Fabbrica di Molina factory, Vietri sul Mare
Majolica shaped in mould and decorated
with underglaze polychrome enamels; h 21
Museo della Ceramica, Raito di Vietri

450
Irene Kowaliska
*Vase decorated with a shepherd playing music,
a dog and plant motifs*, 1935–37
Industria Ceramica Salernitana (I.C.S.) factory,
Vietri sul Mare
Majolica shaped in mould with applications
in relief decorated with underglaze polychrome
enamels; h 24
Private collection

451
Irene Kowaliska
Bottle with village scenes, 1935–40
Industria Ceramica Salernitana (I.C.S.) factory,
Vietri sul Mare
Majolica shaped in mould and decorated
with underglaze polychrome enamels; h 28
Private collection

452
Irene Kowaliska
Arab merchant on camel, 1935–40
Industria Ceramica Salernitana (I.C.S.) factory,
Vietri sul Mare
Majolica shaped in mould and decorated
with underglaze polychrome enamels; h 21
Private collection

444

445

446

447

448

449

450

451

452

211

453
Guido Gambone
Flask in the form of a female figure: 'La Faenzanella', 1938–40
La Faenzanella factory, Vietri sul Mare
Majolica modelled and decorated with underglaze polychrome enamels; h 38 x 47
Inscriptions: 'GG' and mark (kid)
Museo Internazionale della Ceramica, Faenza, inv. no. 2262

454
Simone Lai and Salvatore Fancello
'The Watering Place' plate, 1930–35
Istituto Superiore Industrie Artistiche, Monza
Terracotta modelled, incised and decorated without firing; Ø 38
Inscriptions: 'made in Italy /Simeone Lai / Ceramiche Sarde Dorgali (Nuoro) / Creazione Fancello' on the bottom
Archivio per le Arti Applicate, Nuoro

455
Melkiorre Melis
Centrepiece: Bedouin woman, 1930–35
C.A.M.M. factory, Rome
Majolica shaped in mould and decorated with underglaze polychrome enamels; h 21.5
Private collection

456
Salvatore Fancello
Wild boar, 1936
Istituto Superiore Industrie Artistiche, Monza
Terracotta modelled and coated with slip; h 8.1 x 20.6 x 9.7
Civiche Raccolte d'Arti Applicate del Castello Sforzesco, Milan, inv. no. 1634

457
Salvatore Fancello
Ram, 1934–37
Mazzotti factory, Albisola Marina
Fireclay modelled, incised and coloured with different shades of slip; h 10 x 20.5
Archivio per le Arti Applicate, Nuoro

458
Salvatore Fancello
Octopus, 1938–39
Mazzotti factory, Albisola Marina
Terracotta modelled, glazed and coated with another layer of reflective glaze; h 18.5 x 38
Inscriptions: 'Fancello MGA' on the back
Private collection

459
Salvatore Fancello
Goat, 1934–37
Mazzotti factory, Albisola Marina
Fireclay modelled, incised and coloured with different shades of slip; h 14 x 23
Archivio per le Arti Applicate, Nuoro

460
Salvatore Fancello
Zebra, circa 1937
Mazzotti factory, Albisola Marina
Fireclay modelled, incised and coloured
with different shades of slip; h 27.6
Archivio per le Arti Applicate, Nuoro

461
Salvatore Fancello
Kangaroo, 1934–37
Mazzotti factory, Albisola Marina
Fireclay modelled, incised and coloured
with different shades of slip; h 21
Archivio per le Arti Applicate, Nuoro

462
Salvatore Fancello
Lions and wild boar, circa 1938
Mazzotti factory, Albisola Marina
Terracotta modelled and decorated with
underglaze polychrome enamels; h 44 x 30.5
Inscriptions: 'Fancello' engraved on the bottom
Archivio per le Arti Applicate, Nuoro

463
Salvatore Fancello
Woman's head, circa 1938
Mazzotti factory, Albisola Marina
Terracotta modelled and decorated with lustres;
h 25 x 16
Inscriptions: 'Fancello - MGA'
Gilli Collection, Milan

464
Salvatore Fancello
Woman's head, circa 1938
Mazzotti factory, Albisola Marina
Terracotta modelled and decorated with lustres;
h 24 x 14
Inscriptions: 'Fancello - MGA'
Gilli Collection, Milan

465
Vase, circa 1936
TreRe factory, Faenza
Majolica shaped in mould and decorated with
monochrome black glaze; h 82.3 x Ø 42.4
Civiche Raccolte d'Arti Applicate del Castello
Sforzesco, Milan, inv. no. 3358

466
Ugo Zaccagnini
Umbrella stand with decorative pattern of circles,
1938–42
Faenza
Majolica shaped in mould and decorated
with black glaze applied cold; h 83 x Ø 41
Private collection

461

462

463

464

465

466

467
Giuseppe Mazzullo
Maternity and Childhood: panel with scenes of the life of the mother and child, 1941
'I due fornaciari' pottery, Naples
Majolica shaped in mould, assembled and decorated with underglaze polychrome enamels; h 142 x 104
Inscriptions: 'ESECUZIONE I DUE FORNACIARI – A. XX'
Museo Internazionale della Ceramica, Faenza, inv. no. AB4632

468
Lucio Fontana
Cock, 1938
Mazzotti factory (M.G.A.), Albisola Marina
Terracotta modelled and decorated with underglaze polychrome enamels and gilded on third firing
Private collection

469
Lucio Fontana
Still life with bananas and figs, 1938
Mazzotti factory (M.G.A.), Albisola Marina
Terracotta modelled and decorated with underglaze polychrome enamels; h 11 x 25 x 35
Inscriptions: 'L. Fontana 38' on the other side
Museo Internazionale della Ceramica, Faenza, inv. no. 2571

470
Lucio Fontana
Portrait of Raffaella, 1949
Mazzotti factory (M.G.A.), Albisola Marina
Terracotta modelled and decorated with underglaze polychrome enamels and gold applied on third firing;
h 29 x 24.5 x 17
Private collection

467

468

469

470

471
Leoncillo
Caryatid-candlestick, 1940–45
Terracotta modelled and decorated
with underglaze polychrome enamels
Antonello Collection, Milan

472
Leoncillo
Portrait of Elsa, 1948
Terracotta modelled and decorated with
underglaze polychrome enamels; h 55 x 55 x 35
Private collection

473
Leoncillo
The Typist, circa 1949
Rome
Terracotta modelled and decorated with
underglaze polychrome enamels; h 7.55 x 40 x 23
Private collection

474
Fausto Melotti
Woman in mantle, circa 1950
Milan
Terracotta modelled and decorated
with underglaze white; h 53.5 x 28 x 27
Private collection

471

473

472

474

Marks of the Main Italian Ceramics Factories and Artists
edited by Roberta D'Adda

Alba Docilia. Albisola Marina (Savona)	Antonelli, Enea (1887–1951)	Bassanelli, Renato (1896–1973)	Bucci, Anselmo (1887–1959)
Alba Docilia. Albisola Marina (Savona)	Ars Pulchra. Torino	Berardi, Romeo (1882–1961)	Cacciapuoti. Napoli
Alba Docilia. Albisola Marina (Savona)	Arte della Ceramica. Florence and then Fontebuoni (Florence), 1896–1909	Bottazzi, Umberto (1865–1932)	Calzi, Achille (1873–1919)
Alba Docilia. Albisola Marina (Savona)	Arte della Ceramica. Florence and then Fontebuoni (Florence), 1896–1909	Bottega d'Arte Ceramica di Federico Melis, at the Società Ceramica Industriale Cagliari. Cagliari, 1928–31	Calzi, Achille (1873–1919)
Alba Docilia. Albisola Marina (Savona)	Barraud Messeri & C. Colonnata (Florence)	Bucci, Anselmo (1887–1959)	Calzi, Achille (1873–1919)

219

Cambellotti, Duilio (1876–1960)

Cantagalli. Florence, 1872–1987

Cantagalli. Florence, 1872–1987

Cantagalli. Florence, 1872–1987

Carraresi e Lucchesi. Sesto Fiorentino (Florence)

Casadio, Emilio (1902–1964)

Casadio, Emilio (1902–1964)

Castellani, Torquato (1846–1931)

Castellani, Torquato (1846–1931)

C.A.S. (Ceramiche Artistiche Savonesi). Savona, 1927–50

Ceccaroni, Rodolfo (1888–1983)

Cellini, Renzo (1898–1934)

Cellini, Renzo (1898–1934)

Cellini, Renzo (1898–1934)
With the mark of the SPICA factory

Ceramica Florio. Palermo, 1882–1925

C.I.M.A. (Consorzio Italiano Maioliche Artistiche). Perugia, 1926–33

Cooperativa Ceramica di Imola. Imola (Bologna)

Cooperativa Ceramica di Imola. Imola (Bologna)

Cooperativa di Lavoro fra Ceramisti ('Ceramists' Work Cooperative'). Faenza (Ravenna), 1909–23

Dolcetti, Giacomo (1893–1957)

Dolcetti, Giacomo (1893–1957)

Essevi. Turin, 1934-1952

Essevi. Turin, 1934-1952

Fabbriche Riunite di Ceramiche. Faenza (Ravenna), 1900–08

Fabbriche Riunite di Ceramiche. Faenza (Ravenna), 1900–08

Fabbriche Riunite di Ceramiche. Faenza (Ravenna), 1900–08

Fabris, Luigi (1883–1952)

F.A.C.I. (Fabbrica Artistica Ceramiche Italiane). Civita Castellana (Viterbo), 1927–67

Faenzerella. Vietri (Salerno)

Fantoni, Marcello

Faventia Ars.
Faenza (Ravenna), 1923–56

Faventia Ars.
Faenza (Ravenna), 1923–56

Faventia Ars. Faenza (Ravenna),
1923–56

Faventia Ars.
Faenza (Ravenna), 1923–56

Faventia Ars.
Faenza (Ravenna), 1923–56

Faventia Ars.
Faenza (Ravenna), 1923–56

Faventia Ars.
Faenza (Ravenna), 1923–56

Fenice. Albisola Capo (Savona),
1923–36

Fenice. Albisola Capo (Savona),
1923–36

Fenice. Albisola Capo (Savona),
1923–36

Fenice. Albisola Capo (Savona), 1923–36
The mark 'Savona Nuova' identifies
the production of Mario Labò

Finzi, Arrigo (1890–1973)

Finzi, Arrigo (1890–1973)

Florentia Ars. Florence

Fornace Bubani.
Faenza (Ravenna), 1923–1928

Fornaci di San Lorenzo.
Borgo San Lorenzo (Florence), 1906–43

Fornaci di San Lorenzo.
Borgo San Lorenzo (Florence), 1906–43

Fornaci di San Lorenzo.
Borgo San Lorenzo (Florence), 1906–43

Fornaci di San Lorenzo.
Borgo San Lorenzo (Florence), 1906–43

Fratelli Minardi.
Faenza (Ravenna), 1899–1913

Fratelli Minardi.
Faenza (Ravenna), 1899–1913

Fratelli Minardi and C.
Faenza (Ravenna), 1899–1913

Fratelli Minardi and C.
Faenza (Ravenna), 1913–1922

Fratelli Minardi di Focaccia & Melandri.
Faenza (Ravenna), 1922–31.
In the mark the two initials F and M
at the sides of the goshawk were
inverted to M and F as early as 1925

Galvani. Pordenone, 1811–1968

Galvani. Pordenone, 1811–1968

Gatti & C. Faenza (Ravenna)

Gatti & C. Faenza (Ravenna)

Gatti, Riccardo (1886–1972)

Golia (Eugenio Colmo, 1885–1967)

Golia (Eugenio Colmo, 1885–1967)

Gordini Antonio and Casadio Emilio. Faenza (Ravenna)

Gregorj. Treviso

Grès d'Arte Cacciapuoti, Bignami e C. Milan, 1927–82

I.C.S. (Industria Ceramica Salernitana). Vietri (Salerno), 1927–34

Igne Collucent. Rome

I.L.C.A. (Industria Ligure Ceramiche Artistiche). Nervi (Genoa), 1928–31

I.L.C.A. (Industria Ligure Ceramiche Artistiche). Nervi (Genoa), 1928–31. Mark with faces of king and queen, identifying the modern production

I.L.C.A. (Industria Ligure Ceramiche Artistiche). Nervi (Genoa), 1928–31. Mark with the Lantern of Genoa, identifying the traditional production

I.L.S.A. (Industria Ligure Stoviglie e Affini). Albisola (Savona)

Keramos. Rome, 1918–28

Keramos. Rome, 1918–28. With the signature of Renato Bassanelli

König Scavini, Helen (1886–1974)

Kowaliska, Irene (1905–1991)

Laboratorio Nuova Ceramica. Rome

Laboratorio Nuova Ceramica. Rome

Lazzar. Treviso, 1907–12

Lazzar. Treviso, 1907–1912

La Casa dell'Arte. Albisola Capo (Savona), 1921–55

La Casa dell'Arte. Albisola Capo (Savona), 1921–55. With the signature of Manlio Trucco

La Casa dell'Arte. Albisola Capo (Savona), 1921–55

La Faïence. Faenza (Ravenna), 1919–30

La Faïence. Faenza (Ravenna), 1919–30. Mark used at the time of the partnership between Paolo Zoli and Pietro Melandri (1919–21)

La Faïence. Faenza (Ravenna), 1919–30. Mark used at the time of the partnership between Paolo Zoli and Pietro Melandri (1919–21)

La Faïence. Faenza (Ravenna), 1919–30. Mark used after the withdrawal of Pietro Melandri in 1921

La Faïence. Faenza (Ravenna), 1919–30. Mark used after the withdrawal of Pietro Melandri in 1921

La Faïence. Faenza (Ravenna), 1919–30. Mark used after the withdrawal of Pietro Melandri in 1921

La Fiamma. Albisola Capo (Savona), 1929–38

La Fiamma. Rome

La Fiamma. Rome

La Freccia. Vicenza, from 1930

La Nuova Cà Pirota. Faenza (Ravenna), 1922–33

La Nuova Cà Pirota. Faenza (Ravenna), 1922–33

La Nuova Cà Pirota. Faenza (Ravenna), 1922–33

La Nuova Cà Pirota. Faenza (Ravenna), 1922–33

La Salamandra. Perugia, 1922–31

La Faïence. Faenza (Ravenna), 1919–30. Mark used at the time of the partnership between Paolo Zoli and Pietro Melandri (1919–21)

Le Bertetti. Turin, 1932–1942

Lenci. Turin, 1919–64

Lenci. Turin, 1919–64

Lenci. Turin, 1919–64. The flower is the symbol of the artist Mario Sturani

Manifattura Ceramica Faentina. Faenza (Ravenna), 1910–14

Manifattura di Signa. Signa (Florence), 1895–1952

M.A.P. (Maioliche Artistiche Pesaresi). Pesaro

M.A.P. (Maioliche Artistiche Pesaresi). Pesaro

M.A.S. (Maioliche Artistiche Savonesi). Albisola Capo (Savona), 1920–21

Mauzan, Luciano Achille (1883–1952)

Mazzotti. Albisola Marina (Savona)

Mazzotti. Albisola Marina (Savona)

Melandri, Pietro (1885–1976). Initials of the years 1921–22

Melandri, Pietro (1885–1976). Initials used from the thirties to the fifties

Melandri, Pietro (1885–1976). Initials of the period 1923–43

223

Melandri, Pietro (1885–1976).
Initials of the period 1923–43

Melandri, Pietro (1885–1976).
Initials of the period 1946–71, when just the signature appeared as well

Melandri, Pietro (1885–1976).
Initials of the period 1946–71, when just the signature appeared as well

Melandri, Pietro (1885–1976).
Initials of the period 1946–71, when just the signature appeared as well

Minghetti, Angelo (1822–1992)

Modigliani, Olga (1873–1968)

Modigliani, Olga (1873–1968)

Molaroni. Pesaro

Molaroni. Pesaro

Morelli, Mario (1908–1966)

Nonni, Francesco (1885–1976)

Olco. La Spezia, 1920–40

Ortolani. Faenza (Ravenna)

Pacetti, Ivos (1901–1970)

Palatino Ars. Rome

Palatino Ars. Rome

Palatino Ars. Rome

Palatino Ars. Rome

Palazzi. Rome

Palazzi. Rome

Palazzi. Rome

Palazzi. Rome

Pandolfi de Rinaldis, Mary (1890–1933)

Pandolfi de Rinaldis, Mary (1890–1933)

Petucco, Gianni (1910–1961)

Poggi. Albisola Marina (Savona)

Poggi. Albisola Marina (Savona)

Polidori, Giancarlo

Ponti, Gio (1891–1979). Signature that appears on the Richard-Ginori ceramics with decorations designed by Gio Ponti

Pozzo della Garitta. Albisola Marina (Savona), from c. 1937

Quaglino e Poggi. Albisola Marina (Savona), 1898–1902

Randone Horitia

Randone Saturnia

Ravano, Dario (1876–1961)

Ravano, Dario (1876–1961)

Retrosi, Virgilio (1892–1975)

Retrosi, Virgilio (1892–1975)

Richard-Ginori. Factory of Doccia (Florence), from 1896

Richard-Ginori. Factory of Doccia (Florence), from 1896. Mark of the Gio Ponti period; frequently found on the celadons

Richard-Ginori. Factory of Doccia (Florence), from 1896. Mark of the Gio Ponti period; found in different colours, especially gold

Richard-Ginori. Factory of San Cristoforo, Milan, from 1896. The mark is usually in brown

Richard-Ginori. Factory of Mondovì (Cuneo), from 1897

Richard-Ginori. Doccia (Florence) and San Cristoforo (Milan), from 1896. Mark of the Richard factory (1830–1996), it is also found on ceramics decorated by Richard-Ginori

Richard-Ginori. Doccia (Florence) and San Cristoforo (Milan), from 1896. Mark of the Ginori factory (1737–1896), it is also found on ceramics decorated by Richard-Ginori

Richard-Ginori. Doccia (Florence) and San Cristoforo, from 1896. Usually combined with other marks, it identifies the production of decorated porcelain in the late 19th century and first few decades of the 20th

Richard-Ginori. Doccia (Florence) and San Cristoforo, from 1896. Usually combined with other marks, it identifies the production of decorated porcelain in the late 19th century and first few decades of the 20th

Richard-Ginori, Doccia (Florence) and San Cristoforo. Green mark used for porcelain until the early 1940s

Richard-Ginori. Doccia (Florence) and San Cristoforo, from 1896. Crowned mark, used for majolica ware; sometimes accompanied by a Ω

Richard-Ginori. Doccia (Florence) and San Cristoforo, from 1896. Crowned mark, used for majolica ware; sometimes accompanied by a Ω

Richard-Ginori. 'Kaolinite' mark used by the San Cristoforo factory in Milan

Richard-Ginori. 'Serpentine' mark used by the San Cristoforo factory in Milan in the Art Nouveau period

Richard-Ginori, Doccia (Florence) and San Cristoforo, from 1896. Graphic device used to put the titles on pieces by Gio Ponti (in this case 'The Archaeological Stroll'). The mark, designed for the Paris Exhibition of 1925, was used for a short time

R.I.N.I.P. (Regio Istituto Nazionale per l'Istruzione Professionale). Rome, 1918–28

Rosati, Roberto (1890–1949)

Rosati, Roberto (1890–1949)

Rosati, Roberto (1890–1949)

Rosati, Roberto (1890–1949)

Rubboli. Gualdo Tadino (Perugia). Mark pertaining to the denomination Daria Rubboli, 1890–1918

Rubboli. Gualdo Tadino (Perugia). Mark pertaining to the denomination Fratelli Rubboli, 1918–20 and 1931–36

Rubboli. Gualdo Tadino (Perugia). Mark pertaining to the denomination Lorenzo II Rubboli, 1936–55

Rubboli. Gualdo Tadino (Perugia). Mark pertaining to the denomination Alberto Rubboli, 1936–75

Rufa, Giulio (1903–1970)

Ruggeri. Pesaro, 1898–1903

Salvini. Florence

Sansebastiano e Moreno. Genoa, 1883–1904

Santa Lucia, Siena

Santarelli, Alfredo (1874–1957)

Santarelli, Alfredo (1874–1957)

S.C.A.F. (Società Ceramica Artistica Fiorentina). Florence, 1901–03

S.C.A.F. (Società Ceramica Artistica Fiorentina). Florence, 1901–03

Scuola di Ceramica di Faenza. Faenza (Ravenna)

Scuola di Ceramica di Faenza. Faenza (Ravenna)

Scuola di Ceramica di Faenza. Faenza (Ravenna)

Sebelin, Teodoro (1890–1978)

S.I.F.M.A. (Società Industriale per la Fabbricazione di Maioliche Artistiche). Sesto Fiorentino (Florence). With the words 'Stile Botticelli', which indicate the production in a modernist style

S.I.M.A.C. (Società Italiana Maioliche Abruzzesi Castelli). Castelli (Teramo), 1920–38

Sintoni Aldo e Casadio Emilio. Faenza (Ravenna), 1932–35

S.I.P.L.A. Rome

S.I.P.L.A. Rome

S.I.P.L.A. Rome

S.I.P.L.A. Rome

Società Anonima Ceramiche Rometti Umbertide (S.A.C.R.U.). Umbertide (Perugia), from 1933

Società Anonima Ceramiche Rometti Umbertide (S.A.C.R.U.). Umbertide (Perugia), from 1933

Società Anonima Ceramiche Rometti Umbertide (S.A.C.R.U.). Umbertide (Perugia), from 1933

Società Anonima

Società Anonima

Società Anonima

Società Anonima Siciliana

Società Ceramica Colonnata. Sesto Fiorentino (Florence), 1891–1934

Società Ceramica Italiana (S.C.I.). Laveno (Varese), 1883–1965

Società Ceramica Italiana (S.C.I.). Laveno (Varese), 1883–1965

Società Ceramica Italiana (S.C.I.). Laveno (Varese), 1883–1965

Società Ceramica Italiana (S.C.I.). Laveno (Varese), 1883–1965

Società Ceramica Italiana (S.C.I.). Laveno (Varese), 1883–1965

Società Ceramica Italiana (S.C.I.). Laveno (Varese), 1883–1965

Società Ceramica Italiana (S.C.I.). Laveno (Varese), 1883–1965

Società Ceramica

Società Ceramica

Società Ceramica Umbra

Società Ceramica Faentina

Società Ceramica Faentina

SOESCO. Albisola Marina (Savona)

S.P.I.C.A. (Società per Industria Ceramiche Artistiche). Albisola Capo (Savona), 1925–55

S.P.I.C.A. (Società per Industria Ceramiche Artistiche). Albisola Capo (Savona), 1925–55

TAI. Rome, 1919–26. Mark used for the ceramics produced at the Regio Istituto Nazionale per l'Istruzione Professionale to designs by Duilio Cambellotti

TAI. Rome, 1919–26. Mark used for the ceramics produced at the Regio Istituto Nazionale per l'Istruzione Professionale to designs by Duilio Cambellotti

Treré. Faenza (Ravenna), 1878–1944

Treré. Faenza (Ravenna), 1878–1944

Trucco, Manlio (1884–1974)

Zaccagnini. Florence

Zaccagnini. Florence

Zama. Faenza (Ravenna)

Zama. Faenza (Ravenna)

227

Glossary
compiled by Roberta D'Adda

Airbrush
A small instrument powered by compressed air, used since the end of the 19th century for the pictorial decoration of ceramics: it allows colours to be sprayed on, in more than one layer if desired, obtaining blurred effects and soft outlines.
During the process the parts not to be painted are covered by a mask.

Barbotine
Semiliquid clay in aqueous suspension.
In the past it was used for decoration and to apply projecting parts like handles and spouts to the body of the objects; in modern times it is used during modelling and for decoration in relief. In this phase the slip (as it is also called) is utilized to attach elements modelled in advance to the object or applied directly with brushes or syringes to produce various forms (bosses, cords, etc.).

Biscuit (bisque)
A ceramic state obtained after the first firing, in which the object already has its definitive form and dimensions. Some artists buy readymade biscuit, which they then decorate.

Blistering
Technically this is a firing defect in the glaze, when it ends up studded with blisters and craters of various sizes. The effect, which can be the product of a variety of factors, is often sought by ceramists for decorative purposes.

Bucchero
Name of a particular type of clay and pottery made by the Etruscans, characterized by its shiny black colour. There are different ideas about the technique originally used to produce this material: it seems that additives like powdered charcoal were added to the mixture and that the firing was carried out in a strongly reducing atmosphere, which produced the distinctive colouring by chemical reaction. Objects made in this way were coated with wax or resin and polished while still hot.

Celadon
Type of glaze characterized by a particular blue-green colour, due to the presence of small amounts of iron and titanium. Invented in China, the name given to this glaze in the West comes from a character in a play who wore clothes of the same colour.

Ceramic
Generic term used for a variety of materials modelled from a mixture of clays and then fired. The procedures used to make ceramics, also known as pottery, have remained essentially unchanged through centuries of technical and artistic research: modelling, drying, coating, decoration and the various phases of firing. Ceramics are divided into products that are porous in character (terracotta, majolica, earthenware) or impermeable (porcelain and stoneware).

Ceramic pastels
Mixtures of gum arabic, clay and colouring oxides are used to decorate the white biscuit and then fixed with transparent glaze.
It is possible to obtain delicate shadings or strong and well-defined lines with them, depending on the way they are laid on and the texture of the surface.

China clay
A white clay, also called kaolin, used for porcelain.

Clay
Sedimentary rock formed out of a mixture of sand and minerals.
The quality and quantity of the mineral compounds in the clay give rise to types of pottery that differ in their porosity, resistance to temperature and colour. It can be used in the natural state or blended to obtain a wide range of different mixes.

Coating
Stage in the working of the pot that is based on a variety of materials and procedures and that was developed essentially as a means of making porous ceramic objects capable of holding liquids. The techniques used depend on the type and quality of the product: slip, transparent glaze, coloured glaze.

Coiling
This technique of modelling allows an object to be constructed out of simple rolls of clay coiled one on top of the other and fixed in place by pressing them with the fingers or coating them with slip. The forms created in this way can be finished by scraping and smoothing with a spatula or knife.

Coloured glaze (enamel)
Sometimes called enamel to distinguish it from transparent glaze, it is opaque and coloured. It is composed of a liquid suspension of finely ground minerals that can be applied to objects after the first firing. It is applied with a brush or spray or by immersion and, once dry, is subjected to a second firing at its melting point, forming a smooth and gleaming surface. Majolica is one type of glaze. Depending on their composition, glazes have different colours, are shiny or opaque (matt) and after firing can have characteristic surfaces produced by dripping, crazing, blistering and crystallization. Prior to the second firing it is possible to carry out the process called overglaze decoration; glaze can also be applied after the second firing to obtain a decoration in relief similar to that produced with slip. Other decorations can be obtained with the resist technique, or by painting underglaze colours or low-fired colours over the fired glaze.

Combing (feathering)
The technique of decoration known as combing or feathering is done with slip on an unfired piece with a flat surface: a layer of slip, preferably of a dark colour, is spread on the surface of the object and when this begins to dry, parallel stripes of a slip in a lighter colour are laid over the top. When the piece is moved slightly, the lower layer, dampened by contact with the upper one, slides and floats between the stripes of the second slip. Subsequently, a stiff feather or knife is dragged at right angles across the lines in two colours, creating a slight undulation.

Craquelure
See crazing.

Crazing
Technically a flaw produced in the glaze after firing in which the surface is covered by a dense mesh of fine cracks. This effect, due to sudden changes of temperature or to different coefficients of expansion of the glaze and the biscuit resulting in different degrees of shrinkage during cooling, is often deliberately sought by potters as a decoration.

Crystallization
A chemical process that affects certain types of glaze, generally matt ones: after firing the surface is covered with small crystals of various shapes and colours. The phenomenon is exploited by ceramists for decorative purposes.

Decalcomania
See transfer

Decoration
Stage in the working of ceramic successive to modelling. It can be carried out on the object before it has been fired, but is more frequently applied to the biscuit. In the first case the decoration is of a plastic type and obtained by using various tools (bits, moulds, combs, cords, etc.) to impress, scratch, incise or in some way modify the surface of the object; barbotine can be used in various ways for this purpose. In the phase prior to firing

special decorative effects can also be obtained with slip. Techniques of painting are used chiefly for decoration on the biscuit and overglaze and underglaze: special pigments are used to paint on the ceramic with a brush, airbrush, pad or stamp. Pastels or techniques like decalcomania and silk–screening can be used for decoration as well. Special decorative effects are also obtained through the use of coloured glaze and resinate lustre, metallic lustre, the resist technique and with electroplating, engraving and the application of beads or filaments of glass. Finally, special procedures in the firing phase such as the addition of salt and smoking make it possible to obtain unusual results. Attractive chromatic effects can also be achieved simply by mixing different coloured clays, a technique known as neriage.

Dripping
Decorative effect obtained by superimposing different types of glaze with different degrees of fusibility: during firing the different reactions produce particular effects of colour and texture.

Drying
Stage in the working of ceramic, successive to modelling, during which the clay loses a large proportion of its water content and becomes firm. Drying can take place in the open air or in special rooms in which the temperature is kept at a constant and uniformly high level.

Earthenware
Ceramic material with a white paste fired at a temperature of about 900°, characterized by its resistance and porosity. The term is frequently used for pottery of everyday use, especially crockery.

Enamel
See coloured glaze

Electroplating
Electrochemical process that involves covering a conducting object with a thin layer of metal deposited electrolytically. In the manufacture of ceramics, this process is used for decoration with precious metals like silver.

Etching with acid
Technique for the decoration of ceramics that entails covering the whole object with a layer of wax, which is then scratched away with a needle to form the designs to be etched. The piece is then subjected to the corrosive action of a bath of hydrofluoric acid, so that the uncovered parts are etched more or less deeply, depending on the length of the immersion. The grooves cut in this way can be filled with glaze.

Faience
The name given to tin–glazed earthenware made in France, Germany, Spain, and Scandinavia, and the equivalent of the Italian term majolica and the Dutch term delft. Its name derives from Faenza, the important centre for the production of majolica in Emilia.

Firing
Stage in the working of pottery that can be repeated several times and at different temperatures, depending on the nature of the ceramic material and its decoration. The term 'low–fired' is used for objects fired at low temperatures, and 'high–fired' for those fired at high temperatures. The first firing, following the modelling, produces biscuit and is carried out at between 750° and 900° for almost all types of ceramic, apart from stoneware. A second, high–firing (1200–1400°), is used to fix the glazes, enamels and other colours that form the underglaze. The third, low firing, takes place at 700° and permits consolidation of all the overglaze decorations and the lustre. The kilns used to fire ceramics are of different kinds, varying in their structures, systems of fuelling, methods of operation, temperatures attained in firing and refinement of the instruments of control. Depending on the atmosphere present in the firing chamber, reduction or oxidation can take place, and this is controlled by ceramists to produce particular effects on the material. Other effects can be obtained by the introduction of smoke or salt.

Fluxes
Mineral substances in glaze that promote the melting of the other components during firing.

Forming
See modelling.

Gilding
A liquid gold–based enamel is applied with a brush or airbrush over the glaze after the second firing; like all overglaze pigments it is fired at a low temperature (600–700°). After firing it can be polished with a burnisher.

Glass
Refined decorative effects can be obtained by applying beads and filaments of glass to the glaze before the third firing, fixing them with organic adhesives mixed with fluxes. Mosaic tesserae can be applied to the ceramic in a similar way.

Glaze
See coloured glaze and transparent glaze

High firing
Type of firing at high temperatures that is used for stoneware, coloured and transparent glaze and underglaze paintings.

Jasper
Type of ceramic that imitates the semiprecious stone of the same name through the colour and composition of its mix. There is another type of ceramic that imitates basalt.

Jolly (jigger)
Device used for modelling clay: it consists of a metal profile attached to an arm that is used to shape the surface of the clay applied to a plaster mould. The plaster mould revolves on a swivel joint and the lever with the profile is lowered onto the surface of the clay, pressing it against the mould. As the mould turns the excess clay is removed.

Kaolin
See china clay

Klinker
Special mix of clays created by the Piccinelli factory in Bergamo for the manufacture of industrial ceramics. After firing, which is carried out at a very high temperature, it attains a hardness even greater than that of stoneware. It has also been utilized for the production of artistic ceramics.

Low firing
Type of firing at low temperatures, used for overglaze colours, lustre and resinate lustre.

Lustre
Particular type of decoration obtained on third firing, after painting special compounds of salts or oxides of silver, copper, lead or iron over the glaze or majolica. During the third firing, in a reducing atmosphere, some of these metallic compounds are turned into a thin layer of pure metal that confers iridescent effects on the pottery.

Majolica
Technically this is a type of tin–based, white and opaque glaze that gives ceramic materials (which naturally tend to take on shades of grey, green, brown and red after firing) a neutral and attractive surface, ideal for the application of colour. The tin glaze is spread over the biscuit by brush, spray or immersion and the layer it forms can be painted: the brushstrokes have to be light and sure, as the paint tends to blend with the glaze and, above all, it is impossible to make corrections. This stage of the work is often carried out by specialized craftsmen and women, who reproduce the designs of other artists. During the second firing the majolica melts, vitrifying and incorporating the colours. It is possible to add a further painted decoration to the layer obtained in this way, which is then subjected to a third firing. By extension, the term majolica is used for pottery produced in the way described above.

Marbling
Decorative effect obtained with slip, by pouring a small quantity into a pot previously coated with slip in a different colour: the object is shaken to make the fresh slip move around, producing a marbled effect similar to that of agate.

Mask
Device used for painted decoration that consists of a thin perforated sheet reproducing a design: the mask is applied to the object, which can then be painted by brush, airbrush or pad.

Matt
Literally 'opaque', an effect obtained in ceramics through the use of special types of glaze that, through additions and alterations, produce a more or less rough surface lacking lustre or gloss.

Mezza majolica
Ceramic product obtained by dipping the object in a white clay slip, subjecting it to a first firing and adding a simple painted decoration, and then covering it with transparent glaze and firing it again. The end result is similar to that of majolica.

Mix
The material, consisting essentially of clay, that is made by hand or by industrial methods with the aim of purifying (washing, settling, etc.) and altering the original material. In addition to clay, mixes contain two more elements in different quantities: silica or sand, used to make the mix "lean" and facilitate the drying of the pottery, and fluxes like micas and powdered glass. A special type of mix used as decoration is neriage.

Modelling
The mix of clay used to make artistic ceramics can be modelled by a series of techniques, of varying complexity and refinement. Among the simplest methods are hand and slab building and coiling. Technically more advanced are the techniques of throwing on the wheel, jollying, slip casting and

moulding. Hand, slab and coil building are used for the production of one–off pieces.

Mosaic
Mosaic tesserae can be applied to ceramics in a procedure similar to the one used for glass beads.

Moulding
Technique of modelling in which the ceramist uses one or more negative moulds of the piece that he intends to create: the clay is pressed into these moulds by hand and taken out while it is still soft and deformable. This process makes it possible to carry out significant retouches and corrections before it dries, resulting in what are called 'moulded one–off pieces'.

Muffle kiln
A type of kiln in which the chamber, made of brick, is designed to prevent the objects coming into direct contact with the flame.

Neriage (*nerikomi*)
Technique of mixing clays that differ in colour, either naturally or because they have been modified by the addition of oxides, for decorative purposes. Kneading layers of different colour without letting them blend together produces an attractive and variegated surface.

One–off piece
Object modelled by the ceramist as a unique object, and not as part of a series.

Overglaze
There are two types of overglaze, distinguished in Italian by the terms *soprasmalto* and *sopravernice*.
The first (*soprasmalto*) is a process in which the decoration is painted on top of coloured glaze before it is fired; the pigments, made of metallic oxides mixed with fluxes, fuse with the glaze during the second firing.
The second (*sopravernice*) is painted on the majolica, after the second firing: in fact it is possible to paint easily and with a wealth of detail on this vitreous and impermeable layer. The decorated piece is subjected to a third firing which, requiring a lower temperature than the other two (around 700°), allows the use of a wider range of colours, including gold and silver (gilding and silvering).

Oxidation
Chemical process that takes place during firing when a large amount of oxygen is present in the chamber of the kiln. The opposite phenomenon is reduction. When the two phenomena are balanced the result is a neutral firing.

Patination
Procedure that entails polishing a ceramic material when cold, using resin or wax.

Pigment
As they have to be able to resist high temperatures during firing, the pigments used for ceramics cannot be organic and thus are composed of metal oxides. The range of colours is not very wide and the tints are often altered by the heat. Depending on the temperature they are able to withstand during firing, glazes for pottery are categorized as high–fired or low–fired pigments.

Porcelain
Ceramic material that is obtained by firing at very high temperatures (over 1200°) and the use of a clay of special composition, kaolin or china clay: the paste produced in this way is white, hard, translucent and impermeable. Soft–paste porcelain, created in imitation of Chinese porcelain, is made from a mixture of various materials, such as glass, alabaster, lime and clay, and has to be covered with glaze and fired at a temperature of less than 1100°.

Reduction
Phenomenon that is obtained during firing by limiting the amount of oxygen present in the kiln (by closing valves and doors and using damp wood). The chemical reactions produced in the materials in this way are used by potters to alter colours and lustre. The opposite phenomenon to reduction is oxidation. When the two phenomena balance out the result is a neutral firing.

Resinate lustre
An effect similar to lustre obtained with a metallic resinate composed of oxides and salts. It is applied over the glaze and subjected to a third firing at a low temperature, in a neutral atmosphere. It is spread on with a brush and creates iridescent effects.

Resist
Technique used in decoration to stop parts of the object being covered with glaze, slip or colour: these areas are coated with liquid wax and thus they maintain their original colour after decoration.
Extremely complicated decorative effects can be achieved with several passages and overlays.

Ribbing
Technique of decoration that consists in tracing horizontal stripes with a brush on the surface of an object as it turns on the wheel.

Salt glaze
Glaze obtained by introducing salt into the chamber of the kiln during firing. As it heats up the salt evaporates and adheres to the surface of the objects. Different decorative effects are obtained in relation to the material, the temperature and the atmosphere of firing.

Sgraffito
Type of decoration carried out on a piece covered entirely with slip or glaze, by incising it when still unfired to reveal the colour of the material underneath.

Silk–screening
Technique of decoration that allows a pictorial motif to be transferred onto the ceramic surface by passing the paint through the mesh of a screen made of silk or some other suitable fabric. Special techniques are used to transfer the design to be reproduced onto the screen; the parts that should be left blank on the ceramic surface are sealed and the paint, pressed with a spatula, passes only through the open holes in the mesh.

Silvering
Application of silver–based enamel, using a process similar to that of gilding.

Single firing
Slip and some special types of glaze can be used to make finished and elaborate pieces in a single firing, instead of the two or three required in the majority of cases.

Slab building
The technique of slab building entails forming clay into flat slabs of various thicknesses, which can then be cut, folded, curved and stuck together with slip in endless ways. The slabs are made by cutting the block of clay with a steel wire and can be worked in a more or less damp state according to need.

Slip (engobe)
Layer of liquid white clay that is applied to the object when wet or dry, either with a brush or by immersion, in order to cover up the natural colour of the clay body. The surface produced in this way is opaque and porous and has to be fired. This technique is used to make single–fired pieces and for the production of mezza majolica.
The inclusion of metal oxides in the solution allows different colours to be obtained, while the addition of fluxes produces a vitrified slip. Slip (natural or coloured) can be used on the raw piece for decorative purposes, making it possible to create special chromatic effects (resist) and, like barbotine, relief and sgraffito decorations. Two particular decorative techniques that are based on the use of slip are combing and marbling.

Slip Casting
Technique of modelling in multiples with a complex structure, based on the use of liquid clay poured into plaster moulds in two or more pieces, very similar to those used for moulding with solid clay. During the shaping the mould is closed, leaving just one side of the object open, usually the base: the craftsman pours fluid clay (slip) through this side until the mould is full. The plaster absorbs the water in the slip, resulting in the formation of a crust of solidified clay on the walls of the mould.
After a short time (from 10 to 30 minutes) the slip that has remained liquid is poured out of the mould, which is then opened to take out the piece. The marks left by the joints in the mould are removed by hand.

Smoking
During firing it is possible to introduce special metallic compounds into the kiln that vaporize on contact with the heat: the smoke produced in this way deposits on the objects, creating a thin metallic film similar to that of metallic lustre and resinate lustre.

Stoneware
Ceramic material obtained by firing clay rich in silica at around 1200°. After firing it becomes hard, vitrified and nonporous and acquires a colour (grey, brown or pink): this type of clay is found in nature, but can also be made by mixing.
Fired with salt, it acquires a glassy and colourless coating, produced by the reaction between sodium and silica (salt–glazed stoneware).

Stamp
Technique of pictorial decoration that entails using stamps made of various materials (rubber, sponge, cork, etc.) engraved with the desired decorative motif. The stamps are soaked in paint and used to transfer the design onto the surface of the article.

Pad
For painted decorations with large areas of colour it is possible to use a sponge (or similar material) soaked in paint and then squeezed and dabbed onto the surface to be decorated. This technique produces a variegated effect and can also be utilized to reproduce the design of a mask.

Terracotta
Coloured ceramic material with a porous body, fired at a low temperature (900–1000°).

Transfer (decalcomania)
Technique of decoration that allows a decoration printed in advance on special paper with ceramic pigments to be applied to the pottery. The print is immersed in water and then applied to the object, with the design facing inward; the paper support is then peeled off and the decoration pressed with a roller or sponge so that it adheres to the ceramic.

Transparent glaze
Vitreous compound made out of siliceous sand and fluxes, applied to the pottery by dipping or spraying after the first firing and any painted decoration. On the second firing the glaze vitrifies, fixing the colours and making the surface of the object shiny and impermeable.

Underglaze
Like overglaze, there two types of underglaze, distinguished in Italian by the terms *sottosmalto* and *sottovernice*.
The type known as *sottosmalto* is a decoration that is painted onto the biscuit before application of a coloured glaze; it is based on the use of special reacting or surfacing colours.
The second type of painted decoration called *sottovernice* is also applied to the biscuit, prior to the application of a transparent glaze which fixes it when it vitrifies during the second firing. Consequently the pigments used for this type of decoration have to be suited to high firing.

Wheel
Device known since antiquity and used to model objects with an axial symmetry. In modern times wheels are powered by electric motors and permit a limited kind of mass production.

Descriptions of the Ceramics Factories and Biographies of the Artists

compiled by Paola Franceschini

Giovanni Acquaviva
(Marciana Marina 1900 – Milan 1971)
Painter, poet and theorist of Futurism, he started to work with pottery, under the influence of Tullio d'Albisola, in the early thirties. His forms were adopted by the CAS in Savona; his best-known creation is the *Life of Marinetti* dinner service, made in 1939 by Mazzotti.
Bibliography
Crispolti 1982; Rosso 1983; Chilosi, Ughetto 1995.

Aemilia Ars
The Aemilia Ars Cooperative Society, set up in Bologna in 1898, worked in the field of the design of ceramics, with contributions from the best-known artists in this sector such as Cesare Alessandrini, Gigi Bonfiglioli, Achille and Giulio Casanova, Giuseppe De Col and Augusto Sezanne. These contributions are documented by the original drawings in the Bolognese public collections. They were mostly decorations for tiles, fireplaces, fountains and baths, but there were also vases and small objects, produced between 1898 and 1904, using the more up-to-date Art Nouveau style. Here we can mention a large fireplace with flamingos designed by Giulio Casanova at the turn of the century and executed by Minghetti of Bologna and a ceramic facing for a bathroom designed in 1902 by the Casanova brothers and manufactured by Minardi of Faenza (Palazzo Conti Sinibaldi in Faenza).
Bibliography
Aitelli 1901–1902; 1st Turin International Exhibition 1902; Melani 1902; Pica 1902; Bojani 1957; Bossaglia 1968; *Il Liberty italiano* 1972; Contini 1977; Bossaglia 1988; Bossaglia 1994; Bernardini 2001.

Aetruria Ars
The pottery was founded in 1913 at Querce, near Prato, by Vincenzo Corrente (Grottaglie 1887 – Florence 1967), who had begun to work with ceramics in his father's pottery on Corfu and then attended the Scuola Ceramica at Grottaglie. In 1910 he worked for Fantechi in Sesto Fiorentino and later became artistic director of the Florentine factory La Majolica Italiana. Aetruria Ars, which was closed from 1915 to 1919 because of the war, specialized in pottery in Greek and Etruscan style, for which it won a prize at the Paris Exhibition of 1923. Later the factory was moved to several different places in the Florentine area, ending up in Castello in 1930. At this point a more modern line began to be produced alongside the period pieces, consisting of figurine amphorae and vases of Deco inspiration, stylized animals and abstract decorations realized with the airbrush that were presented at the Milan Triennale in 1940.
Bibliography
3rd Monza Biennale 1927; *Annuario Industrie della Ceramica e del Vetro* 1930; Minghetti 1939; 7th Milan Triennale 1940; *Stile*, November 1942; *Mostra della ceramica italiana* 1982; Capetta 1990.

Agostinelli & Dal Prà
It was set up in 1904 and derived from the Società Ceramica Cooperativa founded at Nove in 1895 by a group of workers in the ceramics industry, Domenico Agostinelli, Giuseppe Dal Prà, Pietro Righetto and Giovanni Tasca, with Pio Canon as financial backer. Its production was to a great extent inspired by the local tradition of pottery, but between the two wars an attempt was made to update its output, with references to Art Nouveau and Art Deco. In 1917 the co-operative acquired the factory of Luigi Fabris, who had moved to Milan. In the thirties Enrico Caccia Guerra worked with the company. It participated in the principal national and foreign exhibitions, including the Monza Biennali in 1923, where it won a silver medal, and 1933, when it also took part in the exhibition of the ENAPI (Ente Nazionale delle Piccole Industrie). In 1930 the factory employed around fifty workers and exported to North America. It continued its activity until 1954, and then was split into four different firms, still operating at Nove and Bassano.
Bibliography
Musso 1897–98; 1st Monza Biennale 1923; Carrà 1923; *Annuario Industrie della Ceramica e del Vetro* 1930; ENAPI 1933; Ponti, *Le ceramiche alla Triennale* 1933; 5th Milan Triennale 1933; ENAPI 1936; Minghetti 1939; Stringa 1980; *Mostra della ceramica italiana* 1982; Stringa 1986; Stringa, *Omaggio a Bassano e Nove* 1987; Stringa 1988.

Zina Aita
(Belo Horizonte 1900 – Naples 1968)
In 1914 she came to Italy from Brazil, where her parents had emigrated in 1890, to study painting at the Accademia di Belle Arti in Florence with Galileo Chini. In 1919 she returned to Brazil, staying there until 1924 and working with avant-garde artistic movements. She acquired a certain reputation following her participation in the *Modern Art Week* in São Paulo in 1922. In 1923 she exhibited in Rio de Janeiro, and immediately afterwards set off for Italy again. She settled in Naples, where she continued to paint, devoting herself to ceramics as well; she frequented the Museo Artistico Industriale and distinguished herself for creations, mostly sculptural, in a naïve-expressionist style. In 1930 her works were shown at the Ceramics Gallery of the Monza Triennale. From 1937 to 1940 she took part with the ENAPI in the Crafts Exhibitions in Florence.
Bibliography
4th Monza Triennale 1930; *Domus*, July 1939; *Stile*, November 1942; Frattani, Badas 1976; Caròla-Perotti, Ruju 1985; Arbace, in Picone Petrusa 2000.

Aldo Ajò
(Gubbio 1901–1982)
From 1921 to 1926 he was artistic director of the Rubboli factory at Gualdo Tadino. He went on to found the Bottega dell'Arte in Gubbio, where he produced pottery for everyday use as well as ornamental pieces and large decorative panels. In 1937 he took part in the Mostra dell Artigianato ('Crafts Exhibition') in Florence and in 1940 in the Milan Triennale. He was forced to leave Gubbio by the racial laws, but resumed his activity after the war.
Bibliography
Minghetti 1939; 7th Milan Triennale 1940; E. A. Sannipoli, 'Note sulla ceramica eugubina degli anni '20 e '30', in Bojani 1992; Tittarelli 1999.

Alba Docilia
The old name of Albisola Marina, where the pottery was set up in 1919 on the initiative of Adolfo Rossello (Albisola 1878–1953) and other partners. Rossello received his training in Naples and in 1915 was made director of Poggi. For a short period the factory relied on the artistic guidance of the Roman painter Mario Gambetta, who introduced new decorations alongside those inspired by the Savona tradition. The pottery ceased activity in 1982.
Bibliography
2nd Monza Biennale 1925; Marangoni, *Enciclopedia* 1927; *Annuario Industrie della Ceramica e del Vetro* 1930; Minghetti 1939; *Mostra della ceramica italiana* 1982; Rosso 1983; Chilosi, Ughetto 1995.

Edina Altara
(Sassari 1898 – Lanusei, Nuoro 1983)
Her first creations, collages and figurines in Sardinian costume, were successfully shown at a number of exhibitions held in Sassari and Milan between 1916 and 1919. She then devoted herself to magazine and books illustration and in the thirties to ceramics, producing a series of tiles decorated underglaze with figures in Sardinian costume, commissioned by Margelli of Sassari and made by the Manifattura Ceramica Faentina in Faenza. One of her designs, entitled *A convegno* ('Get-together') and representing three women and a man, was produced by Lenci and appeared in the firm's catalogues. During the Second World War she still made tiles that were decorated without firing, but would later give up this activity.
Bibliography
Altea, Magnani 1995; Cuccu 2000.

Guido Andlovitz
(Trieste 1900 – Grado 1965)
Born in Trieste, he moved with his family to Grado. He graduated from Milan Polytechnic (*Domus*, 1928) or, according to Minghetti, the Accademia di Belle Arti di Brera. In 1923 he began his long collaboration with the Società Ceramica Italiana (SCI) of Laveno, which took up the whole of his working life and did not end until 1962. Among his first creations were a dinner service and a series of objects grouped under the name *Monza* with stylized decorations inspired by Rococo presented at the Monza Biennale in 1925. Between 1926 and 1929 he carried out a particularly intense activity of design that he would later give up almost completely to devote himself to services for mass-production (*Pomezia* 1936, *Vittuone* 1936, *Orvieto* 1936, *Urbino* 1951, *Arezzo* 1955). At the 1927 Biennale the SCI achieved a gratifying success with his creations, even judged by some critics (Papini in *Emporium*, July 1937) to be superior to those of its rival Richard-Ginori. At the Monza Triennale of 1930 the factory again presented several large vases in limited runs, but above all 'a broad range of *objets d'art* and modern services' (*Domus*, June 1930) proposed with several types of decoration. At the Milan Triennale of 1933 the SCI presented dinner, tea and coffee services of basically geometric design, the most interesting of which was constructed entirely out of spherical elements. The next year it produced objects of a similar type with a white glaze (*Domus*, January 1934). A few new forms of vases and decorative objects were to appear over the following years: among them were, in 1936, the popular model 1316 vase, with its characteristic squashed globular shape; then the 'large stoneware vase', decorated with images of buildings from imperial Rome and shown at the Triennale in 1940; and again, in the early forties, the 'geometric' candlesticks and oval centrepieces with an M-shaped support. Despite his cultured origins, Andlovitz's ceramic works were not aimed, like so many of Ponti's creations, at an elite public. From 1927 onwards he was not just artistic consultant but also production manager, and in this capacity had to meet the demands of a broader and more varied clientele. For this reason the forms and ornaments were interchangeable and used to produce series that could be varied in their finish and decoration.
Bibliography
Emporium, September, October 1925; 3rd Monza Biennale 1927; *Emporium*, July 1927; Marangoni, *Enciclopedia* 1927; Marangoni, in *La Cultura Moderna*, 1927; Reggiori 1927; *Domus*, March, May, July, November 1928; *Architettura e Arti Decorative*, July 1929; *Domus*, March, September, December 1929; *Architettura e Arti Decorative*, July 1930; Buzzi 1930; *Domus*, March, April, July, August, September, October, November, December 1930; *Emporium*, November 1930; Guigoni 1930; Papini 1930; Ponti 1930; 4th Milan Triennale 1930; *Domus*, May, June, July, September, November, December 1931; *Domus*, February, April, December 1932; *Domus*, July 1933; *Emporium*, December 1933; 5th Milan Triennale 1933; *Domus*, January 1934; *Emporium*, August 1936; 6th Milan Triennale 1936; *Domus*, April 1937; *Domus*, December 1938; Minghetti 1939; *Domus*, May 1940; *Emporium*, May 1940; 7th Milan Triennale 1940; Folliero 1957; Morazzoni 1957; Bossaglia 1980; *Mostra della ceramica italiana* 1982; Rosso 1983; Gallina, Sandini 1985; Munari 1990; Biffi Gentili 1993; Musumeci, Paoli 1994; Biffi Gentili, 'La poetica ceramica di Guido Andlovitz', in Pansera 1995; Bossaglia, Biffi Gentili, De Grassi 1995; Ausenda 1998; Terraroli 1998; Terraroli, *Milano Déco* 1998; Barisione 1999; Ausenda, in *Museo d'Arti Applicate* 2002.
(cat. 84-103, 327-337)

Libero Andreotti
(Pescia 1875 – Florence 1933)
Between 1901 and 1903 he collaborated with Vittorio Giunti's SCAF on the decoration of pottery. In 1904 he came into contact with the Milanese artistic milieu and devoted himself to sculpture. In 1905 he showed for the first time at the Venice Biennale, with a terracotta. From the following year and up until 1914, his point of reference became Paris, where he exhibited successfully at the Salons. In the twenties, in addition to monumental sculpture, he devoted himself to the production of ceramics, as in 1927 when Gio Ponti proposed he collaborate on the realization, for Richard-Ginori of Doccia, of the *cistae The Archaeological Stroll* and *The Classical Conversation* dedicated to Ugo Ojetti and his wife, for which Andreotti designed and modelled the winged figures.
Bibliography
R. Monti (ed.), *Mostra di Libero Andreotti*, Florence 1976; Casazza, Monti, V. Sgarbi, *Libero Andreotti*, Casalecchio di Reno 1993; Lucchesi, Pizzorusso (ed.), *La cultura europea of Libero Andreotti. Da Rodin a Martini*, Cinisello Balsamo 2000.
(cat. 124-127)

Mario Anselmo
(Genoa 1913 – Albisola 1989)
He began work at Mazzotti at a very early age, in 1926, first as a painter and then as a modeller, under the guidance of Virio da Savona and Tullio d'Albisola. He came into contact with Futurism by transforming the creations of the artists who worked with the factory into the medium of ceramics. In 1930 he won a gold medal at the Competition for Arts and Crafts in Rome, and then participated with the Futurists of Albisola at the Futurist exhibition of 1931 in Chiavari, at those of 1932 in Trieste, at Nice in 1934 and at the first exhibition of mural reliefs in Genoa. After the war years he did not resume his activity until the fifties.
Bibliography
Minghetti 1939; Crispolti 1982; Rosso 1983; Chilosi, Ughetto 1995.

Enea Antonelli
(Castiglione di Cervia 1887 – Marino, Rome 1951)
He moved to Rome in 1905 to attend the Accademia di Belle Arti. In 1914 he taught drawing at the Scuola Comunale d'Arte Applicata all'Industria della Ceramica in Civita Castellana, where Duilio Cambellotti had formerly worked. He stayed at this school, with a two-year break from 1916 to 1918 for the war, until 1922, when he moved to the Regia Scuola Professionale at Cascina where he remained until the Second World War. His ceramics were shown at the First Exhibition of Decorative Arts in Monza in 1923, in the 'Sala da Studio' and 'Sala della Musica' of the Lazio section designed by his friend Cambellotti. He also took part in the second Monza Biennale and the Exhibition of Fine Arts of the Società degli Amatori e Cultori in Rome in 1926.
Bibliography
Le Arti Decorative, December 1923; 1st Monza Biennale 1923; 2nd Monza Biennale 1925; Marangoni, *Enciclopedia* 1927; Minghetti 1939; Quesada 1988; Quesada 1992; De Guttry, Maino 2003.
(cat. 235)

Zulimo Aretini
(Monte San Savino, Arezzo 1884 – Rome 1965)
Descended from a long line of potters in Monte San Savino, he came into contact with Galileo Chini in the first decade of the century. He worked as a sculptor and modeller at various factories in Sesto Fiorentino, including Richard-Ginori, the Società Ceramica Colonnata, the SIFMA and the SACA. In 1926 the Società Anonima Maioliche Deruta put him in charge of a new factory at Fontivegge, Perugia, the Società Anonima Maioliche Zulimo Aretini, whose production took its inspiration from the popular Tuscan tradition of 'sgraffito' and, to some extent, Balla's Futurist works. Repository of an ancient tradition and a refined technique, he translated it into original works of an archaic and popular tone that were presented to acclaim at the Triennali in Monza and Milan. In 1930 the factory employed sixty workers.
Bibliography
Le Arti Decorative, June-July 1924; *La Cultura Moderna*, August 1924; *Emporium*, August 1924; Marangoni, *Enciclopedia* 1927; Annuario Industrie della Ceramica e del Vetro 1930; Buzzi 1930; 4th Monza Triennale 1930; ENAPI 1933; 5th Milan Triennale 1933; Minghetti 1939; 7th Milan Triennale 1940; *Mostra della ceramica italiana* 1982; Capetta 1990; Bojani 1992; Busti, Cocchi 1998; Ranocchia 1999.

Ars Pulcra
Ceramics factory founded in Turin in 1935 by Bartolo Camisassa. It produced works chiefly of a religious and folk character, distin-

guished by the quality of their execution and their bright colours, that met with a certain amount of success abroad as well.
Bibliography
Minghetti 1939; *Le ceramiche Lenci* 1983; Rosso 1983.

Arte della Ceramica
The Arte della Ceramica was set up in Florence in 1896 (the year Ginori of Doccia was sold to the Milanese Società Ceramica Richard) by four young Florentines, Galileo Chini, Vittorio Giunti, Giovanni Montelatici and Giovanni Vannuzzi, who wanted to do something about what they considered a grave loss for their city. Galileo Chini had already undergone a long period of training as a decorator in his uncle's restoration workshop and was also interested in painting, attending courses, evening schools and, in 1895, the Scuola Libera del Nudo at the Accademia di Belle Arti. The Florentine artistic milieu was fairly up to date with the new modernist tendencies, immediately taken up by the pottery which rapidly managed to acquire an international prestige unmatched in Italy. In the small enterprise, Chini took on the role of artistic guide and designer of the whole output, which consisted initially of majolica vases with decorations inspired by Franco-Belgian Art Nouveau and pre-Raphaelite painting, but not forgetting the Italian tradition. In addition to decorative objects, the factory produced articles of everyday use, such as tea and coffee services, jugs, inkpots and tiles. Shortly after its foundation two of Galileo's relatives, Chino and Guido, joined the pottery, while toward the end of the century a new partner, Count Vincenzo Giustiniani of Ferrara, brought in a large amount of capital that allowed the factory to expand. A few years after it was set up, the Arte della Ceramica achieved important recognition at the exhibitions in which it took part, from the 1898 one in Turin, where it won a gold medal, to the grand prize at the 1900 Universal Exhibition in Paris. At the latter it showed articles that used metal lustre, an ancient technique that had already been revived in the 19th century by Ginori of Doccia and Cantagalli and then spread throughout Europe in the more innovative modernist production. At the Turin Exhibition of 1902 Chini's ceramics were the undisputed stars of the Italian section, with examples of the already established production of majolica painted with floral motifs and women's faces and the first articles in stoneware: these ranged from four large bas-reliefs by Domenico Trentacoste representing the phases in the process of making ceramics to vases with stylized decorations in cobalt blue on a natural grey ground, covered with transparent glaze obtained by the reaction of sodium chloride in the kiln, whence the name of salt-glazed stoneware. To meet the growing demand the factory was moved to more suitable premises at Fontebuoni, near Settignano, where it would be equipped with more up-to-date machinery. The two Chini brothers left the pottery, Galileo in 1904 and Chino in 1905, and in 1909 it closed its doors. In 1906 the brothers founded the Fornaci pottery at San Lorenzo.
Bibliography
Musso 1897–98; Antelling 1898; *Arte Italiana Decorativa e Industriale*, October 1900; Melani 1902; *Emporium*, 1899, pp. 295-98; Aitelli 1901–02; Melani 1902; Pica 1902; *Le Arti Decorative*, September 1925; Ettorre 1936; Vianello 1964; Brosio 1967; Marsan 1971; Marsan 1974; Nuzzi 1977; Cefariello Grosso 1979; Monti 1981; Benzi 1982; Cefariello Grosso 1982; Préaud, Gauthier 1982; Cefariello Grosso 1984; Benzi, Milan 1986; Benzi 1988; Cefariello Grosso 1990; Cefariello Grosso 1993; Bossaglia 1994; Stringa 1995; Benzi 1998; Maldini 1999; Benzi 2001.
(cat. 1-16)

Lina Assalini Poggi
(Savona 1907 – Albisola Marina 2002)
She attended the Scuola di Disegno at Savona and in 1923 was taken on as an apprentice decorator at Nicolò Poggi in Albisola Marina. In 1927 she married Domenico Poggi and in 1929, following the break-up of the firm, became its proprietor. At the Milan Triennale of 1936 she presented a vase inlaid by hand with rustic figures and adorned with applications in relief. After the war she went into partnership with the ceramists Platino, Mantero and Rosso to set up the Ce.As, of which she became the artistic director. The pottery specialized in the 'Ce.As decoration' devised by Poggi, characterized by a matt ground on which were set glossy glazed figures in bright colours, and worked for manufacturers of sweets and liqueurs. She was acquainted with numerous artists, including Fontana and Baj. In 1954 Lina Poggi left the Ce.As and with her husband reopened the old kiln in Via Isola at Albisola Marina. Between the fifties and the sixties she created many one-off pieces. The firm closed down at the end of the seventies, but in 1990 Poggi created, at La Fenice, another large vase inspired by Albisola.
Bibliography
Minghetti 1939; 7th Milan Triennale 1940; Chilosi, Ughetto 1995.

Avallone
Andrea Avallone's factory was active at Vietri from 1888 onwards, employing almost fifty workers and producing crockery on a fairly large scale. Between the end of the twenties and the early thirties Andrea's son, Francesco, made use of the services of Guido Gambone and some students at the Scuola di Ceramica in Faenza, including Dario Poppi. The production was inspired by the styles of the past (emblematic of this is a dish with the motto 'Diana Bella' based on a 15th-century Florentine original) mixed up with elements of the local tradition and the new sensibility brought by the 'Germans'. Characteristic of the production in the twenties and thirties was the decoration in relief with indented edges.
Bibliography
Domus, October 1928; 4th Monza Triennale 1930; Buzzi 1930; 7th Milan Triennale 1940; Napolitano 1989; Romito 1994; Napolitano 1995; Romito, *La ceramica vietrese nel periodo tedesco* 1999; Romito, *La Collezione Camponi* 1999.

Domenico Baccarini
(Faenza 1882–1907)
At the age of twelve he enrolled in the local School of Arts and Crafts run by Antonio Berti. At eighteen he was given a scholarship to attend the Accademia di Belle Arti in Florence, where he studied painting and sculpture, and two years later enrolled in the sculpture course at the Scuola Libera del Nudo. A coterie of very well-known artists formed around him in Faenza. In 1904 he was in Rome, where he got to know the work of Balla and Severini and contributed as an illustrator to the newspaper *La Patria*. Returning to Faenza towards the end of the year, he devoted himself to the modelling of small figures and the decoration of majolica plates and vases for the factory of the Minardi brothers and then the Fabbriche Ceramiche Riunite. Both the statuettes and the sculptural decoration of objects took their inspiration from Art Nouveau and Symbolism. He died of consumption at the age of only twenty-five. The potteries in Faenza for which he had worked went on producing his models for several years.
Bibliography
6th Venice International Exhibition of Art, 1905; Sapori 1926; Marangoni, *Enciclopedia* 1927; Sapori 1928; Minghetti 1939; Dirani, Vitali 1982; Bojani 1977; Contini 1977; *Domenico Baccarini* 1983; Rosso 1983; De Guttry, Maino, Quesada 1985; Castagnoli 1989; Savini 1992; Maldini, Tacchella 1999; Benzi 2001.
(cat. 36-38)

Dante Baldelli
(Città di Castello 1904–1954)
Nephew of Settimio Rometti, he took over from him as director of the ceramics factory at Umbertide in 1928. He attended the Accademia di Belle Arti in Rome, and it was probably here that he met Corrado Cagli, who towards the end of the same year began to work with him on the design of the factory's production, bringing it radically up to date. The collaboration between the two men was very close, so that it is sometimes hard to assign the pieces to one or the other, but it was likely that in this period Baldelli focused chiefly on the forms of the objects. Even after Cagli left in 1930, he still continued to exercise a strong influence on Baldelli's creations. Later on Baldelli's pictorial decorations underwent a progressive stylization that brought them ever closer to abstraction. In these years Baldelli took part in several exhibitions: in 1931 at Perugia, in 1932 at Città di Castello, in a one-man show comprising drawings, posters, paintings, sculptures and about thirty ceramic works. With Rometti he participated in the 1931 Fiera dell'Artigianato in Florence and the Milan Triennale of 1933. The same year the firm went bankrupt and was immediately relaunched as a joint-stock company (SACRU). Baldelli remained the artistic director, but the quality and originality of the production declined, perhaps as a consequence of requirements of a commercial character introduced by new partners, at least as far as the sculptural and decorative objects were concerned, while the services remained at a good level.
Bibliography
Minghetti 1939; Cortenova 1986; Bojani 1992; Barisione 1999; Barisione 2001; Caputo Mascelloni 2005.

(cat. 410, 412, 413, 416, 418, 421, 422, 428-432)

Giacomo Balla
(Turin 1871 – Rome 1958)
Giacomo Balla's encounter with ceramics took place after his publication, with Depero, of the manifesto *Futurist Reconstruction of the Universe* in 1915. His was the first contribution made by a Futurist to this art. His earliest designs were for planters in dynamic shapes and bright colours, but he went on to propose less experimental and avant-garde forms. Only a few of the numerous models were actually made, some by Rocchi in Rome, and some, in 1928, at the kilns of Riccardo Gatti and Mario Ortolani in Faenza for the brand Ceramiche Futuriste G. Fabbri. They included tea services, bowls, plates, vases and tiles that were shown, along with ceramics by M.G. Dal Monte, at an exhibition in Faenza at the end of the same year. In 1929 Fabbri's Futurist production in Faenza was presented at the Exhibition International in Barcelona. In 1929 Galvani of Pordenone brought out a dinner service designed by Balla. His involvement in the design of ceramics continued in the early thirties but came to an end with his estrangement from Futurism in 1937.
Bibliography
Mostra di trentatré artisti futuristi, 1929; Crispolti 1982; De Guttry, Maino, Quesada 1985; Morelli 2002.

Gaetano Ballardini
(Faenza 1878–1954)
A student of ceramics with profound ties to the local tradition of manufacture, Gaetano Ballardini embarked while still a young man on a tireless effort to preserve and make the most of the heritage of Italian pottery. This culminated in the creation of the Museo Internazionale delle Ceramiche in Faenza (1908) and its Scuola di Ceramica (1916). As well as directing the two institutions, and teaching the history of ceramics at the latter, Ballardini edited the journal *Faenza*, founded in 1913, and organized, from 1926 on, the *Permanent Exhibition of Modern Italian Art Ceramics* at the museum. Finally, in 1928, he promoted the 'Inter-university Course in the History of Italian Ceramics'. After the war, during which the museum and its external storehouses were devastated by bombs, Ballardini launched a new campaign for the acquisition of specimens from all over the world.
Bibliography
Emporium, September 1908; July 1923; October 1925; *La Cultura Moderna*, August 1924; Marangoni 1927; *Domus*, May 1931; Minghetti 1939; Liverani 1941; *Stile*, November 1942; Folliero 1957; Korach 1964; Bojani 1989.

Bruno Baratti
(Cattolica 1911 – ?)
At the age of fifteen he entered Pietro Ciccoli's pottery in Pesaro, where the production was similar in style to that of Molaroni. A decorator under the guidance of Achille Wildi, he followed the latter in a short-lived independent enterprise, again in Pesaro. Afterwards he went back to Ciccoli, where he also embarked on an artistic production of his own, with which he participated in the fourth Faenza National Ceramics Competition in 1942. He made ceramics designed by Eugenio Fegarotti for the ENAPI. In the fifties, the potter Nanni Valentini worked in his studio.
Bibliography
Domus, September 1941; Folliero 1957; *Mostra della ceramica italiana* 1982; Bojani 1997.

Barettoni
In 1906, Ludovico Barettoni and Italo Beltrame took over the Antonibon factory, founded at Nove in the 18th century and previously famous for its production of porcelain, abandoned over the course of the 19th century to concentrate exclusively on period majolica ware and earthenware for domestic use. Initially the new management chose to focus on pottery inspired by folk art, such as the well-known plates decorated with cockerels, other birds or fruit painted in vivid and essential brushstrokes. In 1912, the date of Beltrame's retirement, a line of pottery decorated with Art Nouveau transfers was added. The factory also produced majolica ware, drawing on the legacy of the old Antonibon pottery for the forms as well as the glazes. In 1930 the factory employed thirty-seven workers. An innovation came, in the thirties and forties, with the tiles in relief designed by the painter Felice Vellani. In the sixties the decorator Pompeo Pianezzola, known for works of quite of another type, became involved in the continuing production of period pieces, reproducing paintings by Tiepolo and Guardi.
Bibliography
Annuario Industrie della Ceramica e del Vetro 1930; ENAPI 1936; Minghetti 1939; Stringa 1986; Stringa, *Omaggio a Bassano e Nove* 1987; Stringa, *Terre Ferme...* 1987.

Pietro Barillà
(Radicena, Reggio Calabria 1890 – Naples, before 1944)
We don't have many biographical data on the ceramist, in all likelihood of Neapolitan origin. However, there are numerous traces of his activity, as a potter in Calabria and as a teacher at the Museo Artistico Industriale in Naples. As far as the first aspect is concerned we have records of his participation in exhibitions, from the first Monza Biennale in 1923, where his 'figured pottery' adorned the 'refined salon of Calabrian art' (and his place of origin was given as Cittanuova in the province of Reggio Calabria) to the one in 1925, where his 'fine ceramics' and 'vases, figurines in costume and cups decorated with evident reminiscence of country motifs' were shown in the Calabrian section, and lastly that of 1927, where he was said to be based at Radicena and Cerzeto. The catalogue of the same exhibition also referred to his association with the school in Naples, where he was said to teach pictorial decoration and be the head of the ceramics department: in fact Marangoni speaks of the '[...] excellence of the school of Ceramics run by Barillà, who does not limit himself to the vase or the tile, but ventures into architectural composition in the fireplace... in an emerald-green fountain, in a decorative panel'. Some of the works conserved in the Museo Artistico Industriale bear his signature alongside those of his students.
Bibliography
Le Arti Decorative, September 1923; 1st Monza Biennale 1923; *Emporium*, July 1923; 2nd Monza Biennale 1925; 3rd Monza Biennale 1927; Marangoni, *Enciclopedia* 1927; Marangoni, *La III Mostra*, 1927; *La Casa Bella*, June 1928; Minghetti 1939; Caròla-Perrotti 1985; Arbace, in Picone Petrusa 2000.

Barraud Messeri e C., BMC.
In the twenties Giorgio Massari, Nello Messeri and Renato Trallori set up a workshop of painting on alabaster at Colonnata where, at the beginning of the next decade, they began to produce pottery as well. The articles were among the most innovative of those produced by the numerous factories operating in the Sesto Fiorentino area, and in some pieces a very clear stylistic reference to Guido Andlovitz can be discerned. In 1937 Barraud and Messeri closed the factory and with others set up the Arte Ceramica Italiana company, located on the premises of the Società Ceramica Colonnata and active up until the sixties.
Bibliography
7th Milan Triennale 1940; *Mostra della ceramica italiana* 1982; Rosso 1983; Capetta 1990.

Renato Bassanelli
(Civita Castellana 1896 – Rome 1973)
He attended the Scuola di Ceramica at Civita Castellana. After a short experience in local factories at the end of the First World War he moved to Rome and opened a workshop close to the Tarpeian Rock, where he commenced, under the name of Keramos, a production of art ceramics of notable technical and aesthetic quality that comprised vases, some of large dimensions, plates, tiles and services. They were distinguished by the use of strong and contrasting colours, primarily yellow and blue, and the complexity and variety of the decorations, on landscape and floral themes with animals and mythological creatures like nymphs and fauns. He won a gold medal at the first Roman Exhibition of Industry, Agriculture and Applied Arts in Villa Borghese. –His contacts with the ENAPI paved the way for the export of his ceramic ware, especially to America. In 1928 the factory was forced to close because of the demolitions in the area of the Capitol and Bassanelli moved to Biella, where he set up the SACB, Società Anonima Ceramiche Biellesi. In 1930 he was back in Rome and the same year took part in the ENAPI section of the Monza Triennale with some vases designed by Tomaso Buzzi. In 1933 he showed at the new Milanese venue of the same exhibition with ceramics designed by Angelo Biancini, while in 1936 and 1940 he participated in the Florence Crafts Exhibition. With respect to the previous decade, Bas-

sanelli dispensed almost completely with painted decoration in favour of a greater variety of forms and relief decorations. He also made small sculptures, mostly of animals along with portraits of women in white or green monochrome. In those years he also worked for government bodies in an educational and institutional capacity. For two years from 1948 he ran the Industria Ceramica Umbra at Città di Castello, and over the next two years was in Viterbo, at the Ceramiche Bassanello. At the end of this experience, he spent the following twenty years making one-off pieces in his Roman workshop.
Bibliography
Le Arti Decorative, February 1925; Marangoni, Enciclopedia 1927; Domus, October 1930; Arte Decorativa 1931; Domus, June 1933; ENAPI 1933; Minghetti 1939; Frattani, Badas 1976; Rosso 1983; Quesada 1988; Quesada 1992; Benzi 2001; De Guttry, Maino 2003.
(cat. 236-239)

Umberto Bellotto
(Venice 1882–1940)
Known for his wrought-iron work, Umberto Bellotto tried his hand at pottery too from the mid-twenties on. First he frequented, like Cadorin, Giacomo Dolcetti's Bottega del Vasaio and the Benedettelli kiln in Venice, and then designed some ceramic ware, manufactured by the SPADA factory at Ascoli Piceno and presented at the Monza Biennale in 1927. Over the following decade he produced a series of plates in a popular style at Giulio Guerrieri's workshop.
Bibliography
3rd Monza Biennale 1927; Papini 1927; La Casa Bella, September 1929; Stringa, L'arte decorativa... 1987.

Nello Beltrami
(Fornero, Novara 1899 – ?)
A sculptor, he was a pupil of Edoardo Rubino and came under the influence of Arturo Martini in the thirties. Over the same period he made a number of models for Lenci. He won an ENAPI award at the Triennale in 1930 and showed a small bronze at the Venice Biennale in 1932.
Bibliography
ENAPI 1930; Proverbio 1979; Le ceramiche Lenci 1983; Panzetta 1992.

Benedettelli
In 1921 Adriano Benedettelli (Venice 1883–1930), formerly a cabinet-maker and manufacturer of tin toys, set up a ceramics factory called Benedettelli & C. in Venice with his brother Adrio and some other partners. In 1922 Enrico Caccia Guerra worked there. The production was initially historicist or, at the most, late-Art Nouveau, but the workshop was also frequented by artists, including Flavio Poli, Guido Cadorin, Umberto Bellotto and Teodoro Wolf Ferrari, several of whose designs for vases have been preserved. It took part in the first Monza Biennale ('Conversation room for the high-class residence', section of the three Venetias) with pottery designed by the sculptor Battistin. In 1925 Giovan Battista Vorano made an injection of capital and the factory's name was changed to Benedettelli Succ. Vorano. In 1929 it was taken over by the ceramist Giovanni D'Arcangelo.
Bibliography
1st Monza Biennale 1923; Carrà 1923; Stringa, L'arte decorativa... 1987.

Romeo Berardi
(Rome 1882–1961)
He very soon entered an artistic partnership with Duilio Cambellotti, with whom he began to work in 1910, on the execution of the frieze on the outside of Villino Vitale. He started to devote himself to ceramics around 1912. It is likely, but not certain, that he worked with the Treia kiln set up by the Roman gallery owner Giuseppe Sprovieri and frequented by Virgilio Retrosi and Roberto Rosati, who were also pupils of Cambellotti. He taught alongside the latter at the Istituto San Michele in the capital where the students produced pottery under the factory marks RINIP and TAI. Vases by Berardi, decorated with motifs of the Roman countryside so dear to his master, were included in Cambellotti's one-man show held at Maria Monaci Gallenga's Bottega d'Arte Moderna Italiana in 1921. His last documented appearance at an exhibition was in 1926, at the one staged by the Società degli Amatori e Cultori di Belle Arti, in the 'Room of the Sea' of the Lazio section.
Bibliography
Quesada 1988; Quesada 1992; De Guttry, Maino 2003.
(cat. 45, 46, 50, 240)

Clelia Bertetti
(Turin 1904–1995)
She attended the Accademia Albertina in Turin and the academy in Florence, where she studied under Guido Calori. From 1927 on she collaborated on the design and production of ceramics at Lenci, where she was also in charge of the retouching department. In 1929 one of her vases was shown at the exhibition, organized by the Galleria Pesaro in Milan, that marked the success of the Turinese factory. In 1931 she stopped working with Lenci and, the following year, opened a business of her own, Le Bertetti, which was the first of a series of small potteries set up by the company's employees or collaborators. The workshop produced ceramics in series, chiefly female nudes, as well as one-off pieces in glazed terracotta, mostly of religious subjects, presented at several exhibitions. She participated in the ENAPI Exhibitions at the Milan Triennali of 1936 and 1940. In 1942 she sold the factory to devote herself exclusively to sculpture.
Bibliography
Ceramiche di Lenci 1929; Domus, May 1935; ENAPI 1936; Minghetti 1939; ENAPI 1940; Mostra della ceramica italiana 1982; Le ceramiche Lenci 1983; Rosso 1983; Panzetta 1992.
(cat. 374)

Lino Berzoini
(Ficarolo, Rovigo 1893 – Albisola 1971)
He attended the courses of painting at the Accademia Albertina in Turin, where he had moved after the First World War. He joined Lenci in the early years of the factory's activity, when it mainly produced dolls. With the beginning of the production of ceramics in 1928, Berzoini devoted himself with growing interest to this art before moving on, in 1936, to the more engrossing experience at the Mazzotti factory in Albisola, for which he had already supplied numerous models. The collaboration with the Ligurian pottery continued until 1939 and resulted in one-off pieces personally modelled by the artist as well as pieces mass-produced by casting. At the beginning the subjects, many of them female nudes, were influenced by the Lenci factory, but then moved closer to the sculptures of Lucio Fontana. In the meantime Berzoini had continued to paint, frequenting Casorati and the Turinese Futurist movement. In 1930 he took part in the Exhibition of the Friends of Art Association with the Futurists Diulgheroff, Tullio d'Albisola and Gaudenzi, also collaborators of Mazzotti and, from 1938 to 1942, showed paintings at the Venice Biennale on three occasions. In 1940 he presented a series of animals, with Bianco, at the Milan Triennale and, in 1943, won a prize in the Faenza competition for the ceramic work entitled Fish. After the war, he worked for the Giuseppe Barile factory.
Bibliography
Ceramiche di Lenci 1929; Minghetti 1939; 7th Milan Triennale 1940; Domus, September 1940; Lino Berzoini 1965; Proverbio 1979; Mostra della ceramica italiana 1982; Le ceramiche Lenci 1983; Rosso 1983; Lino Berzoini 1988; Panzetta 1992; Chilosi, Ughetto 1995; Chilosi, in Museo d'Arti Applicate 2002.

Paolo Bevilacqua
(Palermo 1894–1938)
The activity of Paolo, who worked with his wife Vittoria Lo Iacono in the decorative arts, and his brother Alberto in the field of the design of ceramics is documented in connection with the Monza Triennale of 1930, where they were present, with Pippo Rizzo, as designers for the Coniglione factory in Catania, and by several pieces for the Caltagirone school. In May 1930 the magazine Domus published four plates made by Alberto for the Triennale, decorated in high-fire glaze with scenes of strange horsemen and slender gazelles and original abstract patterns on the rim.
Bibliography
Le Arti plastiche, April 1930; Buzzi 1930; Domus, May 1930; Emporium, November 1930; 4th Monza Triennale 1930; Ruta 1985; Ragona, in Museo d'Arti Applicate 2002.

Romeo Bevilacqua
(Florence 1908 – Savona 1958)
He moved with his family to Albisola in 1919 and, at the age of just seventeen, was director of a small pottery called Landa, opened in 1925 and active for only two years. Around 1930 he went to work at Mazzotti, where he executed designs by Prampolini and Tato, among others, as well as works of his own, such as decorations of plates that translated Futurist dynamic decomposition in an original way (Billiards Player, Motorcyclists) and small sculptures, some of them caricatures. In 1936 he became artistic director of La Fenice, where produced mostly ceramic plates painted with Futurists themes (Motorcyclist, Racing Car, Airscrew), high reliefs (The Avantgardist) and small sculptures (The Sower). After these experiences the ceramist went back to the interpretation of styles of the past, developing a version of his own that is known in Albisola as the

237

'Romeo style'. In 1952 he made an amphora over four metres high for the Loggia Longhena in Vicenza, with a representation of the *Last Judgment* updated in the manner of leading artists of the time.
Bibliography
Minghetti 1939; Folliero 1957; Crispolti 1982; *Mostra della ceramica italiana* 1982; Rosso 1983; Chilosi, Ughetto 1995; Barisione 1999; Barisione 2001.

Alfredo Biagini
(Rome 1896–1952)
He studied architecture and sculpture and attended anatomy courses in Paris. In 1912 he won the ministerial competition for the Artistic Bursary of Decoration with two plaster bas-reliefs in a classicizing style. The following year he designed plates and other objects in majolica with complicated polychrome decorations turning on female nudes or mythological themes for Minardi of Faenza. In 1915 and 1916, he took part in the exhibitions of the Roman Secession with works that bore witness to his talent as a sculptor of animals, something that was reaffirmed at the *Exhibition of Youthful Art* held on the Pincio in 1918 and at the Rome Biennale of 1921, where he showed a series of majolica works with high-fire glaze representing for the most part domestic and exotic animals. In 1923 he showed at the first Monza Biennale, in the Roman section organized by Duilio Cambellotti, and the same year one of his *buccheri* was presented at the second Rome Biennale. In 1924 and 1926 he exhibited bronzes at the Venice Biennale. In the second half of the twenties he produced refined decorations in a variety of materials for the Ambasciatori Hotel, the Quirinetta Theatre and the Barberini Cinema in Rome, the first and the last to designs by Marcello Piacentini. In 1930 he organized the first *National Exhibition of the Animal in Art* at Rome Zoo, where he showed eight sculptures, including the majolica *Serval*. At the 1936 Venice Biennale a room was dedicated to him, with sculptures in bronze and terracotta. Towards the end of the decade he began to devote himself almost exclusively to religious themes and the creation of works for places of worship, like the doors of St Peter's, for which he won the competition after the war with Giacomo Manzù.
Bibliography
Emporium, June 1921; *Opere di A. Biagini* 1954; Benzi 1983; De Guttry, Maino, Quesada 1985; Terraroli 1988; Quesada 1988; Quesada 1992; Benzi 2001; De Guttry, Maino 2003.
(cat. 241-245)

Angelo Biancini
(Castelbolognese 1911–1988)
He studied at the Scuola d'Arti e Mestieri in Imola and then the Istituto d'Arte in Florence, where he followed the course taught by Libero Andreotti. His first important accomplishment was the statue of the *Victorious Athlete* in Rome's Stadio dei Marmi, in 1933, but at the same time he was making ceramic statuettes with Renato Bassanelli that were shown at the Milan Triennale of 1933. In 1934 and 1936 he took part in the Venice Biennale, and over the same period produced designs for ceramics for the ENAPI, executed and presented at the 1936 Triennale by Mario Morelli from Faenza (*Head of a Girl*), which anticipated, with their decoration in relief, the ones that the sculptor would make for the SCI when he moved to Laveno in 1937 to collaborate with Guido Andlovitz. In 1938 he showed some of his works in Faenza, while at the Milan Triennale in 1940 he exhibited the large high relief in several pieces *Orpheus in the Wood*, the sculptures *Actaeon and Diana* and several garden vases. Beside mythological figures, the preferred subjects of his works, both in the round and in relief, were animals (*Duck with Ducklings*, *Horse*, *Turbots*), putti in playful poses (*Singing Putti*, *Putto with Goose*, *Spring*, *Agriculture*) female figures (*The Four Seasons*, *Plenty*, *Water-carrier*, *Reaper*, *Fortuna*), portraits (*Little Girl from Laveno*, *Maria Grazia*) and religious themes (*Flight into Egypt*, *Crèche*, *Our Lady of Sorrows*). To enhance the sculptural effect of his pieces Biancini preferred crackled monochromatic glazes. For the 1940 Triennale the SCI made several large garden statues, around two metres high, to Biancini's designs, including the *Water-carrier*, illustrated in *Domus*. In 1940 the sculptor ended his collaboration with the SCI and returned to the Faenza milieu for good. In 1941 he won the National Ceramics Competition with the large sculpture *The Legionary's Mother*, and would go to win other Faenza prizes in 1946 and 1957. In 1943 he began to teach plastic art at the Istituto d'Arte per la Ceramica, where went on working until 1981. A one-man show was dedicated to him at the Venice Biennale in 1958.
Bibliography
ENAPI 1933; *Domus*, June 1933; *Domus*, December 1936; *Emporium*, August 1936; ENAPI 1936; Pagano 1938; *Domus*, December 1939; Minghetti 1939; *Emporium*, May 1940; *Domus*, September 1941; Folliero 1957; Morazzoni 1957; Frattani, Badas 1976; *Angelo Biancini* 1980; *Mostra della ceramica italiana* 1982; Rosso 1983; Gallina, Sandini 1985; Castagnoli 1989; Cefariello Grosso 1990; Bojani 1993; Mingotti 1994; Ausenda 1998.
(cat. 338-352)

Bianco, Bartolomeo Tortarolo
(Celle Ligure 1906 – Albisola Marina 1978)
In the mid-thirties, Bartolomeo Tortarolo called Bianco worked at Mazzotti in Albisola, creating a series of animals. In 1937, following a disagreement with Tullio Mazzotti, he and Umberto Ghersi set up their own workshop on Mazzotti's former premises at Pozzo della Garitta, continuing to make animals that would be a success when presented at the Milan Triennale of 1940. In 1946 he founded the SOESCO with Ghersi and other partners at the old Piccone site in Albisola Marina. De Salvo collaborated with the company, but after a few years it went bankrupt and Bianco ran the kiln at Pozzo della Garitta by himself. It was frequented by numerous artists, including Fontana, Fabbri, Broggini, Scanavino and Luzzati. Alongside animals, Bianco made interesting vases based on marine themes.
Bibliography
Minghetti 1939; Chilosi, Ughetto 1995.

Umberto Bottazzi
(Rome 1865–1932)
With Vittorio Grassi, he designed and built a small house for the National Architecture Competition in 1911, now destroyed, in which ceramic facings were utilized that had been made to the two architects' design by Richard-Ginori and the Fornaci di San Lorenzo. Very active in the design of artistic stained-glass for Cesare Picchiarini, he also collaborated with Richard-Ginori, designing a group of ceramic works that were shown at the Venice Biennale in 1912, along with other models by Aleardo Terzi, Vittorio Grassi and Giovanni Maria Mataloni.
Bibliography
De Guttry, Maino, Quesada 1985; Quesada 1988; Quesada 1992; De Guttry, Maino 2003.

Bottega d'Arte Ceramica,
see Federico Melis

Fred Brown
(1891–1979)
A collaborator at Richard-Ginori between 1930 and 1936, we have no information on his origin and training. At the Monza Triennale of 1930 the factory presented a collection of celadons attributed to him. In 1933, at the Milan Triennale, he exhibited porcelain vases with flame-red glaze and the *Silvana* tea service in fine gold and green, salmon pink and powder blue glaze. At the 1936 Triennale, he organized Richard-Ginori's exhibition (in the catalogue he is described as 'Head of the Company's Art Department').
Bibliography
Reggiori 1930; 4th Monza Triennale 1930; 5th Milan Triennale 1933; *Domus*, May, August 1933; *Domus*, January 1934; *Domus*, January 1935; 6th Milan Triennale 1936; Papini 1936.

Bubani
In 1909 Ugo Bubani (Faenza 1872–1941), secretary of the Workers' Association of Faenza, took the initiative of setting up a Ceramic Workers' Cooperative to carry on the activity of the former Ferniani factory, founded in the city at the end of the 17th century. The artistic director was the painter Minghetti. The factory in Faenza continued to expand its activity until the First World War. In the twenties it began also to produce period pieces, drawing on local forms and decorations from the 15th and 16th centuries. In 1928 a line for the production of facing tiles was introduced, but its high costs, combined with the unsatisfactory quality of the products, resulted in the bankruptcy and sale of the pottery at a time when it employed just over twenty workers.
Bibliography
Le Arti Decorative, September 1923; *Le Arti Decorative*, June-July 1924; *La Cultura Moderna*, August 1924; *Emporium*, October 1924; *Le Arti Decorative*, August 1925; 2nd Monza Biennale 1925; *Emporium*, September, October 1925; *Opere scelte* 1925; Buscaroli 1926; 3rd Monza Biennale 1927; Marangoni, *Enciclopedia* 1927; *Annuario Industrie della Ceramica e del Vetro* 1930; Monza Triennale 1930; *Emporium*, December 1933; Minghetti 1939; Folliero 1957; Dirani, Vitali 1982; Bojani, Morganti 1989; Dirani 1991; Savini 1992; Cimatti 1995; Ravanelli Guidotti, in *Museo d'Arti Applicate* 2002.

Anselmo Bucci
(Faenza 1887–1959)
He entered a ceramics workshop while still very young. At the age of fourteen he began to attend Antonio Berti's Scuola d'Arte e Mestieri, where his fellow students included Pietro Melandri, Riccardo Gatti, Giovanni Guerrini and Aldo Zama. The following year he started work at the Minardi brothers' factory, which in 1913, following the death of Virgilio Minardi, was transformed into a company run by its former workers, Bucci among them. After the war, Achille Calzi offered him the chance tobe come his partner in a workshop. On Calzi's death in 1919, he commenced a collaboration with the new Ceramics School in Faenza, where he worked alongside the artistic director Domenico Rambelli, taking responsibility for the workshops. At the same time he carried out independent research in his studio, experimenting at length with techniques like metal lustre and producing a limited number of works, often in collaboration with others: in particular Francesco Nonni who, after ending his partnership with Melandri, made his models here and entrusted Bucci with their decoration. He also worked with the architect Ennio Golfieri, the sculptor Ercole Drei and the ENAPI designer Giovanni Guerrini. His prolific activity was interrupted by war again, only to be resumed in 1946 in a new workshop.
Bibliography
2nd Monza Biennale 1925; *Opere scelte* 1925; Sapori 1925; 3rd Monza Biennale 1927; Marangoni, *Enciclopedia* 1927; *Faenza* 1928, issue VI; *La Casa Bella*, December 1928, September 1929; ENAPI 1930; Guigoni 1930; Reggiori 1930; *Arte Decorativa* 1931; ENAPI 1933; 5th Milan Triennale 1933; *Domus*, June 1933; ENAPI 1936; ENAPI 1938; Minghetti 1939; 7th Milan Triennale 1940; *Domus*, May, September 1941; Folliero 1957; Frattani, Badas 1976; Crispolti 1982; *Mostra della ceramica italiana* 1982; Dirani, Vitali 1982; Bojani, Morganti 1989; Bojani 1990; Savini 1992; Ravanelli Guidotti, in *Museo d'Arti Applicate* 2002.
(cat. 66, 71, 289-291)

Tomaso Buzzi
(Sondrio 1900 – Milan 1981)
Graduating in architecture at Milan in 1923, he opened a studio the following year and in 1927 formed the group Il Labirinto with his friends Gio Ponti, Emilio Lancia, Michele Marelli, Pietro Chiesa and Paolo Venini, for which he designed pieces of furniture and furnishings, including ceramics. He worked with Ponti on the design of the centrepiece for embassies presented by Richard-Ginori at the Monza Biennale of 1927. For the Triennale of 1930 he designed the spectacular display of the Ceramics Gallery, made up of twelve rooms, which was warmly received by the critics. In 1933 he was again responsible for the Ceramics Gallery at the Triennale, and also showed several pieces of his own design (*Sea of Ulysses* and *The Trojan Horse* plates) and a centre for a fountain executed by the Milanese ceramist Aldo Zerbi. Other ceramic pieces he designed for the ENAPI were made by Anselmo Bucci, Bassanelli and the ILSA.
Bibliography
3rd Monza Biennale 1927; *Domus*, November 1928; Buzzi 1930; Pacini 1930; Reggiori 1930; 4th Monza Triennale 1930; *Domus*, October 1933; Milan Triennale 1933; ENAPI 1936; Minghetti 1939; Frattani, Badas 1976; *Annitrenta*, Milan 1982; Terraroli, *Milano Déco* 1998; Ausenda, Milan 1998; Ausenda, in *Museo d'Arti Applicate* 2002.

Giuseppe Cacciapuoti
(Naples 1828–1888)
Born into a family of Neapolitan makers of majolica ware, he began his activity in Naples in 1877. He was present at the Turin Exhibition in 1880, where his original creations in painted terracotta, made up of groups of figures or vases with decorations in relief, aroused interest. His sons Ettore and Guglielmo, who worked for a while at Richard in Milan, continued their father's activity, specializing in the production of statuettes and bas-reliefs in Neapolitan costume. Another son, Cesare, opened a factory of artistic terracottas where among other things he executed sculptures for Vincenzo Gemito. In 1927 Cesare's sons Guido and Mario opened a ceramics factory in Milan.
Bibliography
Musso 1897; Minghetti 1939; Rosso 1983; Ruju, Alamaro, Caròla-Perrotti 1984; Melegati 1988; Arbace, Stringa 2000.

Guido and Mario Cacciapuoti
(Naples 1892 – Milan 1953; Naples 1890 – Milan 1930)
Descendants of a family of Neapolitan makers of majolica ware, they moved to Treviso in 1907, where the former initially collaborated with Lazzar & Marcon, supplying models for sculptural groups. On the factory's closure, in 1915, he and his brother opened a workshop specializing in the production of sculptures, at first one-off pieces and then small series, in natural and glazed terracotta. While Mario concentrated on figures or groups in 18th- to 19th-century style, Guido distinguished himself as a modeller of animals. The workshop in Treviso was frequented by other sculptors, including Arturo Martini who brought Guido into the Ca' Pesaro group, where he presented several pieces as early as 1913. In 1915 he took part in the *Exhibition of the Art of Treviso* organized by Martini and in 1920 showed two works at the Venice Biennale. In 1927 the brothers moved to Milan, where they founded the Grès d'Arte Cacciapuoti, Bignami e C. with Angelo Bignami, continuing the production of animal figures modelled and painted in a naturalistic manner. In the thirties, alongside this traditionalistic production, which also comprised figures from history and in 18th- or 19th-century dress, the factory began to make pieces of more contemporary taste, in particular profiles of women. The factory remained active until 1982.
Bibliography
Minghetti 1939; *Mostra della ceramica italiana* 1982; Stringa, *L'arte decorativa*...1987; Melegati 1988; Ausenda 1998; Maldini 1999; Arbace 2000.
(cat. 444, 445)

Guido Cadorin
(Venice 1892–1976)
The Venetian painter had first come into contact with ceramics within his own family, since his father Vincenzo used to collaborate with the G.B. Viero pottery in Nove. From 1908 to 1910, he showed painted dishes at the exhibitions of designs held at the Lido, in 1912 he presented a series of plates with caricatures at the *Exhibition of Humorous Art* in Treviso and in 1914 he showed ceramics at the exhibition of the 'rejected' at the Biennale. After the war he worked with the Giacomo Dolcetti's Bottega del Vasaio, producing majolica ware that was influenced by the folk tradition as well as that of the Venetian Renaissance. He also went on to collaborate with the Benedettelli factory in Venice and other potteries at Nove, on the production of painted plates.
Bibliography
8th Venice International Exhibition of Art 1909; 13th Venice International Exhibition of Art 1922; Carrà 1923; Mezzanotte 1923; Minghetti 1939; *Mostra di Guido Cadorin* 1968; Marchiori, Gardin 1968; Stringa, *L'arte decorativa*... 1987; *Terre Ferme*... 1987; Stringa 1995; *Venezia e la Biennale* 1995.

Corrado Cagli
(Ancona 1910 – Rome 1976)
He attended the Accademia di Belle Arti in Rome. At the end of 1928 he went to Umbertide, probably called there by Dante Baldelli whom he had met at the academy, to work in the Rometti ceramics factory. The first works produced by the artist from Ancona at Rometti were pieces representing figures like *The Holy Man* and *Aeolus*, in *nero di Fratta*, a glaze typical of this pottery. Along with the influences of Martini and Wildt, they introduced elements of the Art Deco style. At the end of 1929 Cagli exhibited in Rome with Balla, Dottori, Fillia and Prampolini and this move towards Futurism can also be discerned in the work he did for Rometti, especially in the painted plates and vases designed by the artist in the last year of his collaboration, 1930, characterized by dynamic grounds of concentric circles on which figurative themes favoured by the Fascist regime, like the *Battle for Grain* and *March on Rome*, alternated with more traditional ones linked to work, sport and hunting. He left Rometti at the end of the year, officially for health reasons, but the Umbrian factory went on producing his pieces for two years. For the Milan Triennale of 1933 he executed the mural *Harbingers of War* and, for the one in 1936, the *Battle of San Martino*. In 1938 racial persecution forced him to leave Italy for France and then the United States. He returned to Italy at the end of the war.
Bibliography
5th Milan Triennale 1933; 6th Milan Triennale 1936; Cortenova 1986; Cortenova 1989; Bojani 1992; Barisione 1999; Barisione 2001; Ruiz de Infante 2002; Caputo Mascelloni 2005; Prisco 2006.
(cat. 411, 415-420, 423-425, 427)

Calò
Factory active at Grottaglie between 1910 and 1953 with a production, some of it exported, documented by a number of rustic and traditional pieces in Faenza's Museo delle Ceramiche. The pottery also developed new and eclectic forms. In 1930 it employed twenty-five workers. Cosimo Calò was head of the Nove Art School

from 1938 to 1941 and the one in Grottaglie from 1949 to 1954. At the first Monza Biennale of 1923 Carlo Calò showed some black ceramic pieces of archaeological inspiration.
Bibliography
1st Monza Biennale 1923; *Annuario Industrie della Ceramica e del Vetro* 1930; Minghetti 1939.

Achille Calzi
(Faenza 1873–1919)
Son of a skilled decorator in Faenza, Giuseppe Calzi, he attended Antonio Berti's School of Arts and Crafts and then A. Burchi's school in Florence, where he qualified as a teacher of industrial and artistic design. In 1905 he became artistic director of the Fabbriche Riunite Faentine, with which he won a gold medal at the Simplon Exhibition in Milan in 1906. The production, for which he designed the forms as well as the decorations, was partly a reworking of styles of the past and partly new in conception. He held the post until 1908, when he succeeded Antonio Berti as principal of the School of Arts and Crafts. He was involved in setting up a majolica factory for the 1911 Handicrafts and Ethnographic Exhibition in Rome. In 1917 he opened a workshop, which he called Ex Arte Dominicis De Calcis, with Bucci, excellent executor of his ceramic designs, based very freely on the Faenza tradition. In 1918, the workshop played host to Arturo Martini, in Faenza to perfect his ceramic technique, who modelled several objects that were then reproduced in ceramics by Calzi. On Calzi's death, Bucci did not take up his widow's offer to carry on the business and the workshop was closed. It was later taken over by Pietro Melandri.
Bibliography
Marangoni, *Enciclopedia* 1927; Minghetti 1939; *Mostra di Achille Calzi…*1968; Dirani, Vitali 1982; Bojani 1991; Savini 1992.
(cat. 40)

Duilio Cambellotti
(Rome 1876–1960)
His family was of Tuscan origin, but Duilio was born in Rome and served his early apprenticeship in the carving and decorating workshop of his father Antonio. From 1893 al 1896 he followed the course of decoration in painting and design applied to the artistic industries at the Museo Artistico Industriale. His great passion for sculpture did not prevent him from devoting himself to the design of household objects, as well as to commercial art and the illustration of magazines and books, especially for children, and to set design. He made his first bronze vases with figures of animals, horses, buffaloes and bulls in 1903, but it was ceramics that brought him closer than any other art to his love for the land. His first works in terracotta date from the last years of the 19th century, and towards the end of the first decade of the 20th century the medium became a habitual one, commencing with the decoration of articles of everyday use, chiefly bowls whose inside was entirely taken up with drawings of animals, sometimes on spiral and speckled grounds traceable to the influence of Galileo Chini, whom Cambellotti met in 1907. In 1908 he started to teach modelled ornamentation at the Museo Artistico Industriale, in 1918 renamed the Regio Istituto Nazionale per l'Istruzione Professionale (RINIP), where he would produce ceramics with the collaboration of Fernando Frigiotti, an expert on *buccheri*, and Romeo Berardi, Virginio Retrosi and Roberto Rosati. The central role played by teaching in his career and life is also attested by his association with the Scuole dell'Agro Romano from 1904 on and with courses of applied arts for women and workers at the Scuola Comunale d'Arte in Civita Castellana between 1910 and 1915 and at the Accademia di Belle Arti from 1930. In 1911, on the occasion of the celebrations for the fiftieth anniversary of the unification of Italy staged in Rome, he took part in an exhibition on the countryside around the city, for which he designed a large hut in which rustic furniture and farm implements where mixed up with works by himself and Giacomo Balla. In 1920 his ceramics were shown at an exhibition in Ferruccio Palazzi's studio in Piazza Venezia along with works by Mauzan, Cellini and Rosati. In 1921 he held a one-man show of bronzes and ceramics (*Bowl with Hands*, *Cybele*) at Maria Monaci Gallenga's Bottega Italiana in Via Veneto, Rome. Gallenga, who in 1928 would open a branch of her shop in Paris, was also responsible for the diffusion of his works abroad. In 1922 he participated in the exhibition of the Società degli Amatori e Cultori di Belle Arti with works in bronze, plaster and ceramics (*bucchero* vases *The Suckling Pigs*, *The Crows*). In 1923 he headed the Roman contribution to the Biennale of Applied Arts in Monza, presenting a study complete with furniture, hangings, bronzes and pottery (*Vase with Swallows*) that was awarded the grand certificate of honour. At the next Biennale, in 1925, he exhibited not only stained-glass and furniture but also *bucchero* (*Vase of the Zodiac*, *The Cowherd*) and majolica ware (*Vase of the Fishing Smacks*) executed at the RINIP and sculptures like the *Magister equitum*. His most ambitious decorative undertaking was carried out in 1931, in the office building of the Puglia Waterworks at Bari, of which he designed every detail, from the floors to the stained-glass windows and from the lamps to the furniture, all inspired by the motif of water. In the mid-thirties at Vetralla, a small town near Viterbo where a widespread tradition of popular ceramics had been preserved, he produced works in painted and glazed terracotta based on the forms, decorations and colours of the local production. The artist went on working intensely up until the last years of his life, which were devoted chiefly to sculpture, mural painting, graphic and set design and teaching.
Bibliography
Emporium, January 1921; *Emporium*, July 1923; *Le Arti Decorative*, September, December 1923; Sapori 1923; *Le Arti Decorative*, May, September 1925; *Emporium*, September 1925; Marangoni, *Enciclopedia* 1927; Folliero 1957; *Mostra della ceramica italiana* 1982; De Guttry, Maino, Quesada 1985; Quesada 1988; Castagnoli 1989; Castagnoli 1990; Quesada 1992; Bossaglia 1994; Bonasegale, Damigella, Mantura 1999; Benzi 2001; Morelli 2002; Tetro 2002; De Guttry, Maino 2003.
(cat. 49, 246-252, 436)

Cantagalli
Ulisse Cantagalli (Florence 1839 – Cairo 1901) was heir to an ancient tradition of Florentine potters. Around the middle of the 19th century the family kiln produced bricks for building and glazed crockery, but later, under the direction of Ulisse, the production of majolica ware based on Italian Renaissance models came to predominate. These objects were particularly in demand by British and American visitors and collectors, like Drury E. Fortnum, Frederick Stibbert, Herbert Horne and Bernard Berenson with whom Ulisse Cantagalli established lasting relations, facilitated by his marriage, in 1880, to Margaret Tod, daughter of a businessman from Edinburgh. The famous English potter William De Morgan also frequented the Cantagalli workshop, appreciating its skill in the creation of lustreware in particular. In 1878 the factory showed at the Universal Exhibition of Paris. At the Italian Exhibition held in London in 1888, Ulisse met William Morris, while many pieces were acquired by the South Kensington Museum. The factory was present at Paris again in 1889, at Brussels in 1897, at Turin in 1898 and once more at Paris in 1900. Alongside crockery, Cantagalli produced tiles and glazed earthenware in the Della Robbia style. Towards the end of the century, the factory employed 121 people and published an illustrated catalogue with colour photographs of around a thousand articles, complete with measurements and prices, which it guaranteed to be made by hand. Historicism of Renaissance derivation and exoticism, freely inspired by Persian, Japanese and Hispano-Moorish ceramics, were the dominant styles. Ulisse Cantagalli died in Cairo in 1901. His widow and children, especially Flavia, a pupil of the Macchiaiolo painter Eugenio Cecconi, carried on the business, bringing in artists like Adolfo De Carolis as collaborators. At the Turin Exhibition of 1902, whose rules excluded imitations of the past, the pottery showed a large panel representing two cocks surrounded by ears of grain and corn poppies set in the pediment of the Palazzina del Lauro and with a facing of majolica tiles made to designs by Cecconi. The rustic and plant themes adopted by several vases also on display denoted a move in the direction of Art Nouveau, although the greater part of the production continued to imitate Renaissance models, present again at the Turin Exhibition of 1911 and in the new catalogue of 1913. The collaboration with Guido Balsamo Stella began in 1921, while the one with Antonio Maraini dated from two years earlier. In 1923 Carlo Guerrini, a teacher at the nearby Art School, became artistic director and designed a set of apothecary's jars, vases, bowls and services exhibited at the first Monza Biennale, alongside articles designed by Guido Balsamo Stella and Antonio Maraini. The factory went on to participate in the exhibition at Pesaro of 1924, the Paris Expo of 1925 and the subsequent Monza Biennali. At the time of Margaret Tod's death in 1930, it employed around a hundred people. The catalogue of reproduction pieces was almost

completely eliminated; Margaret's daughter Flavia and her husband Neri Farina Cini promoted a shift towards neoclassicism, advocated by the regime, through the interpretations of Romano Dazzi, Maurizio Tempestini, Giovanni Vagnetti and Amerigo Menegatti. At the Monza Triennale of 1930 Cantagalli was present with a 'map of Italy' by Vagnetti and large 'Roman-style' vases by Dazzi. Commercially, however, the company was encountering serious difficulties, partly overcome by generous financial support from Marchesi Niccolò and Carlotta Antinori and a reorganization of management and technology carried out in 1932 by the British expert Aubrey Adam with the help of a technician from Karlsruhe, Müller von Bazsko. At the Milan Triennale in 1933 Cantagalli showed several pieces in majolica (panels dedicated to the arts, small fountains and sculptures) by Dante Morozzi that won the grand prize. But the difficulties continued and the factory, entrusted to Amerigo Menegatti in 1934, was obliged to lay off workers and cut down its activity. In 1936 the management of Cantagalli was placed in the hands of the Melamersons from the ICS in Vietri, who brought Guido Gambone with them to Florence, where he remained active at Cantagalli until 1939. The new management also withdrew, and was replaced in 1940, again with little success, by the Consorzio Italiano Maioliche Artistiche of Deruta. Other attempts to salvage the business followed, while the factory continued to operate, without making much impact, until 1987. In 1983 the Museo della Ceramica in Faenza acquired the stock of tracings, drawings tinted with watercolour, photographs and other paper materials utilized by the Florentine pottery.

Bibliography
Musso 1897–1898; *Arte Italiana Decorativa e Industriale*, November 1898; *Arte Italiana Decorativa e Industriale*, December 1900; Pica 1902; *Le Arti Decorative*, September, December 1923; 1st Monza Biennale 1923; Carrà 1923; *Emporium*, July 1923; Sarfatti 1923; *Le Arti Decorative*, June-July 1924; *La Cultura Moderna*, August 1924; *Emporium*, August 1924; *Emporium*, July 1925; *Faenza*, 1927, issues II-III; 3rd Monza Biennale 1927; Marangoni, *Enciclopedia* 1927; *Annuario Industrie della Ceramica e del Vetro* 1930; Buzzi 1930; *Domus*, May, August 1930; *Emporium*, November 1930; Ponti 1930; Reggiori 1930; 4th Milan Triennale 1930; *Domus*, May, June 1933; *Emporium*, December 1933; 5th Milan Triennale 1933; *Domus*, July 1934; 6th Milan Triennale 1936; Minghetti 1939; *Emporium*, May 1940; 8th Milan Triennale 1947; Mallet 1978; *Mostra della ceramica italiana* 1982; Préaud, Gauthier 1982; Rosso 1983; Conti, G. Cefariello Grosso 1990; Cappelli, Soldani 1994; Barisione 1999; Maldini 1999; Benzi 2001; Cefariello Grosso, in *Museo d'Arti Appli e* 2002.
(cat. 73, 75, 435)

Carraresi e Lucchesi
Founded at Sesto Fiorentino in the second half of the thirties by Daniele Lucchesi and Virgilio Carraresi, the son of Bianco Carraresi who had run a small factory of artistic ceramics from 1923 to about 1930. The pottery distinguished itself with a production of modern character that took its inspiration from the repertoires of other factories, such as Richard-Ginori, Zaccagnini of Florence and, for the sculptures, Lenci of Turin. Most of the decorations were executed by airbrush. After the Second World War, the factory became the property of the Carraresi alone who, with their sons Vittorio and Vitaliano, continued its activity until 1967.

Bibliography
Annuario Industrie della Ceramica e del Vetro 1930; Rosso 1983; Capetta 1990.

CAS Ceramiche Antiche Savonesi
The founder of the pottery located in Savona was Bartolomeo Rossi (Varazze 1864 – Savona 1955), who in 1919 acquired a clay pipe and toy factory. The enterprise was given the name CAS in 1927 and, in the wake of the success achieved by the modern output of the potteries in Albisola, converted to the production of artistic ceramics. Initially the articles were functional and domestic, but in the thirties figures of small size were added. As well as by the owner, the models of this period were designed by the artists Nino Strada, Ivos Pacetti and Giovanni Acquaviva. The latter designed, and often decorated, vases and services of Futurist inspiration, whose forms were also produced by the CAS with different decorations. The factory remained in operation until 1950.

Bibliography
Marangoni, *Enciclopedia* 1927 (Bartolomeo Rossi); Minghetti 1939; Crispolti 1982; Préaud, Gauthier 1982; Rosso 1983; Chilosi, Ughetto 1995.

La Casa dell'Arte
Pottery founded in 1921 at Albisola Capo by Giuseppe Agnino and his brothers Angelo and Giulio Barile, it was directed until 1922 by Manlio Trucco, responsible for the artistic side, and Pietro Rabbia, for the traditional output. After the closure of the MAS, Ivos Pacetti and Dario Ravano collaborated on production. Trucco's first objects had decorations inspired by the plant and marine world, but these were then replaced by ornamental and geometric motifs derived from Art Deco. The factory was also frequented by artists, like Francesco Messina and Adelina Zandrino, who made one-off pieces there. From the end of the twenties until the beginning of the war, the pottery was run by the painter Giovanni Battista De Salvo. His creations in matt glaze were shown at the Monza Triennale of 1930. The production, on which just over twenty workers were employed in 1930, was also carried out to order from confectionery manufacturers and was highly appreciated abroad, especially in the United States, but in Northern Europe as well. After the war the factory experienced a slump in demand and closed down in 1955.

Bibliography
Le Arti Decorative, August 1923; 1st Monza Biennale 1923; Carrà 1923; *Emporium*, August 1924; *Le Arti Decorative*, September 1925; 2nd Monza Biennale 1925; *Opere scelte* 1925; 3rd Monza Biennale 1927; Marangoni, *Enciclopedia* 1927; *Annuario Industrie della Ceramica e del Vetro* 1930; Buzzi 1930; Ponti 1930; 4th Monza Triennale 1930; ENAPI 1932; *Domus*, May June 1933; 5th Milan Triennale 1933; *Emporium*, August 1936; Ettorre 1936; 6th Milan Triennale 1936; *Domus*, February March October 1937; *Domus*, July 1939; Minghetti 1939 (Agnino and Barile); *Domus*, May 1940; *Emporium*, May 1940; 7th Milan Triennale 1940; 8th Milan Triennale, 1947; Frattani, Badas 1976; *Mostra della ceramica italiana* 1982; Préaud, Gauthier 1982; Rosso 1983; Chilosi, Ughetto 1995; Chilosi, in *Museo d'Arti Applicate* 2002.
(cat. 383, 404-406)

Emilio Casadio
(Faenza 1902 – Florence 1964)
Emilio Casadio opened a workshop at Faenza in 1935, after collaborating with several local potteries (Focaccia & Melandri, La Faïence, Ortolani), a factory in Pescara and, from 1932 to 1935, Aldo Sintoni (Faenza 1905–1945). From the outset he took an original approach, in line with the artistic trends of the time both in its style and in the experimentation and application of special techniques. He produced tiles with very thick or highly reflective decorations, groups of small figures and vases in relief. The workshop became a meeting place for potters and artists, so that it came to be known as the 'Bagutta of Faenza'. In 1935 he showed at the International Exhibition in Brussels, where he won a prize. With Antonio Gandini he made the large wall clock in the telegraph room of the General Post Office in Faenza. In 1939 he won the Gaetano Ballardini Prize, in 1940 took part in the exhibition of ENAPI models at the Milan Triennale and in 1941 went to teach at the Istituto Statale d'Arte in Parma, where he continued his work. He won the Faenza Prize in 1941 with a plate decorated with the reflective-glaze technique, and in 1942 the first prize in the crèche competition. Later he developed an overriding interest in painting. In 1944 he gave up teaching in Parma and the next year was taken on at Eugenio Pattarino's CAPEF Ceramica d'Arte factory in Florence. Returning to Faenza, he was one of the founders of the ceramics cooperative based at the Farina factory, but left very soon to teach at the art school in Sesto Fiorentino. The following year he moved to Switzerland to work in a ceramics factory near Lausanne, going on to set up, in partnership with the Florentine Beatrice Cenci di Bello, the Ceramica Artistica Romande factory at Chavanny-Renens. It was his most lasting initiative, brought to a conclusion in 1957 when he returned to Italy and became artistic director of the Florentine factory for which he had already worked in 1945.

Bibliography
Minghetti 1939; ENAPI 1940; Dirani, Vitali 1982; Savini 1992.

Basilio Cascella
(Pescara 1860 – Rome 1950)
He initiated his sons Michele and Tommaso into the practice of the art at a very early age. For the whole family the involvement in ceramics began after the First World War, when they moved to Rapino, in the province of Chieti, and commenced production of plates and tiles decorated with landscapes and figures at the kiln run by Luigi Bozzelli. The Cascella family's works were exhibited at the Monza Biennali of 1923, 1925 and 1927. The large panels for the spa of Montecatini Terme were made in 1926 at

the Percossi kiln in Civita Castellana. Another demanding work was that of the panels with views of five Italian cities for the arcade of Milan's Stazione Centrale (1931). According to the *Annuario Industrie della Ceramica e del Vetro* of 1930 the pottery employed eleven workers.
Bibliography
Architettura e Arti Decorative 1923; 1st Monza Biennale 1923; Carrà 1923; *Emporium*, July 1923; Sarfatti 1923; *Le Arti Decorative*, June-July 1924; *La Cultura Moderna*, August 1924; *Emporium*, August 1924; *Le Arti Decorative*, April-May 1925; 2nd Monza Biennale 1925; *Emporium*, October 1925; *Opere scelte* 1925; 3rd Monza Biennale 1927; Marangoni, *Enciclopedia* 1927; *Annuario Industrie della Ceramica e del Vetro* 1930; *La Cultura Moderna*, September 1930; Ettorre 1936; Minghetti 1939; Folliero 1957; De Guttry, Maino, Quesada 1985; Bossaglia 1994; L. Arbace, in *Museo d'Arti Applicate* 2002.
(cat. 269)

Gioacchino Cascella
(Pescara 1903 – Ravenna 1983)
The youngest of Basilio Cascella's sons was the one who devoted himself almost exclusively to ceramics. He was initiated into the art by his father, with whom he collaborated on the realization of several works. He held a one-man show in Piazza di Spagna in 1934. He retained his ties to the town of Rapino in the province of Chieti, Abruzzo, where the family's ceramics business had been launched.
Bibliography
Le Arti Decorative, June 1925; 2nd Monza Biennale 1925; 3rd Monza Biennale 1927; Marangoni, *Enciclopedia* 1927; Minghetti 1939; Folliero 1957; De Guttry, Maino, Quesada 1985.

Michele Cascella
(Ortona 1892 – Milan 1989)
Initiated by his father Basilio into first painting and then pottery, he held his first exhibition in Milan with his brother Tommaso, in 1907. Over the following years he took part in exhibitions in Italy and abroad. During the war he painted scenes of military life. In 1920 he moved to Milan, where he showed his ceramics at the Galleria Pesaro. Dal 1923 al 1927 he took part in three Monza Biennali, again with ceramic works. Subsequently, he devoted himself exclusively to painting for about ten years, participating in the Venice Biennale from 1928 al 1942 and holding one-man shows in Italy and abroad. In 1935 he worked at the Richard-Ginori factory in Doccia. In 1940 he moved to Portofino.
Bibliography
1st Monza Biennale 1923; *Le Arti Decorative*, November 1924; *Le Arti Decorative*, June 1925; Marangoni, *Enciclopedia* 1927; 4th Monza Triennale 1930; 5th Milan Triennale 1933; Ettorre 1936; Minghetti 1939; Folliero 1957; De Guttry, Maino, Quesada 1985; Arbace, in *Museo d'Arti Applicate* 2002.

Tommaso Cascella
(Ortona 1890–1968)
Pupil of his father Basilio, he attended the Accademia di Belle Arti in Rome for a short time and then spent two years in Paris. In 1907 he held his first exhibition with his brother Michele in Milan, followed by others in Paris, London and São Paulo. In 1914 he was war correspondent for his father's magazine *La Grande Illustrazione*. His participation in the National Exhibition of Ceramics at Pesaro in 1924 was important. Awarded a prize at the Venice Biennale of 1932, he retained strong links to the land of his birth, which he portrayed in his paintings as well as his ceramics. He settled in Pescara, in what had once been his father's chromolithographic print shop and is now the Museo Cascella.
Bibliography
1st Monza Biennale 1923; *Emporium*, August 1924; 2nd Monza Biennale 1925; *Le Arti Decorative*, June, September 1925; *Opere scelte* 1925; Marangoni, *Enciclopedia* 1927; *La Casa Bella*, September 1929; 5th Milan Triennale 1933; Ettorre 1936; Minghetti 1939; Folliero 1957; De Guttry, Maino, Quesada 1985; Arbace, in *Museo d'Arti Applicate* 2002.

Leonardo Castellani
(Cesena 1896–1984)
Between 1920 and 1921 he opened the Bottega di Ceramiche Artistiche at Cesena with his father, who had been a potter in Faenza. He joined the Futurist movement but his ceramic works, especially the panels of architectural decoration preserved at Cesena (villa on Via Pola), reflect the persistence of an Art Nouveau influence of English and Austrian derivation. The pottery closed at the end of 1923.
Bibliography
Bojani 1921; *Le Arti Decorative*, June-July 1924; *La Cultura Moderna*, August 1924; *Emporium*, August 1924; 2nd Monza Biennale 1925; Marangoni, *Enciclopedia* 1927; Minghetti 1939; Gardelli 1994; Benzi 2001.
(cat. 234)

Torquato Castellani
(Rome 1843–1931)
Born into a well-known family of Roman goldsmiths, he spent the years from 1860 to 1870 with his father Alessandro, a political exile, first in Paris and then in Naples, where they ran together a goldsmithry school and a pottery at which they made copies of Renaissance majolica ware. In 1870 Torquato went back to Rome and carried on by himself with this type of production, which proved highly popular with foreign scholars and collectors, such as the Englishman Fortnum, who commissioned from him several pieces that are now in the Ashmolean Museum, Oxford. He achieved success at the principal exhibitions of decorative arts held in Italy from the beginning of the 1880s onwards. In 1900 he was at the great Paris Exhibition, showing works still inspired by the Italian Renaissance, as well as by Turkish and Persian ceramics. In 1902 he took part, along with his daughter Olga, in the International Exhibition of Decorative Arts at Turin that, with its espousal of the modern style, threw the historicist model from which he still took his inspiration into crisis. Later on his workshop's production of earthenware and majolica was characterized by a cautious adoption of the Art Nouveau style, tempered by a persistent naturalism, especially with regard to the decoration of large plates in vivid colours. His and his daughter Olga's works were also shown at the exhibition held in Faenza in 1908 to mark the centenary of Torricelli's birth.
Bibliography
Arte Italiana Decorativa e Industriale, May 1900; Turin Exhibition 1902; Minghetti 1939; Mallet 1978; Quesada 1988; Conti, Cefariello Grosso 1990; Maldini 1999; De Guttry, Maino 2003.
(cat. 48)

Rodolfo Ceccaroni
(Recanati 1888–1983)
Of noble descent, he studied at the Accademia di Belle Arti in Rome and then, prompted by his interest in ceramics, attended the Museo Artistico Industriale. After following the Higher Course of Decoration and Restoration as well, he became a teacher first at a Roman technical college and then at the ceramics schools in Grottaglie and Sesto Fiorentino, which allowed him to improve his knowledge of the technique. In 1917 he built a wood-fired pottery kiln in his palace at Recanati and devoted himself to an entirely hand-made production of works that took their inspiration from the artistic and cultural tradition of his homeland. He was influenced in particular by the pottery decorated with figures of the 16th century, with regard to both the forms (plate, bowl, goblet) and the painted subjects, behind which lay folktales, rural customs and religious rites and feelings. However, the tone of this reinterpretation shunned any kind of imitation, and can be classed among certain primitivist and rustic forms of expression of the 20th century. He showed his works at the Monza Biennali of 1923, 1925 and 1927 and then at the National Exhibition of Ceramics at Pesaro in 1928, the principal exhibitions of sacred art in Rome, the Milan Triennale of 1936 and numerous regional exhibitions.
Bibliography
Le Arti Decorative, November 1923; 1st Monza Biennale 1923; Carrà 1923; Sarfatti 1923; *Le Arti Decorative*, June-July 1924; *La Cultura Moderna*, August 1924; Serra 1924; *Le Arti Decorative*, April-May, July, September 1925; 2nd Monza Biennale 1925; *Opere scelte* 1925; 3rd Monza Biennale 1927; Marangoni, *Enciclopedia* 1927; Buzzi 1930; 4th Monza Triennale 1930; *Arte Decorativa* 1931; 6th Milan Triennale 1936; Minghetti 1939; Folliero 1957; *Rodolfo Ceccaroni* 1981; *Mostra della ceramica italiana* 1982; Préaud, Gauthier 1982; Rosso 1983; Bojani 1988; Bojani 1989; Bojani 1997; Alessandrini, in *Museo d'Arti Applicate* 2002.
(cat. 276)

Enzo Ceccherini
(Sesto Fiorentino 1894–1970)
After studying painting at the Istituto d'Arte in Florence, he adopted the style of the Macchiaioli. He showed at the 1913 *International Exhibition of Black and White* in Florence and exhibited a painting at the Venice Biennale of 1920. Like his father Luigi, who was one of the founders of the SIFMA, he painted on ceramics and in 1922 showed in Florence, along with the Macchiaiolo painter Ruggero Focardi whose pupil he had been, several vases executed at the Conti pottery in Sesto Fiorentino and characterized by a decoration using the Divisionist technique. In 1923 and 1925 his ceramics won prizes at the Mostra delle Piccole Industrie in

Florence. He collaborated on the decoration of the Italian Pavilion at the Paris International Exhibition in 1925. Toward the end of the twenties he opened a workshop at Querceto that he called Alma, where he made some interesting Futurist pieces. After a period at Alinari making copies of famous pictures, he became a decorator at Richard-Ginori of Doccia, while continuing to devote himself to painting.
Bibliography
Capetta 1990; Monti 1995; Ragionieri 1997.
(cat. 51)

Renzo Cellini
(Rome 1894–1934)
He started to frequent Roman potteries at a very early age. After the war, which undermined his health, he helped to found the ceramics factory La Salamandra. In 1920 he took part in an exhibition organized by Ferruccio Palazzi. From 1922 onwards he was in charge of the ceramic workshops at the Istituto San Michele, where Duilio Cambellotti and Romeo Berardi taught. In 1924 he set up a kiln, financed by Princess Maria Mouroy Borghese Del Vivaro, at Pratica di Mare and, in the same period, also established a small factory, the Igne Collucent. In 1928 he became artistic adviser to Coen in Rome, for which he designed lace, fabrics and clothes. In the same years he resumed his collaboration with Palazzi. Death overtook him while he was planning the launch of a magazine devoted to ceramics and a new studio, both of which were to have been called Keramos.
Bibliography
De Guttry, Maino, Quesada 1985; Quesada 1988; Quesada 1992; De Guttry, Maino 2003.

Ceramiche Albissola Spica (CAS)
see SPICA

Ceramiche Artistiche di Posillipo
Workshop active in Naples between 1937 and 1943, founded by the painter and potter Giuseppina De Feo with the sculptors Antonio De Val and Aniellantonio Mascolo and the painters Eduardo Giordano and Paolo Ricci, and with the collaboration of the Pinto manufacturers of majolica ware for the throwing. It produced sculptural groups of ironic and folk character, small objects of everyday use and furnishings, as well as architectural decorations, such as the ones for the Italian Exhibition of the Overseas Territories (friezes in the bar and restaurant, panels and floor, wall of the Tropical Aquarium). It showed tiles and plates decorated with lively views of Naples and seascapes at the 1939 Crafts Exhibition in Florence, and presented panels at the exhibition of ENAPI models at the Triennale of 1940.
Bibliography
Domus, June 1937; July 1939; ENAPI 1940; Frattani, Badas 1976; Romito, La Collezione Camponi 1999; Salvatori, in Picone Petrusa 2000.

Gigi Chessa
(Turin 1898–1935)
Initiated into painting by his father Carlo, an etcher and illustrator, he went on to attend the Accademia Albertina and frequent the studio of the painter Agostino Bosia. Introduced by Carena and Casorati to the industrialist, collector and patron Riccardo Gualino, he was commissioned by the latter to renovate and furnish the Turin Theatre in 1925. Chessa also devoted himself to the applied arts. In 1922 he commenced his collaboration with Lenci, supplying the factory with designs for carpets and furniture and then, from 1928 to 1930, ceramics, in which the favourite subjects were female nudes inspired by classicism and primitivism. For the same factory in Turin he also designed, with Sandro Vacchetti, the prize-winning displays at the first Monza Biennale in 1923 and the Paris Exhibition in 1925. From 1927 he taught set design at the Scuola Superiore d'Architettura in Turin. In 1928 he participated in the Venice Biennale and, the following year, joined the Group of Six in Turin that was set up in opposition to the official character of the Novecento movement. In 1930 he prepared, with the architects Cuzzi and Turina, 'Room 130' at the Monza Triennale, also known as the 'Room of Metals'.
Bibliography
Papini 1927; Ceramiche di Lenci 1929; La Casa Bella, April 1929; Domus, August 1929; Buzzi 1930; Domus, August 1930; Proverbio 1979; Mostra della ceramica italiana 1982; Le ceramiche Lenci 1983; Chessa, Da Milano, Levi, Menzio 1984; Guttry, Maino, Quesada 1985; Gigi Chessa 1987; Panzetta 1992.
(cat. 375)

Galileo Chini
(Florence 1873–1956)
In 1895 he began to attend the Scuola Libera del Nudo at the Accademia di Belle Arti of Florence. Here he came into contact not only with artists like Adolfo De Carolis, Plinio Nomellini and Telemaco Signorini, but also with Vittorio Giunti and Giovanni Vannuzzi, with whom he and Giovanni Montelatici founded the Arte della Ceramica in 1896. Galileo took on the role of artistic director and from the outset imparted a style to the production that was in line with the new modernist tendencies. At the same time he made significant excursions into the field of graphics (magazine illustrations, Alinari competition for the illustration of the Divine Comedy) and painting (Venice Biennali from 1901 to 1936, including the 'Room of Dream' with Nomellini and Gaetano Previati in 1906, the decorations of the dome of the entrance in 1908, eighteen panels for Ivan Mestrovic's room of sculptures in 1914). In 1904 he left the Arte della Ceramica as a result of disagreements with his partners and in 1906 founded the Fornaci factory at San Lorenzo, with his brothers Chino and Pietro. From 1911 to 1914 he was in Bangkok, at the invitation of the king of Siam, to paint the frescoes in the Throne Room of the Royal Palace. On his return, he began to teach decoration at the Accademia di Belle Arti in Florence. In 1917 he signed with other artists the manifesto Rinnovandoci Rinnoviamo ('Let's Modernize by Renewing Ourselves') calling for the abolition of the academies and their replacement by artistic-industrial schools. In the first half of the twenties he was engaged, personally and with the factory, in the execution of the frescoes and the ceramic facings of the Berzieri Baths at Salsomaggiore. His last contribution to the ceramic art was the design of the pieces presented at the 1925 Exhibition of Decorative Arts in Paris by the Fornaci San Lorenzo. Later he devoted himself almost exclusively to easel painting.
Bibliography
Arte Italiana Decorativa e Industriale, November 1898; Emporium, January 1899; Sandier 1900; Pica 1902; 5th Venice International Exhibition of Art 1903; 7th Venice International Exhibition of Art 1907; 10th Venice International Exhibition of Art 1914; 11th Venice International Exhibition of Art 1920; Le Arti Decorative, June-July 1924; La Cultura Moderna, August 1924; 14th Venice International Exhibition of Art 1924; Le Arti Decorative, September 1925; Emporium, October 1925; Ponti 1926; Minghetti 1939; Vianello 1964; Marsan 1971; Marsan 1974; Nuzzi 1977; Cefariello Grosso 1979; Bossaglia 1980; Monti 1981; Benzi 1982; Cefariello Grosso 1982; Mostra della ceramica italiana 1982; Préaud, Gauthier 1982; Rosso 1983; Cefariello Grosso 1984; De Guttry, Maino, Quesada 1985; Benzi 1986; Benzi 1988; Cefariello Grosso 1990; Cefariello Grosso 1993; Bossaglia 1994; Stringa 1995; Benzi 1998;Cefariello Grosso 2000; Benzi 2001; G. Cefariello Grosso, in Museo d'Arti Applicate 2002; Benzi 2006.
(cat. 1-23, 72)

CIA
Pottery set up at the beginning of the thirties by Manna, formerly a decorator at the Lenci, with a repertoire very similar to that of the better-known Turinese factory. Towards the end of the decade the Sardinian ceramist Alessandro Mola collaborated on the design of a number of figurines of women wearing Sardinian costume.
Bibliography
Rosso 1983; Cuccu 2000.

Ilario Ciaurro
(Cicciano, Naples 1889 – Terni 1992)
He grew up in Umbria, where he returned after the war, devoting himself to pottery, first at Gualdo Tadino, as artistic director of Rubboli, and then, from 1920, at Gubbio, where he set up with others the Vasellari Eugubini Mastro Giorgio. Here, while showing a marked preference for the lustres he had tried out earlier, he practiced a pottery that was freer from the conditionings of tradition, in its decorations as well as its forms. In 1924 he moved to Orvieto at the invitation of the historian Pericle Perali, who had founded a new factory there, the Arte de' Vascellari di Orvieto. He stayed there until 1925, the year in which his presence is recorded at the Monza Biennale. But his relationship with the scholar proved too much of a limitation on his attempts to modernize the production and Ciaurro decided to open a pottery of his own, active until 1937, where he diversified the range of products and their forms and decorations. After the closure of the factory, he went back to Terni and devoted himself to other art forms as well.
Bibliography
2nd Monza Biennale 1925; Marangoni, Enciclopedia 1927; Minghetti 1939; Ilario Ciaurro 1989; Satolli 1983; Sannipoli, 'Note sulla ceramica eugubina degli anni '20 e '30', in Bojani 1992; Satolli 1994; Busti, Cocchi, in Museo d'Arti Applicate 2002.

Francesco Ciusa
(Nuoro 1883 – Cagliari 1949)
A sculptor trained at the Accademia di Belle Arti in Florence, he tried his hand at ceramics after receiving gratifying awards, such as the gold medal at the Venice Biennale for the sculpture *The Victim's Mother* in 1907. The practice of a decorative art allowed him to start implementing the program of 'reinvention of the Sardinian universe' that many of the island's artists adhered to at the beginning of the century. From 1919 to 1924 he devoted himself to ceramics in the ambit of the SPICA. In his terracottas made in moulds in short runs it is possible to discern both the tradition of the 15th century and the rustic local one, both updated to bring them into line with Art Deco. In 1923 the artist received a certificate of honour at the 1st Biennale of Decorative Arts in Monza. In 1924 he closed the SPICA to concentrate on the production of multiples cast in 'marble paste', a stucco used in building. The following year he became principal of the Scuola d'Arte Applicata in Oristano, staying there until 1929, when he gave up ceramics for good.
Bibliography
7th Venice International Exhibition of Art 1907; *Le Arti Decorative*, June, August, September 1923; 1st Monza Biennale 1923; *Emporium*, July 1923; Sarfatti 1923; Minghetti 1939; Altea, Magnani 1995; Cuccu 2000.; Altea 2004.
(cat. 279-281)

Colonnata
Founded at Sesto Fiorentino in 1891, the Società Ceramica Colonnata took part in the exhibitions in Chicago in 1893, where it won a gold medal, in Paris in 1900 and in Turin in 1902, where its production showed affinities with that of Chini. The Art Nouveau plates and vases were usually decorated with a female figure set between plant motifs, but objects decorated in relief were also made, always drawing on the most obvious decorative repertoire of the new style.
A leading figure in the early decades of the century was Giovan Battista Ciampi, designer of almost all the products. The factory, which employed around twenty workers, did well up until the First World War. It closed its doors in 1934 and in 1937 its premises were acquired by the Arte Ceramica Italiana, which carried on the same tradition of production.
Bibliography
Pica 1902; *Annuario Industrie della Ceramica e del Vetro* 1930; Capetta 1990; Maldini 1999.
(cat. 24, 25)

Coniglione
A pottery in Catania that in the thirties, with around ten employees, produced ceramic works designed by artists from Palermo, including the Futurists Pippo Rizzo and Paolo and Vittorio Bevilacqua. It was present at the fourth Monza Triennale and the second Art Exhibition of the Fascist Sicilian Union of the Artists of Palermo in 1929.
Bibliography
Annuario Industrie della Ceramica e del Vetro 1930; Buzzi 1930; *Emporium*, November 1930; Reggiori 1930; 4th Monza Triennale 1930; Minghetti 1939.

Cooperativa Ceramica di Imola
It was set up in 1874 on the initiative of Giuseppe Bucci, who ceded his factory to a cooperative of its workers. The production, on which over 500 people were employed in 1930, was based chiefly on the tradition of Faenza and had eclectic characteristics. Alongside the ordinary crockery department, the factory had an artistic section that, after 1920 and up until the forties, mass-produced small figures of women and Pierrots very similar to those conceived by Nonni at Faenza in the twenties. In the following decade it introduced vases decorated with dark silhouettes and blurred bands executed with the airbrush that recalled the production of Galvani in Pordenone. The outstanding figure among its collaborators was Walter Martelli (1911–1942), who joined the cooperative at a very early age and then took up painting as well; interesting his production in Novecento style of the years between 1935 and 1940. Another prominent figure, Umberto Marfisi, active at the factory from the twenties to the fifties, was the author of vases whose decoration recalled on the one hand Carlo Carrà's Giottesque primitivism and on the other Ponti's manner. After the war the ceramic sculptor Domenico Minganti, director of the artistic section from 1946 al 1974, designed the forms, while Marfisi and Arrigo Visani, active in the cooperative between 1946 and 1950, took care of the decoration. In 1946 Gio Ponti supplied the factory with models, executed by Minganti, of bottles enlivened with applications and inserts alluding to the work of Morandi, Campigli and de Chirico. Later the factory brought out other sculptures (*The Whale*, *The Trojan Horse*) and 'living bottles', again to Ponti's design, with variants that it went on producing until the mid-sixties.
Bibliography
Le Arti Decorative, June-July 1924; *La Cultura Moderna*, August 1924; Serra 1924; 2nd Monza Biennale 1925; Marangoni, *Enciclopedia* 1927; *Le Arti plastiche*, March 1929; *Annuario Industrie della Ceramica e del Vetro* 1930; *Mostra della ceramica italiana* 1982; Mingotti 1991; Ravanelli Guidotti 1994; Benzi 2001.
(cat. 74)

Giovanni D'Arcangelo
(Lucera 1888 – Mestre 1955)
Born and raised in a family of potters at Lucera and trained at the Neapolitan school of Portici, D'Arcangelo chose to move to the Veneto in the twenties. From 1924 to 1937 he taught ceramics at the Istituto d'Arte dei Carmini in Venice. At the same time he collaborated with Dolcetti and the Ceramiche San Marco at Ponte di Brenta. In 1929 he took over Benedettelli and started up his own Bottega del Vasaio or 'Pottery', where he almost single-handedly produced majolica ware thrown on the wheel. He took part in national and international exhibitions, including the Brussels Exhibition and the Milan Triennale in 1936 and the exhibitions in Paris and New York in 1939. In 1946 he moved to Mestre.
Bibliography
6th Milan Triennale 1936; Minghetti 1939; Stringa, *L'arte decorativa…* 1987.

Giulio Da Milano
(Nice 1895 – Turin 1990)
In 1928 he began his collaboration with Lenci, and the following year five of his pieces, two painted plates (*Fisherman* and *Dancing Women*) and three sculptures (*Harlequin and Lady*, *Lady Singing* and *Woman with Cactus*) were included in the exhibition at the Galleria Pesaro. In the thirties he was precocious in adopting abstract motifs in his painting, a choice that was reflected in his participation in important exhibitions like that of the Society for the Promotion of Fine Arts in Turin, the Venice Biennale and the Rome Quadriennale.
Bibliography
Ceramiche di Lenci 1929; Buzzi 1930; Proverbio 1979; *Mostra della ceramica italiana* 1982; *Le ceramiche Lenci* 1983; Rosso 1983; Chessa, Da Milano, Levi, Menzio 1984; *Da Milano* 1985; Panzetta 1992.
(cat. 376)

Mario Guido Dal Monte
(Imola 1906–1990)
He joined the Futurist movement in 1925, and in 1928–29 produced designs for the decoration of vases, plates, services and tiles that were executed in the workshops of Riccardo Gatti and Mario Ortolani at Faenza, for the mark Ceramiche Futuriste G. Fabbri. The same year, his ceramics were exhibited in Faenza, along with those of Giacomo Balla, and then in Rome, at the Casa d'Arte Bragaglia, and Mantua, at the *Exhibition of Futurist, Novecento and Strapaese Art*.
Bibliography
Crispolti 1982.
(cat. 231)

Teonesto De Abate
(Turin 1898–1981)
His involvement with ceramics began in 1921, working with the Galvani factory in Pordenone, a collaboration that lasted until 1925 and that is unfortunately not documented owing to the dispersal of the company's archives. In 1923 we find De Abate in the role of director of the Ceramiche Vittoria at Mondovì and, from 1928, collaborating with Lenci. The historic exhibition held in 1929 at the Galleria Pesaro in Milan, dedicated to Lenci's ceramic production, included two figures (*Maid with Cat* and *Hawayana*) and a tile (*Fawns*) by De Abate. He also created displays for exhibitions, in particular the potters' and glassworker's pavilions at the Turin Exhibition in 1928, furnishings for public places and scenery for the theatre and cinema. After the war he devoted himself almost exclusively to painting.
Bibliography
Ceramiche di Lenci 1929; Buzzi 1930; Proverbio 1979; *Le ceramiche Lenci* 1983; *Teonesto Deabate* 1984; Panzetta 1992.

Adolfo De Carolis
(Montefiore dell'Aso, Ascoli Piceno 1874 – Rome 1928)
His experiences in the ceramic field commenced in 1898 with the panels in relief executed at Ginori for the decoration of Villa Blanc in Rome. Next came his collaborations with Cantagalli, for which he designed several vases shown at the 1902 Exhibition of Decorative Arts in Turin, with Vittorio Giunti's SCAF, between 1902 and 1903 and, lastly, with Matricardi in Ascoli Pi-

ceno, which made two services designed for himself and his daughter between 1924 and 1927. In 1908 he began work on the decoration of the Salone dei Quattrocento in the Palazzo del Podestà in Bologna, which was to occupy him until his death.
Bibliography
Pica 1902; 6th Venice International Exhibition of Art 1905; 7th Venice International Exhibition of Art 1907; 8th Venice International Exhibition of Art 1909; 1st Monza Biennale 1923; Serra 1924; Minghetti 1939; Conti, Cefariello Grosso 1990; Bossaglia 1994; Barisione 1999; Benzi 2001; De Guttry, Maino 2003.

Giovanni Battista De Salvo
(Savona 1903–1964)
A painter from Savona, he directed La Casa dell'Arte from around the end of the twenties until the beginning of the war. The distinctive characteristics of his production were the use of matt and crazed glazes in a wide range of colours and, with regard to the forms, vertical and horizontal ribbing, known as *satelliti* or planet wheels. His creations in matt glaze were shown at the Monza Triennale of 1930, while to the Milan Triennale of 1933 he brought works with the *Circus and Riders* decorations and several interesting sculptures, to the one in 1936 vases with embossed decorations, and to the one in 1940 female figures, birds and new vases. After giving up management of the factory, he went on working with ceramics, but producing only one-off pieces, fired in Bianco's kiln at Pozzo della Garitta and, after the war, at the SOESCO and other potteries in Albisola.
Bibliography
Domus, March 1932; *Domus*, May 1933; 5th Milan Triennale 1933; ENAPI 1936; 6th Milan Triennale 1936; *Domus*, February March June December 1937; *Domus*, July 1938; Minghetti 1939; *Domus*, May 1940; Frattani, Badas 1976; *Mostra della ceramica italiana* 1982; Rosso 1983; Chilosi, Ughetto 1995; O. Chilosi, in *Museo d'Arti Applicate* 2002.
(cat. 404, 405)

Vincenzo Del Monaco
(Grottaglie 1910–1978)
Proprietor of the oldest pottery at Grottaglie, active since the 17th century. He attended the art school in the town in Puglia and then began to work at his father Giuseppe's pottery. Here a number of ceramists who taught at the school, such as Roberto Rosati, Biagio Lista and Michele Esposito, also worked and carried out experiments. Del Monaco's production took its inspiration from Art Deco, but without forgetting traditional forms, of which he devised distinctly more refined versions. In 1937 he took part in the Crafts Exhibition in Florence.
Bibliography
Minghetti 1939; *Mostra della ceramica italiana* 1982.

Società Anonima Maioliche CIMA, Deruta
When the cooperative formed by the potteries of Deruta in 1904, the Società Anonima Cooperativa per la Fabbricazione delle Maioliche in Deruta, known as the 'great factory', went bankrupt in 1910, the Società Anonima Maioliche Deruta, with Alpinolo Magnini as artistic director, was set up to take its place. Its products were in the style of the Deruta ware of previous centuries. The only concessions to innovation were a few, vaguely Art Nouveau vases with slender forms and Magnini's attempt to bring, within the traditional repertoire, the models of decoration more into line with modern tastes. In the early twenties the Perugian entrepreneurs Biagio Biagiotti, Giuseppe Baduel and Giovanni and Francesco Buitoni invested in the company, modifying the craft character of the factory and raising the level of production considerably. This led to the establishment of a new company in 1923, called La Salamandra and based in Perugia. Both companies took part in the Monza Biennale of 1925, the former with vases and plates with a gold lustre, *bobole* in black and white and plates decorated with figures. In 1926 the partners in Maioliche Deruta promoted the setting up of another factory at Fontivegge, Perugia, entrusted to the potter Zulimo Aretini from Monte San Savino. For the manufacture of objects decorated with metal lustres a fourth company was added, the Società Ceramica Umbra, formerly the Fabbrica Rubboli, with works at Gualdo Tadino and Gubbio, while from Castelli d'Abruzzo came the contribution of the Società Anonima Maioliche Castelli. The five companies combined to form the Consorzio Italiano Maioliche Artistiche (CIMA), which also comprised Santarelli of Gualdo Tadino and Matricardi of Ascoli Piceno, responsible solely for marketing the products. In the meantime changes had been made to the output of the Maioliche Deruta, to make room on the one hand for decorations less closely tied to the Renaissance tradition of Umbria and on the other for the virtuosity of a Russian painter, David Zipirovič, author from 1923 to 1927 of one-off or limited-run pieces with reproductions of pictures by great painters of the Renaissance. In 1925 the CIMA opened the Bottega dei Vasari in Via Montenapoleone, Milan, which, along with other shops and the participation in international trade fairs and exhibitions, contributed to the commercial success of its products. The first difficulties arose in 1929, with the Great Depression, and were aggravated by the closure for political reasons of the foreign markets at which most of the traditional production of Deruta was aimed. In 1930 the consortium took part in the Milan Triennale, with the production of all its factories (employing a total of 239 workers) displayed on a spiral shelf in the first room of the Ceramics Gallery prepared by Tomaso Buzzi. In 1933 it was transformed into a joint-stock company with only the potteries based in Deruta and La Salamandra in Perugia and with a production almost completely in a modern style. Among the innovations we find objects decorated with landscapes by the Neapolitan painter and ceramist Gennaro Strino and vases in typically Novecento and Deco styles, most of them in two colours, including gold and silver, with metallic glints, by Enzo Cocchioni and Gabriele Bicchioni, works manager at the factory in Deruta until the mid-forties, or with decorations alluding to the ceramic work of Ponti and Andlovitz. It was probably the heavy cutback in the production of articles that drew on the styles of the past that prompted Alpinolo Magnini's resignation in 1937 as artistic director of the factory, which by this time relied on collaboration with artists, such as the Perugian ceramist and xylographer Aldo Pascucci, the sculptor Ruffo Giuntini, author of figures presented at the Triennale in 1940 and the Faenza competition of 1941, the painter and ceramist Gaetano Magazzù, formerly active at Lenci in Turin and Cacciapuoti in Milan, the painter and decorator from Bolzano Alberto Stolz, the Milanese Nino Strada who would remain at Deruta after the war as well, and the Milanese painter Enrico Ciuti (1910), author of the 'Derutanova' line presented at the 1940 Triennale and in *Domus* (July 1940). The war imposed a slackening in production and brought a decline in quality, but the factories remained in operation. Indeed the company was sound enough to play a part in the difficult management of Cantagalli in Florence. After the war, production returned to earlier levels and was shown at the main national and international exhibitions. The company now had around 400 employees and eighty per cent of its production was exported, half of it going to the United States. The artistic director was the Milanese ceramist Nino Strada, known for his Futurist work at Albisola with Mazzotti, who had already collaborated with the factory, winning the Faenza Prize in 1942 with a dinner service decorated with female figures ironically inspired by the traditional theme of 'beautiful women'. He was a prolific and original creator of forms and above all decorations that were figurative (*Frattaglie* – 'Offal' – series with flowers and fruit, *Peacock*, *Leaves*), abstract (*Harlequin* decoration), anticipating the style of the fifties, or reworkings of the classical repertoire. The company was forced to close by financial difficulties in 1956, only to be reopened as a cooperative.
Bibliography
Le Arti Decorative, June-July 1924; *La Cultura Moderna*, August 1924; 2nd Monza Biennale 1925; Marangoni, *Enciclopedia* 1927; *Annuario Industrie della Ceramica e del Vetro* 1930; Buzzi 1930; 4th Monza Triennale 1930; *Domus*, July, December 1940; *Emporium*, May 1940; 7th Milan Triennale 1940; *Domus*, December 1941; Bossaglia 1980; *Mostra della ceramica italiana* 1982; Rosso 1983; Bojani 1992; Busti 1998; Ranocchia 1999; Bojani 2000; Busti, Cocchi, in *Museo d'Arti Applicate* 2002.

Francesco Di Cocco
(Rome 1900–1989)
An artist from Rome, he began to work with ceramics in that city at the beginning of the twenties, with the sculptor Alfredo Biagini. He went on to collaborate with a number of factories in Albisola, in particular La Fenice, where he made interesting figures (*Crèche*, *Lovers*). Subsequently he worked with La Casa dell'Arte, where he made vases of an archaic character. He collaborated with the ENAPI from 1930 onwards, designing among other things ceramics produced by Anselmo Bucci, Marcon of Bassano and Melandri. A horse executed by the SIMAC at Castelli and a group made by La Fenice were exhibited in the room

of ENAPI models at the Milan Triennale in 1933. In 1938 he moved to the United States, where he stayed for about thirty years.
Bibliography
ENAPI 1933; *Domus*, October 1933; *Domus*, July 1938; *Domus*, March 1939; Frattani, Badas 1976; Rosso 1983; Chilosi, Ughetto 1995; Barisione 2001.

DIANA
Company set up in 1928 by the modernist architect, art historian and critic Mario Labò (1884–1961), who had organized the Ligurian exhibition at the Monza Biennali from 1923 to 1927. In 1926 he had commissioned some pieces for the Ligurian Oratory at the third Biennale from Arturo Martini, who had them made at La Fenice. The pieces by Martini produced at the same factory on order from Labò would be given the mark Savona Nuova. From the commissioning of ceramics, Labò moved on to the establishment of a company, DIANA (Decorazioni Industrie Artistiche Nuovi Arredamenti), for the design, production and marketing of furnishings and objects, and the foundation, a few months later, of a ceramics factory, the ILCA, at Genoa Nervi. DIANA attracted attention at the Monza Triennale of 1930 with Martini's one-off and mass-produced ceramic pieces.
Bibliography
Buzzi 1930; *Domus*, November 1930; *Emporium*, November 1930; Ponti 1930; 4th Monza Triennale 1930; Frattani, Badas 1976; Chilosi, Ughetto 1995.

Nicolaj Diulgheroff
(Kyustendil, Bulgaria 1901 – Turin 1982)
A keen painter from an early age, he attended art schools in Vienna, Dresden, Weimar (the Bauhaus) and Turin (studying architecture at the Accademia Albertina), where he settled in 1926 and joined the Futurist movement. Without giving up painting, he devoted himself to the design of furniture and objects and to graphics. In 1929 be began to collaborate with Mazzotti, designing, in Rationalist style, the company's new premises at the mouth of the Sansobbia (finished in 1932) and numerous ceramics, in particular the famous tea service in matt glazed terracotta. For the factory's production of articles commissioned by commercial enterprises, he designed liqueur sets for Cora and ashtrays for Campari and La Rinascente. As a painter he showed at the Venice Biennale on many occasions, while his ceramic works were presented at the *Futurist Exhibition of Aeropainting and Set Design* at the Galleria Pesaro and the *Futurist Exhibition* held at Chiavari in 1931. After the war he concentrated mostly on painting.
Bibliography
Mostra di trentatré artisti futuristi, 1929; Crispolti 1982; *Mostra della ceramica italiana* 1982; Rosso 1983; Chilosi, Ughetto 1995; Barisione 2001.
(cat. 382, 383)

Giacomo Dolcetti
(Venice 1893 – San Donà di Piave 1957)
In 1921 he opened the Bottega del Vasaio in Venice. From 1921 to 1924 its director was Giancarlo Polidori from Pesaro, who commenced a painstaking production of majolica ware. Characteristic of the refined output of this small pottery were the decorations in bright colours (yellow, blue and green) of Renaissance inspiration, with Venetian buildings and figures from the 18th century. After the departure of Polidori, Dolcetti moved closer to Art Deco, in his subjects as well as style. The articles were boxes with lids, ornamental plates and vases that sometimes harked back to traditional forms. Guido Cadorin, Bortolo Sacchi, Umberto Bellotto and Vittorio Zecchin worked at Dolcetti's Bottega del Vasaio. The products of the Venetian pottery were presented at exhibitions in Ca' Pesaro, Venice, in 1922, and the first Monza Biennale in 1923. In 1925 the factory was renamed Dolcetti & Missier. VIVA (Venezia Industriale Venezia Artistica), owing to the entry of a partner, Achille Missier, who decided to commence industrial production alongside the handcrafted one. A year later the project had already failed: Missier set up a new factory on Murano and Dolcetti once again became the sole owner of the Bottega, which closed in 1928.
Bibliography
Le Arti Decorative, June 1923; 1st Monza Biennale 1923; Carrà 1923; Carnevale 1925; Marangoni, *Enciclopedia* 1927; Minghetti 1939; *Mostra della ceramica italiana* 1982; Stringa, *L'arte decorativa…* 1987; Stringa, *Terre Ferme…*1987; Stringa 1995.
(cat. 76, 77)

Ercole Drei
(Faenza 1886–1973)
In Faenza he attended the Scuola di Arti e Mestieri and frequented Baccarini's circle. In 1906 he was in Florence, to follow the painting course taught by Giovanni Fattori and the sculpture one taught by Augusto Rivolta at the Accademia. He devoted himself to sculpture, winning various prizes, including that of the Florentine Società di Belle Arti in 1912, the year in which he also exhibited at the Venice Biennale. In 1920 he opened a studio at Rome, in the Villa Strohl-Fern where other Roman artists and ceramists worked. In 1921 and in 1923 he took part in the Rome Biennali. Influenced at first by Art Nouveau and Symbolism, he established links with the Novecento group in the twenties, showing with it in Milan in 1926 and 1929, the year he won the gold medal at the International Exhibition in Barcelona. From 1927, for over thirty years, he held the chair of sculpture at the Accademia di Belle Arti in Bologna, of which he was also principal from 1952 al 1957. From the second half of the twenties, he devoted himself to celebratory monumental sculpture for about two decades, but at the same time made small bronzes and models for ceramics that were executed in Faenza by Pietro Melandri and Anselmo Bucci. At the Rome Quadriennale of 1935 he was given a whole room, where he exhibited works in bronze, wax, terracotta and marble.
Bibliography
La Casa Bella, May 1930; Arte Decorativa 1931; *Domus*, May 1941; Frattani, Badas 1976; Castagnoli 1989; Quesada 1992; Savini 1992.
(cat. 295)

Essevi
Ceramics factory founded at Turin in 1934 by Sandro Vacchetti and the ceramist Nello Franchini. The former, whose initials gave the factory its name, had been the artistic director of Lenci. The production, which would eventually comprise hundreds of models, was inspired by that of the better-known Turinese manufacturer and consisted essentially of female figures in fashionable clothes and attitudes or roguish nudes. Ines Grande and Otto Maraini collaborated on the conception of some models. From the thirties to the fifties, a long series of figures with marked Sardinian regional characteristics was produced to designs by the sculptor Alessandro Mola. The factory interrupted its activity during the war, reopening in 1946 only to close for good in 1952.
Bibliography
Minghetti 1939; Proverbio 1979; *Mostra della ceramica italiana* 1982; *Le ceramiche Lenci* 1983; Rosso 1983; Cuccu 2000.
(cat. 378-380)

Agenore Fabbri
(Barba, Pistoia 1911–2000)
He moved at an early age from Tuscany to Albisola, where he started out as shop boy, then pupil, worker, craftsman and finally artist. Around the middle of the thirties he was a modeller at La Fiamma run by his fellow Tuscan Ivos Pacetti. With the latter he created the series of girls in fancy dress and the group of the *Three Marys* presented at the Triennale in 1936. At the same time he executed terracotta portraits which he showed at major exhibitions like the Venice Biennale of 1938 (*The Stranger*). After the war, which left a deep mark on him, he made a series of tormented terracotta figures at the Cooperativa Stovigliai in Albisola. The ceramic bas-relief executed by Mazzotti for the Astor Cinema in Savona dates from 1946, and the one representing *The Legend of Orpheus* for the atrium of the 9th Milan Triennale from 1951. Over his long artistic career, the sculptor always found ceramics to be the medium best-suited to expressing his deeply-felt inspiration.
Bibliography
Domus, July 1938; Minghetti 1939; Folliero 1957; Rosso 1983; Riolfo Marengo 1988; Reggiori, Pozzi 1991; Chilosi, Ughetto 1995.

Giuseppe Fabbri
(Pieve di Cento 1901 – ?)
A Futurist journalist and writer, in 1928–29 he promoted a factory mark in Faenza, that of the Ceramiche Futuriste G. Fabbri-Faenza, for the manufacture and sale of Futurist ceramics, produced at the workshops of Riccardo Gatti, Mario Ortolani and Anselmo Bucci to designs by Giacomo Balla, Mario Guido Dal Monte, Benedetta, Pippo Rizzo, Gerardo Dottori and others. The pieces were shown at the *Futurist Exhibition* in Faenza in 1928, at the *Exhibition of Futurist, Novecento and Strapaese Art* in Mantua in 1928–29 and at the International Exhibition in Barcelona in 1929. After the war he became personally involved in the production of ceramics at Vietri.
Bibliography
Crispolti 1982; Ruta 1985.

Fabbriche Riunite di Ceramiche – Società Ceramiche Faentine
In 1898 the Milanese Giorgio Mylius carried out a merger between the factory which he owned

in Faenza, founded by Achille Farina (1804–1879) in 1864, and two other factories in the city, the Treré and the ex-Ferniani. The venture did not take off and went into liquidation, but at the beginning of the century Count Carlo Cavina intervened, leasing the three factories and setting up the Fabbriche Riunite di Ceramiche company. The artistic director was Tommaso dal Pozzo (1862–1906) and, from 1906 to 1908, Achille Calzi; the collaborators were Domenico Baccarini, whose models would still be utilized even after his premature death, and Ercole Drei. Alongside an eclectic and historicist production, it made pieces inspired by Art Nouveau, with both painted and relief decorations. The products of the highest artistic level were made at the former Farina factory, while the other two, and in particular the Treré, turned out articles for everyday use. In 1908 the company took part in the Torricelli Exhibition in Faenza, winning a prize for a decorative panel. In 1908 it changed its name to Fabbrica di Maioliche Faentine and the following year closed, only to reopen shortly afterwards, without the ex-Ferniani and Trerè which were separately constituted as a cooperative, under the name Società Ceramiche Faentine. In 1910 it took part in the International Exhibition in Brussels and opened a shop in Milan, but the company was wound up the same year. Acquired by Massimiliano Pooper, it became the Manifattura Ceramica Faentina and resumed production with about ten workers. The artistic director of the decoration department was Aldo Zama, a ceramist from Faenza who stayed until 1925. But the attempts to launch a more profitable production of tiles failed and the factory closed its doors again in 1914. It was taken over by Monari Vitolo & C., a firm that owned other potteries, and its name changed again to Industrie Riunite Faentine and then Manifattura Ceramiche di Monari Vitolo & C. In 1926 this management too ended up in bankruptcy and a new bail-out by three of its employees, who changed its name yet again to Manifatture Ceramiche Faentine, Antica Fabbrica A. Farina and ran it between ups and downs, with a workforce that in the best periods rose to as many as thirty, until its final closure as a result of the destruction caused by bombing in 1944.
Bibliography
Annuario Industrie della Ceramica e del Vetro 1930; ENAPI 1938; Dirani, Vitali 1982; Savini 1992; Maldini 1999.
(cat. 36-38, 40)

Luigi Fabris
(Bassano 1883–1952)
In Venice he frequented the studio of the sculptor Antonio dal Zotto and took a diploma in sculpture at the Accademia di Belle Arti. In 1912 he took over a small factory in Bassano, Passarin, where he devoted himself to the manufacture of statuettes in earthenware and terracotta. Between 1914 and 1915 he made with Teodoro Sebelin (Zanolli, Sebelin, Zarpellon) the bas-relief majolica slabs for the facades of the Hotel Hungaria at the Venice Lido. In 1917 he moved to Milan, where two years later he began a similar production, but in porcelain. His nudes and women in 18th-century costumes, groups which could attain a remarkable size, were well-made and appreciated by the public, abroad as well, but did not appear to have been touched by modernity. Around 1930 the factory employed around twenty people. The ceramist returned to Bassano in 1942, after a bombing raid had almost destroyed the factory, with the exception of the print shop in which he was able to carry out the same activity until 1952, when his place was taken by his son Augusto, who kept it going until 1980.
Bibliography
Marangoni, *Enciclopedia* 1927; *Annuario Industrie della Ceramica e del Vetro* 1930; Guigoni 1930; Minghetti 1939; *Mostra della ceramica italiana* 1982; Stringa 1980.

FACI
The Fabbrica Artistica Ceramiche Italiane, FACI, was set up at Civita Castellana in 1927, rising from the ashes of the Falisca Ars (FACC), a factory of artistic ceramics active from 1900 to 1920. Unlike the latter, whose production was still rooted in historicist eclecticism, the FACI updated its repertoire along Art Deco lines and made extensive use of airbrush decoration. Some interesting examples of its production are reproduced in the slim volume by Cosimo Ettorre, principal of the local art school and collaborator with the factory, like many other teachers at the school. In 1930 it employed around twenty workers. Among its presences at trade fairs, it is worth mentioning the Campionaria in Milan in 1929, that of Leipzig in 1930, the Fiera del Levante in Bari in 1933 and the one in Tripoli in 1936. After the war the style of the production changed, taking its inspiration from Northern Europe. The factory continued to operate until 1967.
Bibliography
Annuario Industrie della Ceramica e del Vetro 1930; Ettorre 1936; Rosso 1983; Terraroli 2001.

La Faïence
In 1919, after working in the Minardi brothers' factory and then running it with other workers from 1913 until he was called up to fight in the war, Paoli Zoli founded the La Faïence factory with the decorator Dino Fabbri and the kiln operator Amerigo Masotti. Dino Fabbri very soon left the company and Pietro Melandri joined it, only to leave shortly after as well. The production was partly of a traditional type and partly oriented toward innovative pieces, like the small figures of Francesco Nonni, made here during the period when Zoli was in partnership with Melandri, and several pieces designed by Giovanni Guerrini. The factory was closed in 1930, when it was listed in the *Annuario Industrie della Ceramica e del Vetro* as having around twenty workers, as a result of the problems caused by the heavy reduction in exports.
Bibliography
Le Arti Decorative, September 1923; Le Arti Decorative, June-July 1924; La Cultura Moderna, August 1924; Serra 1924; 2nd Monza Biennale 1925; Marangoni, *Enciclopedia* 1927; Annuario Industrie della Ceramica e del Vetro 1930; Dirani, Vitali 1982; Benzi 2001.
(cat. 64)

Salvatore Fancello
(Dorgali 1916 – Albania 1941)
At the age of just thirteen he started to work with ceramics in the pottery run by Ciriaco Piras at Dorgali. In 1929 he won a scholarship to attend the ISIA in Monza. Two other Sardinians, Giovanni Pintori and Costantino Nivola, were among his fellow students, while his teachers would include Virgilio Ferraresso, Giuseppe Pagano (who immediately followed his work with great interest), Arturo Martini, Marino Marini, Raffaele De Grada and Semeghini. His ceramics, figures, plates and vases decorated in sgraffito or relief that took their inspiration from the Sardinian land and culture, portrayed wild and domestic animals, alone or in groups and often set against natural backdrops. The technique that distinguished them entailed colouring the biscuit with metal oxides while leaving some portions uncovered, and then firing it without fluxes, producing an effect very like that of a matt coloured stoneware. In 1935 he received his diploma and went to Padua for several months with the ceramist Ferraresso, his teacher since 1932. He also worked for his brother-in-law Simone Lai, a potter in Dorgali, supplying him with the designs for several plates (Creazioni Fancello). The following year he was present at the 6th Milan Triennale with a large sgraffito work representing exotic animals (created in collaboration with Nivola) and twelve tiles in unglazed terracotta and glazed ceramic depicting the signs of the Zodiac with which he won the grand prize. In 1937 he met Tullio d'Albisola and in 1938 moved to the latter's hometown in Liguria, where he made 125 pieces at the Mazzotti factory without the involvement of anyone else apart from some lustres applied by Mariano Baldantoni: most of them were figures of animals, along with groups of statuettes for crèches and vases and plates with reliefs and sgraffito designs (the only moulds made were of a series of six small animals). Called up in 1939, in the autumn of 1940 he was still able to fulfil a commission from the architect Giuseppe Pagano for the bas-relief for the refectory of the Bocconi University of Milan at the ILSA in Albisola (cover of *Domus* in November 1941). He died the following March in Albania. A year later, the Pinacoteca di Brera staged an exhibition of his ceramics.
Bibliography
6th Milan Triennale 1936; Pasqui 1937; Pagano 1938; *Domus* July 1940, *Domus*, November 1941; *Domus*, December 1941; *Domus*, March 1942; *Domus*, April 1942; *Stile*, February, April, June 1942; Folliero 1957; *Mostra della ceramica italiana* 1982; Bossaglia 1986; *Salvatore Fancello* 1988; Chilosi, Ughetto 1995; Cuccu 2000; Ausenda, in *Museo d'Arti Applicate* 2002; Cassanelli 2004.
(cat. 456-464)

Farfa, Vittorio Osvaldo Tommasini
(Trieste 1879 – Sanremo 1964)
Futurist poet and painter from the second decade of the century, he was the founder of the Turinese Futurist group in 1919 and later, with Tullio d'Albisola, of the Ligurian one as well. In 1929 he moved to Savona, drawn there by his friendship with Giovanni Acquaviva. His contribution to ceramics, characterized by a particular attention to

the forms, at once original and functional, was made in the thirties. Between 1929 and 1931 he worked with Mazzotti in Albisola, supplying designs for ceramics that would be shown at the exhibitions at the Galleria Pesaro in 1929 and 1930. His Futurist ceramics would also be exhibited at Florence and Chiavari in 1931 and at Trieste, Savona and Paris in 1932. Later he devoted himself chiefly to poetry, drama and, after the war, painting.
Bibliography
Mostra di trentatré artisti futuristi, 1929; Crispolti 1982; Chilosi, Ughetto 1995
(cat. 384)

Faventia Ars, Castellini e Masini
The history of this factory in Faenza is intertwined with that of Minardi. In fact its founders, Francesco Castellini and Luigi Masini, had been among the employees who had taken the factory over on the death of Virgilio Minardi in 1913, and kept it going until 1922. Francesco Castellini opened a workshop and was joined by his brother Ezio, who had previously worked as a cabinet-maker, and Luigi Masini. The company, whose mark consisted of two Cs and an M, was established in 1923, with a production of the traditional type, intended largely for export. Several artists collaborated with the factory, including Giannetto Malmerendi (1893–1968) and Domenico Liverani, while Riccardo Gatti worked there from 1924 al 1928. In 1934 Faventia Ars took over Paolo Zoli's former factory and, in 1937, the former Bubani cooperative. By 1935 it employed around fifty workers, up from the fifteen reported by the *Annuario Industrie della Ceramica e del Vetro* in 1930. It continued its activity, despite many difficulties, even during the war. The factory closed for good in 1956.
Bibliography
Le Arti Decorative, June-July 1924; *La Cultura Moderna*, August 1924; Serra 1924; 2nd Monza Biennale 1925; Marangoni, *Enciclopedia* 1927; *Annuario Industrie della Ceramica e del Vetro* 1930; Minghetti 1939; Dirani, Vitali 1982; Di Genoa 1993.

La Fenice
The factory was set up at Albisola Capo in 1923 by Manlio Trucco and the Genoese painter Cornelio Gerenzani on the former premises of the MAS. Gerenzani, in charge of production in the Antico Savona style, left the company the following year and his role of manager was taken, in 1927, by Manlio's brother Urbano. Trucco imposed his own Deco-modernist style and carried out experiments with sgraffito, lustres and undecorated glazes. In those years the factory was used to produce one-off and multiple pieces by numerous artists, including Adelina Zandrino, Francesco Messina, Emanuele Rambaldi, Mann Servettaz and Francesco di Cocco. Around 1926 Arturo Martini also began to frequent the factory, realizing numerous series of works at La Fenice, commencing with the ones for Mario Labò's Ligurian Oratory at the third Monza Biennale in 1927. After attaining its maximum size in the years 1928–30 (about thirty workers), it came back under the exclusive control of Manlio, who regarded the direction taken by the production as too commercial. In 1933 he had to look for a partner, Ernesto Daglio, to whom he sold out completely in 1936. Romeo Bevilacqua became the artistic director.
Bibliography
Le Arti Decorative, August 1923; 1st Monza Biennale 1923; Carrà 1923; *Emporium*, August 1924; *Le Arti Decorative*, September 1925; 2nd Monza Biennale 1925; *Opere scelte* 1925; 3rd Monza Biennale 1927; Marangoni, *Enciclopedia* 1927; *La Casa Bella*, April 1928; *Domus*, December 1928; *Domus*, March 1929; *Annuario Industrie della Ceramica e del Vetro* 1930; Buzzi 1930; 4th Monza Triennale 1930; *Arte Decorativa* 1931; *Domus*, December 1932; *Domus*, August 1933; ENAPI 1933; 5th Milan Triennale 1933; 6th Milan Triennale 1936; 7th Milan Triennale 1940; Frattani, Badas 1976; *Mostra della ceramica italiana* 1982; Préaud, Gauthier 1982; Rosso 1983; Chilosi, Ughetto 1995; C. Chilosi and Nico Stringa, in *Museo d'Arti Applicate* 2002.
(cat. 222, 223)

La Fiamma
According to the *Enciclopedia Biografica e Bibliografica dei Ceramisti*, it was set up by Ivos Pacetti as a joint-stock company at Albisola Capo in 1929, in continuation of his own craft activity. It was present at the Milan Triennali of 1933 and 1936, where it won a gold medal with dinner services and figures made by Agenore Fabbri, taken on the previous year as a model maker. It also took part with success in the trade fair in Florence known as the Mostra Mercato Artigianato in 1933 (ENAPI first prize for a coffee service) and 1938, showing a variety of articles, from majolica ware with metal glints and ceramics with matt glazes to figures modelled by Fabbri and executed by Pacetti. In 1938 the latter left to run the ILSA.
Bibliography
5th Milan Triennale 1933; 6th Milan Triennale 1936; *Domus*, July 1938; *Mostra della ceramica italiana* 1982; Rosso 1983; Chilosi, Ughetto 1995.
(cat. 256, 257)

Figulina Artistica Meridionale
Factory founded in Naples at the beginning of the 20th century by Ernesto Montrone and Giuseppe Pettinato. Among its collaborators was Giovanni Tesorone (1845–1913), director of the Museo Artistico Industriale. It was distinguished by an up-to-date production in the Art Nouveau style, with the result that Ernesto Basile selected it, along with the Ceramiche Florio, to represent the pottery of Southern Italy at the 1903 Venice Biennale, where it showed pots designed by the architect himself. Again at the Biennale, in 1905, it executed the majolica frieze and floor in the Sala del Mezzogiorno. In 1902, its products were used in the magazine *Arte Italiana Decorativa e Industriale* to illustrate an article by G. Tesorone on the decorative arts movement in Naples.
Bibliography
Tesorone 1902; 5th Venice International Exhibition of Art 1903; *Arte Italiana Decorativa e Industriale* 1906, pp. 27-36; Minghetti 1939; Stringa 1995; *Venezia e la Biennale* 1995; Maldini 1999; Arbace, in *Museo d'Arti Applicate* 2002.

Fillia, Luigi Colombo
(Revello, Cuneo 1904 – Turin 1936)
Painter and writer, he founded the Futurist group in Turin and was an active presence at all the movement's main exhibitions. Fillia came into contact with ceramics in 1929 through Tullio d'Albisola, designing decorations of plates for his factory in Albisola and later, in 1932, *aerovasi*, which were not so much functional vases as Rationalist sculptures created by the interpenetration of solids. In 1934 he made an evocative relief in glazed terracotta depicting a religious subject, *The Cross and the Angel*.
Bibliography
Mostra di trentatré artisti futuristi, 1929; Minghetti 1939; Crispolti 1982; *Mostra della ceramica italiana* 1982; Rosso 1983; Chilosi, Ughetto 1995.
(cat. 396)

Finzi
In the thirties the Milanese silversmith Arrigo Finzi (Venice 1890 – Milan 1973) introduced a line of porcelain, jars and boxes made in Germany and decorated with a refined technique of goldsmithry. The experimentation in this sector began after the Great Depression of 1929: to make the products of his work more accessible, Arrigo Finzi developed methods of applying silver to less expensive materials than precious metals. For this purpose he used Bohemian crystal as well as porcelain from Rosenthal, which were coated with a thick layer of silver in a galvanic bath. After the war some pieces of china, still made in Germany, would no longer be covered with silver, but etched directly with acid and hand-painted in gold and enamel.
Bibliography
Rosso 1983.

Florentia Ars
There are no official records of Florentia Ars until 1902, when the Florentine factory took part in the Universal Exhibition of Modern Decorative Art in Turin. Its production is known to us essentially through photographs that show vases of elongated forms decorated with floral motifs. In the Museo delle Ceramiche in Faenza there is a vase with an unusual organic shape decorated with metal lustres. Writings of the time speak of its derivation from Galileo Chini's Arte della Ceramica, but the claim is not supported elsewhere. Later the factory was unable to maintain this modernist production and switched, like other Tuscan factories, to making copies that ranged from garden furnishings in terracotta to majolica ware decorated with figures and grotesques. Around 1920 it attempted a renewal, adopting bright and contrasting colours, but the Art Nouveau decorative themes were already out of step with the evolution in taste. In 1923 the factory took part in the first Florentine Crafts Exhibition, but the following year was taken over by Chini's Fornaci San Lorenzo, which transferred its production on the wheel to its premises.
Bibliography
Melani 1902; Pica 1902; Conti, Cefariello Grosso 1990; Maldini 1999.

Florio
Ceramics factory founded in Palermo in 1882 by Ignazio Florio, son of Vincenzo, a well-known Sicilian entrepreneur and proprietor of industrial and commercial enterpris-

es like the steamship company Società dei Battelli a Vapore Siciliani, for which the factory initially produced dinner services with the line's trademark. Later the production was expanded, adopting the factory mark of a seahorse in relief and adding to the services objects of Oriental or Art Nouveau inspiration, close to the contemporary output of Ginori and Laveno. The production was subdivided into a first series in matt white porcelain, made up of functional pieces of traditional form, a second series in Iris white porcelain with decorations in relief, and a third series in soft-paste porcelain with painted or transferred decorations. The subjects of the decorations were portraits, mythological scenes, landscapes, Japonaiseries, pre-Art Nouveau floral motifs and, more rarely, vaguely Secessionist geometric patterns. The most important contribution by an artist came from Ernesto Basile (1857–1932), some of whose designs for objects (cup of 1906 for Vincenzo Florio) and tiles (Grand Hotel Villa Igea and Villino Basile) have survived. Limited series were designed and produced for the Florio family and for the industries in Marsala and tuna factories on Favignana which it owned, as well as for several families of the Sicilian aristocracy and for boarding schools and colleges. The *Annuario Industrie della Ceramica e del Vetro* of 1930 lists a Società Anonima Siciliana Ceramiche, which must have been a successor of the factory, where 150 workers produced dinner services. Caught up in the collapse of the Florio's industrial fortunes, the pottery was acquired by Richard-Ginori in 1940 and closed down just a year later.
Bibliography
2nd Monza Biennale 1925; *Annuario Industrie della Ceramica e del Vetro* 1930; Minghetti 1939; Biavati 1973; Fagone 1985; Maldini 1999.

Folco, Fratelli

Factory set up at Savona in 1856 by Carlo Folco and run by his sons Antonio and Sebastiano after his death (1874). The production in soft earthenware was composed of dinner services both for everyday use and of fine quality, some of them decorated in relief, as well as large plates, decorative vases and Della Robbia ware and ceramics for furnishing and architecture, such as frames for fireplaces, mirrors and doorways. The decorations chosen were mostly old-fashioned, sometimes drawn from well-known paintings of the 16th and 17th centuries, and were shown at the most important exhibitions in the closing decades of the century (Milan 1881, Turin 1884, Genoa 1892). The factory shut its doors in 1913, on the death of Antonio Folco.
Bibliography
Minghetti 1939; Chilosi, Ughetto 1995.

Lucio Fontana

(Rosario, Santa Fe, Argentina 1899 – Comabbio, Varese 1968)
In 1928 he moved with his family from Argentina, where he had begun to practise sculpture and to exhibit in 1925, to Milan. With Fausto Melotti, he followed the course of sculpture taught at Brera by Adolfo Wildt. His first works in terracotta date from 1929 and were shown in two exhibitions at the Galleria del Milione in 1931. Even in these early experiences Fontana broke with tradition, experimenting with abstractionism and, using unfired colouring, an unprecedented combination of sculpture and painting. In 1935 he also began to work with ceramics and stoneware, probably firing his first works at Melotti's kiln in Milan. He joined the group of artists headed by Edoardo Persico, with which he showed at the Milan Triennale of 1936. Persico introduced him to Tullio d'Albisola, who brought him to the Mazzotti factory several times between 1936 to 1939 to create polychrome ceramic works that marked a return to figuration, mostly with animal and marine subjects but also still lifes and busts. They were creations that had nothing to do with the production of ceramics and everything to do with art, to the point that he himself felt it necessary to declare 'I am a sculptor and not a potter. I have never thrown a plate on a wheel nor painted a vase.' In 1937 he was able to get an entry into the Sèvres factory, to experiment with the techniques of 'high-fired' ceramics, and while there created works again on the theme of the *Sea Bottom* and *Still Lives* that were shown the same year in two exhibitions in the French capital. At the beginning of 1938 he was back in Italy, producing more pieces that were shown in two exhibitions at the Milione. Between 1940 and 1947 he returned to Argentina, where he went on making ceramic works of the same two types: small pieces mostly representing animals and figures or busts. On his return to Italy he again frequented the potteries of Albisola, where he created works with religious subjects (*Via Crucis*, *Madonnas*, *Crucifixions*, *Deposition*), as well as figurative ones, including several portraits of women, and the series of *Masks* and *Harlequins* presented at the Venice Biennale of 1948. In the fifties and sixties Fontana executed more coloured terracottas at Albisola that were inspired by his new theory of Spatialism (*Spatial Concept*, *Nature*).
Bibliography
6th Milan Triennale 1936; Baumbach 1938; Minghetti 1939; Folliero 1957; *Mostra della ceramica italiana* 1982; Préaud, Gauthier 1982; Rosso 1983; Crispolti 1986; Precotto 1987; Crispolti 1990; Castagnoli 1991; Campiglio 1994; Chilosi, Ughetto 1995; Crispolti, Silicato 1998; Crispolti 1999; Ruiz de Infante, Bojani 1999; Morelli 2002; Crispolti 2006).
(cat. 468-470)

Fornaci di San Lorenzo

Bringing their experience with the Arte della Ceramica to an end as a result of disagreements with the management, Galileo, Chino and Pietro Chini founded the Fornaci di San Lorenzo in 1906, at Borgo San Lorenzo in the Mugello region. The factory did not limit itself to the production of ceramics, but made glassware as well, from chandeliers to stained-glass. Galileo and Chino took the same roles they had had at the Arte della Ceramica, of artistic and technical director respectively. The production in stoneware, made up of pots of essential forms decorated with repeated geometric or figurative motifs such as palmettes and fawns, in cobalt blue on a natural grey or coloured yellow ochre ground, became very important. Large vases in polychrome stoneware with metal-lustre lids were produced as well. The Fornaci San Lorenzo also acquired a financial backer in 1909, in the person of Marquise Teresa Torlonia Germi. In 1911, Galileo went to Bangkok to paint the frescoes in the Royal Palace. On his return, in 1913, the products of the factory came under an Oriental influence that led to the adoption of oval forms, often with lids, with painstaking floral decorations on a speckled ground and covered with metal lustres. The war created difficulties for the factory, and to overcome them a merger with other factories, including Cantagalli, was considered, but the problems would be solved independently, largely thanks to the sector of architectural facings in stoneware. The most important of these was for the Berzieri Baths at Salsomaggiore, for which the factory produced a variety of materials in the twenties, from roof tiles to balustrades and from plaited and gilded fillets to decorative bas-reliefs. The factory in San Lorenzo was given over entirely to these products, made in moulds, and this made it necessary to open a new plant, on the premises of Florentia Ars in Florence, for articles thrown on the wheel. In the same period Tito Chini, Chino's son, began to work for the factory, where he would be given the post of artistic director as a result of disputes between his father and Galileo. The latter still designed the pieces that were sent to represent the Fornaci San Lorenzo at the 1925 Exhibition of Decorative Arts in Paris, but later on left the factory for good. The demanding work for the Berzieri Baths left a permanent mark on the catalogue, in the form of a wide range of articles intended chiefly for use in architectural decoration, formed in moulds and characterized by glazes in brilliant colours, in particular turquoise. In 1930 the business was reorganized by Chino Chini, who assigned the production of ceramics to the factory in San Lorenzo, where about fifty people worked, and that of tiles and glass to the one in Florence. After 1925 the new production bore the signature of Tito Chini and was characterized by geometric decorations in lively colours on Futurist lines or by motifs that were still floral but derived from Art Deco. His brother Augusto, a sculptor, joined the factory in the thirties and was responsible for large monochrome vases, figures and animals. Alongside this decorative output, that of pottery for everyday use continued, including tea and coffee services, jars for preserves, bottles and jugs, often in stoneware and with simple decorations. The factory was destroyed by bombs in 1944 and ceased its activity.
Bibliography
Arte Italiana Decorativa e Industriale, November 1911; *Emporium*, October 1924; 2nd Monza Biennale 1925; *Emporium*, October 1925; *Annuario Industrie della Ceramica e del Vetro* 1930; Vianello 1964; Marsan 1971; Marsan 1974; Nuzzi 1977; Cefariello Grosso 1979; Monti 1981; Benzi 1982; Cefariello Grosso 1982; Préaud, Gauthier 1982; Cefariello Grosso 1984; Benzi 1986; Benzi 1988; Cefariello Grosso 1990; Cefariello Grosso 1993; Benzi 1998;

Benzi 2001; G. Cefariello Grosso, in *Museo d'Arti Applicate* 2002.
(cat. 17-23, 72)

La Freccia
In 1927 Tarcisio Tosin was hired as a modeller at the factory founded in Vicenza by two brothers from Nove, Giobatta and Domenico Brotto. On the latter's death, in 1930, Tarcisio took over the factory, which had a traditional output, and changed its mark to La Freccia. Distinguishing itself from the majority of the local potteries, still clinging to reproduction of the models of the past, the factory cast vases, plates, small sculptures, bookends in the shape of animals and objects of modern taste, decorated by airbrush with glazes in mellow tones. In the space of a few years the number of workers rose from around fifteen to sixty. In the forties and sixties the painters Otello De Maria and Felice Vellani were among its collaborators.
Bibliography
Mostra della ceramica italiana 1982; Rosso 1983; Stringa, Venice 1986.

Fernando Frigiotti
(Macerata 1876 – Rome 1948)
After the First World War he moved from Marseilles, where he had been living, to Rome to teach at the Museo Artistico Industriale, known from 1919 on as the Regio Istituto Nazionale di Istruzione Professionale (RINIP), where he made *buccheri* to designs by Duilio Cambellotti. In 1923 he took part in the first Monza Biennale with the SICLA. Thanks to his technical skill he proved an invaluable collaborator of many Roman artists working in ceramics.
Bibliography
1st Monza Biennale 1923; Quesada 1992.

Galvani
Factory founded at Pordenone by Giuseppe Galvani in 1811. Around 1880 it employed 200 people and up until the First World War produced low-cost earthenware articles for export to Britain. After the war and a serious fire, in 1921, Enrico Galvani took the family business in a new direction, updating both the technology and the style. In 1923 it took part in the first Biennale of Decorative Arts in Monza, exhibiting rustic plates with stencilled decorations in the 'Friulian Dining Room'. Later artists were brought in to collaborate on the production, including the Turinese Teonesto De Abate, who would go on to design for Lenci, Gino Rossi and Eugenio Polesello. At the third Biennale, in 1927, the renewal of production was evident. In 1929 Giacomo Balla provided Galvani with designs for ceramic ware, including a dinner service. The service for the Compagnia di Navigazione Libera Triestina, decorated with stylized real and fantastic animals in bright colours and rapid brushstrokes by the painter Anselmo Bucci (1887–1955), one of the founders of the Novecento movement, dates from 1930. The same year the Venetian painter Angelo Simonetto arrived at Galvani (where he was to remain for over thirty years), becoming the artistic director of the factory and, like Ponti at Richard-Ginori or Andlovitz at the SCI, designing the whole of its output, made up of dinner services and articles in earthenware decorated by airbrush in an Art Deco style. The *Annuario Industrie della Ceramica e del Vetro* of 1930 assigns the factory 240 employees, including workers and clerical staff. In the second half of the thirties the Tuscan sculptor Ruffo Giuntini joined Galvani, where he produced dozens of innovative models of animals as well as female figures, mostly made of soft and uncoated earthenware. The Roman ceramist Roberto Rosati also collaborated with the factory while he was principal of the Scuola di Ceramica in Nove, from 1935 to 1937. He was the author of the large yellow *Cock* of 1936, emblem of the factory in Pordenone. In 1942 Galvani was present at the 23rd Venice Biennale with new ceramics of a Rationalist character. After the war hand-decorated articles became less important than mass-produced ones. The factory ceased its activity at the end of the sixties.
Bibliography
Sarfatti 1923; 2nd Monza Biennale 1925; Agostinione 1925; *Emporium*, September 1925; Ponti 1926; 3rd Monza Biennale 1927; *Emporium*, July 1927; Marangoni, *Enciclopedia* 1927; *La Casa Bella*, June 1928; *Annuario Industrie della Ceramica e del Vetro* 1930; Buzzi 1930; *Emporium*, July 1930; Ponti 1930; 4th Monza Triennale 1930; *Domus*, August 1932; ENAPI 1932; 5th Milan Triennale 1933; Minghetti 1939; 7th Milan Triennale 1940; *Mostra della ceramica italiana* 1982; Rosso 1983; Stringa 1986; Ganzer, Stringa 1996; Nico Stringa, in *Museo d'Arti Applicate* 2002.
(cat. 362-373)

Mario Gambetta
(Rome 1886 – Albisola 1968)
After studying classics in Rome, he moved to Albisola at the beginning of the twenties. For a while he was artistic director of Alba Docilia, where he introduced new forms and decorations. Two of his plates made by Mazzotti were shown at the Monza Biennale of 1925, and for the next one, in 1927, he made the lunette depicting *Saint George* set at the entrance to the Ligurian section. From 1928 to 1932 he was head of the Scuola Ceramica in Albisola, where he gave room to the teaching of the Antico Savona style and put it on a sound footing. At the Monza Triennale of 1930 his works (two vases, three panels and four figures) in elegantly Deco style were noticed by Gio Ponti. At the Union Exhibition in Genoa in 1931 he showed a large terracotta sculpture entitled *Record Woman* whose striking realism caused a sensation and prompted Arturo Martini to intervene in its defence. In 1933 he executed the bas-reliefs for the Savona General Post Office. He went on working with ceramics after the war, but devoted more energy to painting.
Bibliography
2nd Monza Biennale 1925; 3rd Monza Biennale 1927; 4th Monza Triennale 1930; *Le Arti plastiche*, April 1930; Buzzi 1930; *Domus*, May 1933; 5th Milan Triennale 1933; Minghetti 1939; Chilosi, Ughetto 1995; Chilosi, in *Museo d'Arti Applicate* 2002.
(cat. 406)

Guido Gambone
(Montella, Avellino 1909 – Florence 1969)
At Salerno, where he moved with his family, he did not pursue regular studies but devoted himself to painting. In 1927 he moved to Vietri and became a decorator of pottery. He worked at Avallone (becoming its director in 1928) and, after 1930, the Industria Ceramica Salernitana run by the German Max Melamerson. In 1933 he had a leg amputated as a result of a road accident. In those years several artists from Northern Europe were working in Vietri. The best-known of them were Richard Dölker and Irene Kowaliska, whose innovative work had an influence on Gambone. In 1936 his ceramics were shown at the Milan Triennale (panels *The Sirens* and *Island of Happiness*). In 1937 he followed Melamerson to Florence, where the German had taken over the management of Cantagalli. Until 1938 he was given complete charge of a separate department in this factory where, alongside products in line with the Vietri tradition, he made pottery that reflected a cultivated Novecento taste. In 1943 he opened, with the ceramist Andrea D'Arienzo, a factory in Vietri called La Faenzerella, whose products were distinguished by a glaze, made from glass and sand, with a rough and dense appearance. The models ranged from objects of everyday use that harked back to the Vietri tradition to original forms of a zoomorphic and anthropomorphic character, like the flask in the shape of a reclining woman with which it won the Faenza Prize in 1949 (other Faenza Prizes in 1947, 1948, 1950 and 1960). In 1950 the artist moved permanently to Florence, where he continued his work as a ceramist independently.
Bibliography
Domus, June 1937; Minghetti 1939; *Stile*, November 1942; 8th Milan Triennale 1947; Folliero 1957; Frattani, Badas 1976; *Mostra della ceramica italiana* 1982; Préaud, Gauthier 1982; Caròla-Perrotti, Ruju 1985; Napolitano 1989; Alamaro, Donato 1991; Caserta 1994; Romito 1994; Biffi Gentili, 'Dalle civiltà del passato,' in Pansera 1995; Alamaro 1996; Viscusi 1996; Romito1999; Romito, *La Collezione Camponi* 1999; Salvatori, in Picone Petrusa 2000; Bignardi 2003.
(cat. 453)

Giovanni Gariboldi
(Milan 1908–1971)
He attended the Brera art school and immediately afterwards commenced a long collaboration with Richard-Ginori. His name appears alongside that of Gio Ponti in the catalogue of the 1930 Monza Triennale as the author of a series of 'art earthenware painted over the glaze' produced by the factory of San Cristoforo. At the Milan Triennale of 1933 he was listed as the creator (although his name is still associated with Ponti's in the catalogue) of vases with engravings in silver on a matt grey ground, plates in engraved and glazed stoneware, more pots with a matt coloured glaze and ivory decoration and small figures (*Pegasus*, *Farewell*, *Sea*, *Dolphins*) in matt white or metallic black glaze, all made at the factory of San Cristoforo in Milan. At the 1936 Triennale Gariboldi's name finally appears independently of Ponti's, although he was still not yet head of the artistic department, a post held by Fred Brown, a specialist in the design of

dinner services. He presented some realistic sculptures of animals in stoneware (*Foal*, *Deer*, *Dromedary*), vases glazed in different colours and characterized by irregular walls, with pitted surfaces or mock drapery, and a decorative panel of tiles. The following year, his production in matt porcelain and gold (*Cockerel*, candlesticks, vases, tea services) or in earthenware with a shiny or matt glaze, decorated with scoring and reliefs, was shown at the Paris Exhibition. In June 1940 an article in *Domus* entitled 'Richard-Ginori or On Refinement' and devoted to the evolution of Gariboldi's design illustrated numerous pieces presented at the Triennale that year. They consisted of a tea service in white porcelain spattered with gold, two frames, a set of vases in porcelain and decorative dishes (*Antique Weapons*, *Bowl of the Sea*) with cameo decorations inspired by the production of the Wedgwood factory in England. In October 1942 it was the magazine *Stile* that featured him, describing him as the 'artist, Giovanni Gariboldi, formed at Richard-Ginori and therefore legitimately representative of it'. In 1946 he was placed in charge of Richard-Ginori's Artistic Centre. In 1954 he won the Compasso d'Oro for a dinner service. He would continue to work with the Milan-based company until the beginning of the seventies.
Bibliography
4th Monza Triennale 1930; *Domus*, May and August 1933; 5th Milan Triennale 1933; *Domus*, June 1936; *Emporium*, August 1936; 6th Milan Triennale 1936; Minghetti 1939; *Domus*, June 1940; *Emporium*, May 1940; *Stile*, December 1941, October 1942; Folliero 1957; Morazzoni 1957; *Mostra della ceramica italiana* 1982; Rosso 1983; Cefariello Grosso, Maggini Catarsi, Monti 1988; Biffi Gentili, *Viva Gariboldi*, in Pansera 1995; Terraroli, *Milano Déco* 1998; Ausenda, Milan 1998; Barisione 1999; Ausenda, in *Museo d'Arti Applicate* 2002.
(cat. 312-323)

Riccardo Gatti
(Faenza 1886–1972)
He attended Antonio Berti's Scuola di Arti e Mestieri and, at the same time, worked at Minardi. At the Torricelli Exhibition in Faenza in 1908 he was awarded the silver medal for a bust of a woman. The following year he left Faenza for Florence, where he attended the Accademia di Belle Arti with Francesco Nonni, focusing chiefly on sculpture. In 1911 he was obliged to go back to Faenza and work at the Minardi factory again, remaining there until 1913. He then moved to Rome, living off occasional jobs and concentrating on ceramic sculpture until the beginning of the war, when he was enlisted. Returning to Faenza, he found work at the Fabbriche Riunite and stayed there until 1924, when he moved to Faventia Ars, where he was allowed to express himself freely and given the time to build and use a small kiln in his own home. In 1928 he opened the workshop Gatti & C., where he worked with his wife Lucia Servadei and no more than eight employees. Gatti was attracted by Futurism, with which he came into contact through the writer Giuseppe Fabbri from Pieve di Cento, who supplied him with designs for ceramics by Giacomo Balla and the most active exponent of the movement in the region, Mario Guido Dal Monte. The same year the Futurist creations of the Gatti workshop were shown in Faenza at the *First Exhibition of Futurist Ceramics*. At the Barcelona International Exhibition in 1929, Giuseppe Fabbri presented works by Gatti and Ortolani to designs by Balla, Dal Monte, Benedetta Marinetti, Remo Fabbri and Pippo Rizzo under the mark 'Ceramiche Futuriste G. Fabbri Faenza'. But in October of the same year Gatti showed his own creations in the *Exhibition of Thirty-three Futurist Artists* at the Galleria Pesaro in Milan, the only ceramist apart from Tullio d'Albisola. However the Futurism of the artist from Faenza remained more superficial than the Ligurian's, limited to the decoration and not affecting the form of the objects. In 1930 the workshop abandoned Futurism and adapted to the Art Deco taste, which in those years found two authoritative guides in Giovanni Guerrini, director of the ENAPI, and Gio Ponti, editor of *Domus*. The ceramist set about experimenting with the glazes, reflective surfaces and metal lustres that were to become the main characteristic of his workshop. Following his original vocation for sculpture, he conceived and realized small figures of women and animals with reflective surfaces. In 1933 the workshop was enlarged and the first electric kiln in Faenza installed. It showed at the International Exhibition in Paris in 1937 and at the one in Berlin in 1938, where it won a gold medal. In 1942, one of his vases with a resinate lustre won the National Competition in Faenza.
Bibliography
Mostra di trentatré artisti futuristi, 1929; ENAPI 1932, 1936, 1938; Minghetti 1939; 7th Milan Triennale 1940; *Domus*, September 1941; Crispolti, Florence 1982; Dirani, Vitali 1982; *Mostra della ceramica italiana* 1982; Rosso 1983; Riccardo Gatti, *Faenza* 1986; Bojani, *Faenza* 1987; Savini 1992.
(cat. 231-233, 292-294)

Alf Gaudenzi
(Genoa 1908–80)
In 1926 he joined the Futurist movement. Initially he devoted himself to exhibition design and commercial art. At the end of 1929 he made contact with Tullio d'Albisola and the Mazzotti factory, for which he designed the decorations of a set of plates dedicated to the celebration of Fascism, presented at the Monza Triennale of 1930. He was also the author of several series of small humorous sculptures (*Moustached Men*, *Musicians*, *Circus*, *Couples*).
Bibliography
Mostra di trentatré artisti futuristi, 1929; *Domus*, February 1935; Minghetti 1939; *Stile*, November 1942; Folliero 1957; Crispolti 1982; *Mostra della ceramica italiana* 1982; Rosso 1983; Chilosi, Ughetto 1995.

Golia, Eugenio Colmo
(Turin 1885–1967)
The Turinese caricaturist, illustrator and poster designer Eugenio Colmo, known as Golia (the nickname was given him by his friend Guido Gozzano), began to devote himself to the decoration of ceramics in 1922. He used porcelain or earthenware plates available on the market and painted them overglaze in his studio, before firing them at low temperature. In this way he produced an incredible series of over 1500 signed, dated and progressively numbered one-off pieces. He took part in the Monza Biennale of 1923 and the Paris Exhibition in 1925, where his work was well-received, although Ugo Nebbia in *Emporium* expressed his doubts over a 'graphic virtuosity' that seemed remote from the actual nature of the pottery. In 1927 this activity came to an end; after that date he only made a few pieces, in 1936, on order from friends. Later he went back to graphic art, fashion and the poster. Many of his painted ceramics would be destroyed in a bombing raid in 1943 that hit his house and studio. His works were characterized by a clear line and brilliant colouring. The subjects could be dense expanses of flowers and leaves, sometimes interspersed with birds and other animals, often the isolated protagonists of the pieces, Oriental in flavour and still reminiscent of Art Nouveau, or female figures of clear Art Deco derivation, close to the Ballets Russes and the world of Erté and fashion, but also to 18th-century art. Only a very limited number of pieces have survived from his vast output.
Bibliography
Carrà 1923; Nebbia 1925; Bossaglia 1980; Bojani 1981; *Annitrenta* 1982; Bojani 1982; *Mostra della ceramica italiana* 1982; Préaud, Gauthier 1982; Rosso 1983; Taverna, De Caria 200).
(cat. 196, 197)

Giovanni Grande
(Turin 1887–1937)
He attended the courses of painting at the Accademia Albertina in Turin and painted pictures characterized by intense psychological introspection and profound religious feelings. At the Milan Biennale in 1914 he showed *The Philosopher*, now in the Galleria d'Arte Moderna in Turin, and in 1926 took part in the Venice Biennale. In 1928 he began to collaborate with Lenci, producing numerous models, mostly groups of figures on a mythological or biblical theme. The exhibition at the Galleria Pesaro in Milan in 1929 included a total of nineteen of his works. He made use of his experience at Lenci to set up a school of ceramics called Laros with his wife Ines.
Bibliography
Ceramiche di Lenci 1929; *La Casa Bella*, April 1929; *Domus*, July 1929; *La Casa Bella*, April 1930; *Domus*, March, April, May, December 1930; *La Casa Bella*, November, December 1931; Buzzi 1930; Minghetti 1939; *Mostra retrospettiva* 1942; Proverbio 1979; Bossaglia 1980; *Mostra della ceramica italiana* 1982; *Le ceramiche Lenci* 1983; Rosso 1983; Panzetta 1992.
(cat. 198-203)

Ines Grande
(Brescia 1890 – Rome 1978)
Wife of Giovanni Grande and a painter who produced numerous models for Lenci, Ines Grande also collaborated with other factories set up in the wake of its success, such as Sandro Vacchetti's Essevi and Nello Franchini's Igni. She and her husband went on to found the Laros school of ceramics.

Bibliography
Proverbio 1979; *Le ceramiche Lenci* 1983; Panzetta 1992.

Grazia

Founded at Deruta in 1923 by Ubaldo Grazia as the Società per Azioni Combattenti Giuseppe Grazia, in which citizens of Deruta from different social backgrounds held shares. The production consisted in a wide variety of copies and reworkings of Deruta ware and Italian pottery in general. Some of the forms used for traditional decorations were also made in monochromatic versions, which at the beginning represented the only modernization of the firm's historicist repertoire. In the twenties the Roman ceramist Virgilio Retrosi frequented the factory, and was responsible for a plate with a head of Medusa dated 1928. From the end of the thirties the pottery alternated periods of crisis, which even forced it to close down for several months in 1940, with periods in which it remained active but the quality of the production was fairly poor. A degree of stability was not attained until after 1948, when the factory managed to regain a foothold on the foreign markets that had always been the chief outlet for a production based on the revival of models from the past.
Bibliography
Annuario Industrie della Ceramica e del Vetro 1930; Minghetti 1939; Bojani 1992; Ranocchia 1999; Busti, Cocchi, in *Museo d'Arti Applicate* 2002.

Gregorj

Factory founded at Treviso around 1840 as a brickyard that was destroyed by fire and reopened in 1887 by Gregorio Gregorj (Casier 1853 – Treviso 1938). At the turn of the century, the factory branched out from the production of bricks to make facing tiles and signs decorated with naturalistic motifs that drew in part on Renaissance painting and in part on Art Nouveau. In 1903 Cesare Laurenti made the *Frieze of the Portrait* (with its best-known part, *The Golden Statues*) at the kiln: made up of tiles decorated with gold and lustres in a third firing, it was presented at the Venice Biennale, the first to which the decorative arts were admitted. In the early years of the century, Gregorj sought the collaboration of other Trevisan artists, including Arturo Martini. As well as buying some of his terracottas at the exhibitions held in Treviso in 1907 and 1908, the factory allowed him to use its workshop, where the sculptor also made some models to be brought into production. In 1909 Martini was sent by Gregorj to the school of the sculptor Adolf von Hildebrand in Munich, where he studied Secessionist Symbolism. On his return, the artist supplied the factory with models for earthenware vases in low relief (*Fables Vase*, *Lions Vase*, *Caryatids Vase*, *'In girum' Vase*), tiles in high relief and small sculptures (*Icarus*, *The She-wolf*, *The Mushroom*, *Woman Sowing*, *The Reading*, *The Pensive Woman*) that would remain in production until the twenties. These pieces were influenced by his Secessionist experiences and in some ways anticipated Art Deco. Some of these creations were shown at the Exhibition of Fine Arts in Milan in 1912 and, before that, at the exhibition at Ca' Pesaro in 1911. In 1913 Martini executed his fundamental work the *Girl Full of Love* at the factory, in six versions decorated in different ways. Around 1910 the Venetian painter Gino Rossi (1884–1947) also collaborated with the factory. In 1925 it took part in the Monza Biennale with some pottery and a fireplace. The *Annuario Industrie della Ceramica e del Vetro* of 1930 lists the factory as having sixty workers.
Bibliography
Pica 1902; *Arte Italiana Decorativa e Industriale*, May 1903; Agostinione 1925; 2nd Monza Biennale 1925; *Opere scelte* 1925; *Annuario Industrie della Ceramica e del Vetro* 1930; Minghetti 1939; Melegati 1988; Stringa 1995; Maldini 1999; Bojani 2001.

Italo Griselli

(Montescudaio, Pisa 1880 – Florence 1958)
He studied art in Florence and devoted himself to sculpture, winning the 1905 competition for a statue for the monument to Victor Emmanuel II in Rome and, in 1908, the one for the group celebrating *Military Valour* on the Ponte Vittorio Emanuele II, again in the capital. For a long period, spanning the revolution, he was in Russia, where he first worked for Tsar Nicholas II and then taught at the academy in St Petersburg. He returned to Italy in 1923 and collaborated with Richard-Ginori, modelling ceramic sculptures designed by Gio Ponti, including the *Centrepiece of the Embassies*, *The Promised Land* and *The Greyhound*. He also worked for the Manifattura di Signa (large female figure exhibited at the Triennale of 1933). In 1935 he won the competition for the marble group representing an *Allegory of the Arno* at Florence station. In 1939 he won a gold medal at Paris Exhibition with the work *Nude Woman*.
Bibliography
3rd Monza Biennale 1927; 4th Monza Triennale 1930; Ponti 1930; 5th Milan Triennale 1933; ENAPI 1933; *Domus* September 1933; Minghetti 1939; *Annitrenta* 1982; Cefariello Grosso, Maggini Catarsi, Monti 1988; Conti, Cefariello Grosso 1990.

Giulio Guerrieri

(Castelli 1899 – Venice 1963)
In 1925 Giulio Guerrieri moved from Castelli, where he had attended the art school, to Venice, where he probably worked in one of the small factories active in the city in those years. Towards the end of the decade he opened a workshop of his own on Murano, on the premises of the ICAM, and would be joined there in 1934 by his brother Archimede, an expert decorator of ceramics. The production ranged from the traditional pottery of Castelli and popular Venetian plates to modern creations. In the thirties, Umberto Bellotto made a series of popular plates there and Emilio Vedova would carry out his first experiments with ceramics at the factory after the war. It closed its doors in 1965.
Bibliography
Minghetti 1939; Stringa, *Terre Ferme*…1987.

Carlo Guerrini

(Florence 1880 – ?)
Graduating in 1903 from the Scuola Professionale di Arti Decorative e Industriali di Santa Croce in Florence, he then qualified as a teacher of artistic subjects. From 1902 he worked at Cantagalli as a designer and teacher of drawing at the attached school, and from 1907 also taught professional drawing and geometry at the Santa Croce school. At the Monza Biennale of 1923 he presented with Cantagalli a set of apothecary jars that was later acquired by Cincinnati University. On this occasion Guerrini offered an example of a decorative production that interpreted folk and rural themes in a new way, in line with the Art Deco style. Following this experience the factory offered the artist the job of artistic director of the decorative department. In 1924 he went with the Santa Croce school, now an art college, to its new home at Porta Romana, still with the role of teacher of geometry and professional drawing as well as that of head of the ceramics and glass department, although the latter courses did not start until 1927. Despite his teaching commitments Guerrini did not neglect his relations with Cantagalli, to which the school had in any case been linked since its origin.
Bibliography
Domus May 1930; 4th Monza Triennale 1930; Ettorre 1936; *Mostra della ceramica italiana* 1982; Cappelli, Soldani 1994.

Giovanni Guerrini

(Imola 1887 – Rome 1972)
He received his artistic and cultural training at the Scuola di Disegno T. Minardi in Faenza and in the so-called coterie of Baccarini. He spent time in Florence, devoting himself to graphic art and fresco decoration. In 1915 he became a teacher of architecture and decorative painting at the Accademia di Belle Arti in Ravenna. He showed at the most important national art exhibitions, from the Secessions and Biennali in Rome to the Venice Biennali, Monza Biennali and Milan Triennali. In parallel to his activity as an engraver and painter he worked on the design of furniture and objects of applied art in wood, glass, metal and ceramics. Around 1920, in Faenza, he supplied designs for ceramics to Zoli and Melandri's La Faïence, then to Melandri and Focaccia and to Anselmo Bucci. In 1926 he took part in the *Exhibition of the Italian Twentieth Century* and promoted the Scuola del Mosaico in Ravenna. From 1927 to 1946 he was artistic director at the ENAPI (Ente Nazionale delle Piccole Industrie) in Rome, for which he would organize the Italian contribution to the International Exhibition in Barcelona in 1929, one room of the Pavilion of Decorative Arts at the Venice Biennale of 1932, the 'Handicrafts of Italy' section at the Milan Triennale of 1936 and numerous other national and international exhibitions. Between 1927 and 1932 he designed a series of objects for the ENAPI to be made out of various materials, from glass to ceramic and from wood to metal. These designs were characterized by basically geometric forms with the addition of highly stylized figurative elements. His designs for ceramics were executed by Bubani, Bucci, the ILSA, La Fiamma, Melandri, Mario Morelli and the SIMAC. In 1928 he presented several vases at the Turin Exhibition characterized by a decoration in relief on a white glaze similar to the

one already tried out by Bucci and Rambelli at the school in Faenza. At the Milan Triennale of 1933 his creations, made by Melandri, had no decorations but made an impression with their refined Deco design. In 1939 he worked on the design of the building for the Crafts Exhibition at the EUR and in 1941 won the competition for the execution of part of the mosaics in the Palazzo dei Congressi at the EUR. His indefatigable activity as an organizer and promoter of the decorative arts continued after the war.
Bibliography
Domus, December 1928; *Domus*, October 1933; ENAPI 1933; ENAPI 1936; Frattani, Badas 1976; Contini 1977; Bossaglia 1980; De Guttry, Maino, Quesada 1985; Bertoni, Ghetti Baldi 1990; Savini 1992.

Icaro
Founded in 1930 on the island of Rhodes in the Aegean by Luigi De Lerma, from the Avallone factory in Vietri, and Dario Poppi from Faenza, active in the same factory from 1927 with Guido Gambone. Much of its production was reproduced in a manual for use in schools of handicrafts and by amateurs published in 1936: it consisted for the most part of plates and pots decorated with motifs, some of them fairly complicated, drawn from tradition, but there were also a few modern pieces.
Bibliography
Ettorre 1936; Minghetti (entries De Lerma and Poppi) 1939; Caròla-Perrotti, Ruju 1985.

ICS, Industria Ceramica Salernitana
Flora and Max Melamerson, entrepreneurs from Hamburg, came to Vietri in 1926 and took over the Della Monaca factory at Marina, where they opened the ICS the following year. Its management was entrusted to Richard Dölker and the ceramist Margaret Thewalt Hannasch, in Florence at that time, the thrower Piesche from Dresden and the sculptor Lothar Eglin were called to work there. Dölker left the factory in 1928, but had already taken its production in a way that distinguished it from the craft industry and made it a success at a national level. *Domus* devoted an article to it in the May of 1929 in which Dölker's name is not mentioned, but many of the objects represented clearly bear his mark, while three panels made up of tiles still have his logo, a Möbius strip surmounted by a cross, whose elimination from the objects made in the factory under his management had been the main reason for the break with Melamerson. His collaboration with Guido Gambone began in 1930. Ceramic ware made by the ICS and selected by Domus Nova appeared in the January 1930 issue of *Domus*, while in October of the same year some pieces were placed on a corner cupboard by Tomaso Buzzi shown at the Monza Triennale. At this time the factory employed about fifty people. In 1931 Irene Kowaliska joined the factory as a decorator. In 1934, the ICS closed and the Melamersons then moved to Florence to run the troubled Cantagalli factory. The attempt to save the business, made in collaboration with Guido Gambone, entailed the transfer of production of some of the articles made by the ICS to the Florentine factory, with the result that some of them bore both marks (in July 1938 *Domus* published two figurines with the old mark, a *donkey* and a *Noah's Ark* shown at the ENAPI Exhibition in Florence), but was not successful and came to an end in 1939. At the beginning of the forties the Melamersons re-established the Manifattura Artistica Ceramica Salernitana (MACS) at Vietri, which remained active until 1947 and obtained commissions from public bodies like the Triennale d'Oltremare in Naples in 1940 (the *Arab Café*), on which the Sardinian artist Melkiorre Melis collaborated. It also took part in the ENAPI Exhibition at the 7th Milan Triennale, showing masks and various pieces of pottery. During the war the Melamersons were interned in a concentration camp at Viterbo.
Bibliography
Faenza, I, 1927; *La Casa Bella*, September 1928; *Domus*, May, December 1929: *Problemi d'arte attuale*, March 1929; *Annuario Industrie della Ceramica e del Vetro* 1930; Buzzi 1930; *Domus*, January 1930; Reggiori 1930; 4th Monza Triennale 1930; *Arte Decorativa* 1931; *Domus*, June, August 1932; ENAPI 1932; *Domus*, September 1933; ENAPI 1933; 5th Milan Triennale 1933; ENAPI 1936; 5th Triennale 1936; *Domus*, June 1937; *Domus*, July 1938; Pagano 1938; ENAPI 1940; *Stile*, November 1942; Frattani, Badas 1976; *Mostra della ceramica italiana* 1982; Rosso 1983; Caròla-Perrotti, Ruju 1985; Romito 1994; Romito 1999; Romito, *La Collezione Camponi* 1999; Salvatori, in M. Picone Petrusa 2000; Arbace, in *Museo d'Arti Applicate* 2002.
(cat. 447-452)

Igni
Ceramics factory active in Turin in the thirties. Run by Nello Franchini and S. Bertrand, it produced figurines in Art Deco style, mostly of women. As at Essevi, Otto Maraini and Ines Grande collaborated with the factory.
Bibliography
Minghetti 1939; Rosso 1983.

ILCA, Industria Ligure Ceramiche Artistiche
Ceramics factory founded at Genoa Nervi in 1928 by Mario Labò. The production was split between the traditional (the Genoese symbol of the Lantern) and the modern (two-faced king/queen). Its first products in relief were small decorative sculptures conceived by Arturo Martini and shown in 1927 at an exhibition at the Galleria Pesaro, formerly made at La Fenice under the Savona Nuova mark, and several ceramic slabs by the same author. In 1929–30, a new series of one-off figures (modelled as single pieces) by Martini was brought out, including several representing animals presented at the Monza Triennale. Artists like Emanuele Rambaldi and Oscar and Fausto Saccorotti worked on colouring Martini's works, as well as the design of other decorations and pieces. The production was characterized by a deliberate simplicity of modelling that sometimes verged on sloppiness. This, combined with the experimental character of many works and their high prices, resulted in the production's commercial failure, to which Labò reacted by giving greater space to a more popular range of objects. The operation was not a success and, after the closure of DIANA, the factory ceased its activity in 1931.
Bibliography
Annuario Industrie della Ceramica e del Vetro 1930; Buzzi 1930; 4th Monza Triennale 1930; *Mostra della ceramica italiana* 1982; Chilosi, Ughetto 1995.
(cat. 216, 217, 219-221)

ILSA, Industria Ligure Stoviglie e Affini
Founded in 1920 as a cooperative of workers in the crockery industry of Albisola, it was transformed into a joint-stock company called the ILSA in 1923. It was run by a technician, Francesco Perotti, who between 1928 and 1929 added to the crockery factory an artistic department, headed until 1932 by Ivos Pacetti. In 1930 the factory had eighty workers, a large number for the Ligurian ceramics industry. The production took its inspiration from both the Art Deco of La Fenice and the Futurism of Mazzotti, without finding a distinctive style of its own until Nino Strada became the artistic director and focused on archaism and the quality of glazing and painting. The sculptor Mario Raimondi modelled several small figures (*Bagpiper*, *Adolescence*) for the factory. Ivos Pacetti returned in 1939, designing a substantial number of pieces (sculptures and paintings on ceramic) that, along with others by Agenore Fabbri and Mario Raimondi, were shown at the ninth Crafts Exhibition in Florence and the Milan Triennale of 1940. In the same year the factory made the tiles in relief of the large panel by Salvatore Fancello for the Bocconi University. After the war the factory became a cooperative again, while Perotti set up a new ILSA at Carcare in 1948, where various artists, from Agenore Fabbri to Lucio Fontana, would work in the fifties and sixties.
Bibliography
Annuario Industrie della Ceramica e del Vetro 1930; *Arte Decorativa* 1931; *Domus*, July 1939; 7th Milan Triennale 1940; Frattani, Badas 1976; *Mostra della ceramica italiana* 1982; Rosso 1983; Chilosi, Ughetto 1995.

Industria Ceramica Napolitana
Factory founded in Naples in 1882 by Count Candida Gonzaga, Prince Capece Minutolo and Cavalier Lignola. The three men were directly involved in the running of the pottery, which produced ornamental vases with naturalistic decorations, often in relief, painted plates and groups inspired by Neapolitan costume and folklore. The technical manager was Giuseppe Mosca, who introduced the technique of barbotine, or slip decoration.
Bibliography
Minghetti 1939 (entry Candida Gonzaga); Ruju, Alamaro, Caròla-Perrotti 1984; Maldini 1999.

ISIA
The Istituto Superiore per le Industrie Artistiche in Monza was founded in 1922 by a consortium of philanthropic associations in Milan and the municipalities of Monza and Milan, the same one that ran the Biennial Exhibitions of Decorative Art. It was intended to be a 'university of the decorative arts', something which had no

counterpart in Italy at the time, inasmuch as it was not directly aimed at vocational education, and so was different from the training schools, but was not limited to the study and practice of the so-called pure arts, and thus differed from the academies of fine arts. Among its various 'specialities' was ceramics, whose teaching was entrusted to the German ceramist Karl Walter Posern. In 1929–30 Arturo Martini held the chair of plastic arts, which would then be occupied, until 1940, by Marino Marini. In 1931 the ISIA staged an exhibition at the Galleria Milano with articles made in all its workshops, i.e. furniture and other objects that were used to create fully furnished rooms. From 1933 until the school's closure in 1943, Umberto Zimelli taught decorative composition. Among the students to reach the highest level of expression in the medium of ceramics were Mario Sturani, who went straight to work at Lenci, and Salvatore Fancello, while the Swiss Amato Fumagalli was first a pupil and then a teacher. At the Triennale of 1936 the ISIA showed numerous pieces (ceramic groups, vases decorated in sgraffito, terracotta sculptures and various pieces of coloured pottery and stoneware) and two large works, a ceramic decoration with the signs of the Zodiac to a design by Nivola and a wall decorated in sgraffito, executed by Fancello.
Bibliography
La Casa Bella, August 1930; *Domus*, May 1930; 4th Monza Triennale 1930; *Mostra of the Istituto Superiore Industrie Artistiche* 1931; *Domus*, February 1936; Papini 1936; 6th Milan Triennale 1936; Pasqui 1937; *Domus*, February 1939; *Domus*, July 1940; Bossaglia 1986; Terraroli, *Le Arti Decorative…* 1998; Ausenda, in *Museo d'Arti Applicate* 2002.
(cat. 454, 456)

Alberto Issel
(Genoa 1848–1926)
A realist painter who was forced to devote himself to the applied arts by a disease of the eyes. Known chiefly for his furniture in the Art Nouveau style, he also worked with ceramics, although more as a commissioner of pieces for a shop he ran in Genoa than as an entrepreneur or craftsman. He took part in the Turin Exhibition of 1884, where he worked in one of the medieval shops, describing himself as a 'master potter and crockery maker'. The few ceramic pieces to have survived suggest an abiding attachment to historicism. He is known to have had links with Chini, with Alba Docilia, at which some of the ceramics presented at the Monza Biennale in 1923 were made, and with La Fenice.
Bibliography
2nd Monza Biennale 1925; Chilosi, Ughetto 1995; Barisione 1999.

Istituto d'Arte of Florence
In 1867 the School of Applied Drawing was set up in Florence for the training of cabinetmakers and woodcarvers. It was not until 1919 that it became an Industrial Artistic School with three levels of teaching, i.e. no longer focused exclusively on the training of woodworkers but also on that of draughtsmen and designers, and until 1923 that the teaching of ceramics was included. Pre-eminent among the teachers at the school, run by Ugo Ojetti, was the sculptor Libero Andreotti, who held the chair of decorative sculpture, while the head of the ceramics department was Carlo Guerrini, an expert ceramist and artistic director of Cantagalli, with which the school established a relationship of exchange that led well-known artists like Guido Balsamo Stella and Gianni Vagnetti to collaborate simultaneously with one and teach at the other. In 1930 the Istituto d'Arte participated in the fourth Monza Triennale with ceramic pieces conceived by promising students like Fantoni and Tempestini, displayed in Buzzi's 'Theatre of Italian Ceramics' along with the most successful products of Albisola. *Domus* (May 1930) published several of these vases and plates decorated with motifs of rustic inspiration, very close to the style of Cantagalli's contemporary production. A pot with a lid made at the school appeared on the magazine's cover in the February of the following year. Figurines and panels with allegories of work would be shown in the *Exhibition of the Schools of Art* at the sixth Triennale.
Bibliography
Domus November, May 1930; 4th Monza Triennale 1930; *Domus*, February, March 1931; Ettorre 1936; 5th Milan Triennale 1936; Pasqui 1937; *Domus*, December 1938; *Mostra della ceramica italiana* 1982; Cefariello Grosso, in *Museo d'Arti Applicate* 2002.

Istituto d'Arte of Venice
Set up in 1873 as the Venetian School of Art Applied to the Industries, it became an Istituto d'Arte, or Art College, in 1917 and from 1924 had a regular course of ceramics, taught by Giovanni D'Arcangelo until 1937. Some of those who were to become the best-known ceramists of the Veneto region in the second half of the 20th century, Alessio Tasca, Federico Bonaldi, Angelo Spagnolo, Elio Schiavon and Cesare Sartori, were trained there. It participated in the Monza Biennale of 1925 and the Venice Biennali of the early fifties.
Bibliography
2nd Monza Biennale 1925; Marangoni, *Enciclopedia* 1927; Stringa, *Terre Ferme…*1987; Nico Stringa, in *Museo d'Arti Applicate* 2002.

Abele Jacopi
(Pietrasanta, Lucca 1882–1957)
He studied sculpture at the art college in Pietrasanta and devoted himself to the creation of celebratory and monumental works, including the monument to the fallen in his hometown. In 1934 he began to collaborate with Lenci, making several pieces that were distinguished by the quality of their execution. Particularly outstanding was the series of regional costumes, but also the group *Family of Tritons*. His son Giovanni, also a sculptor, had collaborated with Lenci before him.
Bibliography
Proverbio 1979; *Le ceramiche Lenci* 1983; Panzetta1992; Barisione 1999.
(cat. 207-209, 377)

Elena König Scavini
(Turin 1886–1974)
Her father had moved with his family to Italy from Germany to run the agricultural station at Turin University. In 1898, after her father's death, she and her sister Herda followed Madame Nouma-Hawa's circus for five months, an experience that left a deep impression on her and was to influence her work as a ceramist. In 1902 she went to Lausanne with her mother, employed as an interpreter in a hotel, and then both moved to Frankfurt. She returned to Turin in 1905, to stay with her sister who was living with the poet Ignazio Vacchetti. The following year she was back in Germany, at Düsseldorf, where she attended the School of Applied Art and took a diploma in photography in 1907. She opened a studio of photography and hand-printing on fabric in the same city and frequented many young artists, including Clare Burchart, creator of models for large porcelain factories who was to collaborate with her later on. She went back to Turin in 1915 and married Enrico Scavini, with whom she founded Ars Lenci in 1919. The factory produced wooden toys, furniture, cloth dolls and, from 1928 on, the ceramics it is best known for. She personally designed numerous models, including six (*Say Yes to Me*, *Snail*, *Marianna*, *Angelus*, *Nude with Apple*, *Tanagra*) of the ones presented at the exhibition held at the Galleria Pesaro in Milan in 1929. The same year *Domus* published two of her pieces (*Marianna* and *Box with Pensive Female Figure*) in its July and August issues, and the figurine *Resignation* in that of July 1932. Her activity at Lenci continued until 1941, when the company changed hands. After the war she devoted herself to antiques, interior decoration and sculpture.
Bibliography
Ceramiche di Lenci 1929; *La Casa Bella*, April 1929; *Domus*, July and August 1929, July 1932, June 1936; Minghetti 1939; Proverbio 1979; Bossaglia 1980; *Annitrenta* 1982; *Mostra della ceramica italiana* 1982; *Le ceramiche Lenci* 1983; Rosso 1983; König Scavini 1990; Panzetta 1992; Ausenda, in *Museo d'Arti Applicate* 2002.
(cat. 204)

Maurizio Korach
(Hungary 1888 – Budapest 1975)
A Hungarian chemical engineer, he graduated from the Budapest Polytechnic under Vincent Wartha, an expert on ceramic technology who developed the lustres used by the Zsolnay factory in Pécs. In 1911 he moved to Italy, and in 1914 was assistant in the faculty of mineralogy at the University of Padua. The following year he met Gaetano Ballardini, who asked him to define the terms for the teaching of technological subjects at the School of Ceramics that he was trying to set up alongside the Ceramics Museum in Faenza. When this opened, in 1919, Korach became the head of the experimental workshop and a teacher of ceramic technology. In 1925 he qualified for university teaching and took up a post at Bologna. At the same time, from 1920 to 1938, he established close links with the SIMAC in Castelli in an advisory role. In 1939 he left Italy for political and racial reasons and lived in France, Belgium, the Netherlands and Britain. He returned to Italy clandestinely and took part in the Resistance. After the war he worked as a consultant

to the Italian ceramics industry and in 1952 returned to Hungary.
Bibliography
Korach 1920; Marangoni, *Enciclopedia* 1927; *Faenza*, n. 4-5 1964; Liverani 1976; Vecchi 1988; Bojani 1989; *La porcellana di Castelli* 1997.

Irene Kowaliska
(Warsaw 1905 – Rome 1991)
In 1911 she moved with her family from Warsaw to Vienna, where she attended the Kunstgewerbeschule. From 1929 to 1930 she was in Berlin, employed in the photographic archives of the publisher Ulstein. She came to Vietri in 1931, at the invitation of her friend, the ceramist Margaret Tewalt Hannash, and in 1932, at the suggestion of Richard Dölker, made a journey to Sardinia in search of the 'primitive' that was to deeply influence her art. She worked as a decorator at Melamerson's ICS and at the same time worked on her own on the decoration of some rejected pieces that she sent to a gallery in Vienna, where they proved a great success. In 1933 she went to Vallauris and stayed for several months but, not finding the right working conditions there, returned to Vietri. Here she began to work again at the Pinto factory, where she was also able to produce things independently, but when this became predominant and started to represent dangerous competition for the workshop, she set up on her own, opening a kiln at Molina di Vietri in 1937. Her products were most in demand abroad, in Germany, Britain, Sweden and the United States. In Italy she attracted the attention of Gio Ponti, who in 1937 and 1938 published some of her pieces in *Domus*. The jugs and pots that recalled the forms of the local tradition were decorated, like the plates and tiles, with female figures of archaic composure, fishermen or peasants astride the typical donkey of Vietri. The drawings, naïve in appearance, are in reality very refined, the fruit of a conscious simplification of form. In 1940 the difficulty of obtaining material because of the war forced the artist to close the kiln, which would be destroyed by bombs in 1943. She moved with her companion Armin Teophil Wegner, a German Expressionist poet, to Positano, where she devoted herself to printing on fabric. In 1956 she moved to Rome and opened a workshop making textiles for clothing and the home that would remain active until 1968. She collaborated with state bodies like the ENAPI and the ICE and with foreign factories. Her other activities included embroidery, mosaic, painting on glass and book illustration.
Bibliography
Domus, July 1937; *Domus*, July 1938; *Domus*, July 1939; ENAPI 1940; 7th Milan Triennale 1940; Frattani, Badas 1976; Bojani 1991; Cuccu 1991; Alamaro 1992; Romito 1994; Napolitano 1995; Romito, *La Collezione Di Marino* 1996; Romito, *La Collezione Dölker* 1999; Romito, *La Collezione Camponi* 1999; Salvatori, in Picone Petrusa 2000.
(cat. 446-452)

Laboratorio Nuova Ceramica
see Ferruccio Palazzi

La Bottega del Versatoio
see Giacomo Dolcetti

Simone Lai
(Dorgali 1907 – Cagliari 1984)
Apprentice from 1925 to 1927 in the workshop of his uncle Ciriaco Piras, he went on to carry out the same activity with pottery and leather independently, falling in with the trend for the rediscovery and utilization of the Sardinian folk tradition. In 1931 he received awards at the Crafts Exhibition in Sassari and, the following year, a gold medal at the Lictorian Contests in Bologna. The production of his workshop, in terracotta painted without firing, had a wide circulation even outside the region, so that its clients included La Rinascente. In 1935 he brought out a series of pieces designed by Salvatore Fancello under the mark 'Creazione Fancello' that were published by *Domus*. His activity continued along the same lines until the fifties, when he reduced the level of production and made pottery in two colours.
Bibliography
Domus, July 1938; *Domus*, July 1939; Altea, Magnani 1995; Cuccu 2000.
(cat. 454)

Lazzar & Marcon
Enrico Lazzar (Gorizia 1862–1935) founded a ceramics factory at Treviso in 1907 that specialized in the production of Art Nouveau clockstands, jewel boxes and ornaments in terracotta coated with chalky whitener or slip coloured without firing. From an output that very quickly descended into bad taste, a few interesting pieces stood out, like the vase in Treviso Museum and a few planters in Secessionist style, perhaps influenced by the contemporary production designed by Arturo Martini for Gregorj. Guido Cacciapuoti collaborated with the pottery, which changed its name to Lazzar & Marcon in 1912 and closed down in 1915. The *Annuario Industrie della Ceramica e del Vetro* of 1930 still listed a firm in Treviso registered in the name of Enrico Lazzar and manufacturing artistic and ordinary terracottas and ceramics, with about thirty employees.
Bibliography
Annuario Industrie della Ceramica e del Vetro 1930; Minghetti 1939; Melegati 1988.

La Bertetti
see Clelia Bertetti

Lenci
Lenci of Turin commenced the production of ceramics in 1928, after nine years of activity in the sectors of toys, and cloth dolls in particular, clothing and furnishing. The founders of the workshop were Enrico Scavini and his wife Helen König. The company had already taken part in major exhibitions like the Monza Biennali (in 1923 and 1927) and the International Exhibition of Decorative Arts in Paris in 1925, coming back laden with prizes. It also had a well-organized sales network, in Europe and across the Atlantic (shops in Turin and Milan since 1923). Right from the outset, the Turinese factory had turned, for the design of models of dolls and furniture, to artists like Marcello Dudovich (in 1919), Sandro and Emilio Vacchetti (from 1919), Gigi Chessa (from 1922), Beppe Porcheddu (from 1922), Lino Berzoini (around 1922), Giovanni Riva, Mario Sturani, Teonesto De Abate (from 1926), Clelia Bertetti (from 1927) and Claudia Formica (1927–30). Among these, Sandro Vacchetti and De Abate had already practiced the art of ceramics, the former in the United States, the latter at Galvani in Pordenone. In 1928 the factory embarked on collaborations with the sculptor Felice Tosalli, a specialist in animal figures, the painter Giovanni Grande and his wife Ines, the painter Giulio Da Milano and the illustrator Massimo Quaglino. Taken on in 1928 and assisted by the technician Lionello Franchini, the ceramist Pietro Spertini came from a long collaboration with the SCI in Laveno, while a German friend of Helen König, Clare Burchart, brought with her the experience she had gained at Rosenthal. A mixture of national china clays and clay from the Netherlands was used as ceramic material, fired at 1000 degrees and decorated with brilliant colours underglaze. The ceramic products did not diverge widely from the style that already characterized the brightly coloured, engaging cloth dolls, drawing on designs and sketches already utilized by Lenci for this or that product. They were also influenced by contemporary European ceramics, in particular the figures of the Danish Royal Porcelain Factory in Copenhagen, Rosenthal and, above all, the Austrian experiences of the Wiener Werkstätte, with the female figures in painted terracotta of Susi Singer and Vally Wieselthier. In general the piece would bear the signature of the executor of the model, who was not always the person who had conceived it. This was because artists provided designs that became part of a stock, organized by subject (nudes, figures, animals, wall plates, etc.) that was utilized fairly freely within the factory. Lenci showed its ceramics for the first time in 1928, at the Turin International Exhibition, where they were present in three sections ('Ceramists and Glassworkers', 'Mines and Ceramics', 'Architects' House'), finding favour with the public and attracting the attention of critics. In the autumn of 1929 they were shown at the Callows Gallery in London, and in December of the same year a memorable exhibition of ninety-five pieces signed by almost all the artists collaborating with the company was held at the Galleria Pesaro in Milan. The following year it would be the turn of the Monza Triennale, in the 'Ceramics Gallery' mounted by Tommaso Buzzi. Keen interest was also shown by the trend-setting magazines, *Domus* and *La Casa Bella*, which praised them in numerous editorials. The *Annuario Industrie della Ceramica e del Vetro*, published in Milan in 1930, lists the Turinese factory as employing sixty workers and exporting its products to Great Britain, France, Spain, Austria, Czechoslovakia and North and South America. In 1931, despite its success with the public and critics, Lenci showed signs of crisis, due both to the worldwide depression and to failings of management. Two years later, the accountant Pilade Garella, charged with balancing the books, and his brother Flavio entered into partnership with the Scavini, and towards the end of the decade took over the whole firm. The artistic director was Sandro Vacchetti until 1934, when he left to set up his own factory, Esse-

vi, and was replaced by Mario Sturani. Helen König Scavini continued to collaborate until 1942 and Felice Tosalli until 1936, and others who worked with the factory were Abele Jacopi, Camillo Ghigo, Otto Maraini, Luigi Comazzi, Piero Ducato, Paola Bologna and Antonio and Giovanni Ronzan. In 1936 Lenci exhibited a series of objects and figures by Sturani and Tosalli characterized by the use of new colours and glazes at the sixth Milan Triennale. In comparison with the production of the early period, from 1928 to 1932, the second phase, from the mid-thirties until the end of the following decade (catalogue nos. 420-1160), was distinguished by a simplification of the forms and decorations, no longer executed exclusively with the paintbrush but also by airbrush, aimed at reducing costs. The factory went on making figures and groups of considerable quality, but also produced more basic objects, such as decorative plates, coffee services, vases, bonbonnières and boxes. In the final period, ending with the closure of the factory in 1964, a number of tested and emblematic models were still produced, but the output was also geared to meet a much less refined demand. The last signs of originality came in the early fifties, when Mario Sturani went to Vallauris, which Picasso had made the world capital of ceramics, and created a series of bowls and vases inspired by nature.
Bibliography
La Casa Bella, July 1928; *Ceramiche di Lenci* 1929; *La Casa Bella*, April 1929; *Domus*, July and August 1929; *The Studio*, October 1929; *Annuario Industrie della Ceramica e del Vetro* 1930; Buzzi 1930; *Domus*, March, April, July, December 1930; *Emporium*, November 1930; Guigoni 1930; Ponti 1930; Reggiori 1930; 4th Monza Triennale 1930; *La Casa Bella*, November and December 1931; *Domus*, November 1931; *Emporium*, July 1931; *Domus*, July and November 1932, *La Casa Bella*, January 1933; *Domus*, August 1935; *Domus*, June, December, October 1936; Papini 1936; 6th Milan Triennale 1936; *Domus*, December 1938; Minghetti 1939; *Domus*, May 1941; Morazzoni 1957; Bossaglia 1975; Rosci 1976; *Ceramiche italiane* 1978; Pansera 1978; Rosci 1978; Proverbio 1979; Bossaglia 1980; *Annitrenta* 1982; *Mostra della ceramica italiana* 1982; *Le ceramiche Lenci* 1983; Rosso 1983; Pansera 1985; Cerutti 1985; Pélichet 1988; König Scavini 1990; Rosso 1991; Panzetta 1992; Biffi Gentili, 'Stupidi ninnoli graziosi', in Pansera 1995; R. Ausenda, in *Museo d'Arti Applicate* 2002.
(cat. 198-205, 207-215, 375-377, 381)

Leoncillo Leonardi
(Spoleto 1915 – Rome 1968)
Leoncillo Leonardi, who began to devote himself to ceramic sculpture from an early age, moved to Rome in 1935 and followed the course of sculpture at the Accademia di Belle Arti, coming into contact with the artists of the School of Rome who had a profound influence on his thematic and expressive choices. The artist adopted the ceramic medium as a rejection of the monumental and classical, 'as a break with a traditional concept of sculpture', and persevered in this choice to the point of polemically defining himself as 'a ceramist'. His first work in polychrome ceramic dates from 1935, a *Saint Sebastian* of which he would make a second, better-known version in 1939. In 1936 he made contact with the Galleria La Cometa and the group of artists associated with it, headed by Corrado Cagli. In 1938, following his marriage to Maria Zampa from Umbertide, be began to work at Rometti. His activity in the factory was not connected with mass-production, but with research into technical know-how and the creation of artistic ceramics that for the most part remained one-off pieces, even when they were utilitarian objects like plates, cups and candlesticks. At Umbertide he made coloured ceramic works characterized by a baroque and grotesque expressionism centred on the revisiting of mythological and sacred subjects, like the series of *Monsters* (*Harpy*, *Hermaphroditus*, *Siren*), *Seasons* and *Saint Sebastian*. Settimio Rometti introduced Leoncillo to Gio Ponti, who gave him a one-man show at the Triennale of 1940: among the objects exhibited were a group of anthropomorphic ornaments made at Umbertide and the figures of the *Seasons*. From 1940 date the *Trophies*, assemblages of military mementoes stripped of all bravado but covered with ornate glazes and reflections, commissioned for the Palazzo della Civiltà at the E'42. Between the end of 1941 and the beginning of 1942 the artist returned to Rome and taught sculpture and ceramics at the Istituto Statale d'Arte. In 1944 he took part in the exhibition *Art Against Barbarism*. After the war he abandoned mythological themes for subjects linked to daily life and current events, among other things creating Monuments to the Resistance in Venice and Albisola. In the fifties his work moved in the direction of non-representational art, winning prizes in Italy and abroad.
Bibliography
Domus 1940; 7th Milan Triennale 1940; Longhi 1954; Folliero 1957; Carandente 1969; Préaud, Gauthier 1982; Leoncillo 1983; Spadoni 1983; Cortenova 1985; Cortenova 1986; Castagnoli 1989; Mascelloni 1990; *Leoncillo* 1991; Bojani 1992; Ferrari, Mascelloni 1995; *Leoncillo* 2002; Morelli 2002; Ruiz de Infante 2002.
(cat. 471-473)

Biagio Lista
(Grottaglie 1908–1989)
He attended the school of art in Grottaglie and later got a job as a decorator of artistic ceramics at a factory in Civita Castellana. He then moved to Arezzo to work at Zulimo Aretini's factory, where he remained until 1927. He went back to Grottaglie and worked in a management position in the factory of Vincenzo Calò. In 1930 he was called on to run Nervi's ILCA, which closed down the following year. Returning to Grottaglie yet again, he became an assistant at the school of art, going on to teach decoration there from 1943 onward. In 1936 he won the national Lictorian competition with the panel *The Return from the Fields*. His work was confined to the sphere of painted decoration, applied to ceramic pieces made in the Calò workshop or at the school.
Bibliography
Ettorre 1936.

Paolo Loddo
(Orani 1903 – Dorgali 1983)
He began work as a woodcarver in Sassari, at the Clemente furniture factory. In 1930 he left the city for political reasons and moved to Dorgali, where he was introduced to ceramics in the workshop of Ciriaco Piras. He went on to work on his own, producing terracottas formed in moulds and decorated without firing that initially remained anchored to the manners and forms of woodcarving. Like those of the other ceramists of the Dorgali school, his themes were derived from folk art.
Bibliography
Cuccu 2000.

Giuseppe Macedonio
(Naples 1906–1986)
He interrupted his studies at the Istituto d'Arte in Naples to work in Salvatore Chiurazzi's porcelain workshop and then in the workshops of the Mollica and Freda families. Between 1928 and 1934 he frequented Melamerson's ICS, where he came into contact with the modes of expression of the colony of Northern European artists in Vietri. In 1938 he and Romolo Vetere (Naples 1912–1988), an expert in the embossing of metals, founded the workshop I Due Fornaciari, which alongside pottery for everyday use produced works of greater artistic quality, such as the panel *Motherhood and Childhood*, conceived by the sculptor G. Mazzullo, with which it won the Faenza Prize in 1942. The workshop was forced to close during the war, but afterwards Macedonio continued his activity as a ceramist, creating works of considerable quality.
Bibliography
Stile, November 1942; Salvatori, in Picone Petrusa 2000.

Alpinolo Magnini
(Deruta 1877–1953)
He studied at the Accademia di Belle Arti and the Museo Artistico Industriale in Rome. From 1903 to 1907 he was in Laveno, teaching at the Scuola di Disegno Industriale and creating a series of portraits of celebrated people on ceramics. Returning to Deruta, he took up the posts of principal of the Scuola Comunale di Disegno and curator of the Museo delle Ceramiche. In 1910, on the establishment of the Società Anonima Maioliche Deruta, he was made its artistic director, a position that he held until 1937, focusing constantly on the revival and updating of the traditional repertoire, from which he selected motifs, from geometric patterns to contrasts of colour, that came closest to modern tastes.
Bibliography
Minghetti 1939; Bojani 1992; Busti 1998; Ranocchia 1999; Busti, Cocchi, in *Museo d'Arti Applicate* 2002.

Carmelo Mangione
(Seminara Calabra 1875– ?)
We have no biographical data on this Calabrian potter, active at Seminara in the province of Reggio Calabria, who in the twenties attracted the attention of the magazines and took part in the most important exhibitions of decorative arts. His production, illustrated in the catalogue of the Monza Biennale in 1925 and by a plate in Marangoni's encyclopaedia, was popular in tone, both in its forms, typified by two-handled amphorae,

and its decoration, consisting at first of roughly applied mono- or dichromatic glazes and then of repeated pictorial motifs or representations of popular costumes. He won a silver medal at the first Monza Biennale; at the following Biennale, in 1925, he showed in the room of Calabrian artists resident in Rome and, at the one in 1927, in the section devoted to handicrafts. In 1928 he took part in the exhibition of Italian ceramics at Pesaro, and at the Monza Triennale of 1930 his pottery was presented in the Ceramics Gallery organized by Buzzi, who described him as 'faithful to himself' in an article in *Dedalo*, as well as in the Calabrian section.
Bibliography
Le Arti Decorative, September 1923; 1st Monza Biennale 1923; Carrà 1923; 2nd Monza Biennale 1925; *Opere scelte* 1925; 3rd Monza Biennale 1927; Marangoni, *Enciclopedia* 1927; *Domus* October 1928; Buzzi 1930; 4th Monza Triennale 1930; Ponti 1930; Minghetti 1939.

Manifattura Francia
see Ferruccio Palazzi

Otto Maraini
(Savigliano, Cuneo 1904 – Borgio Verezzi, Savona 1970)
An architect and painter, he commenced a brief collaboration with Lenci in 1930 that resulted in the creation of a few pieces, amongst them a *Madonna and Child*. He also worked with other Turinese factories, from Essevi to Ars Pulchra and Igni.
Bibliography
Otto Maraini 1960; Panzetta 1992.

Antonio Marcon
(Bassano del Grappa 1898–1974)
He showed a number of vases at the fourth Monza Triennale, in room 110, that were probably designed by Francesco di Cocco. His ceramic works did not go unnoticed, with *La Casa Bella* publishing several examples (vases for lamps and pots with lids) in its November issue and Gio Ponti referring to them in an article in *Le Arti plastiche*. Vases made to designs by Diego Carnelutti of Rome were included in the exhibition of Italian decorative art held in Athens in 1931. His name appeared again at the following Triennale, as the author of vases in a showcase in the Ceramics Gallery, as well as at the exhibition of ENAPI models, as the executor of a statue by the Roman sculptor Amedeo Vecchi.

Bibliography
La Casa Bella, November 1930; Ponti 1930; 4th Monza Triennale 1930; *Arte Decorativa* 1931; ENAPI 1932; 5th Milan Triennale 1933; ENAPI 1933; Minghetti 1939; Frattani, Badas 1976

Arturo Martini
(Treviso 1889 – Milan 1947)
Ceramics played a very important part in the artistic development of the great sculptor who, in the absence of any academic training, gained his first experience of the plastic arts in this medium, working for the Gregorj factory in Treviso. Martini created objects and small sculptures for the factory. And it was Gregorj who sent the young Martini to Munich in 1909, to study at the school of the sculptor Adolf von Hildebrand, where he came under the influence of Secessionist Symbolism. Returning to Italy, he joined the Ca' Pesaro group, which since 1908 had been exhibiting works that ran counter to the establishment of the Biennale. In 1912 he went to Paris with the sculptor Gino Rossi, where he encountered Modigliani and Boccioni and found new inspiration in Expressionism, as can be seen from two heads of 1913, *The Whore*, in polychrome terracotta, and *Girl Full of Love*, in gilded majolica. Subsequently, in the climate of the 'return to order', he established links with the Valori Plastici movement, coming up with his own interpretation of the myth of classicism and primitivism. In 1918 Martini was in Faenza, where he made a baptismal font and improved his ceramic technique, but his real commitment to this art came in the following decade, in his wife's hometown of Vado Ligure where he moved in 1920 and stayed for long periods up until the early thirties, creating his Monument to the Fallen. In 1926 Mario Labò commissioned some pieces from him for the Ligurian Oratory set up at the third Monza Biennale in 1927 (*Large Crèche*, *Flight into Egypt*, panels for the *Via Crucis*). They were made at La Fenice, where the trilogy dedicated to the *Legend of Saint George*, the twelve plates of the *Legend of Saint Ursula* and the six plates of the *Parable of the Prodigal Son* were also executed. In 1927 he made the models for a series of twenty-four small ceramic sculptures (among the best known: *Judith*, *Birth of Venus*, *The Annunciation*, *The Ship and the Whale* and *Small Crèche*), miniature monuments of literary, mytho-

logical and biblical inspiration that were produced, again at La Fenice, under Labò's mark Savona Nuova. The same year, these small majolica figures formed in moulds in small runs and coloured by Manlio Trucco on the instructions of the sculptor, were used to stage an exhibition at the Galleria Pesaro in Milan that would ensure their success. From the following year date several slabs in relief (*Saint George and the Dragon*, *The Tired Gods*, *The Cup of Plenty*, *Scroll with Fruit and Flowers*, *Still Life with Fish*). Martini's ceramics were also made at Labò's ILCA, where the first significant realizations were the small sculptures previously produced at La Fenice under the Savona Nuova mark and some slabs. In 1929–30, a new series of one-off pieces by Martini were made (modelled in a single piece by the sculptor), many of them representing animals (*Heron*, *Francolin*, *Running Rabbit*, *Dog*), but also portraits like *The English Girl* (made in several copies) and groups like the series of *Lovers*, all presented at the Monza Triennale in 1930. Emanuele Rambaldi and Oscar and Fausto Saccorotti worked on the colouring of these works. With respect to the series shown at the Galleria Pesaro, '[...] based on the smooth and rounded sculpture of the Valori Plastici period', these works appeared 'perfunctorily modelled and worked, with the thumb, subjected to rapid, incisive interventions on the fresh majolica', and 'document the profound renewal of Martini's sculpture that even in small works of the "Copenhagen porcelain" kind animates the autonomy of the material in its expressive tension, through an evocative colour, used to create an effect of dematerialization' (L. Ughetto). In 1929 the sculptor started to teach at the ISIA in Monza and in 1931 won the sculpture prize at the Rome Quadriennale. At the beginning of the thirties he resumed his collaboration with Manlio Trucco's La Fenice, which reproduced several of his works in terracotta (*The Brigands*, *The Schoolgirls*). The group of the *Madonna of Mercy* of Savona, conceived in 1933 to a commission from the SPICA, was the last product of his collaboration with Ligurian factories. From 1934 on Martini worked with the entrepreneur Jean-Charles Mathon, owner of the ILVA firebrick works at Vado Ligure, Livorno and Corsico, on the difficult task of creating, by industrial casting processes, large

works like the *Gypsy Woman*, *Lion* and *Lioness* (1936) in coloured stoneware for use as garden seats, and the *Fascist Victory* of 1937. The artist died suddenly in 1947, after going through a period of rejection of sculpture to which his 1945 writing entitled *Sculpture, a Dead Language* bears witness.
Bibliography
3rd Monza Biennale 1927; *Emporium*, July 1927; Marangoni, *Enciclopedia* 1927; *Problemi d'arte attuale*, November 1927; *Domus*, December 1928; *La Casa Bella*, February 1929; *Domus*, August 1929; Buzzi 1930; *La Casa Bella*, June 1930; *Emporium*, November 1930; 4th Monza Triennale 1930; *Domus*, December 1932; *Domus*, June 1935; Minghetti 1939; Barile 1963; Perocco 1966; Mazzotti 1967; Frattani, Badas 1976; Bossaglia 1980; *Mostra della ceramica italiana* 1982; Préaud, Gauthier 1982; Rosso 1983; Vianello 1985; Melegati 1988; *Il giovane Arturo Martini*, 1989; Mazzotti 1989; Gian Ferrari 1993; Massaioli 1994; Chilosi, Ughetto 1995; Vianello, Stringa, Gian Ferrari 1998; Morelli 2002; Nico Stringa, in *Museo d'Arti Applicate* 2002.
(cat. 42, 216-221, 407-409)

MAS, Maioliche Artistiche Savonesi
Factory founded at Albisola in 1920 under the guidance of Dario Ravano and closed in 1921. Specializing in the production of majolica ware in Antico Savona style, its collaborators included Ivos Pacetti, who had just arrived in Albisola from Prato, and, although this is not certain, the painter Cornelio Gerenzani.
Bibliography
Chilosi, Ughetto 1995.

Mastro Giorgio, Benveduti-Granata
Founded in Gubbio around 1921 by Marquis Polidoro Benveduti (1891–1979) and the Italo-American Granata. Toward the end of the decade Benveduti focused his interest on the *bucchero* technique, and this would later be taken up by other potters in Gubbio, becoming a characteristic of local production. In 1928 the factory took part in the Ceramics Exhibition at Pesaro, winning a gold medal.
Bibliography
Domus, October 1928; *Domus*, May 1929; Minghetti 1939; Bojani 1992; Ranocchia 1999.

Matricardi
Majolica factory active at Ascoli Piceno from 1920. Between 1925 and 1930 Giancarlo Polidori worked

there, making pieces of modern taste but inspired by the local environment and culture. In 1924–25 it produced pieces to designs by Adolfo De Carolis. It took part in the Ceramics Exhibition held in Pesaro in 1924 and the Monza Biennale of 1925, showing dinner, coffee and tea services. Around the middle of the twenties it joined the CIMA consortium, promoted by the Società Anonima Maioliche Deruta. It was present at the Milan Triennale of 1930, with pottery by Polidori. At this date the factory employed twenty-five workers.
Bibliography
Le Arti Decorative, June-July 1924, July, September 1925; *La Cultura Moderna*, August 1924; Serra 1924; 2nd Monza Biennale 1925; *Opere scelte* 1925; *Annuario Industrie della Ceramica e del Vetro* 1930; Buzzi 1930; 4th Monza Triennale 1930; Minghetti 1939; Biscontini Ugolini, in *Museo d'Arti Applicate* 2002.
(cat. 278)

Domenico Matteucci
(Faenza 1914–1991)
A painter and sculptor in ceramic, he made figures and panels characterized by a classic style and strong colours on grounds of thick glazes and with touches of lustre at Mario Morelli's workshop in the thirties. He won three prizes at the Ceramics Exhibition of the Angelicum and the Crèche Exhibition at Palazzo Braschi in Rome.
Bibliography
Dirani, Vitali 1982; Savini 1992.

Achille Luciano Mauzan
(Gap, France 1883–1952)
A poster designer and illustrator active in Italy from 1911 to 1926, he took up ceramics during his stay in Rome, from 1917 to 1922. His works bore the mark of the Laboratorio Nuova Ceramica Roma (LNCR), founded by Ferruccio Palazzi, probably the person responsible for Mauzan's involvement in ceramics. In 1920 Mauzan's ceramics were shown at an exhibition in Palazzi's studio, in Piazza Venezia, alongside works by Cambellotti, Rosati, Saltelli and Cellini.
In 1922 Mauzan moved to Milan and two years later built a villa in Monza that he designed in its entirety, from the architecture to the furnishings. In 1926 he went to Argentina, where the following year he held an exhibition of posters, paintings, sculptures and ceramics. In 1932 he settled for good at Gap in France.
Bibliography
Marangoni, *Enciclopedia* 1927; *La Casa Bella*, May 1928; Bossaglia 1980; Quesada 1988; Quesada 1992; De Guttry, Maino 2003.
(cat. 253, 254)

Enrico Mazzolani
(Senigallia 1876 – Milan 1968)
Born into a noble family of Senigallia, he moved to Rome in 1897, frequenting the studio of the sculptor Ettore Ferrari and the Scuola Libera di Nudo. In 1901 he returned to Senigallia and opened a studio there the next year. In 1904 he was in Faenza, to make a lunette for the church of San Filippo in Senigallia at the kiln of Salvatore Farina, and came into contact with Baccarini's coterie. In 1906 he moved to Milan, but it was not until after the war that his passion for sculpture finally found expression in the creation of works in plaster, terracotta and bronze (*The Blind Organist*, *The Landlord*). He began to fire and glaze his ceramics at the Cooperativa Lavoranti in Terracotta in Viale Monza. At the beginning the white glaze of the majolica had various zones of colour, but later the artist preferred to do without colour entirely. He made many of his best-known works in majolica in the twenties: *The Mask* (1921), *The Virgin and the Billy Goat* (1922), *The Adolescent* (1923), *The Cock's Feather* (1923–24), *Leda* (1924), *The Canticle of the Sun'* (1925), *Mary* (1926), *Beethoven* (1926), *The Adolescent Hero* (1927), *The Night* (1927), *The Shawl* (1927) and *Youth* (1928). In 1924 he took part in the National Exhibition of Modern Ceramics in Pesaro and the annual exhibition of the Società per le Belle Arti ed Esposizione Permanente in Milan. The following year he showed twenty-five pieces at the second Monza Biennale, including, alongside sculptures, about ten majolica vases decorated with plant motifs that were to remain unique in his production. In 1927 he was at the Monza Biennale with twenty pieces and the same year exhibited thirty-four pieces at the Galleria Pesaro in Milan. He also showed at the Venice Biennale, at the Galleria Pesaro again in 1929, 1932 and 1936 and at the exhibitions of the Permanente from 1934 to 1941. In 1928 he began to work with the factory in Faenza run by Melandri, to whom he entrusted his ceramics for firing and glazing. Although the artist did not always appreciate the precious finish (gold lustre) Melandri gave to his works, the collaboration between the two men lasted until 1948, while in 1932 he lost the valuable support of the Cooperativa Lavoranti in Terracotta. Between the end of the thirties and the early forties the artist, owing to the impossibility of obtaining suitable glazes, made almost exclusively terracottas, both new models and reworkings of old ones, that utilized clays of different colours and were sometimes coloured without firing or given a bronze patina. During the war his studio was bombed and from 1943 to 1945 he went to live in Varese. On his return to Milan, he resumed his activity in the studio, reconstructed in makeshift fashion. In 1948 and 1950 he held one-man shows at the Cenacolo in Via Bagutta and regularly participated in the exhibitions of the Permanente with sculptures in plaster and bronze.
Bibliography
Le Arti Decorative, April-May, July 1925; 2nd Monza Biennale 1925; *Opere scelte* 1925; 3rd Monza Biennale 1927; Marangoni, *Enciclopedia* 1927; *La Casa Bella*, September 1929; Minghetti 1939; Folliero 1957; *Mostra della ceramica italiana* 1982; Pansera, Venturini 1988; Pansera, Venturini 1989; Amari 1995; Ausenda 1998; Bojani 1998; *Mazzolani* 1998; Terraroli, *Milano Déco* 1998; A. Pansera, in *Museo d'Arti Applicate* 2002.
(cat. 192-195, 311)

Giuseppe Mazzotti, MGA
(Albisola Marina 1865–1944)
He started to work with ceramics at the age of just twelve, in a crockery factory at Albisola and then at other potteries in Livorno and Naples. Returning to his hometown, he became a thrower at Poggi until 1903, when he set up a kiln at Pozzo della Garitta, where at the outset he produced chimney pots, crockery and small devotional sculptures. His sons Torido and Tullio began to work with him while still very young. In 1922, following Tullio's imprisonment for political reasons, he formed a partnership with Guido Cavallero, whose name would be added to the firm's until 1927. In 1925 Torido opened a kiln at Albisola Superiore, active until the construction of the new Futurist house and factory designed by Nicolaj Diulgheroff in 1934. Around the middle of the twenties the production was renewed, to the point where it was included in the main exhibitions of decorative art in Europe, from the Paris Expo of 1925 to the Monza Biennali. Towards the end of the decade, Tullio's links with the Futurist movement led to the pottery, where about forty people worked, bringing out a line of articles inspired by it, although without abandoning its traditional production. While Torido's role was chiefly one of technical management, Tullio was responsible for the artistic side and the conception of numerous pieces, some of which would be shown at the *Thirty-three Futurists* exhibition staged at the Galleria Pesaro in Milan in 1929. The participation in Futurist art exhibitions and exhibitions of applied art like the Monza Triennale continued without a break and contributed to the success of Mazzotti's Futurist ceramics, on which many of the principal exponents of the movement collaborated: Nino Strada, Bruno Munari, Alf Gaudenzi, Dino Gambetti, Fillia, Mino Rosso, Nicolaj Diulgheroff, Mario Anselmo, Romeo Bevilacqua, Giovanni Acquaviva, Giuseppe Piccone, Farfa, Tato and Benedetta. Alongside Futurist artists there were ceramists: Virio da Savona, Paolo Rodocanachi and Eliseo Salino. In 1935, Tullio met Lucio Fontana, with whom he commenced a long collaboration, interrupted during the years the artist spent in Argentina (1940–47) but resumed on his return. In 1937 came the encounter between Tullio and Salvatore Fancello, who would make numerous sculptures, animals and crèche figurines at Mazzotti, as well as pots and plates. In 1939 the factory began its collaboration with Aligi Sassu, who came to the medium of sculpture through ceramics. In parallel to this artistic activity, Mazzotti carried on with a commercial production, based in part on commissions from large companies (Unica, Campari, Motta, Perugina and others) for the manufacture of promotional ceramics that were often in turn designed by artists (the bottles for Cora and the ashtrays for Campari designed by Diulgheroff and Mario Anselmo's bottles for Vlahov are just some of the best-known). In the thirties the number of workers at the factory rose to about a hundred; production was still entirely by hand, mostly on the wheel or with moulds, rarely by casting. After the war, and Giuseppe's death, Tullio resumed the collaboration with artists, alongside a traditional output. In 1959 the long journey through the ceramic art taken by the Mazzotti as a family (Tullio's sister Vittoria had joined the firm following Giuseppe's death) came to an end when two different companies were set up: Giuseppe Mazzotti 1903 Ceramiche e Maioliche

Artistiche and Vittoria Mazzotti.
Bibliography
Le Arti Decorative, September 1925; 2nd Monza Biennale 1925; *Emporium*, July 1925; *Opere scelte* 1925; 3rd Monza Biennale 1927; Marangoni, *Enciclopedia* 1927; *La Casa Bella*, June 1928; *Domus*, December 1929; *Mostra di trentatré artisti futuristi*, 1929; *Annuario Industrie della Ceramica e del Vetro* 1930; Buzzi 1930; Ponti 1930; 4th Monza Triennale 1930; *Domus*, February 1935; *Emporium*, February 1935, August 1936; Ettorre 1936; 6th Milan Triennale 1936; Minghetti 1939; 7th Milan Triennale 1940; *Domus*, September 1941; *Stile*, November 1942; 8th Milan Triennale, 1947; Frattani, Badas 1976; Golfieri 1977; Golfieri 1979; *Mostra della ceramica italiana* 1982; Crispolti 1982; Rosso 1983; Chilosi, Ughetto 1995; Barisione 1999; O. Chilosi, in *Museo d'Arti Applicate* 2002.
(cat. 224-230, 382, 384-396, 400-402

Torido Mazzotti
(Albisola Marina 1895 – Savona 1988)
The son of Giuseppe Mazzotti, he attended the Istituto Professionale di Arti e Mestieri in Savona and then began to work in his father's workshop at Pozzo della Garitta, under the guidance of Dario Ravano and Pietro Rabbia who introduced him to traditional techniques and styles. During the war he worked as a draughtsman at Ansaldo in Genoa. From 1925 to 1934 he also ran a workshop at Albisola Superiore, where he devoted himself to a more commercial type of production. His role in his father's company was essentially that of technical manager, taking care among other things of the accurate drawings and the execution of his own pieces as well as those of Tullio and the many other artists who worked with the factory. In 1928 he attended the Istituto d'Arte in Faenza. He shared Tullio's enthusiasm for Futurism and was the author of numerous pieces, first figures of animals and then *aerovasi* formed from geometric solids on the example of those devised by Fillia. Torido took part in numerous exhibitions by the Futurist group in Italy and France, as well as the 1937 Universal Exhibition in Paris. During the war the factory was forced to suspend its activity and Torido worked as technical manager of a foundry in Savona. After the war and the death of his father Giuseppe, the factory commenced operation again and Torido tried to update its artistic production as well, with pieces inspired by non-representational art, but the bulk of its output was based on traditional styles. In 1959 Torido split up with his brother Tullio, who founded a new business with their sister Vittoria. He continued to work as a ceramist, with his wife Rosa Bovio and children Celina and Bepi, devoting himself chiefly to the antique.
Bibliography
Minghetti 1939; Crispolti 1982; *Mostra della ceramica italiana* 1982; Rosso 1983; Chilosi, Ughetto 1995.
(cat. 394, 395)

Pietro Melandri
(Faenza 1885–1976)
Like others of his age who were to become famous ceramists, he served his apprenticeship at the Minardi factory, attended Antonio Berti's evening school and was part of Baccarini's coterie. From 1906 to 1916 he was in Milan, where he worked as a decorator and followed the evening courses at the Accademia di Brera. Some of his pictures were shown at the Torricelli Exhibition in Faenza in 1908, where Melandri was able to see the products of the main European factories, including the lustres of Zsolnay. He was taken prisoner at Caporetto and deported to a concentration camp on the border with Hungary, where he remained over a year. On his return, in 1919, he joined Paolo Zoli in his La Faïence factory, where he made ceramics that were in part based on models by other artists like Nonni and Giovanni Guerrini. In 1921 he left Zoli, but went on working in a pottery of his own that used the facilities of the now defunct Calzi while maintaining the collaboration with Nonni, who modelled its figures while Melandri turned them into ceramic and glazed and decorated them. In 1923 Umberto Focaccia, an industrialist from Ravenna, put the building that had formerly housed the Minardi factory at his disposal, and the Focaccia & Melandri factory was born. Among his collaborators was Angelo Ungania, who helped him to develop the technique of casting, little practiced in Faenza. In 1925 he took part in the Monza Biennale and the Exhibition of Decorative Arts in Paris, where his lustreware won a grand prix. He showed at Monza again in 1927 and 1930, when he met Gio Ponti, who was to become a great admirer and promoter of his work through *Domus*. In 1930–32 he made a series of plates for Gabriele d'Annunzio inscribed with mottoes by the poet ('*Ardisco non ordisco*', '*Io ho quel che ho donato*', etc.), which he gave to his visitors. In 1931 Focaccia was obliged to reduce the space in the factory, to which the *Annuario Industrie della Ceramica e del Vetro* of 1930 assigned a workforce of about twenty. Melandri then added painted and ceramic mural decoration to the more limited production of ceramics, such as that of the Rocca delle Caminate at Forlì. Over the years, Melandri translated the creations of many artists into the ceramic medium, from Nonni, already mentioned, to Carlo Lorenzetti, from whom he acquired several models (*Diana* and *Spring*) and Arturo Martini, applying lustre to some of the sculptures made by the artist in Achille Calzi's workshop at Faenza in the thirties. He also collaborated with Ercole Drei, whose *Leda and Swan* he transformed into ceramic in 1928, Giovanni Guerrini, for whom he made two vases in 1933, and Gio Ponti, creator of the *Angels on a Bicycle* of 1936 and other pieces. In 1933 he commenced his collaboration with the architect Melchiorre Bega (decoration of the Motta pastry shop in Milan's Piazza Duomo). The Milan Triennale of 1933, to which he contributed a one-man show that included some of his best-known works (*Satyr*, *Siren* and *Melancholy*), and was given an enthusiastic reception by the critics. At the next Triennale he presented a large panel representing the myth of *Perseus and Medusa*, shown again the following year in Paris, where it won the Grand Prize for Sculpture. He also won, in 1938 and 1939, the National Competition of Ceramics organized by the Faenza Museum. Among his more ambitious decorative undertakings we can mention the large panel of the *Myth of Orpheus* for the Teatro Eliseo in Rome, in 1938, and the panels for the banking halls of the Cassa di Risparmio at Imola, in 1941. He continued his activity through the war until 1943, when his house and workshop were destroyed by bombs, but at the end of 1945 he was already back at work as a ceramist and a collaborator with the architects Ponti and Bega. In 1947 he took part in the Milan Triennale and the following year made a new version of *Perseus and Medusa* for the Metropolitan cinema in Bologna. This would be followed, between 1948 and 1952, by the complex decoration of the bar of the Albergo Roma in Bologna and the contributions to the fittings designed by Gio Ponti and Nino Zoncada for the *Biancamano* and *Conte Grande* ships. In 1951 he showed again at the Triennale and at an exhibition organized by the Galleria del Naviglio at the seat of the Friends of France association in Milan, made up of works by great French and Italian ceramists. An exhibition with which the Triennale celebrated its tenth anniversary brought together the works presented by Melandri on the previous occasions the event had been staged, commencing with the one held in Monza in 1927. There was no letup in the ceramist's activity until the sixties.
Bibliography
Emporium, June 1921, July 1923; *Le Arti Decorative*, June-July 1924; *La Cultura Moderna*, August 1924; *Emporium*, August 1924; *Le Arti Decorative*, August, September 1925; 2nd Monza Biennale 1925; Buscaroli 1925; *Emporium*, September, October 1925; *Opere scelte* 1925; 3rd Monza Biennale 1927; Marangoni, *Enciclopedia* 1927; *Domus*, October 1928, May, November 1929; *Annuario Industrie della Ceramica e del Vetro* 1930; Papini 1930; *Arte Decorativa* 1931; *Domus*, May, July 1933; *Emporium*, December 1933; ENAPI 1933; 5th Milan Triennale 1933; *Domus*, December 1934, May 1935; *Emporium*, August 1936; 6th Milan Triennale 1936; *Domus*, December 1938; ENAPI 1938; Pagano 1938; *Domus*, July, September, December 1939; Minghetti 1939; *Emporium*, May 1940; 7th Milan Triennale 1940; *Domus*, September, November 1941; *Domus*, September 1943; Folliero 1957; Frattani, Badas 1976; Golfieri 1977; Golfieri 1979; Bossaglia 1980; *Annitrenta* 1982; *Mostra della ceramica italiana* 1982; Préaud, Gauthier 1982; Dirani, Vitali 1982; Rosso 1983; Stefanelli Torossi 1987; Castagnoli 1989; Savini 1992; Benzi 2001; Gaudenzi 2002; Ravanelli Guidotti, in *Museo d'Arti Applicate* 2002.
(cat. 52-64, 67, 295-300, 309, 310)

Federico Melis
(Bosa 1891 – Urbania 1969)
Federico Melis, brother of Melkiorre, moved to Cagliari from Bosa in 1911 and frequented the circle of Francesco Ciusa. In 1917 he showed several polychrome terracottas at the *Exhibition of Sardinian Art* in Milan. In 1919 he moved to Assemini, a town near Cagliari where there was an old tradition of pottery, and opened a workshop where he experimented

with glazing and firing techniques and made pieces that he exhibited at various events. In 1923 he was at the Monza Biennale and in 1925 at the Exhibition of Art in Cagliari, where he presented his first high-fired ceramics that went beyond the Sardinian tradition of unfired decorations. As far as types and decorative themes were concerned, however, his works remained close to the folklore of the island: small sculptures made in moulds, painted plates and tiles with painted or relief decorations, all representing women and men in costume, or vases and services with decorations typical of Sardinian handicrafts, mostly in black on a white ground. Over the same period, in partnership with Ennio Dessy, he set up the Bottega d'Arte Ceramica at Assemini, whose products were shown in 1926 at the exhibition staged by the Società degli Amatori e Cultori in Rome. The following year the Sardinian Board of Culture and Education, with the aim of promoting the island's clays and the training of skilled workers, put him in charge of the Bottega d'Arte Ceramica, at Cagliari, which from 1928 to 1931 operated at the SCIC firebrick and stoneware factory. In 1931 he showed the large ceramic work entitled The Old-Fashioned Bride at the Rome Quadriennale. The following year he moved to Rome, where he opened a workshop with some Sardinian collaborators. In 1935 he was teaching ceramics at the Istituto d'Arte di Urbino. In 1945 he founded the Ceramica d'Arte Durante at Urbania, whose name was changed at the beginning of the fifties to the Scuola Artigiana Arte Ceramica Metauro.
Bibliography
1st Monza Biennale 1923; Mezzanotte 1923; La Casa Bella, March 1928; Minghetti 1939; Altea, Magnani 1995; Cuccu 2000.
(cat. 282-287)

Melkiorre Melis
(Bosa 1889 – Rome 1982).
At the age of twenty he moved from Bosa to Rome, where he attended the Accademia di Belle Arti and frequented Duilio Cambellotti's studio. While preferring ceramics, he also devoted himself to furniture design and commercial art. At the exhibition of the Società degli Amatori e Cultori in 1926 he showed plates and tiles decorated with underglaze colours, while at the Monza Biennale of 1927 he was given a room of his own in which he showed forty works. In this period, as far as ceramics was concerned, the artist limited himself to the painted decoration of tiles that he made personally in small runs. In 1930 he founded the MIAR, with which he began to model small figures on an exotic-colonial theme. In 1934 he was given the job of running the Libyan Craft School of Ceramics and then the whole School of Arts and Crafts in Tripoli, where he was to remain for seven years: a period which he dedicated to the study of North African artistic production, teaching and the design of articles in metal, fabric and leather and of furniture, and above all to the production of ceramics of every kind, from crockery to ornamental plates and from tiles to large decorative panels. Between 1939 and 1940 he moved for a short time to Vietri sul Mare, to make tiles to be inserted in some furnishings for the Triennale d'Oltremare in Naples in 1940. Here he worked with Guido Gambone and encountered and was influenced by the work of Irene Kowaliska and the other members of the 'German colony'. After the war he left Bosa, where he had spent the years following his return from Africa, for Rome, continuing to work with ceramics up until the mid-sixties.
Bibliography
3rd Monza Biennale 1927; Marangoni, in La Cultura Moderna 1927; Minghetti 1939; Mostra della ceramica italiana 1982; De Guttry, Maino, Quesada 1985; Altea, Magnani 1995; Cuccu 2000
(cat. 288, 455)

Fausto Melotti
(Rovereto 1901 – Milan 1986)
Graduating in electrical engineering at Milan in 1924, he went on to study art, first at the Accademia Albertina in Turin under Rubino, and then at Brera, where in 1927–28 he followed Wildt's courses with Lucio Fontana. His first creations were in the ambit of Novecento figuration, but in 1934 he moved toward abstractionism, joining the Milanese group that gravitated around the Galleria del Milione, where in 1935 he held a one-man show of sculptures that experimented with the transfer of musical values to the plastic arts. In 1937 he was in Paris to make contacts with artists and galleries; on his return he distanced himself from the group of abstractionists to devote himself to the creation of large, monumental works in the Novecento style. In parallel to this activity we can follow, through his participations in the Milan Triennali, a not insignificant collaboration with the more important ceramic factories in Italy. In 1930 Richard-Ginori showed a Madonna and a Saint Christopher modelled by him in the section of sacred art, while the rooms reserved for the factory in the Ceramics Gallery housed a collection of statues in porcelain by him and by Griselli and other earthenware statues of St Christopher that were attributed to him. Evidence for Melotti's involvement with ceramics is also provided by such minor episodes as a few plates published by La Casa Bella in July 1931, decorated by Melotti with designs that the magazine defined as Cubist. At the 1936 Triennale, his name appeared in the SCI of Laveno's section, linked with some 'masks in crystalline black and semi-gloss green glaze' along with 'bookends and a pedestal in brown glaze and dull green mask'. After the war and in the fifties his involvement with ceramics became predominant, partly for economic reasons, and found expression in the creation of terracotta sculptures, exhibited at the Venice Biennali of 1948, 1950 and 1952, as well as in a production of vases and figures that stood out for their originality and quality of execution. In the fifties he and Gio Ponti made demanding ceramic decorations for public and private interiors. In the sixties his sculptural work gained the upper hand again and finally achieved recognition.
Bibliography
4th Monza Triennale 1930; Ponti 1930; La Casa Bella, July 1931; 6th Milan Triennaleo1936; Minghetti 1939; Folliero 1957; Annitrenta, Milan 1982; Mostra della ceramica italiana 1982; Castagnoli 1989; Fausto Melotti, 1991; Celanti, Gianelli, Soldaini 1992; Celant 1994; Pirovano 1996; Morelli 2002; Pola, in Museo d'Arti Applicate 2002; Fausto Melotti 2003.
(cat. 474)

Ferruccio Mengaroni
(Pesaro 1875 – Monza 1925)
Of middle-class origin, he started to work with ceramics at the age of just twelve, at the Molaroni factory in Pesaro, after being expelled from all the schools of the kingdom because of his exuberant and agitated character. After a stay of about a year at Antonibon in Nove, he went back to Molaroni. Here, and with a small kiln constructed at his own home in 1908, he set about experimenting with old techniques, using the 16th-century treatise by the master potter Cipriano Piccolpasso from the Marche as a guide. In 1915 he founded the MAP (Maioliche Artistiche Pesaresi) with Aristodemo Mancini, former owner of a pottery, and within two years it already had around fifty workers. Its production was in part devoted to imitations of the past and in part to pieces of original conception. The artist was equally skilled in the painted decoration of plates, services and tiles and in modelling, with a preference for larger than life-size figure of animals like the Marine Crab and John Dory shown at the National Ceramics Exhibition in Pesaro in 1924 and the Monza Biennale of 1925. To this last exhibition Mengaroni also brought a tondo with a diameter of almost two and a half metres representing a Medusa with his own features in high relief, which then fell on him and killed him. The story became known far and wide and contributed to the posthumous myth of the artist, which was also fuelled by acknowledged experts on ceramics like Gaetano Ballardini and Guido Marangoni: nine of the twenty-three pages dealing with contemporary ceramics in the volume Le arti del fuoco of the latter's Enciclopedia delle moderne arti decorative published in 1927 were devoted to him. Ponti held a different view, declaring in his essay on ceramics in the catalogue of the Italian contribution to the Paris Expo of 1925 that the ceramist had 'a generous nature that drove him towards feverish expressions of his art [...]. But what has this to do, I won't say with industrial art, but with modern decorative art?' After Mengaroni's death the MAP, exploiting the huge stock of models (2000 for 120 types of decoration) built up over the previous decade, continued to produce ceramics for the national market and for export, especially to the United States. In 1930 it employed around thirty people.
Bibliography
Carrà 1923; Emporium, July 1923; Le Arti Decorative, January 1924; La Cultura Moderna August 1924; Emporium, August 1924; Le Arti Decorative, June, July, September 1925; 2nd Monza Biennale 1925; Emporium, May, October 1925; Opere scelte 1925; Marangoni, Enciclopedia 1927; La Casa Bella, January, May, June, September 1928; Ballardini 1929; La Casa Bella, September 1929; Annuario Industrie della Ceramica e del Vetro 1930; La Cultura Moderna, September 1930; Buzzi 1930; Papini 1930; 4th Monza Triennale 1930;

Minghetti 1939; *Faenza* 1945, issue III-IV; *Mostra della ceramica italiana* 1982; Rosso 1983; Biscontini Ugolini, in *Museo d'Arti Applicate* 2002
(cat. 471-473)

Francesco Messina
(Linguaglossa 1900 – Milan 1995)
The sculptor's first encounter with ceramics took place at the beginning of the twenties, at La Casa dell'Arte in Albisola run by Manlio Trucco and frequented by Genoese artists. However, we know nothing of the fruits of this collaboration. Better documented is his relationship with La Fenice, where the bas-relief entitled *The Generative Flame*, presented at the Paris Expo of 1925, was executed. The following year, the same factory made several of the series of characters of the Commedia dell'Arte to his models, while at the Monza Biennale of 1927 he exhibited several small figures in glazed terracotta, among them the *Shepherd in Love* and *Solitude*, that were included in the factory's catalogue. At La Fenice the sculptor deepened his knowledge of Arturo Martini's ceramic work, which did not fail to have an influence on him, prompting him to move in the direction of a synthesis between archaism and Art Deco. At the Monza Triennale of 1930 Messina presented a polychrome *Ceres* executed at the ILCA on behalf of Labò's DIANA. At the Venice Biennale of 1932 he exhibited a series of one-off pieces in terracotta (*Portrait of My Mother*, *Head of a Young Man*, *Seated Boxer*, *Fallen Boxer*, *Lady with Fan*, *Torso of Venus*) that reflected a new realistic and classicizing approach. In 1932 Messina moved from Genoa to Milan.
Bibliography
Emporium, July 1925; 3rd Monza Biennale 1927; 4th Monza Triennale 1930; 5th Milan Triennale 1933; *Domus*, May, August 1933, February 1936; Minghetti 1939; Rosso 1983; *Francesco Messina* 1989; Chilosi, Ughetto 1995.
(cat. 222)

Fratelli Minardi
The brothers Virginio (1864–1913) and Venturino (1886–1907) Minardi, born in Russi, commenced their careers as ceramists at the Società Ceramiche Faentine, formerly the Farina factory, and then moved to Tuscany, where they worked at the Chini and Cantagalli factories. Returning to Faenza in 1899, they opened a workshop on the premises of a former candle factory and devoted themselves to a production of high quality. Virgilio promoted experimentation and research into the techniques of metal lustres and crystalline glazes for stoneware, even visiting the L'Hospied factory at Golfe Juan in France. In 1903, thanks to Venturino's marriage to the French noblewoman Caterina Lefèvre, the Minardi were able to build a new factory in the vicinity of the railway station. At the Romagna Regional Exhibition of 1904 they showed a large collection made up of facings, architectural decorations and household articles of everyday use inspired chiefly by tradition, but also by Art Nouveau. The objects they showed at the first Romagna Biennial Art Exhibition in 1908 and the Torricelli Exhibition held in Faenza the same year proved a success. Future masters like Domenico Baccarini, Anselmo Bucci, Ercole Drei, Riccardo Gatti, Pietro Melandri and Paolo Zoli gained their first experiences at the factory. Around 1913 Alfredo Biagini designed a series of plates and other objects in majolica decorated with images of exotic subjects and animals. The two brothers both died young: Venturino in 1907 and Virginio in 1913. After that date the factory was run, under the name Fabbrica Minardi e Soci, by its collaborators, Anselmo Bucci, Paolo Zoli, Amerigo Masotti, Pietro Golfari and Francesco Castellini. The first three soon had to abandon the factory to fight in the war, but the other partners were still able to keep it in production, although they had to put aside experiments of uncertain outcome. In 1916 evening courses were organized at the factory by Gaetano Ballardini, a prelude to the School of Ceramics that would be set up in 1919. At the end of the war the three partners who had had to leave the factory did not return, so that it was left in the hands of just Francesco Castellini and Luigi Masini, who devoted themselves to a predominantly commercial production up until its closure in 1922.
Bibliography
Le Arti Decorative, September 1923; Marangoni, *Enciclopedia* 1927; Minghetti 1939; Bojani 1957; Dirani, Vitali 1982; Rosso 1983; Savini 1992; Maldini 1999; Benzi 2001.
(cat. 39, 52-63, 65-71, 241)

Olga Modigliani
(Rome 1873–1968)
She studied painting with her sister Corinna but later decided to devote herself to the decoration of ceramics. In 1904 she won a gold medal at the International Exhibition in St Louis and in 1906 a silver medal at the Simplon Exhibition in Milan. The artist did not usually model her pieces, which ranged from decorative plates and panels to vases and dinner services, but applied her talent for decoration to ceramic supports available on the market, or made to her design. While she attended personally to the decoration of each object, however small and utilitarian, there are no signs of lapses of quality in her copious production, appreciated by an elite clientele which included Queen Elena. In her early works she drew chiefly on the Art Nouveau style, but there were also references to classical and Renaissance art and to Islamic and Oriental ceramics. In the second decade of the century female figures and floral designs gave way to exotic and familiar animals that still had plants in the background, but now more stylized ones. In 1911 the Valle Giulia Exhibition included around fifty of her pieces. She showed at the Venice Biennali of 1912 and 1914 and the exhibitions of the Società degli Amatori e Cultori delle Belle Arti of Rome from 1914 to 1917. Her ceramics were exhibited at the first Rome Biennale in 1921 and at the first Monza Biennale in 1923.
Bibliography
10th Venice International Exhibition of Art 1912; 11th Venice International Exhibition of Art, 1914; *Emporium*, June 1916; June 1921; *Le Arti Decorative*, December 1923; 1st Monza Biennale 1923; Carrà 1923; Marangoni, *Enciclopedia* 1927; 4th Monza Triennale 1930; Ettorre 1936; Minghetti 1939; Quesada 1988; Quesada 1992; *Venezia e la Biennale* 1995; De Guttry, Maino 2003.
(cat. 44)

Alessandro Mola
(Monti 1903 – Cagliari 1957)
Practitioner, from the mid-thirties onwards, of a ceramics still based on Sardinian subjects, adapted to the canons of a charming but superficial taste imposed by the commercial success of Lenci. His once hieratic and austere figures in costume Sardinian became, in what has been defined as 'rustic Lencism', figurines in fluttering clothes. He collaborated with Sandro Vacchetti's Turinese factory Essevi until the beginning of the fifties and conceived a series of female figures in Sardinian costume for the CIA pottery in the same city. From 1940 to 1943 he worked for the Galleria d'Arte Palladino in Cagliari, using the mark Nuovo Fiore.
Bibliography
7th Florence Craft Exhibition 1937; Minghetti 1939; Altea, Magnani 1995; Cuccu 2000.

Vincenzo Molaroni
(Pesaro 1859–1912)
The nephew of Pietro Latti, since 1814 proprietor of the Benucci and Latti factory which Vincenzo joined in 1873 as an apprentice painter. One of his teachers was Ernesto Sprega, former director of the Ginori paint-works at Doccia. In 1880 he took over the factory, remaining faithful to the high level of technical perfection of its production, inspired by Renaissance majolica. In 1885 it took part in the Universal Exhibition in Antwerp and then in the principal national and international exhibitions. Between the last decade of the 19th century and the first of the 20th Ferruccio Mengaroni worked there, deepening his knowledge of Renaissance majolica to the point where he was capable of making copies so perfect that they could deceive even the most expert. The attempts to introduce decorations in a more modern taste initiated in the early years of the 20th century, probably after the Turin Exhibition of 1902, had limited commercial success and circulation. On Vincenzo's death in 1912, the factory passed into the hands of his son Francesco. It is known to have taken part in the Paris Expo of 1925 under the name S.A. Molaroni & C. In 1930 it employed around a hundred workers.
Bibliography
Musso 1897–98; *Arte Italiana Decorativa e Industriale*, November 1898; Aitelli 1901–02; Melani 1902; *Le Arti Decorative*, June-July 1924; *La Cultura Moderna*, August 1924; Serra 1924; Ponti 1926; *Annuario Industrie della Ceramica e del Vetro* 1930; Buzzi 1930; 4th Monza Triennale 1930; Minghetti 1939; *Mostra della ceramica italiana* 1982; Rosso 1983; Maldini 1999; Biscontini Ugolini, in *Museo d'Arti Applicate* 2002.
(cat. 274)

Mario Morelli
(Faenza 1908–1966)
He took a diploma at the Istituto d'Arte in Faenza in 1927 and began to frequent the workshops of Paolo Zoli and Mario Ortolani. In 1930 he moved to Bergamo to work at the Ceramiche Bergamasche factory. Returning to Faenza in 1933, he set

up his own business, with an exclusively modern production that benefited from the advice of his friends Emilio Casadio and Angelo Biancini. Figures by the latter were turned into ceramic in Morelli's workshop, where they were given the crackled monochrome glazes that we find again in the creations of the same author at the SCI in Laveno. In addition to sculptures, like the head of a girl presented at the sixth Milan Triennale, Biancini devised a series of vases and plates with decorations in relief for Morelli that also foreshadowed the production in Laveno. Domenico Matteucci also made for Morelli a number of figures decorated in bright colours and with touches of lustre, a technique in which Morelli's wife, Margherita Perroli, was a specialist. The ceramics produced in this workshop, for the most part stylized figures of animals and people or tiles also decorated with figures, were distinguished by the refinement of their glazes and by their crazed surfaces. Winning prizes at the International Exhibitions in Brussels in 1935 and Paris in 1937, he was appointed a teacher of ceramics at the Istituto d'Arte in Florence in 1939. In 1940 the Galleria Gian Ferrari in Milan devoted an exhibition to his work that was presented by Gio Ponti. The artist spent more and more time in Florence, leaving the workshop in the hands of his wife until he decided to close it in 1950.
Bibliography
Domus, June 1934, July, August 1935, December 1936; ENAPI 1936; 6th Milan Triennale 1936; ENAPI 1938; Minghetti 1939; 7th Milan Triennale 1940; Frattani, Badas 1976; Dirani, Vitali 1982; Mostra della ceramica italiana 1982; Savini 1992; Barberini 1994.

Dante Morozzi
(San Colombano a Settimo, Florence 1899 – Vesenaz, Geneva 1965)
A sculptor trained under Augusto Passaglia, he took part in the Primaverile Fiorentina of 1922 with a bronze and, from 1931, in the exhibitions of the Promotrice di Belle Arti in Turin. His contribution to the creation of ceramics initiated with Cantagalli was given a favourable reception by authoritative critics. While he had already shown ceramics at the Venice Biennale in 1932, it was at the Milan Triennale of 1933 that he distinguished himself with a frieze made up five panels representing the arts, a series of sculptures (Sampson and Delilah, The Pilgrim Woman, Madonna and Child, Fascist Freedom) and other pieces executed at Cantagalli. One of the most prominent admirers of his work was Ponti, who declared in Domus: 'He has renewed Cantagalli and the honour of Italian majolica'. Ending his relationship with Cantagalli, probably because of the factory's difficulties, he established a new one with the State Factory in Karlsruhe, probably contacted through a technician, Müller von Bazsko, who had worked at Cantagalli around 1932: testimony to this is provided by Domus, which in 1939 published several sculptures of sacred subjects (Crucifixion, Pietà, Saint Anthony) made at the German factory. From 1933 to 1941 Morozzi was principal of the School of Art at Cortina d'Ampezzo, with which he took part in the Milan Triennale of 1940.
Bibliography
La Casa Bella, January 1933; Domus, May and June 1933; Emporium, December 1933; 5th Milan Triennale 1933; Domus, July and August 1934, October 1936, September 1939; Emporium, May 1940; 7th Milan Triennale 1940; Stile, March 1942; Faenza 1963, nos. 1-6; Conti, Cefariello Grosso 1990; Cappelli Soldani 1994; Panzetta 1994.

Bruno Munari
(Milan 1907–2000)
Within the wide range of his experience in the fields of art and design, covering a period of seventy years, his involvement with the medium of ceramics was limited to his years of Futurist activism and collaboration with Mazzotti in Albisola, between the end of the twenties and the first half of the thirties. Munari joined the Futurist movement in 1927 and in 1928 met Tullio d'Albisola, with whom he began to collaborate at once, supplying designs for Futurist ceramics. At the Exhibition of Thirty-three Futurist Artists, held at the Galleria Pesaro in Milan in 1929, he showed a Hors d'Oeuvre Set made up of small triangular plates decorated with landscapes consisting exclusively of cones and cylinders. His ceramics were also present at the Futurist Exhibition in Chiavari in 1931 and at the exhibition of Italian Futurist Aeropaintings in Nice. His ceramic creations were relatively few in number: it is worth mentioning in particular the series of animals made out of cylindrical elements in 1929, the ones in 1932–33 that were constructed like mechanical toys and the ironic objects that played on the double meanings of words.
Bibliography
Mostra di trentatré artisti futuristi, 1929; Domus, February 1935; Minghetti 1939; Annitrenta 1982; Crispolti 1982; Rosso 1983; Chilosi, Ughetto 1995.
(cat. 401, 402)

MUSA
The Montecchi Urbani Società in Accomandita was active at Vietri from 1937 to 1942, although other sources claim it to have been in operation between 1943 and 1948. Run by the painter-decorator-ceramist Renato Rossi, who had previously collaborated with Pinto at Vietri and then, in 1931, set up the Scuola di Ceramica Salernitana at the Istituto d'Arte in Caserta, its mark was a trowel and sea-horse. There are records of a ceramic panel by Rossi, made in 1941 and later destroyed, which covered the whole of one façade of the Fascist Headquarters in Salerno.
Bibliography
Minghetti 1939 (Rossi); Romito, La Collezione Camponi 1999; Salvatori, in Picone Petrusa 2000.

Museo Artistico Industriale of Naples
The Scuola-Officina della Ceramica del Museo Artistico Industriale in Naples was opened in 1882, on the initiative of Prince Gaetano Filangieri (1824–1892). The museum, which was at once a school and a functional workshop, set itself the objective of improving the artistic level of production in Naples and promoting the use of ceramics for the decoration of buildings. The Neapolitan artists Filippo Palizzi (1818–1899) and Domenico Morelli worked there, and until 1902 it was run by Giovanni Tesorone (1845–1913). In 1900 the museum took part in the Universal Exhibition in Paris and won a gold medal. Tesorone's place was taken, until 1912, by Stefano Farneti, himself the author of numerous pieces and a champion of collaboration with artists. Initially the production adopted a historicist and naturalistic style, but then took up elements of French Art Nouveau and reworked them in a way that was sometimes original, especially with regard to the motifs of the decoration, while the forms remained fairly traditional. A series of decorations for fireplaces which probably also inspired Galileo Chini date from the early years of the century. Under the guidance of Orazio Rebuffat, principal from 1912 to 1918, the school, called the Reale Istituto Artistico Industriale from 1917, focused chiefly on research, while under Lionello Balestrieri, from 1918 to 1937, it tried to establish closer links with the needs of local manufacturers, but with scanty success. In the twenties the ceramics department was run by Pietro Barillà. For just one year, in 1930–31, its head was the Sicilian artist Paolo Bevilacqua, who promoted the acquisition of contemporary ceramics (Richard-Ginori, SCI, ICS) that were to exercise a certain influence on the production of the students. On the other hand, the objects made in those years do not reflect the existence of a common line, but of various tendencies, from the one inspired by the best-known creations of Ponti and Andlovitz to the naïve current derived from Vietri (Zina Aita) and an enduring pictorial naturalism. The institution took part in the second and third Monza Biennali, in 1925 and 1927, and the two following Triennali, in 1930 and 1933.
Bibliography
Faenza, 1901, issue I; Tesorone 1902; 2nd Monza Biennale 1925; Opere scelte 1925; 3rd Monza Biennale 1927; 4th Monza Triennale 1930; 5th Milan Triennale 1933; Ettorre 1936; Minghetti 1939 (Filangeri); 7th Triennale 1940; Ruju, Alamaro, Caròla-Perrotti 1984; Caròla-Perrotti 1985; Alamaro 1990; Arbace, Naples 1998; Maldini 1999; Arbace, in Picone Petrusa 2000; Salvatori 2000; Arbace, in Museo d'Arti Applicate 2002.

Museo Artistico Industriale of Rome-RINIP
The Regio Istituto Nazionale per l'Istruzione Professionale (RINIP) of Rome grew out of the schools of applied art set up in 1876 under the auspices of the Museo Artistico Industriale. In 1901 the schools were structured by royal decree into three courses (decorative painting, decorative modelling, architectural decoration), with three workshops or schools of industrial applications (ceramics, woodcarving, metalworking). In 1918 the schools took the name of the RNIP ('Royal National School for Vocational Training') and in 1926, again by royal decree, were merged until 1928 into the Istituto Professionale di San Michele (along with the Museo Artistico Industriale and the Ospizio di San Michele). Cambellotti, who had taken a diploma here in 1896, began to teach ceramic decoration in the first decade of the century and, in the mid-twen-

ties, created numerous pieces bearing the marks RINIP and TAI with Romeo Berardi, Virginio Retrosi and Roberto Rosati, and with the collaboration of the technical expert on *bucchero* ware Fernando Frigiotti. At the beginning of the thirties, Roberto Papini was called in to reorganize the school and reported on it in an article in *Domus*. It was still divided into two sections, plastic decoration and painted decoration, but Papini put the teaching on a more concrete and modern basis, so that from a 'factory of cheap geniuses' the school went back to being a 'breeding ground of excellent artisans'.
Bibliography
2nd Monza Biennale 1925; *Domus*, February 1932; *Mostra della ceramica italiana* 1982; Quesada 1988; Quesada 1992; De Guttry, Maino 2003.
(cat. 246-251)

Francesco Nonni
(Faenza 1885–1976)
He started work at an early age as a woodcarver at the Ebanisteria Castellini. He attended the Scuola d'Arti e Mestieri run by Antonio Berti, where he met Baccarini and became part of his circle. He devoted himself to xylography, making illustrations for books and magazines. He showed graphic works at the Simplon Exhibition held in Milan in 1906 and the Venice Biennali of 1910, 1912 and 1914. He attended the Scuola del Nudo at the academy in Florence, and in 1915 began to teach plastic arts at the school in Faenza where he had been trained. During the war he was taken prisoner and interned in a camp, returning at the end of the conflict. In 1919 he started to model small figures that were translated into ceramics produced in short runs at Paolo Zoli and Pietro Melandri's La Faïence pottery and then at Melandri's workshop and Focaccia & Melandri. From 1922 onwards Anselmo Bucci executed and decorated the majority of Nonni's figures. Initially the subjects were ladies in loose 18th-century dresses with designs in the Secessionist style that concealed containers for face powder, perfumes, jewellery or sweets: refined objects of everyday use produced in limited runs whose popularity led to many imitations. In addition to female figures in full dresses and with small heads, Nonni modelled Pierrots, dancers, exotic figures and portraits of women and children from the local bourgeoisie, or of his best-known friends and acquaintances, ranging from the classical ballerina Cia Fornaroli Toscanini, daughter-in-law of the conductor, to members of the Mondadori family. One of Nonni's most famous works, representative of the refined Art Deco style he adopted, is the *Oriental Procession* made with Bucci and presented at the Paris Expo of 1925, where it won the silver medal. By this time the most interesting and creative period of Nonni's ceramics can be considered at an end, although a limited production of pieces continued at Anselmo Bucci's workshop, while imitations of them were made by other factories, such as Salamandra in Perugia and the Società Cooperativa Ceramisti in Imola. After the twenties and up until his death, ceramics would be only an occasional activity for Nonni, who devoted most of his energies to painting.
Bibliography
2nd Monza Biennale 1925; 3rd Monza Biennale 1927; Marangoni, *Enciclopedia* 1927; ENAPI 1936; *Domus*, May 1941; Azzolini 1971; Bojani 1976; Frattani, Badas 1976; Bossaglia 1980; *Mostra della ceramica italiana* 1982; Dirani, Vitali 1982; Préaud, Gauthier 1982; Rosso 1983; De Guttry, Maino, Quesada 1985; Bojani 1986; Castagnoli 1989; Savini 1992; Benzi 2001; Dironi 2003; Dironi 2004.
(cat. 63-71)

La Nuova Cà Pirota
Founded by Giuseppe Fiumi (Faenza 1892–1965), formerly an employee of the Fratelli Minardi, in 1922. For a few months, one of the partners in the initiative was the potter Achille Wildi from Pesaro. The production took its inspiration, as the name implied, from the local tradition and met with moderate success until 1930, when the effects of the international crisis began to make themselves felt. In 1933 the factory closed and Fiumi became a decorator at the Trerè factory. Following the latter's temporary closure, Fiumi went to San Marino, to work at Luigi Masi's factory, where he would remain until 1954.
Bibliography
Le Arti Decorative, June-July 1924; *La Cultura Moderna*, August 1924; *Emporium*, August 1924; Minghetti 1939; Dirani, Vitali 1982; Benzi 2001.

Olco
Small ceramics factory founded in the 1920s by the architect Franco Oliva and the painter Alba Coacci (the name is formed out the initial syllables of his and her surnames). Oliva provided the designs, of Secessionist inspiration and the painted turned them into ceramics, with the collaboration, for the small decorative figures, of the sculptor Augusto Magli. Much of the production was intended for architectural use and was often limited to the decoration of tiles. The factory was wound up before the war.
Bibliography
Chilosi, Ughetto 1995.

Mario Ortolani
(Faenza 1901–1955)
He attended the Scuola di Disegno Minardi in Faenza and was taught by Achille Calzi. From time to time he followed the courses of painting at the academy in Florence, a city where he often went to stay with his brother-in-law Giannetto Malmerendi (1893–1968), an adherent of Futurism. He devoted himself to painting, feeling more drawn to Impressionism and Post-Impressionism. In 1927 he opened a ceramics workshop in Faenza. The economic security that stemmed from his father's wealth allowed him to produce ceramics following his own inclinations. In 1928 he was involved, with Riccardo Gatti and Anselmo Bucci, in G. Fabbri's scheme for the production of Futurist ceramics to designs by Balla, Dal Monte, Benedetta Marinetti, Remo Fabbri and Pippo Rizzo that would be presented at the 1929 International Exhibition in Barcelona under the mark 'Ceramiche Futuriste G. Fabbri Faenza'. His lack of interest in the commercial aspect of the activity led, after an attempt to join forces with Natale Cornacchia and Angelo Melandri, to financial difficulties and the closure of the workshop. He continued with his studies of painting, the art for which he felt he had most aptitude, and theosophy. From 1936 to 1942 he found work as a decorator at Castellini and Masini's factory. In 1945 he joined the Cooperativa Artigiana Ceramisti Faentini and started to teach courses of drawing at the T. Minardi School, an activity that he continued until 1954.
Bibliography
Domus May 1932; ENAPI 1932; Minghetti 1939; Dirani, Vitali 1982; Crispolti 1982; Savini 1992.

Ivos Pacetti
(Figline di Prato 1901 – Albisola 1970)
He arrived in Albisola from the Valdarno in 1920 and the next year got a job at the MAS, where he executed Antico Savona decorations under the guidance of Dario Ravano. After the closure of this factory the following year, he collaborated with Manlio Trucco's La Casa dell'Arte and Alba Docilia. From 1928 to 1932 he ran the artistic ceramics department at the ILSA, where he made toys and animals inspired by Futurism, and then went on to set up a factory of his own, La Fiamma, where from 1932 to 1933 he produced sculptures and slabs in relief representing astronomical subjects in a clearly Futurist style. Characterized by a masterly handing of glaze and paint, they were shown at the Milan Triennale in 1933 and the one in 1936, where they won a gold medal, as well as the Mostra Mercato dell'Artigianato in Florence (winning first prize in 1933 with a coffee service). In 1938, abandoning Futurism, Pacetti returned to the ILSA, for which he created a considerable number of pieces (sculptures and paintings on ceramic) that were presented at the 9th Crafts Exhibition in Florence and the Milan Triennale in 1940.
Bibliography
ENAPI 1933; *Domus*, September 1933; 5th Milan Triennale 1933; 6th Milan Triennale 1936; *Domus*, July 1938; Minghetti 1939; 8th Milan Triennale, 1947; Crispolti 1982; *Mostra della ceramica italiana* 1982; Rosso 1983; Chilosi, Ughetto 1995; Barisone 2001.
(cat. 437-439)

Ferruccio Palazzi
(Arcevia, Ancona 1886 – Osimo 1972)
He settled in Rome after the war and quickly became a leading figure in the world of ceramics, both by practicing the art personally and gaining a profound understanding of the techniques and by placing workshops and exhibition and sales facilities at the disposal of other artists and ceramists. In 1920, for example, he held an exhibition in his own studio in Piazza Venezia with works by Cambellotti, Mauzan and Cellini. From 1923, with the Casa d'Arte Palazzi, which also published the magazine *Il focolare*, he worked on the design and production of furnishings, creating decorative *objets d'art* of all kinds, from majolica ware to fabrics and from wrought iron to furniture and carpets. His ceramics were shown at the first Monza Biennale of Decorative Arts, along with those of Giulio Rufa and Roberto Rosati, his collaborators in the production of marks created on his initiative, commencing with the LNCR, Laboratorio Nuova Ceramica Roma and followed by Palatino

Ars, La Fiamma, Ceramiche Palazzi and Manifattura Picena. The most important of these was La Fiamma, founded between 1923 and 1924 and located in the Palazzo dei Piceni in Piazza San Salvatore in Lauro, once the home of the Bottega d'Arte Romana, a place for the exhibition and sale of high-quality craft products. La Fiamma was not just a kiln, but also a centre for the study, promotion and teaching of the ceramic art, run by Roberto Rosati and frequented by other artists, to fire their pieces and leave them on display. In addition to the aforementioned Giulio Rufa, these included Duilio Cambellotti, Virgilio Retrosi and Virginio La Rovere. The production comprised dinner services and tableware, decorative plates and vases, in modern styles as well as those of the past. The dynamic entrepreneur-ceramist also published a book on ceramic technology (*Tecnologia della ceramica*, 1932), a monthly bulletin (*C.S.C.*, from 1934 to 1937), carried out teaching activities and even planned to set up a college for the ceramic art. In 1937, after closing La Fiamma, he left for Ethiopia and founded a school of ceramics there. The failure of the Italian colonial adventure also put an end to Palazzi's involvement in this sector of the arts.
Bibliography
Le Arti Decorative, October, December 1923; 1st Monza Biennale 1923; *Le Arti Decorative*, June-July 1924; *La Cultura Moderna*, August 1924; *Emporium*, August 1924; Marangoni, *Enciclopedia* 1927; Minghetti 1939; Quesada 1988; Quesada 1992; De Guttry, Maino 2003.
(cat. 253-255, 261, 262)

Paleni

It appeared at the Monza Biennale of 1927 as the firm E. Paleni of Bergamo, showing ceramics in the room of the Zonca brothers, some of them executed to the latter's design. The *Annuario Industrie della Ceramica e del Vetro* of 1930 list the factory as having eight workers. It reappeared as Cesare Paleni with several vases in the ceramics gallery of the Milan Triennale in 1933, and with two ceramic statues based on a model by the sculptor Pietro Fabbri in the room of ENAPI models. At the next Triennale several of its vases were shown in the gallery of the decorative arts and it appeared again in the room of the ENAPI, as it would do in 1940. Its ceramics are in the Museo della Ceramica in Faenza.

Bibliography
3rd Monza Biennale 1927; *Annuario Industrie della Ceramica e del Vetro* 1930; ENAPI 1932; ENAPI 1933; 5th Milan Triennale 1933; ENAPI 1936; Triennale 1936; Minghetti 1939; Triennale 1940.

Alessandro Pandolfi
(Castellamare Adriatico, Pescara 1887 – Pavia 1953)
A painter and wood-engraver trained at the Istituto di Belle Arti in Bologna and the Accademia Albertina in Turin, Pandolfi applied his talent for painting to the ceramic medium as well, decorating ironstone china produced at Laveno underglaze. In 1923 he took part in the first Monza Biennale: his ceramics were shown among the majolica ware of Castelli, alongside those of Virginio La Rovere, the local school and the SIMAC. The subjects were chiefly rural landscapes with women in Abruzzian costume represented with agreeable realism, like the ones published by Marangoni in 1927 in two plates of his *Enciclopedia* (where the artist was said to be resident at Vigevano).
Bibliography
1st Monza Biennale 1923; Carrà 1923; Marangoni, *Enciclopedia* 1927; *La Casa Bella*, July 1928, September 1929; Minghetti 1939; Morazzoni 1957; Comanducci, IV 1973; Pagano Conforto 1998; Ausenda, in *Museo d'Arti Applicate* 2002.

Mary Pandolfi de Rinaldis
(Monsano, Ancona, 1890 – Zoverallo, Ivrea 1933)
She lived with the family in Rome, where she studied at the Accademia di Belle Arti. Very close to Giovanni Prini, who was her teacher and friend, and Cambellotti's group, she devoted herself first to embroidery and tapestry. When she began to work with ceramics, she showed a preference for modelling, even when making vases and articles for everyday use, which incorporated realistic figures of animals. In 1922 she showed ceramics and embroideries at the Exhibition of Fine Arts of the Società Amatori e Cultori in Rome, in the same room as Prini's ceramics and bronzes. The following year, at the first Monza Biennale of Decorative Arts, she appeared in the Lazio section, organized by Cambellotti, again with embroideries and ceramics, winning a silver medal with the latter. At Pesaro, in 1924, her ceramics were shown alongside those of Ferruccio Palazzi's La Fiamma, where it is likely that she fired her own pieces. At the end of the twenties the artist entered a religious order and then the convent of Zoverallo, where she died of leukaemia the following year.
Bibliography
1st Monza Biennale 1923; *Architettura e Arti Decorative* 1923; *Le Arti Decorative*, September, December 1923, June-July 1924; 1st Monza Biennale 1923; Carrà 1923; *La Cultura Moderna*, August 1924; Serra 1924; Marangoni, *Enciclopedia* 1927; Minghetti 1939; *Mostra della ceramica italiana* 1982; Quesada 1988; Quesada 1992; Longo, in *Museo d'Arti Applicate* 2002; De Guttry, Maino 2003.
(cat. 259, 260)

Giovanni Pardi
(Castelli 1853 – Rapino 1929)
A native of Castelli in Abruzzo, he worked first at the Musso factory in Mondovì and then, around 1880, moved to the factory run by Niccolò Poggi's widow at Albisola. From 1883 to 1890 he ran his own workshop, still at Albisola, and at the beginning of the century moved to Alassio. Tullio Mazzotti considered him one of the people who made the greatest contribution to the birth of artistic ceramics in Albisola. In the twenties he went back to Castelli, where he continued to work with ceramics.
Bibliography
Minghetti 1939; Chilosi, Ughetto 1995.

Andrea Parini
(Caltagirone 1906 – Gorizia 1975)
He attended art school in Palermo, going on to take a diploma in sculpture at the Accademia di Belle Arti. Returning to Caltagirone, he opened a studio where he made marble sculptures and woodcuts, probably under the influence of Luigi Bartolini, interned at Caltagirone following a quarrel with the Fascist authorities in Pula. In 1932 he began to work with clay, making busts and high reliefs and taking part in all the exhibitions of the Union of Fine Arts until 1942 (prize in 1941 for the majolica *The Obstetrician*). In 1934 and 1939 he exhibited at the Venice Biennale; in 1934 and 1936 at the Rome Quadriennale. In 1942 he moved to Nove, to run the Art School there. In the town he found a range of production dominated by historicist reproductions, into which he managed to insert his own, antithetical language, at once ironic and ornate, based on irregular modelling and bold colours, in popular and fantastic tones. The following year he met Gio Ponti and the two frequently exchanged letters. The most original creations of those years were his *split vases*, i.e. containers of traditional form but open at the front and filled with symbolic applications. His chess and crèche series date from 1950. In 1947 and 1951 he took part in the Milan Triennale; from 1948 to 1956 he was invited to show at the Venice Biennale, winning the prize for ceramics in 1950. In 1953 he won the ENAPI gold medal at the *Exhibition of Art in the Life of Southern Italy* in Rome. In 1963 he became principal of the Scuola d'Arte in Padua, of the Istituto d'Arte in Venice the following year and that of Gorizia in 1966.
Bibliography
Folliero 1957; *Mostra della ceramica italiana* 1982; Stringa 1983; Stringa 1986; Stringa, *Omaggio a Bassano e Nove* 1987.

Piccinelli

When still a very young man Mario Piccinelli (Scanzo, Bergamo 1865–1937) founded the Ceramiche Piccinelli factory, specializing in the production of ceramics for the building trade from national raw materials. He also set up a company for research into the china and other clays of Sardinia, the Caolino di Sardegna S.A., and the Società Italiana Refrattari of Santo Stefano Magra. An exclusive of the firm was klinker, which differed from traditional clay materials in the inclusion of plastic and binding substances (feldspathic clays and quartz) in the mix and in being fired at very high temperatures. The product was a very hard, impermeable and almost unalterable material, used as an external facing for buildings in the place of painted decorations or plaster and as a facing for interiors. Also made out of this material, which could be produced in a wide range of colours, were friezes and bas-reliefs, as well, though more for promotional than commercial purposes, as large vases and statues of various sizes that were shown at the Milan Triennali of 1933 (basin and large vases), 1936 (sculpture by G. Ursi) and 1940, among other exhibitions.
Bibliography
Annuario Industrie della Ceramica e del Vetro 1930; Papini 1933; 5th Milan Triennale 1933; 6th Milan Triennale 1936; Minghetti 1939; 7th Milan Triennale 1940.
(cat. 354)

Giuseppe Piccone
(Albisola 1912–1960)
Descended from a family of ceramists, including Gio Batta, owner of a pot and crockery factory, and another Giuseppe, active at Albisola from 1856 onwards with a production in Antico Savona style and dinner services 'in the Mondovì fashion', Giuseppe Piccone was the proprietor of a workshop that employed about ten people in 1930. He also made sculptures and reliefs within the Futurist group at the MGA.
Bibliography
Annuario Industrie della Ceramica e del Vetro 1930; Minghetti 1939; Crispolti 1982; Chilosi, Ughetto 1995.

Vincenzo Pinto
(Vietri sul Mare 1870–1939)
In 1896 Vincenzo Pinto became the owner of a ceramics factory at Vietri which had previously specialized in the manufacture of crockery. To this production he added facing tiles and artistic ceramics that from the first half of the twenties were exported regularly, to the United States in particular. From the end of the twenties to the beginning of the forties it was run by Renato Rossi and its collaborators included Margarethe Thewalt Hannasch, Irene Kowaliska, Luigi Anelli from Vietri, Giovannino Carrano, Giuseppe Capogrossi and the Hungarian Amerigo Tot, designer of the canopy of Stazione Termini in Rome. Around 1930 it employed some twenty workers. It took part in the Milan Triennali of 1937 and 1940. Between the thirties and forties, the Ceramica Pinto also used the mark Fiamma Italica and, from 1945 to 1952, that of the ICAM, Industria Ceramica Artistica Meridionale.
Bibliography
3rd Monza Biennale 1927; Annuario Industrie della Ceramica e del Vetro 1930; 4th Monza Triennale 1930; Minghetti 1939; Frattani, Badas 1976; Romito 1994; Napolitano 1995; Romito, La ceramica vietrese...1999; Romito, La Collezione Camponi 1999.

Giuseppe Piombanti Ammannati
(San Lorenzo a Colline, Florence 1898 – Florence 1996)
He studied at the Scuola Professionale di Arti Decorative e Industriali di Santa Croce under Libero Andreotti. Initially his main interests were mural decoration and graphics, but he also designed furnishings. At the beginning of the twenties he worked for a year as a decorator at the Florentia Ars factory. He taught ornamental design and the history of ceramics at the Scuola d'Arte Ceramica in Sesto Fiorentino and was its principal from 1934 to 1936. Later he would teach at the art schools of Grottaglie, Penne and Urbino. In the meantime, and thanks in part to these experiences, his interest in ceramics became predominant and he devoted himself to making small, fanciful and ironic sculptures, in the Art Deco manner. He showed at the Milan Triennale of 1933, at the Paris Exhibition of 1937 and at the Florence Crafts Exhibition of 1939. In 1942 he won the Gaetano Ballardini ceramics prize.
Bibliography
5th Milan Triennale 1933; 6th Milan Triennale 1936; Papini 1936; Pagano 1938; Domus, July 1939; 7th Milan Triennale 1940; Mostra della ceramica italiana 1982; Mostra di opere 1987; Bojani 1988; Capetta 1990; Cefariello Grosso 1990; M. Pratesi, in Museo d'Arti Applicate 2002.
(cat. 440-443)

Ciriaco Piras
(Dorgali 1891–1955)
After working in Cagliari with Francesco Ciusa, he opened a workshop at Dorgali where he devoted himself to the decoration of leather and to woodcarving as well as ceramics. His products were aimed at a more popular market than Ciusa's artistic ones, and inaugurated a genre that was to have many imitators and long success on the island. A common choice was to produce terracottas made in moulds and decorated without firing that translated themes and motifs of the Sardinian tradition into an up-to-date language. Less care was taken over the execution, especially with regard to the decoration, often carried out by children, while the range of articles was wide as well as less rigid, comprising figures, vases, amphorae, bonbonnières and boxes, all of which could also be made to order. From 1925 to 1927, Piras's nephew Simone Lai was an apprentice in the workshop, and the latter's young brother-in-law Salvatore Fancello also worked there for a short period in 1929. Active up until the fifties, Piras showed his ceramics at numerous regional and national exhibitions.
Bibliography
Altea, Magnani 1995; Cuccu 2000.

Niccolò Poggi – Quaglino e Poggi
Factory created in 1892 by the subdivision of Maria Rosciano Vedova Poggi e Figli, founded at Albisola in 1862 by Santino Poggi, among the Poggi children, it immediately distinguished itself for its production, alongside ordinary pottery, of fine and artistic ceramics. In 1898 Nicolò Poggi went into partnership with the Turinese painter Luigi Quaglino, who introduced the Art Nouveau style. The factory took part in the Turin International Exhibition in 1902. The same year the partnership was wound up at the behest of Quaglino, who in 1905 moved to New York, where he went on working with ceramics. The factory continued its activity, maintaining the same stylistic approach for a long time. Among its collaborators we find Giuseppe Mazzotti and Adolfo Rossello until 1903 and Pietro Rabbia and Dario Ravano until 1907. In 1905 the Poggi factory acquired the moulds of Quinzio e Canepa di Sampiedarena (formerly Sansebastiano e Moreno). On Nicolò's death in 1815, the factory passed into the hands of his widow and three children, who entrusted its management to Adolfo Rossello until 1919, when he founded Alba Docilia. Domenico and Luigi Poggi kept the factory going, turning it into a cooperative in which several painters were involved. In 1923 Lina Assalini joined as an apprentice decorator, marrying Domenico Poggi in 1927 and, after a new division of the company in 1929, becoming its proprietor. At this point the production consisted essentially of small sculptures, figures of girls in fancy dress and vases that were also shown at the Triennale.
Bibliography
Aitelli 1901–1902; Melani 1902; Pica 1902; Minghetti 1939; Rosso 1983; Chilosi, Ughetto 1995; Maldini 1999.

Gian Polidori
(Urbino 1895 – Pesaro 1962)
The son of Ferruccio Mengaroni's sister, he started to work with ceramics at a very early age in Vincenzo Molaroni's factory before going to the academy in Urbino, to Milan, where he frequented Brera and the Castello Sforzesco and executed mural decorations, and to Faenza, where he worked as a ceramic painter at Farina and then Castellini e Masini. From 1921 to 1925 he was artistic director at Giacomo Dolcetti's Bottega del Vasaio in Venice, where his painting skills won him the admiration of artists like De Maria, Laurenti, Cadorin and Zecchin and critics like Vittorio Pica. The subjects of his decorations were mostly figures: doges, doge's wives and masqueraders. In 1923 he showed a panel entitled In Time at the Venice Biennale. He then went to Ancona to run a new ceramics factory, La Dorica, with which he participated in the Monza Biennale of 1925. Its production consisted largely of tiles and panels painted with portraits, often with detailed landscape or architectural backdrops, as well as plates and bowls decorated with motifs that harked back to the tradition of the Marche. From 1925 to 1930 he was at Matricardi in Ascoli Piceno. In 1931 he won a prize at the Faenza Ceramics Competition. Later on, he held the post of principal of the Scuola d'Arte Ceramica in Castelli and, in 1940, of the one in Castellamonte. From that time on he devoted his energies primarily to the history of ceramics and of the Museo Comunale in Pesaro.
Bibliography
Emporium, August 1924; Le Arti Decorative, July, September 1925; 2nd Monza Biennale 1925; Emporium, November 1925; La Casa Bella, November 1928; Buzzi 1930; Guigoni 1930; 4th Monza Triennale 1930; Minghetti 1939; Folliero 1957; Mostra della ceramica italiana 1982; Stringa, L'arte decorativa...1987; Alessandrini, in Museo d'Arti Applicate 2002.
(cat. 278)

Gio Ponti
(Milan 1891–1979)
Gio Ponti's work as a designer of ceramics marked the first important stage in his long career, undertaken immediately after he graduated in architecture. The young architect began to frequent the factory at San Cristoforo around 1921, and soon won the confidence of its owner Augusto Richard, who in 1923 appointed him artistic director of the whole of Richard-Ginori. He worked out of the Milanese factory, and the former artistic director Luigi Tazzini acted as an intermediary between the designer and the workshops in Doccia where the prototypes of the majolica ware and porcelain were made. At the first Biennale of Decorative Arts in Monza the many innovations presented by Richard-Ginori bore Ponti's signature: along with a bust of a woman modelled by the sculptor Gigi Supino and made in ironstone china at San Cristoforo, there were large plates in majolica with the decoration

called *My Woman on Clouds* and the motif of the *Archaeological Stroll* anticipated on a large urn with a lid. At the next Biennale, in 1925, Ponti's repertoire had been enriched with other figures in ironstone china made at San Cristoforo, such as *Hospitality* and the *Tired Pilgrim* modelled by Salvatore Saponaro, as well as numerous pieces of majolica ware and goblets, vases and other objects in porcelain with extremely interesting figured decorations that cite the classical world with great irony and elegance. The method he followed, more that of a designer than of an artist, was to study decorations that could be applied to different objects to create families. What was originally intended to be a type of industrial production was in reality only applied in part and to varying degrees to the ceramics he designed: the ironstone articles made at San Cristoforo came the closest to being mass-produced, then the porcelain, although this required the decisive intervention of skilled modellers and decorators, and finally the majolica ware, whose quality depended on the brushwork of genuine artists. As a consequence many majolica objects were very expensive, produced in extremely limited runs or even as one-off pieces. In 1925 Ponti organized Richard-Ginori's display at the Paris Expo, where the new production obtained ample international recognition (two grand prizes: one to the designer and one to the factory). The following year he and Tomaso Buzzi designed the *Centrepiece* for the embassies of Italy and two porcelain *cistae* for Ojetti with the collaboration, for the figures, of Libero Andreotti, whose studio had begun to work with the factory two years earlier. The vases decorated with feathers and the three motifs of *Plenty*, *Justice* and *Temperance* date from the same year. In 1927 Ponti was involved in the organization of the third Monza Biennale, but Richard-Ginori did not present any significant novelties. In 1928 the high-fired blue porcelain with decorations in gold polished with an agate-tipped stylus appeared, reusing earlier forms and decorations. New decorations included the *Triumph of Love and Death*, *Mermaids*, *Angels* and, for the majolica, *Hunting Scenes*. Many decorations were also created that were inspired not by classical antiquity but by sport (*The Jockeys*, *Boating*, *Sailing*, *Celesio* and *Alato* – images of skies and flying – and *Skiers*), the circus and various other themes. The year 1928 was important as it marked the birth, on Ponti's own initiative, of the magazine *Domus*, in whose pages Italian avant-garde ceramic production found an important means of promotion. In 1929 the vases of the *My Lands* series appeared, followed in 1930 by the blacks and gold of San Cristoforo and the red of Doccia known as *gran rosso*. This year can be considered to mark the end of the golden age of Ponti's ceramics, even though he went on working with Richard-Ginori, but no longer with the vivacity and the results attained between 1923 and 1930, in part because the designer was engaged on many other fronts, but perhaps also because it was on this date that Augusto Richard died, while the decorator Vittorio Faggi and the invaluable Tazzini retired. In 1931 he again designed the San Cristoforo hand-decorated series, with unique drawings in red over an ivory glaze, and the Exagon series, which took its name from the original hexagonal forms, in soft-paste porcelain and celadon glaze, which were used to make other objects as well, including the figure of the *Baboon with Bowls* modelled by Fausto Melotti. In 1935 he designed, for the factory in Doccia, the series of *Hands* modelled in full relief (*The Witch's Hand*, *The Hand with a Flower*), and then small plates with naïve designs (*Vispa Teresa*, *Life of the Angels*), flasks and bottles with applications of flowers in relief that would be presented in Paris. Finally it is worth mentioning the bringing back into production of some of Gio Ponti's works in 1983, including the *Alato* and *Celesio* cups and the plates of the *Seasons* and *Mermaids*.

Bibliography
Emporium, July 1923; 1st Monza Biennale 1923; Carrà 1923; Mezzanotte 1923; Papini 1923; Sarfatti 1923; 2nd Monza Biennale 1925; *Emporium*, July, September, October 1925; *Opere scelte* 1925; Ponti 1926; 3rd Monza Biennale 1927; *Emporium*, July 1927; Liverani 1927; Marangoni, *Enciclopedia* 1927; *Problemi d'arte attuale*, October 1927; Reggiori 1927; *Domus*, January, February, March, April, May, June, August, September, October, November, December 1928, January, February, April, August, September, October, November, December 1929; *Emporium*, September 1929; *Problemi d'arte attuale*, January-February 1929; *La Casa Bella*, March, December 1930; *Ceramiche moderne d'arte Richard-Ginori* 1930; Buzzi 1930; *Domus*, January, March, May, July, August, September, October, November 1930; *Emporium*, November 1930; 4th Monza Triennale 1930; Papini 1930; Ponti 1930; *Domus*, February, April, June, July, August, September, December 1931; *Emporium*, July 1931; *Domus*, January, February, March, May, June, July, November, December 1932; January, February, May, July, August, October; 1933; *Emporium*, December 1933; 5th Milan Triennale 1933; *Domus*, February, June, September, October, November, December 1934; March, June, September, October, November, December 1935; June, September, October 1936; June, October, December 1937; June, July, September 1938; January, June, December 1939; Minghetti 1939; *Domus*, February, June, September 1940; Morazzoni 1957; Bojani, *L'opera di Gio Ponti* 1977; Bossaglia 1980; *Annitrenta* 1982; *Mostra della ceramica italiana* 1982; Portoghesi, Pansera 1982; Préaud, Gauthier 1982; *Gio Ponti* 1983; Rosso 1983; Bojani, *Gio Ponti ceramica e architettura* 1987; Gio Ponti 1987; Cefariello Grosso, Maggini Catarsi, Monti 1988; Amari 1995; La Pietra 1995; Ausenda 1998; Terraroli, *Milano Déco* 1998; Barisione 1999; Manna 2000; Miodini 2001; Ausenda and Pansera, in *Museo d'Arti Applicate* 2002.
(cat. 104-189, 191, 303-310)

Pozzo della Garitta
A factory with this name was set up around 1937 on the initiative of Bartolomeo Tortarolo, called Bianco, and Umberto Ghersi (1913–1993) on the former premises of the Mazzotti factory at Pozzo della Garitta. It took part in the Triennale in 1940, where it won a prize for a series of animals, and the Faenza competition in 1942. In 1941 the sculptor Luigi Broggini was at the pottery, and would return at the end of the war, to make figures of female nudes, objects characterized by an opulent decoration and, in the fifties, bas-reliefs. After the war Bianco and Ghersi founded the SOESCO with other partners, but after a few years relations between the two soured and Bianco continued alone in the old kiln, which was frequented by many artists.
Bibliography
Chilosi, Ughetto 1995.

Giovanni Prini
(Genoa 1877 – Rome 1958)
He attended the Accademia Ligustica in Genoa and devoted himself to sculpture. In 1900 he moved to Rome, where made friends with Giacomo Balla and joined the group of artists gathered around the magazine *Novissima*. In 1903 he formed the Unione degli Artisti with Ximenes, Gioia and Coleman. At the exhibition of the Società degli Amatori e Cultori delle Belle Arti in 1905 he had a room to himself in which he showed drawings, pastels and bronzes. The small sculptures of this period were influenced by Leonardo Bistolfi and Medardo Rosso and usually portrayed the world of childhood, or explored, like Cambellotti and Balla, such social themes as old age and work. Some of these subjects, mostly children and busts, were reproduced in ceramic by the Manifattura di Signa. In the second decade of the century he began to tackle celebratory themes, basing them on Greek statuary and Michelangelo's sculptures. In 1911 he took this approach to the bas-relief *The Artist and Artistic Battles*, also called *The Paean of the Arts*, located on the front of the Galleria Nazionale d'Arte Moderna. In the ceramic medium, in which he started to work from 1915 onward, he represented subjects from daily life, ranging from his beloved world of children to female figures, and religious themes. A number of figures of putti, babies and ladies are linked to his work as a designer of toys for the SFAGI, of which he became artistic director in 1919. His ceramics were first shown at the Roman Secession of 1916, but above all at the exhibition of the Società degli Amatori e Cultori in 1922, where they appeared alongside the works of his pupil Mary Pandolfi de Rinaldis. His presence at the first Monza Biennale was significant, with decorative sculptures, polychrome ceramics, toys and representations of religious subjects in majolica. Two years later, at the same event in Monza, he prepared the 'Room of Sacred Art' with statues and tondi in terracotta.
Bibliography
Mezzanotte, 1923; *Le Arti Decorative*, September, December 1923; 1st Monza Biennale 1923; Papini 1923; Sapori 1923; *Le Arti Decorative*, August-September 1924; Marangoni, *Enciclopedia* 1927; *La Casa Bella*, June 1928; Minghetti 1939; *Mostra della ceramica italiana* 1982; De Guttry, Maino, Quesada 1985; Quesada 1988; Conti, Cefariello Grosso 1990; Contini 1992; Quesada 1992; Giovanni Prini

1998; Morelli 2002; De Guttry, Maino 2003.
(cat. 263)

Salvatore Procida
(Vietri sul Mare 1900–1965)
Manager of the ICS from 1930, after Dölker and before Gambone, he moved to Florence in 1937, to run Cantagalli with Melamerson. Later he returned to Vietri, where he set up a business of his own. Among the things most characteristic of his production, anthropomorphic candlesticks, sculptural groups, modelled vases with two sides and circular crèches.
Bibliography
Romito 1994; Napolitano 1995; Romito 1996; Bignardi 1996; Romito, La ceramica vietrese… 1999.

Massimo Quaglino
(Refrancore, Asti 1899 – Turin 1982)
Initially working as an illustrator for several magazines, he went on to paint and execute mural decorations for the rooms of exhibitions like the one in Turin in 1928 and the Monza Triennale of 1930. He collaborated with Lenci for two years from 1928 on, modelling figures with a caricatural tone, close to the style of his illustrations. Two of his works were shown at the Galleria Pesaro in 1929, a Donkey and Putto and a Bombardier. He exhibited a series of drawings at the Venice Biennale in 1936 and a year later was in Libya, where he also realized frescoes and paintings. After the war he executed more works of mural decoration and illustrations. From 1955 to 1969 he was professor of decoration at the Accademia Albertina in Turin.
Bibliography
Ceramiche di Lenci 1929; Minghetti 1939; Proverbio 1979; Panzetta, Préaud, Gauthier 1982. Panzetta 1992; Le ceramiche Lenci 1983.

Pietro Rabbia
(Cogoleto 1877 – Turin 1948)
Along with Dario Ravano, he was among the most active master decorators in Albisola, much in demand by the local factories. He worked with Poggi until 1907 and then Piccone, the MAS, La Casa dell'Arte and Mazzotti. Between these work experiences he spent time studying at the Accademia Ligustica in Genoa. Highly skilled in the reproduction of styles of the past, in particular the Antico Savona and Levantino, he was also quite at home with a modernist language. His best-known works are the plates commissioned by Father Semeria for the benefactors of war orphans and attached to the façade of the Monterosso Orphanage, and the ones for the holiday home in the mountain resort of Courmayeur, known as the 'house of plates'.
Bibliography
2nd Monza Biennale 1925; 3rd Monza Biennale 1927; Minghetti 1939; Chilosi, Ughetto 1995.

Mario Raimondi
(Torresine 1899 – Vado Ligure 1953)
Sculptor who served his apprenticeship at the beginning of the thirties, frequenting Arturo Martini's studio at Vado Ligure as a simple worker. In addition to terracotta works that fall within the sphere of art, he devoted himself to the production of decorative ceramics, both one-off pieces and in series, the latter with the ILSA (Adolescence, Bagpiper).
Bibliography
Rosso 1983; Chilosi, Ughetto 1995.

Emanuele Rambaldi
(Pieve di Teco 1903 – Savona 1968)
Influenced by Salietti and Funi, he joined the Novecento movement in 1925. He was one of the founders of the Gruppo d'Azione d'Arte in Chiavari, within which he focused on the design of furniture. He was involved by Labò in the design of ceramics for the Savona Nuova mark at La Fenice in Albisola and then for the ILCA at Genoa-Nervi, where he also coloured the ceramic works of Martini. These last, a crèche and several painted vases, were presented at the Monza Triennale of 1930. For the decoration of vases and plates he preferred still lifes and landscapes, and for figures, simplified forms somewhere between the Novecento and folk. He took part in the Triennale of 1933 with La Casa dell'Arte, showing among other things a Small Head of a Woman in a Hat, along with more demanding works like a Ceres, a Homage to Campigli and a Ligurian Landscape. After the war he was principal of the Accademia Ligustica in Genoa and continued to work with ceramics, again with La Casa dell'Arte and then with Umberto Ghersi's factory.
Bibliography
Buzzi 1930; 4th Monza Triennale 1930; Domus, May 1933; 5th Milan Triennale 1933; Minghetti 1939; Chilosi, Ughetto 1995.

Domenico Rambelli
(Pieve di Cento 1886 – Rome 1972)
He started to work in potteries in Faenza at an early age and then at the Ebanisteria Castellini. At the same time he attended Antonio Berti's Night School of Arts and Crafts and frequented the group of artists that has gone down in history as the Baccarini coterie. With Baccarini he attended the Scuola Libera del Nudo in Florence, where he came into contact with Pellizza da Volpedo, Costetti and Lorenzo Viani. He devoted himself to sculpture, passing from an initial Art Nouveau phase close to Baccarini's manner to a vigorous and essential style of Synthetist derivation (simplification and emphasizing of forms). He showed a bronze portrait of his teacher Berti at the Venice Biennale of 1907 and the Torricelli Exhibition in Faenza in 1908, and the same year went to Paris, returning in 1914. After the war he began to collaborate with the Scuola di Ceramica in Faenza, where he would be artistic director until 1944 and inspire an original line of production in the Art Deco style, realized with the decisive support of the ceramist Anselmo Bucci from Faenza. In parallel he continued his activity of drawing and sculpting (Monument to the Fallen in Viareggio, Sleeping Infantryman at Brisighella, Francesco Baracca at Lugo) and joined the Novecento movement. He was a member of the Fascist party and played a prominent part in the regime's major celebratory events. At the Rome Quadriennale of 1939, where an entire room was devoted to his work, he won the first prize. After the war, his undisguised support for Fascism led to his ostracism by most critics. He settled first in Bologna and then in 1947 in Rome, where he taught at the Accademia di Belle Arti and was made a member of the Accademia di San Luca in 1960.
Bibliography
7th Venice International Exhibition of Art, 1907; Sarfatti 1923; 2nd Monza Biennale 1925; Sapori 1925; Marangoni, Enciclopedia 1927; Minghetti 1939; Ghetti Baldi 1980; Quesada 1987; Bojani 1989; Castagnoli 1989; Domenico Rambelli 1990; Savini 1992; Buscaroli Fabbri 2002.

Francesco Randone
(Turin 1864 – Rome 1935)
Francesco moved from Turin to Rome after 1870, following the appointment of his father, Francesco Ansaldi, as undersecretary at the Ministry of Agriculture, Industry and Commerce. He attended the Accademia di Belle Arti in the capital, but did not finish the course of studies. In 1886 he won a prize in a government competition for the execution of fruit in terracotta. In 1890 he set up home in a section of the Aurelian Walls, where he built a kiln and founded the Scuola di Arte Educatrice. While bringing out a first line of painted terracotta fruit and plates with portraits and landscapes, he embarked on a long series of experiments with the Etruscan technique of bucchero. The kiln and the school, recognized by the minister of education in 1894, became a meeting-point for artists and writers, where programs of lectures were organized alongside the lessons for children, like the ones given by Pascoli in 1923. The five daughters and one son of the Maestro delle Mura, or Master of the Walls as he came to be known, were involved in the intense production of the Arte Vasaia Randone, which consisted largely of black bucchero vases, but also red, grey and white ones, whose secrets would never be revealed by the artist. Examples of these products were shown at the first Rome Biennale in 1921, at the first Monza Biennale in 1923 and at the International Exhibition in Barcelona in 1929. After his death the kiln and the attached school were run by his daughters, in particular Honoria. His son Belisario took part in the Milan Triennale of 1936 with the ENAPI.
Bibliography
Emporium, June 1921; Le Arti Decorative, September, December 1923; 1st Monza Biennale 1923; Sapori 1923; Marangoni, Enciclopedia 1927; 4th Monza Triennale 1930; ENAPI 1936; Minghetti 1939; Préaud, Gauthier 1982; Quesada 1988; Quesada 1992; Francesco Randone 2000; De Guttry, Maino 2003.

Dario Ravano
(Casale Monferrato 1876–1961)
The name of Dario Ravano is, along with that of Pietro Rabbia, the one that crops up most often in the history of ceramics at Albisola in the first half of the 20th century. A master decorator, adept in the reproduction of styles of the past, especially the Antico Savona, he began his career in the workshop of Giovanni Pardi, at Albisola, and then continued at the Poggi and Piccone factories. In 1920 he was in charge of the MAS, but in the twenties also worked at Mazzotti and La Casa dell'Arte. From 1925 to 1931 he ran his own factory at Albisola Capo, and from 1928 at Varazze as well, where he set up a

school to train workers at the CAS. Alongside the production of period pieces, which went though a period of great popularity after the First World War, Ravano developed a modern repertoire at his last two factories, ranging from an Art Deco version of the style of the *mezzeri*, the old shawls worn by Ligurian women, to a moderate adoption of Deco-Futurist ideas.
Bibliography
Minghetti 1939; *Mostra della ceramica italiana* 1982; Rosso 1983; Chilosi, Ughetto 1995.

Virgilio Retrosi
(Rome 1892–1975)
Virgilio Retrosi studied at the Accademia di Belle Arti in Rome. His meeting with Cambellotti, who introduced him to ceramics, proved decisive. As early as 1911 one of his vases was on show, alongside his teacher's works, in the Capanna dell'Agro at the Exhibition for the Fiftieth Anniversary of the Unification of Italy. He worked in Roberto Rosati and Giuseppe Sprovieri's factory at Treia. After the war, he used different kilns to fire his ceramics, from Grazia's more distant one at Deruta, where he worked for long periods, to the Roman ones of Ferruccio Palazzi and the RINIP (TAI mark), where he assisted Cambellotti in his teaching. At the exhibition of the Società degli Amatori e Cultori in 1926 he presented a series of twenty-four large plates dedicated to the districts of Rome that were bought by the municipality, while other pieces were shown in the 'Room of the Sea' and in the section devoted to the 'Inhabitants of the Roman Countryside'. He went on producing ceramics with success until 1935, when his interest in commercial art began to predominate.
Bibliography
Mostra della ceramica italiana 1982; Quesada 1988; Quesada 1992; De Guttry, Maino 2003.

Rèvol
Factory of stoneware crockery founded at Vado Ligure in 1897 by the Frenchman L.G. Rèvol and taken over in 1900 by Richard-Ginori, which expanded the works in 1905. Its production consisted of every kind of tableware with decorations applied by pad or, in the more valuable pieces, printed. In 1913, a persistent crisis stemming from falling demand led to the sale and reconversion of the factory.
Bibliography
Chilosi, Ughetto 1995.

Richard-Ginori, Doccia / Richard-Ginori, San Cristoforo, Milan
Richard-Ginori was created in 1896 by the merger of Ginori of Doccia, the best-known porcelain factory in Italy, founded in 1737 by Marquis Carlo Ginori, and the Società Ceramica Richard based at San Cristoforo sul Naviglio, Milan. The latter had been set up by French entrepreneurs in 1830, under the name of Gindrad, to produce porcelain of good quality at reasonable prices. Taken over by the Tinelli family in 1833, it was acquired in 1842 by Giulio Richard, already the owner of a porcelain factory in Turin, who chose to devote it almost entirely to the production of articles, chiefly dinner services, in ironstone china decorated by transfer, while continuing to produce some pieces in hard porcelain. In 1879, his son Augusto Richard (1856–1930) became the technical manager and enlarged the works, making them the biggest in Italy. At the International Exhibition in Milan in 1881 the Società Ceramica Richard presented earthenware services and large vases and plates painted by contemporary artists, including Giacomo Favretto and Francesco Paolo Michetti. The company's excellent performance allowed it to take over a terracotta factory at Pisa in 1887 and Ginori of Doccia in 1896, whose name was added to that of Richard in the new company title, along with Musso of Mondovì, which produced soft earthenware articles, in 1897. In 1900 a new plant was acquired, the Rèvol factory at Vado Ligure, for the production of crockery in stoneware. The production of porcelain was concentrated in the works at Doccia, while San Cristoforo continued to use hard earthenware. Even before their merger the two factories had introduced Art Nouveau elements, although the greater part of their output remained rooted in traditional schemes of an eclectic type. The first significant creations in Art Nouveau style were the panels made in 1898 by Adolfo De Carolis for Villa Blanc in Rome. Later on, the main champion of the new style was the manager of Doccia, the Lombard Luigi Tazzini, who had been able to study the best examples of it at the Paris Exhibition in 1900. At the next exhibition in Turin in 1902, the pieces proposed by the factory confidently spoke the new international language, derived principally from French models and used in relief as well as pictorial decorations. The female figure swathed in long tresses and fluttering dresses was a recurrent plastic element on vases, jardinières, lamps and other objects, while the painted decorations preferred to draw on the plant world, represented with elaborate precision. At Turin the Milanese factory also showed a bathroom that was singled out by the British magazine *The Studio* and the ceramic decoration of a dining room, the result of a competition won by the painter Giovanni Buffa, while at the Milan Exhibition in 1906 the panels of painted tiles that decorated the Civic Aquarium designed by the architect Sebastiano Locati were executed by Richard-Ginori. The decoration had been made in the Milanese works at San Cristoforo, which produced vases, dinner services and toilet sets decorated with printed and transferred floral motifs, under the mark 'liberty' Società Ceramica Richard (even after the merger, the factories went on using the old marks for several years), in low relief with *barbotine* under the mark 'Caolinite' Richard-Ginori with the Visconti snake, or again with designs in relief under the mark 'Serpentina' Richard-Ginori and the snake that certified they were made at the plant in Milan. After the first markedly floral decorations the production of Doccia porcelain moved, especially in the dinner services, toward a stylized and geometrical design, closer to the Viennese Secession than to French and Belgian Art Nouveau. A number of articles were also made using the technique called 'lava flow', i.e. with flowing glazes that were quite different from the traditional figurative decoration, in the wake of the experiments that had been carried out for some time already by French potters like Lachenal and Delaherche. Richard-Ginori's participation in the Venice Biennale of 1912 stood out for the presentation of several vases designed by the Romans Grassi, Bottazzi, Terzi and Mataloni, with motifs of flowers and reptiles. At the beginning of the twenties the company employed 1200 people and was faced with the need to renew its repertoire. Fundamental at this point was the encounter between Augusto Richard and Gio Ponti, who was given the maximum creative freedom and the support of experts like Luigi Tazzini, whom he replaced as artistic director, and Vittorio Faggi, an elderly decorator of majolica ware. The entire output, both the ironstone china produced at San Cristoforo and the porcelain made at Doccia, was redesigned by the young Milanese architect, who devised a series of decorative themes that could be applied to different forms, some already used at the factories, ranging from the large *cista* to the ink-pot. The sources of his inspiration were the classical world, archaeology, sport and social happenings, all represented with subtle irony and stylized line. Porcelain hand-painted and fired for a third time and majolica of very high quality were made in runs that were limited by the high costs at Sesto Fiorentino, while San Cristoforo produced objects of equally refined taste in cheaper earthenware. This ceramic material, fired at a high temperature, was used here to make allegorical statues, again to designs by Ponti: the best-known was called *Hospitality* and modelled by the sculptor Salvatore Saponaro. Thanks to Ponti's work, Richard-Ginori was already able to present a new image of its production at the first Monza Biennale of Decorative Arts in 1923, and would go on to win two grand prizes at the International Exhibition in Paris in 1925. Over the following years the magazine *Domus*, founded by Ponti himself in 1928, would give great prominence to Richard-Ginori ceramics. In 1930, according to the *Annuario Industrie della Ceramica e del Vetro*, the company's six factories already employed around 3600 people (San Cristoforo: 60 clerks, 1170 workers; Doccia: 60 clerks, 1400 workers; Rifredi: 4 clerks, 110 workers; Pisa: 14 clerks, 380 workers; Mondovì: 10 clerks, 335 workers; La Spezia: 6 clerks, 65 workers). By this time Ponti had already completely redefined the repertoire and in 1930 the catalogue *Ceramiche moderne d'arte* was printed: a fundamental point of reference for Ponti's prolific output, it was updated with a supplement in 1932. But by this time Ponti's energies were taken up in other ventures and he was no longer in charge, and the climate of great renewal of the previous decade had waned, perhaps in part as a result of Augusto Richard's death and the retirement of important collaborators like Luigi Tazzini and the decorator Vittorio Faggi. The Milanese architect designed some more ceramics for Richard-Ginori in the mid-thirties and at the end of the forties, but almost all the new pieces after 1930, shown at the Milan Triennali and in Paris in 1937, bore the signatures of Giovanni Gariboldi and Fred

Brown. After the war its production was devoted almost exclusively to dinner services.
Bibliography
Emporium, 1895; Musso 1897–98; Antelling 1898; Aitelli 1901–02; Melani 1902; Società Ceramica Richard-Ginori 1904; Le Arti Decorative, September, December 1923; 1st Monza Biennale 1923; Carrà 1923; Emporium, July 1923; Mezzanotte 1923; Papini 1923; Sarfatti 1923; La Società Ceramica Richard-Ginori 1923; Emporium, August 1924; Le Arti Decorative, September 1925; 2nd Monza Biennale 1925; Emporium, July, September, October 1925; Opere scelte 1925; Architettura e Arti Decorative, March 1927; 3rd Monza Biennale 1927; Emporium, July 1927; Liverani 1927; Marangoni, Enciclopedia 1927; Problemi d'arte attuale, October 1927; Domus, January, February, March, April, May, June, August, September, October, November, December 1928; Architettura e Arti Decorative, July 1929; Domus, January, February, April, August, September, October, November, December 1929; Emporium, September 1929; Problemi d'arte attuale, January-February 1929; Annuario Industrie della Ceramica e del Vetro 1930; Architettura e Arti Decorative, July 1930; La Casa Bella, March, December 1930; Domus, January, March, May, July, August, September, November 1930; Emporium, November 1930; Papini 1930; 4th Monza Triennale 1930; Arte Decorativa 1931; Domus, February, April, June, July, August, September, October, November, December 1931; January, February, March, May, June, July, November, December 1932; January, February, May, August, October 1933; Emporium, July, December 1933; 5th Milan Triennale 1933; Domus, February, June, September, November, December 1934; March, June, September, October, November, December 1935; June, September, October 1936; Emporium, August 1936; 6th Milan Triennale 1936; Domus, June, December 1937; June, July, September 1938; January, June, December 1939; Minghetti 1939; Domus, February, June. September 1940; 7th Milan Triennale, 1940; Stile, April, September 1941; October 1942; 8th Milan Triennale, 1947; Morazzoni 1957; Morazzoni 1960; Liverani 1967; Biavati 1973; Bojani, L'opera di Gio Ponti 1977; Bossaglia 1980; Mostra della ceramica italiana 1982; Préaud, Gauthier 1982; Portoghesi, Pansera 1982; Gio Ponti 1983; Rosso 1983; Gio Ponti 1987; Cefariello Grosso, Maggini Catarsi, Monti 1988; Bossaglia 1994; Amari 1995; Ausenda 1998; Terraroli, Milano Déco 1998; Maldini 1999; Manna 2000; Benzi 2001; Ausenda and Pansera, in Museo d'Arti Applicate 2002.
(cat. 26-28, 104-110, 112-191, 303-308, 312-328, 319-323)

Richard-Ginori, Mondovì
A factory of soft earthenware was founded at Mondovì in 1811 by the Musso brothers from Savona. Its production of cheap but good-quality household crockery was a commercial success both in Italy and abroad. In 1897, the last descendant of the Musso family sold the factory to Richard-Ginori, created the previous year by the merger of the Milanese Richard and the Florentine Ginori. The production of the factory of Mondovì was characterized, in the late twenties and thirties, by plates and vases in soft earthenware with decorations in a rural taste, designed for the most part by Giuseppe Sciolli. A selection of these pieces was presented by Richard-Ginori, alongside Ponti's better-known creations, at the Monza Biennale in 1927 and the following Triennale in 1930.
Bibliography
1st Monza Biennale 1923; Carrà 1923; Mezzanotte 1923; Sarfatti 1923; 2nd Monza Biennale 1925; Emporium, July 1925; Opere scelte 1925; 3rd Monza Biennale 1927; Marangoni, Enciclopedia 1927; Emporium, September 1929; 4th Monza Triennale 1930; Buzzi 1930; Domus, October 1930; Biavati 1973; Rosso 1983; Maldini 1999.
(cat. 324-326)

Pippo Rizzo
(Corleone, Palermo 1897 – Palermo 1964)
After taking a diploma at the Accademia di Belle Arti in Palermo in 1915, Rizzo became, along with Vittorio Corona and Giovanni Varvaro, the leading force in the active Sicilian Futurist group. At the beginning of the twenties he opened a Casa d'Arte Futurista at Palermo in which he made a variety of objects with his wife Maria, from hangings to clothes and from furniture to ceramics. Sketches of the latter, accompanied by detailed instructions for their manufacture by Mario Ortolani's workshop in Faenza for the mark Ceramiche Futuriste G. Fabbri around 1929, have been preserved. The best-known piece in the range is a liqueur service in polychrome majolica, made up of a conical bottle and small glasses in the shape of truncated cones with triangular handles. At the Monza Triennale of 1930 the Coniglione factory in Catania showed ceramics executed to his designs and those of Paolo and Alberto Bevilacqua, who were also the authors of some ceramics presented at the same event by the Caltagirone school. At the beginning of the thirties the artist broke away from Futurism to join the Novecento movement.
Bibliography
Le Arti plastiche, April 1930; Buzzi 1930; 4th Monza Triennale 1930; Crispolti 1982; Ruta 1985; Biffi Gentili, 'L'ora della rivoluzione: servizi d'avanguardia', in Pansera 1994; Ragona, in Museo d'Arti Applicate 2002.

Paolo Rodocanachi
(Genoa 1891–1958)
Son of the Greek consul in Genoa, he attended the Scuola di Arti Decorative in Rome, where he produced his first works in the Secessionist style. Returning to Genoa in the twenties, he began to work with factories in Albisola, and in particular Mazzotti, for which he designed decorations in the mezzero style, with marine or naturalistic subjects. He contributed to the Ligurian section of the Paris Expo in 1925, realizing the decoration of the tiles of the large fireplace, later brought into production by Mazzotti. He took part in the Monza Biennale of 1927 with the same factory, presenting among other things an original Group of Three Vases that anticipated its Futurist production.
Bibliography
Emporium July 1925; 3rd Monza Biennale 1927; Chilosi, Ughetto 1995.
(cat. 47)

Rometti
At Umbertide, in 1927, the brothers Settimio and Aspromonte Rometti founded Ars Umbra, which in 1934 changed its name to the Società Anonima Ceramiche Rometti Umbertide. At the beginning the factory relied on a workforce, made up of around thirty people, trained in the school of the centuries-old ceramic tradition of Gubbio and Gualdo. In the first two years of its activity Settimio Rometti, who had previously devoted himself to painting and sculpture, combined the roles of entrepreneur and artistic director and designed a range of products still inspired by Art Nouveau, but which in a situation like that of Umbria, firmly rooted in the past and the reproduction of Renaissance pieces, was a sign of a remarkable opening to modernity. In 1928 Settimio's nephew Dante Baldelli took his place as artistic director. He gave the production an Art Nouveau character that was more original than before, but still dated. A few months later, at the end of 1928, the arrival of Corrado Cagli transformed the small Umbrian pottery into one of the most innovative manufacturers of ceramics in Italy. He was responsible for several figures in nero di Fratta, a glaze typical of the factory, that introduced a stylistic updating in the direction of Art Deco, and then painted plates and vases characterized by grounds of concentric circles and figurative themes inspired by Fascist rhetoric. Cagli and Baldelli collaborated closely, so that it is sometimes difficult to attribute individual pieces to one or the other. The former was probably responsible for the more complex figurative themes and the latter for the design of the objects. For the two years following Cagli's departure, he continued to leave a deep mark on Rometti's production, through both the re-proposal of his designs and the interpretations of Dante Baldelli, in which the pictorial decorations underwent a progressive stylization that brought them close to abstraction. In 1932 the factory employed around sixty people, and in 1933 was invited to show at the Milan Triennale, where it achieved a certain success. In 1934 the factory went bankrupt and was immediately reconstituted under the name S.A. Ceramiche Umbertide (SACU), still under the management of the Rometti brothers and Baldelli but with the involvement of new partners who probably imposed conditions of a commercial nature. The result was that all of Cagli's creations and Baldelli's early works vanished from the catalogue, as did most of the figures in nero di Fratta by Settimio Rometti and the sculptor Di Giacomo. With the latter's greater commitment to the design of services, there was a loss of interest in figures and decorative works in general. In 1937 the company title became SACRU (Società Anonima Ceramiche Rometti Umbertide). In 1938 the sculptor Leoncillo Leonardi began to work in the factory. Rather than on mass-production, he focused on the creation of vigorously modelled and brightly coloured figures. In 1943 the factory changed its name again to Ceramiche Rometti.

Bibliography
Domus, May 1931; June 1932; ENAPI 1932; 5th Milan Triennale 1933; 6th Milan Triennale 1936; Minghetti 1939; Bossaglia 1980; *Mostra della ceramica italiana* 1982; Rosso 1983; Cortenova 1986; Bojani 1992; Barisione 1999; Barisione 2001; Ruiz de Infante 2002; Caputo, Mascelloni 2005.
(cat. 410-432)

Roberto Rosati
(Rome 1890–1949)
He was introduced to ceramics through his frequentation of Cambellotti's studio. In 1912–13 he and the Roman gallery owner Giuseppe Sprovieri set up a ceramics factory at Treia, in the vicinity of Civita Castellana, which until 1915 produced plates and vases of simple and modern form and tiles with reproductions of pictures by Franz Marc, Gino Severini and Giacomo Balla. The fairly shoddy quality of the production led to the closure of the factory before the war. In 1914 Rosati showed some high-fired majolica ware at the exhibition of the Società degli Amatori e Cultori di Belle Arti. In 1920 his work was included in the exhibition of ceramics held by Palazzi in his studio in Piazza Venezia. In 1923 he took part in the first Monza Biennale and later became associated with Palazzi's workshop La Fiamma, of which he would be the artistic director for about ten years, despite numerous difficulties, largely of an economic nature, in his relations with the owner. The production, which in part bears Rosati's monogram RR, consisted of plates and vases with mostly zoomorphic decorations and small figures of animals. At the same time Rosati devoted himself to commercial art and, from 1926, to teaching, first at the Museo Artistico Industriale in Rome (RINIP), then from 1935 to 1937 as principal of the Scuola d'Arte at Nove and finally, from 1937 until his death, at the Scuola d'Arte in Grottaglie, where he took an interest in the local tradition and made large panels with glazed tiles. At Grottaglie he also collaborated with Vincenzo Del Monaco's factory on the creation of models for sculptures.
Bibliography
1st Monza Biennale 1923; *Le Arti Decorative*, December 1923; Crispolti 1982; *Mostra della ceramica italiana* 1982; Quesada 1988; Quesada 1992; De Guttry, Maino 2003.
(cat. 252-257)

Rubboli, Società Anonima Ceramica Umbra
Paolo Rubboli (1838–1890), born in Pesaro, was the man who initiated the revival of the style of Mastro Giorgio at Gualdo Tadino and Gubbio in the last quarter of the 19th century. A refined creator of lustreware that harked back to the work of the 16th-century potter Giorgio Andreoli, he inspired other ceramists in the area to take the same road, with the result that numerous workshops and factories were named after the Renaissance master. From 1918 the artistic director of the pottery was Ilario Ciaurro, until he and others set up the Vasellari Eugubini Mastro Giorgio two years later. In 1920 Rubboli merged with the Scuola Mastro Giorgio to form the Società Ceramica Umbra, with workshops at Gubbio and Gualdo Tadino. Here Aldo Ajò, Ciaurro's former collaborator, distinguished himself between 1921 and 1926. In 1932, as a consequence of the heavy decline in sales due to the worldwide depression, the factory was taken over by the Società Maioliche Deruta-CIMA.
Bibliography
Liverani 1927; 4th Monza Triennale 1930; Minghetti 1939; 7th Milan Triennale 1940; Sannipoli, 'Note sulla ceramica eugubina degli anni '20 e '30', in Bojani 1992; Tittarelli Rubboli 1996; Busti, Cocchi 1998; Tittarelli 1999; Busti, Cocchi, in *Museo d'Arti Applicate* 2002.

Giulio Rufa
(Rome 1903 – Milan 1970)
Educated at a boarding school in Naples, he went on to attend the Museo Artistico Industriale in the same city, where he developed an interest in ceramics. Returning to Rome, he attended the Accademia di Belle Arti with Duilio Cambellotti. In 1923 his ceramics were presented at the first Monza Biennale, in the 'Studio Room' designed by Cambellotti. Later, in addition to ceramics, he devoted himself to engraving on glass, architecture, sculpture and interior decoration, including the entrance halls of several railway stations, such as the Stazione Centrale in Milan, where he created a large mosaic in 1939. The previous year he had contributed to the creation of the mock station of Ostiense for Hitler's arrival. In the thirties he also developed a passion for engines, which was to become his main occupation after the war. Remaining with ceramics, he was a leading figure at Ferruccio Palazzi's pottery, for which he designed vases characterized by images of nymphs and fauns, although only a few of them bear his signature. After the war he moved to Milan to apply the experience had had gained in the field of aircraft engines at BMW in the Miller factory. He also took part in competitions for the construction of cheap prefabricated housing. From 1947 to 1967 he was in Buenos Aires, running a factory of construction machinery.
Bibliography
Le Arti Decorative, December 1923; 1st Monza Biennale 1923; Quesada 1988; Quesada 1992; De Guttry, Maino 2003.
(cat. 261, 262)

Ruggeri
The pharmaceutical manufacturer Oreste Ruggeri, whose name is linked to the famous villa in the Art Nouveau style he built at Pesaro, opened a small factory in the city in the Marche in 1898 for the production of jars to be used as containers for his medicines. Arnaldo Giuliani (1872–1951) and Giuseppe Brega (1877–1960) worked there, giving the production a more up-to-date style than the historicist one adopted by the better-known factory in Pesaro, Molaroni. The decorative themes drew on pre-Raphaelite art, a style already used in the advertisements for Ruggeri's pharmaceutical products that set diaphanous female figures against a backdrop of landscape, surrounded by bands of floral motifs. The factory remained active until 1903.
Bibliography
Melani 1902; Maldini 1999; Benzi 2001.

Laura Ruschi
(Pisa 1879–1965)
At the beginning of the century she founded a factory in Pisa, the Terrecotte Artistiche di Pisa San Zeno. Some of her creations took their cue from the city's monuments and past, as did the mark, a ship alluding to the ancient maritime republic. Toward the end of the twenties, part of the output adopted a modern style with which it was able to make a good impression at the Triennali, from the one in Monza in 1930 to the exhibition of ENAPI models at the one in Milan in 1933.
Bibliography
Felice 1930; 4th Milan Triennale 1930; ENAPI 1930; Cefariello Grosso, in *Museo d'Arti Applicate* 2002.

SACA
Founded at Sesto Fiorentino in 1923 by Ugo Grassi, Serafino Bittini and Renzo Guarnieri, it maintained a craft character until 1930, but then went on to become, with a workforce of around fifty, one of the largest ceramic factories in the area, second only to Ginori at Doccia. In this second phase of its activity the production, initially of a historicist type, was modernized, especially with regard to a number of figures in an uninhibited Art Deco style and the pictorial decorations of tiles and vases that resembled the creations of Gio Ponti. It closed down in the fifties.
Bibliography
Annuario Industrie della Ceramica e del Vetro 1930; 4th Monza Triennale 1930; *Emporium*, November 1930; *Mostra della ceramica italiana* 1982; Capetta 1990.

Bortolo Sacchi
(Venice 1892 – Bassano del Grappa 1978)
A Venetian painter and sculptor trained in Munich, he was an exponent of the Secession movement centred on Ca' Pesaro who began to use the ceramic medium in the second decade of the century. He would later frequent Dolcetti's Bottega del Vasaio, making ceramics that reflected the surreal and metaphysical themes (chimeras, fantastic animals) of his painting. After the Second World War he moved to Bassano and established links with Andrea Parini and Giovanni Petucco. With the painter Miranda Visonà he made a series of ceramics at Nove that were shown at the Biennale of 1948.
Bibliography
Minghetti 1939; Stringa, *L'arte decorativa…*1987.

Oscar Saccorotti
(Rome 1898 – Recco 1987)
Moving from Rome to Genoa in 1914 to work as a decorator, he opened a workshop of wooden toys with his brother Fausto. His training, received in Udine, where Fausto imported furniture from Austria, and in Genoa made him particularly sensitive to developments in the Secession and then at the Bauhaus, in painting as well as in the applied arts. In the twenties he collaborated with Mario Labò within the MITA (carpet design) of DIANA and then at the IL-CA, where he was also responsible for the colouring of Arturo Martini's figures. At the Monza Triennale of 1930, he showed with DIANA some vases in the shape of

truncated cones decorated with horizontal stripes. After the failure of the companies in Genoa he devoted himself to painting.
Bibliography
Buzzi 1930; Chilosi, Ughetto 1995.

La Salamandra
The factory was set up in Perugia in 1922 on the initiative of the Società Anonima Maioliche Deruta with the aim of diversifying the company's production of a traditional type with ceramics of a modern character. From 1924 to 1929 the artistic director of the new factory was Davide Fabbri, an artist from Faenza active in Rome from 1922 at a workshop of the same name that collaborated with artists like Renzo Cellini, Luciano Mauzan and Alfredo Bigini. The modern output was initially still anchored in outdated Art Nouveau stylistic features and dense floral decorations probably influenced by Galileo Chini, but then saw the adoption of drip glazes, colouring with metallic reflections and forms animated by grooving and knobbing. More extensive was the production of boxes and figurines for sweets made by the Perugina company, many of them designed by Emma Bonazzi (Bologna 1881–1959), a refined artist active in several sectors of the applied arts. The factory took part in the Monza Biennale of 1925 with a *Madonna* and a vase shown in the Umbrian section. In 1932, as a result of the radical restructuring of the CIMA following the crash of 1929 that slashed exports, the factory of La Salamandra (where around thirty people worked) was the only part of the consortium, along with the Maioliche Deruta, which remained active and production at both was radically revamped to meet criteria of modernity, eliminating the specific character that had distinguished them. For a brief breve period around 1935, Settimio Rometti and Marcello Fantoni collaborated with the factory in Perugia, where some of their designs are preserved in the archives.
Bibliography
2nd Monza Biennale 1925; Marangoni, *Enciclopedia* 1927; *Annuario Industrie della Ceramica e del Vetro* 1930; 4th Monza Triennale 1930; *Domus*, February 1930; *Mostra della ceramica italiana* 1982; Bojani 1992; Busti, Cocchi 1998; Barisione 1999; Maldini 1999; Ranocchia 1999; Busti, Cocchi 2000; De Guttry, Maino 2003.
(cat. 266-268)

Eliseo Salino
(Albisola Superiore 1919–1999)
He commenced his activity as a ceramist at Mazzotti in the mid-thirties and then went on to study at the Istituto d'Arte in Faenza and the Accademia di Brera. His specialities were figures of a caricatural tone portraying common personages (fishermen, sportsmen, members of the Italian Fascist Youth Movement) or actual people (*Torido the Alchemist, Torido and Salino on Motorcycles*). During the war he moved to Tuscany, and later continued to work with ceramics, winning major prizes (the Faenza competition in 1941 and 1953).
Bibliography
Minghetti 1939; *Mostra della ceramica italiana* 1982; Chilosi, Ughetto 1995.

Vittorio Saltelli
(Rome 1887–1958)
Towards the end of the second decade of the century he opened a workshop in the centre of Rome. In 1920 he took part with other Roman artists in the exhibition organized by Ferruccio Palazzi, and in 1923 he made his contribution to the significant Roman presence at the Monza Biennale, with a fireplace and two lamps in terracotta. Later he would work on the replacement of parts of the fired-brick and ceramic floors in Palazzo Venezia.
Bibliography
Architettura e Arti Decorative, 1923; 1st Monza Biennale 1923; Sapori 1923; Quesada 1988; Quesada 1992.

Salvini
The Manifattura Salvini was set up in Florence in 1880 on the initiative of Mario Salvini, with a production that followed the historicist and eclectic trend that held sway at the time. It took part in the Chicago Exposition of 1893, where it was awarded the grand prize, and at the Turin Exhibition of 1902 its ceramics reflected a move towards Art Nouveau themes, probably known and appreciated through Chini's already successful work, but with a certain propensity for decorative excess. Among the subjects, in addition to a naturalism that tended to find sculptural expression in bas-reliefs as well, great space was given to the female figure, derived from 15th-century Tuscany but brought back into vogue by the English pre-Raphaelites and also to be found in the production of other Tuscan factories, from the Società Ceramica Colonnata to the Arte della Ceramica.
Bibliography
Melani 1902; Conti, Cefariello Grosso 1990; Maldini 1999; Benzi 2001.

Sansebastiano e Moreno
Factory founded at Genoa in 1883 by the sculptor Michele Sansebastiano (Novi Ligure 1853 – Genoa 1906) and the entrepreneur Cesare Moreno. It took part in the Turin Exhibition of 1884 with majolica ware in an eclectic style, services with sober floral decorations and small realist sculptures judged by the critics of the time to be of good taste and quality. The Neapolitan painter Giuseppe Pennasilico (Naples 1861 – Genoa 1940) also worked on the pictorial decoration, using the casting slip method to adorn plates with landscapes, interiors, animals and portraits of women. In 1885 some particularly elaborate creations were presented at the Promotrice in Genoa, but the factory also participated in international exhibitions. Sansebastiano withdrew from the company around 1887 and Moreno died at the end of the following year. The firm was taken over by Umberto and Gian Battista Villa, who maintained the eclectic approach but put the emphasis on classicism. Towards the end of the century the factory came under the control of the painter Antonino Quinzio (Genoa 1867–1918), who moved to Sampierdarena in 1904 and closed it down the next year, selling the moulds to Nicolò Poggi.
Bibliography
Chilosi, Ughetto 1995.

Santa Lucia
The Manifattura Santa Lucia di Dino Rofi e C. was based at Piano dei Mantellini, in the province of Siena. In the twenties it produced metallic lustreware with figured decorations or Oriental and Renaissance motifs. It took part in the Monza Biennale of 1925, showing a dinner service, wall plates and various ceramics in the Sienese rooms. In the following decade the stylistic language was updated with decorations consisting of stylized scenes inspired by mythology or Sienese folklore.
Bibliography
2nd Monza Biennale 1925; Marangoni, *Enciclopedia* 1927; *Domus*, August 1932; September 1940; *Mostra della ceramica italiana* 1982.

Alfredo Santarelli
(Gualdo Tadino 1874–1957)
Before taking up ceramics he pursued academic studies and frequented artists. He then opened a small factory in his own name to produce refined lustreware that interpreted Renaissance and Oriental models, as well as those of Art Nouveau and Art Deco. It took part in the *Exhibition of Pesaro Ceramics* in 1924 and the second Monza Biennale in 1925, with a large vase in reflective ceramic. In the second half of the twenties the factory became part of the CIMA. In 1930 it employed around thirty workers.
Bibliography
Le Arti Decorative, June-July 1924; *La Cultura Moderna*, August 1924; *Emporium*, August 1924; 2nd Monza Biennale 1925; *Annuario Industrie della Ceramica e del Vetro* 1930; Minghetti 1939; Bojani 1992; Busti 1998; Amoni 1999; Maldini 1999; Ranocchia 1999.

Salvatore Saponaro
(San Cesario, Lecce 1888 – Bizzozero, Varese 1970)
He attended the Accademia di Belle Arti in Rome and after the war moved to Florence and then Milan, where he worked for several famous architects (Fountain of the Tritons with Alessandro Minoli, Monument to the Fallen in Sondrio with Tomaso Buzzi). He collaborated with Richard-Ginori, modelling some well-known figures designed by Gio Ponti, from *Hospitality* to the *Tired Pilgrim*, that were presented at the Monza Biennale in 1925. In 1926 he showed at the Venice Biennale and from 1931 on at the exhibitions of the Promotrice di Belle Arti in Turin.
Bibliography
Emporium, September 1925; 3rd Monza Biennale 1927; *Faenza* 1927, issue I; Marangoni, *Enciclopedia* 1927; *Emporium*, September 1930; Guigoni 1930; Papini 1930; Minghetti 1939; Morazzoni 1957; Bossaglia 1980; *Mostra della ceramica italiana* 1982; Terraroli, *Milano Déco* 1998; Ausenda, in *Museo d'Arti Applicate* 2002.
(cat. 111, 142)

SCAF
The brief history of the Società Ceramica Artistica Fiorentina, set up in 1901, is identified with Vittorio Giunti, former founding partner and manager of the Arte della Ceramica. At the Turin Exhibition in 1902 he showed several vases, with metallic lustres and drip glazes, mounted in silver by Giorgio Ceragioli (1861–1947). Vittorio Giunti, who at the Arte della Ceramica had carried out experiments with techniques and materials with the col-

laboration at a distance of the Sienese pharmacist Bernardino Pepi, presented the results of his attempts to refine and modernize the mix of clays used to make majolica so that it could compete with porcelain. Between 1901 and 1903 Libero Andreotti collaborated with the factory as a decorator. The presence of Adolfo De Carolis, at that time professor of ornamental design at the academy, is documented in 1902. The factory also produced articles in stoneware. As far as we know, the objects had simple forms, some of popular derivation, but were enriched with refined glazes. The factory went bankrupt in 1903, but Giunti continued to work with ceramics, collaborating for example with the architect Adolfo Coppedè on the creation of twelve large majolica vases for the transatlantic liner *Conte Rosso* in the twenties.
Bibliography
Aitelli 1901–1902; Pica 1902; 1st Monza Biennale 1923; Conti, Cefariello Grosso 1990; Maldini 1999.

Giuseppe Sciolli
Author, between the second half of the twenties and the early thirties, of the most interesting and innovative part of the production of earthenware at the Richard-Ginori factory in Mondovì. His name appeared for the first time in the catalogue of the third Monza Biennale, linked to a range of 'vases, small plates and *objets d'art*' presented by Mondovì in the Richard-Ginori stand. At the next Biennale, held in Milan in 1930, Mondovì was represented exclusively by the 'collection of soft earthenware designed and painted by Giuseppe Sciolli'. This was made up of plates and vases with coloured decorations of rural inspiration, apparently naive but in reality carefully studied to suit them to the shapes of the pieces.
Bibliography
3rd Monza Biennale 1927; Marangoni, *Enciclopedia* 1927; Buzzi 1930; *Domus*, October 1930; 4th Monza Triennale 1930; Rosso 1983.
(cat. 324-326)

Scuola Ceramica di Nove
The School of Drawing and Sculpture Applied to Ceramics was set up at Nove in 1875 in fulfilment of the last will and testament of the sculptor Giuseppe de Fabris. From 1916 to 1936 it was directed by Silvio Righetto, a master of artistic and floral decoration. He was succeeded, for two years, by the Roman Roberto Rosati, a pupil of Cambellotti who had previously worked in Giuseppe Sprovieri's factory at Treia, near Civita Castellana. In 1942, after Renzo Dazzi and Cosimo Calò, who was from Grottaglie, Andrea Parini of Caltagirone became the director, bringing with him a wave of renewal. He devoted himself to artistic research remote from the requirements of mass-production and to experimentation with various techniques. The new climate led to new potteries springing up at Nove, including Petucco & Tolio, CAI, La Brenta and L'Originale, while even established factories like Barettoni let themselves be tempted into the creation of modern one-off pieces. They formed the breeding ground for the great Venetian ceramists active in the second half of the century, Federico Bonaldi, Pompeo Pianezzola, Cesare Sartori and Alessio Tasca.
Bibliography
Mostra della ceramica italiana 1982; Stringa 1986; Stringa, *Omaggio a Bassano e Nove* 1987.

Scuola d'Arte Applicata alla Ceramica of Castelli
Set up in 1906, it turned its attention to so-called modern production as well as the traditional type. In 1911 it took part in the Turin International Exhibition. From 1923 to 1925 it was run by F. Maroder, champion of a modern approach, so that the school participated in the second Monza Biennale. In 1923–24 Virginio La Rovere taught there, a fact that Papini reported in *Emporium* in 1925. In 1931 it was at the Crafts Exhibition in Florence, and in 1933 and in 1936 at the Milan Triennale. From 1938 the principal was the painter Giorgio Baitello, who carried out experiments on glazes, paints and lustres. An article in the December 1941 issue of *Domus* on the school's participation in the Triennale of 1940, where it won a grand prize, was illustrated with reproductions of several pieces (vases, cups, figures) and stressed the way he had 'taught how to use the most ancient resources of a precious technique to achieve delightfully up-to-date expressions'.
Bibliography
2nd Monza Biennale 1925; *Emporium*, September, October 1925; *Le Arti Decorative*, June, September 1925; *Opere scelte* 1925; 3rd Monza Biennale 1927; Marangoni, *Enciclopedia* 1927; Guigoni 1930; Baitello 1940; *Domus*, November, December 1941; *Domus*, September 1943; Folliero 1957; Arbace, in *Museo d'Arti Applicate* 2002.

Scuola d'Arte of Grottaglie
Set up in 1887 in the town in Puglia famous for its production of popular pottery. In the early years of the century its principal Anselmo De Simone attempted to take it an industrial direction, but this remained foreign to the local fabric of production, hampered by extremely backward economic and social conditions. Between 1903 and 1920 Rodolfo Ceccaroni also taught at the school. From 1920 the new principal of the school, Gennaro Conte, taking his cue from the renewal of the decorative arts promoted by the Monza Biennali, encouraged the stylistic updating of the so-called artistic repertoire, no longer bound exclusively to tradition. From 1937 the principal was Roberto Rosati, who in addition to promoting a certain revival of the characteristics typical of tradition, favoured the introduction of new systems of production.
Bibliography
Le ceramiche di Grottaglie 1989.

Scuola di Ceramica of Faenza
In 1919 a School of Ceramics was set up as an adjunct to the museum in Faenza, in order to provide subsidiary technical training. Previously, from 1916 on, evening courses had been held at the Minardi factory, with Aurelio and Gennaro Minghetti and Francesco Castellini teaching decoration, Gaetano Ballardini teaching the history of ceramics and the Hungarian chemist Maurizio Korach covering technical subjects. Ballardini, who had founded the Museum of Ceramics in 1908, did not intend to create a school of arts and crafts like others, subordinated to the objective of producing specialized workers for the local industry, but had the more ambitious aim of putting ceramics in Faenza on a new footing, updating it stylistically in the light of contemporary European experiences and the involvement of artists and architects in the renewal of the decorative arts. The regular three-year course was split into two sections, an artistic one entrusted to Domenico Rambelli, with the assistance of Anselmo Bucci for the practical side, and a technological one in the hands of Maurizio Korach. Rambelli's artistic direction was very scrupulous, and from the outset took a unified stylistic approach precociously influenced by Art Deco. From the 1919–44 period the school has conserved three main groups of creations: a series of large objects in unglazed red terracotta with drippings of gilt, some of which were also produced in a version with black glaze, a group of pieces in majolica decorated in relief with motifs that drew on the local tradition, utilizing a 15th-century technique revived by Bucci, and a series of essential objects that from 1933 on displayed a distinctively Rambellian taste. Then there were the creations that made use of the lustres developed by Maurizio Korach. The school, whose method of working echoed that of a traditional local pottery, also fulfilled orders from outside and met with success at the principal exhibitions in Italy and abroad, commencing with the first Monza Biennale of Decorative Arts in 1923, where a series of vases with decorations in relief excited the admiration of Margherita Sarfatti and Roberto Papini. After 1930, Rambelli's espousal of Fascism heavily influenced the subjects of the decoration, especially with regard to the wall tiles in relief that constituted a characteristic product of the school and were inspired by Romano-Gothic sculpture. In 1943 Angelo Biancini took over from Rambelli in the teaching of modelling, remaining in the post until 1981.
Bibliography
Le Arti Decorative, May, July, September 1923; 1st Monza Biennale 1923; *Emporium*, July 1923; Sarfatti 1923; *Le Arti Decorative*, June-July 1924; *La Cultura Moderna*, August 1924; *Le Arti Decorative*, September 1925; 2nd Monza Biennale 1925; *Emporium*, October 1925; *Opere scelte* 1925; 3rd Monza Biennale 1927; *La Cultura Moderna*, October 1927; Marangoni, *Enciclopedia* 1927; *La Casa Bella*, October, December 1928; September 1929; Buzzi 1930; *La Cultura Moderna*, September 1930; Papini 1930; 4th Monza Triennale 1930; *Domus*, May 1931; July 1934; 6th Milan Triennale 1936; Ettorre 1936; Pasqui 1937; Liverani 1941; Bojani 1989; Castagnoli 1989; Ravanelli Guidotti, in *Museo d'Arti Applicate* 2002.

Scuola di Sesto Fiorentino
Set up as a house school by Ginori of Doccia, it was transformed into the Royal School of Industrial Design in 1873. In 1878 it took part in the Universal Exhibition in Paris and was awarded a gold medal. In 1919 it became the School of Applied Art for Ceramics, and in 1928 changed its name again to the Richard-Ginori Royal School of Ce-

ramic Art. In the twenties Chino Chini was a member of the school board, but the creations remained tied to a historicist repertoire. The approach was significantly updated in the following decade, when the school was run by Ferruccio Maroder (1931–34), Giuseppe Piombanti Ammannati (1934–36 and a teacher from 1925) and Leo Ravazzi, with the presence on the board of the sculptor Libero Andreotti and, from 1930 to 1936, the architect Adolfo Coppedè. The production was represented at the Milan Triennali of 1930 and 1933. Many of the school's pieces, characterized by forms and decorations in a sober Art Deco style, were reproduced in the book published by Cosimo Ettorre in 1936.

Bibliography
4th Monza Triennale 1930; 5th Milan Triennale 1933; Ettore 1936; *Domus*, December 1938; *Mostra della ceramica italiana* 1982; Capetta 1990.

Giovanni Servettaz
(Savona 1892–1973)
A sculptor trained in Turin and above all Milan, under Cesare Ravasco and Adolfo Wildt, he began to work with ceramics at Mazzotti towards the end of the twenties, creating small and essential sculptures that were shown at the Crèche Exhibition held in Savona in 1928 (*Annunciation, Holy Family, Heavenly Messenger, Adoration of the Magi*) and the Monza Triennale of 1930. Little is known of his contribution to Futurist production. He also collaborated with La Fenice, modelling sculptures (*Lot's Wife, Cat*) that were presented at the Milan Triennale of 1933. He executed many terracotta sculptures of archaic character and, especially after the war, bas-reliefs in slip.

Bibliography
Marangoni, *Enciclopedia* 1927; *La Casa Bella*, February 1929; 4th Monza Triennale 1930; *Domus*, August, September 1933; Minghetti 1939; *Mostra della ceramica italiana* 1982; Rosso 1983; Chilosi, Ughetto 1995.

SIFMA and Fantechi
The Società Industriale per la Fabbricazione di Maioliche Artistiche (SIFMA) was set up at Sesto Fiorentino between 1896 and 1898 by Paolo Banchelli, Luigi Ceccherini, Giuseppe Conti, Augusto Fantini, Egisto Fantechi, Francesco Grassi and Ugo Zaccagnini. Fantechi and Zaccagnini are known to have come from Ginori of Doccia, but it is likely that the other partners had also worked with the famous factory. The production was chiefly of a historicist type, based among other things on models acquired from Ginori, but the factory also produced pieces in a modernist taste and derived from the pre-Raphaelite movement, defined as 'Botticelli Style' and close to the production of the contemporary Della Robbia factory in England, characterized by the recurrent motif of a female face with sharp outlines framed by floral motifs. In 1906 the company was transformed into the Maioliche Artistiche Egisto Fantechi by the partner who became its sole proprietor. From 1918 the Florentine painter and illustrator Guido Colucci used the factory to make artistic objects of clear modernity under the mark of a black swan and the logo LEDA. After the crisis in the twenties provoked by the war, the production came under the influence of Gio Ponti's manner, as it found expression in the completely renewed catalogue of the nearby Ginori pottery. In 1930 the factory had about thirty workers. On Egisto Fantechi's death in 1933, his sons Mario and Renato took over and the factory was to remain active, even after the crisis caused by the Second World War, until 1961. Between 1935 and 1941 the production was designed by Mario Filippucci, a ceramist active in many centres of the industry.

Bibliography
Annuario Industrie della Ceramica e del Vetro 1930; 8th Milan Triennale 1947; Capetta 1990; Conti, Cefariello Grosso 1990; *Manifattura Egisto Fantechi* 1994; Maldini 1999.

Nino Siglienti
(Sassari 1903–1929)
Ceramics was only one of the applied arts practiced by this Sardinian artist, who died at the age of just twenty-six after devoting himself to set, textile, furniture and graphic design. His creations in the ceramic field consisted exclusively of plates and tiles, decorated with subjects of popular Sardinian origin but represented with a refinement and elegance of Deco derivation. The link to folk themes prompted the rejection of a group of ceramics decorated without firing he had prepared for the Paris Expo of 1925. In 1925 he moved to Milan, where he worked as an assistant set and costume designer at La Scala, and where he would participate in the Monza Biennale of 1927 with a workshop of his own.

Bibliography
3rd Monza Biennale 1927; Rosso 1983; Altea, Magnani 1995; Cuccu 2000.

Signa
The factory was created by Camillo Bondi in 1895 out of an existing company called the Società Fornaci di Signa, set up by his brother Angelo in 1889, to produce artistic terracottas in imitation of the 15th-century examples collected by its owner. It took part in the Turin Exhibition of 1898, where it won a gold medal and the one held in Paris in 1900, while it was excluded from the Turin Exhibition of 1902 because of its historicist production. Its reproductions, created using an exclusive mix of clays and technique of patination, were admired by Gabriele d'Annunzio, who collected them at La Capponcina and inserted them in the scenery of his theatrical works. The factory also made figures based on models provided by the sculptors Giovanni Prini and Raffaello Romanelli (1856–1928) and the German Adolf von Hildebrand. In 1911 the factory, transformed into a joint-stock company, took part in the Regional and Ethnographic Exhibition in Rome, making the terracottas of the Tuscan Pavilion, again of an imitative character. Around 1920, it began to produce majolica ware alongside terracottas. From 1927 it was present at the Permanent Exhibition of Modern Italian Ceramics in Faenza, an initiative of the Museo delle Ceramiche intended to 'present the types characteristic of every Italian workshop to amateurs, scholars, exporters and ceramists themselves on a permanent basis'. In the thirties, to cope with the diminished interest in reproduction pieces, new forms were tried out, such as the large garden vases and the statue modelled by Italo Griselli that were presented at the Milan Triennale of 1933 along with a simplified version of the famous *Corsini Throne*, all given prominence in the pages of *Domus*. In 1930, according to the *Annuario Industrie della Ceramica e del Vetro*, the factory employed sixty workers. In 1940 it was taken over by Fantacci and Montecchi, but its facilities suffered major damage during the war and the revival attempted by its new owner Osvaldo Coisson and, for the artistic section, Countess Pallavicini from Rome, proved ephemeral. In 1952 the factory was closed, the buildings demolished and the collection of samples and archive dispersed.

Bibliography
Musso 1897–98; *Arte Italiana Decorativa e Industriale*, November 1898; *Emporium*, 1898; *Annuario Industrie della Ceramica e del Vetro* 1930; 4th Monza Triennale 1930; 5th Milan Triennale 1933; *Domus*, September 1933; *Stile*, June 1943; *Mostra della ceramica italiana* 1982; Conti, Cefariello Grosso 1990; Maldini 1999.

SIMAC
The Società Italiana Maioliche Abruzzesi was set up at Castelli in the twenties on the initiative of a wealthy physician, Giovanni Fuschi (Castelli 1880 – Albisola 1951), who wanted to see the traditional art of his hometown flourish again in a new and more modern form. The project, which stood out for its high level of commitment to experimentation, leading to the granting of numerous patents, was supervised from the outset by Maurizio Korach, expert on ceramic technique and Gaetano Ballardini's collaborator at the school in Faenza. In 1920 the factory began to produce hand-decorated majolica ware using the kilns of local potteries. In 1923, with the assistance of German technicians, equipment was installed for the production of artistic and ordinary porcelain with decorations partly inspired by the tradition of Castelli and partly in a modern taste. For the larger objects or the ones that needed particular properties of resistance, the SIMAC developed a special porcelain with a high content of talc, in the form known as steatite. In 1925 a line of stoneware was added, described by Marangoni as 'extremely interesting stoneware that has all the streaks and veins of the most beautiful natural stone'. Yet another line of production, introduced after 1930, consisted of innovative cooking pots in an unglazed porcelain containing magnesium silicate that came to be known as *pirofila* ('oven-proof': the patent would later be acquired by Richard-Ginori). In 1930 the factory employed 120 workers, but the high technical and artistic standards were not matched by the company's administrative and commercial capacities, leading to growing financial difficulties and to an attempt to turn it around by introducing a technological product (sparkplugs for engines). The attempt failed and in 1938 the factory in Castelli was sold to the SPICA, which produced nothing but crockery in white porcelain. In 1941 Giovanni Fuschi, now ruined, moved to

Albisola to work at the ILSA.
Bibliography
1st Monza Biennale 1923; Carrà 1923; Marangoni, *Enciclopedia* 1927; *Il Corriere dei Ceramisti* 1929; *Annuario Industrie della Ceramica e del Vetro* 1930; ENAPI 1930; Guigoni 1930; Ponti 1930; *Arte Decorativa* 1931; ENAPI 1933; Korach 1972; Frattani, Badas 1976; Carola-Perrotti 1997; *La porcellana di Castelli* 1997.

Angelo Simonetto
(Venice 1906 – Pordenone 1961)
After attending the Accademia di Belle Arti in Venice, he and a partner opened a factory for the production of ceramics at Ponte di Brenta. Here he met Enrico Galvani, who asked him to take on the job of artistic director in his factory at Pordenone, where Simonetto moved in 1930 and was to remain until his death. The artist redesigned the factory's production in Art Deco style: vases, boxes and services in earthenware painstakingly decorated by airbrush with figurative or simply geometric motifs.
Bibliography
ENAPI 1933; Ganzer, Stringa 1996.
(cat. 365)

SIPLA-SICLA.
While numerous pieces produced by this Roman factory have been preserved, we have little reliable information on it. In the twenties it probably changed its mark to SICLA, Società Italiana Cooperativa Lavori Artistici. The SICLA is recorded as having taken part, with the Roman group coordinated by Cambellotti, in the first Monza Biennale in 1923, where it is said to have executed a majolica doorway designed by Limongelli and modelled by the sculptor Umberto Diano. It is also known that the director was Carlo Ciacci and the kiln operator Fernando Frigiotti, a collaborator of Cambellotti and chief technician at the RINIP. Several Roman ceramists probably worked there, including Biagini, Mauzan, Bassanelli and Cellini, leaving their mark on several of the pieces produced by the factory.
Bibliography
Architettura e Arti Decorative 1923; *Le Arti Decorative*, December 1923; 1st Monza Biennale 1923; Sapori 1923; Quesada 1988; Quesada 1992; De Guttry, Maino 2003.
(cat. 259)

Società Ceramica Italiana, SCI
The factory was set up at Laveno, on Lake Maggiore, in 1856, on the initiative of three of the town's residents who had worked at the Milanese factory of San Cristoforo, formerly owned by the Tinelli family, also from Laveno. The factory was named after its founders, Carnelli, Caspani and Revelli, and installed on the premises of the former Franzosini glassworks. The most economic products were in transfer-printed soft earthenware, of the Wedgwood type, the more valuable in hard earthenware hand-decorated underglaze, but glazed faience and heat-resistant vessels were also made. The decorative repertoire of the early decades of activity ranged from Canton and Colandine motifs to folk and genre subjects. In 1869 an extension to the factory was built at San Michele, and in 1871 it was the first in Italy to be equipped with batch downdraft kilns. In 1875 it employed 400 workers, and in 1883, following the acquisition of a significant share in the company by the Credito Lombardo bank, took the name of Società Ceramica Italiana. In 1886, one of the founding partners and up until that moment a decisive figure, Severino Revelli, withdrew and set up a new factory, the Società Ceramica Revelli. Subsequently management of the SCI was taken over by the two majority shareholders, Tommaso Bossi and Antonio Casanova, who expanded the production facilities, while concentrating them in the Lago (former Franzosini) works, which were supplied with electric power. The SCI took part in the Turin Exhibition of 1898, where it won a gold medal, but was not invited to the one in 1902, dominated by the creations of Galileo Chini and Richard-Ginori. However, the great international showcase of the new style acted as a stimulus for the updating of a production still rooted in eclectic models and for the introduction of Art Nouveau through the collaboration of artists like the landscapist G. Jacopini, the decorators Marco and Luigi Reggiori, Pietro and Silvio De Ambrosis, Luigi De Vecchi, Federico Paglia and, above all, the ceramist Giorgio Spertini, author of the vase with metal handles that is one of the SCI's best known pieces. In 1906 the factory showed a series of pieces in the Art Nouveau style at the great Simplon Exhibition in Milan. In 1916, on Bossi's death, the management passed into the hands of Luciano Scotti, who after the crisis induced by the war carried out a modernization of the plant that permitted a large increase in production. In 1922 the first continuous gas kiln for firing glazes was introduced, in 1925 the production of porcelain commenced and in 1936 the first continuous electric kiln in Italy for firing biscuit was inaugurated. Between 1924 and 1932 the Società Ceramica Revelli merged with the SCI, joining the Società Ceramica del Verbano in the production of table and industrial porcelain in collaboration with Rosenthal. At the same time the factory in Laveno carried out a thorough renewal of its own catalogue, turning, in 1923, to the young Istrian architect Guido Andlovitz. Like Gio Ponti at the rival Richard-Ginori, he gave production at the SCI a modern character and a style blending foreign influences, cultured citations, originality and freshness of language. The collaboration lasted for almost forty years, during which time the factory won commercial success and critical recognition, sanctioned by its participation in the Monza Biennali and Milan Triennali. As far as the Triennali in Milan are concerned, the catalogues do not provide us with a detailed description of the pieces presented, unlike those of Richard-Ginori. That of the first Biennale lists only vases, plates and services and says that one of the vases was over two metres high. Then there is a photograph of part of the stand with a fireplace surmounted by three large plates with heads of warriors (now in the museum of Cerro di Laveno). Even at the second Biennale the official catalogue did not describe the products of the factory in Laveno in detail, but the specialist magazines published pictures of several pieces, in the first place the Monza service, designed by the young architect. In *Emporium* Papini described this new production in enthusiastic terms, asserting that in its ability to create new models the SCI was even 'superior to Richard-Ginori, which often makes use of the rich material of its old forms'. The catalogue of the third Biennale is still extremely terse, simply listing the participation of the three companies based in Laveno, the SCI, the Società Ceramica Revelli and the Società Ceramica del Verbano, but not going into the merit of the pieces presented. However, it does contain photos of some pieces and an image of the beautiful exhibition hall housing the most highly regarded vases. At the Triennale in 1930 there was again just a generic reference to the room of the SCI and the Società del Verbano, and from articles written at the time (Buzzi in *Dedalo*) we know that Laveno's contribution focused chiefly on '[...] a varied and remarkable series of services [...] in porcelain or earthenware, of a good modern character, that also have the merits of a perfect execution and an deliberately moderate price [...]'. It is possible to deduce from the *Annuario Industrie della Ceramica e del Vetro* of 1930 the dimensions of the three companies: Revelli had 200 employees, Verbano 300, the SCI 1060. At the Triennale in 1933 the catalogue listed facing tiles and dinner, coffee, tea and fruit services designed by Andlovitz in collaboration with a certain Dr Altman. Finally we find a detailed description in the catalogue of the 1936 Triennale, where the factory showed many pieces by well-known figures, ranging from Giovanni Patrone's panel of the *Dioscuri* to a crèche by Piero Fornasetti (now in the museum), as well as several figures (*Bacchante*, *Reaper*, *Skier*, *Madonna*) by the sculptor Gabloner and some masks in crystalline black and semi-gloss green glaze by Fausto Melotti. All this alongside the usual production of dinner services, vases, tiles and other objects designed by the artistic director. The original pieces did not meet with much approval (Papini in *Emporium* described them as 'odd and belated imitations of other people's styles'), but the factory did not abandon this type of production and the following year embarked on a collaboration with Angelo Biancini that would last until 1940 and lead to the creation of fine one-off or limited-run pieces like the ones designed by the sculptor of animals Sirio Tofanari. It is important to stress that the designer and the artists were able to draw on the great store of technical knowledge built up by the factory, which could rely on skilled craftsmen like the decorator De Ambrosis and the director of the kilns Antonio Deambroggi. After the Second World War the factory increased its production considerably. In 1948 the sculptress Antonia Campi came to work at the SCI as a simple decorator, and her highly original creations characterized the last period of the factory's existence. In 1965 the SCI was taken over by Richard-Ginori.
Bibliography
Musso 1897–1898; Antelling 1898; *Le Arti Decorative*, July 1923; 1st Monza Biennale 1923; Mezzanotte 1923; Sarfatti 1923; *Le Arti Decorative*, September 1925; 2nd Monza

Biennale 1925; *Emporium*, September, October 1925; *Opere scelte* 1925; *Architettura e Arti Decorative*, March 1927; 3rd Monza Biennale 1927; *Emporium*, July 1927; Marangoni, *Enciclopedia* 1927; Marangoni, in *La Cultura Moderna* 1927; *La Casa Bella*, January, April , May, November, December 1928; *Domus*, January, May, July, October, November, December 1928; *Architettura e Arti Decorative*, July 1929; *Domus*, March, September, December 1929; *Annuario Industrie della Ceramica e del Vetro*, 1930; *Architettura e Arti Decorative*, July 1930; Buzzi 1930; *Domus*, March, April, July, August, October, November, December 1930; *Emporium*, November 1930; Guigoni 1930; Papini 1930; Ponti 1930; 4th Monza Triennale 1930; *Domus*, April, May, June, July, August, September, November, December 1931, January, February, March, April, December 1932;, July 1933; *Emporium*, December 1933; 5th Milan Triennale 1933; *Domus*, January 1934; *Emporium*, August 1936; 6th Milan Triennale 1936; *Domus*, April 1937; December 1938; December 1939; April, May, June 1940; *Emporium*, May 1940; 7th Milan Triennale 1940; 8th Milan Triennale 1947; Morazzoni 1957; Morazzoni 1960; Brosio 1967; *Mostra della ceramica italiana* 1982; Rosso 1983; Gallina, Sandini 1985; Munari 1990; Biffi Gentili 1993; Musumeci 1994; Amari 1995; E. Biffi Gentili, 'La SCI di Laveno', in Pansera 1995; Bossaglia, Biffi Gentili, De Grassi 1995; Ausenda 1998; Terraroli, *Le arti decorative…* 1998; Ausenda, in *Museo d'Arti Applicate* 2002.
(cat. 29-34, 78-103, 111, 327-353)

Società Ceramica Lombarda
Ceramics factory, also known as Spangher & C., founded in Milan in 1900 by Bertoni, Spangher and other partners. Highly mechanized, it quickly attained a considerable size. Among its collaborators was Luigi De Vecchi, formerly a decorator at the SCI in Laveno. It produced imitations of 18th-century majolica ware and Chinese porcelain, small figures and, in ironstone china, dinner services, stoves and Art Nouveau tiles, including the famous Liberty decoration of Casa Galimberti in Via Malpighi in Milan, designed by Brambilla and Pinzauti. The mark of the factory, which in 1930 had a workforce of 450 and a clerical staff of fourteen, was an elephant. It was bought by Richard-Ginori in 1935.
Bibliography
Da *Faenza* 1923; *Annuario Industrie della Ceramica e del Vetro* 1930; Ausenda 1998; Ausenda, *Il risorgimento…*1998.

Solimene
The Solimene brothers commenced their activity as ceramists at Vietri in 1928. In 1943 the business was given the name CAS, Ceramica Artistica Solimene, and after the war its production increased considerably, making necessary the construction of a new factory, designed by the architect Paolo Soleri in 1952.
Bibliography
Frattani, Badas 1976; Rosso 1983; Romito 1994; Napolitano 1995; Salvatori, in Picone Petrusa 2000.

Giorgio and Piero Spertini
We have no biographical data on Giorgio, known for his contribution to the best Art Nouveau creations of the SCI in Laveno. He probably spent his whole career as a ceramist at the factory in Lombardy, which sent him to France as a young man to bring his style up to date. He learned his lesson very well, given that in 1903 he was able to produce the famous vase with a metal mount and handles. Piero, a ceramic technician born in 1887 and active at the SCI from 1900, led a more eventful life. At the beginning of the twenties he opened a small factory of terracottas at Laveno, later transformed into a cooperative. He went on to work at the Ceramica Victoria in Mondovì before moving, in 1928, to Lenci in Turin. Here, in addition to carrying out his duties as a technician until the end of the fifties, he made several models. He appears to have worked at Albisola as well.
Bibliography
Morazzoni 1957; Gallina, Sandini 1985.
(cat. 79)

SPICA
The Società per l'Industria Ceramica Artistica, SPICA, was founded in Cagliari, around 1919, by the sculptor Francesco Ciusa. Located in Villa Asquer, it produced ceramics in small runs to the artist's design, in particular bonbonnières, boxes, slabs and figures in terracotta made exclusively in moulds and decorated without firing. Blue, red and yellow were his preferred colours, together with black, used for the wooden frames of tiles and bas-reliefs. The use of such frames was to become such a common and widespread practice in ceramics and cabinet-making on the island that it came to be regarded as an old tradition. Like the techniques, the themes and motifs drew on popular handicrafts and the world of shepherds and peasants, with particular attention to traditional costumes. In 1921 the SPICA's products were shown at the Exhibition of Art in Cagliari. The factory closed in 1924, as its founder chose to focus on other interests.
Bibliography
Bossaglia 1980; Altea, Magnani 1995; Cuccu 2000.
(cat. 279-281)

SPICA, Società per Industria Ceramiche Artistiche
Founded at Albisola in 1925 on the initiative of the Savona publisher Luigi Brizio, it was originally a co-operative but became a joint-stock company in 1929. The production comprised ordinary and artistic ceramics, the latter characterized by unusual neoclassical motifs, perhaps due to the collaboration of artists. From 1929 to 1932 it was run by the painter and ceramist Romano Di Massa from Parma, under whom the production was improved from the technical viewpoint and distinguished by its innovative forms and decorations, to some extent comparable with those of Richard-Ginori and appreciated at the Monza Triennale of 1930. At this time the factory employed sixteen workers. After the stormy departure of Di Massa, the factory adopted more rational forms and replaced the decorations with a combination of shiny and matt glazes. The results of this new approach were presented at the Milan Triennale of 1933. The same year it made 100 copies of Arturo Martini's figure *The Madonna of Mercy of Savona*, produced in terracotta, underglaze painted and matt-glazed versions.
Bibliography
Annuario Industrie della Ceramica e del Vetro 1930; 5th Milan Triennale 1933; *Domus*, September 1933; Minghetti 1939; 7th Milan Triennale 1940; *Mostra della ceramica italiana* 1982; Rosso 1983; Chilosi, Ughetto 1995; Barisione 2001; Chilosi, in *Museo d'Arti Applicate* 2002.
(cat. 403)

Hans Stoltenberg Lerche
(Düsseldorf 1876 – Rome 1920)
Born in Germany to a family of Norwegian origin, he lived in Florence, Naples and Paris, devoting himself to sculpture and design, before settling in Rome in 1901. In 1902 he took part in the Turin International Exhibition, while in Rome he showed at the exhibitions of the Società degli Amatori e Cultori and the Roman Secession. In 1908 his polychrome ceramics, described as 'refined and bizarre' by *Emporium*, were on show at the Torricelli Exhibition in Faenza. Maintaining contacts with artists all over Europe, from Rodin to Bistolfi, he devoted himself to the creation of portraits in terracotta, marble and bronze, to ceramics, probably made in Switzerland, to goldsmithry and, from 1911, to glass, establishing an intense relationship of collaboration with the Toso Brothers. His ceramics, whether small figures of animals, flowers and women or vases, reflect his sensibilities as a sculptor. In 1918 he also tried his hand at porcelain. The motifs preferred by the artist, in ceramics as well as glass, were botanical, animal and maritime subjects, but there were also pixies, sprites and sleepwalking women. He showed sculptures and ceramics at the Venice Biennale on several occasions. At the first Monza Biennale, in 1923, a posthumous exhibition was dedicated to his work, made up of around a hundred pieces, including ceramics, glassware, jewellery, bronzes and prints.
Bibliography
Pica, in *Emporium*, June and September 1906; 7th Venice International Exhibition of Art, 1907; September 1908; Pica 1912; 11th Venice International Exhibition of Art, 1914; *Faenza*, issue III, 1915; 12th Venice International Exhibition of Art, 1920; Pica 1920; *Emporium*, May 1920; *Le Arti Decorative*, September 1923; 1st Monza Biennale 1923; Papini 1923; Sarfatti 1923; Quesada 1988; Quesada 1992; Bossaglia 1994; *Venezia e la Biennale* 1995; Longo 1996; Quesada 1996; Longo, in *Museo d'Arti Applicate* 2002.

Nino Strada
(Milan 1904–1968)
Son of the sculptor Attilio, he was introduced to ceramics in 1925 by Tullio Mazzotti, whom he met in Milan along with Bruno Munari. He was one of the first artists to work with the Ligurian pottery on the creation of Futurist ceramics, although his adherence to the movement was not total, but diluted by Novecento tendencies that in the end prevailed. In 1929 his works were shown at the exhibition at the Galleria Pesaro, in 1931 at Chiavari and again at the Galleria Pesaro, in 1932 in Paris and in 1934 in Nice. In 1936 he was present at the Milan

Triennale with a ceramic wall (*The Fascist Forces*) realized in collaboration with Tullio, and in 1937 at the Paris Expo with the panel of the *Corporations*. His best-known creations of smaller size were his original animals (*Giraffe*, *Fawn*, *Foal with Two Heads*), but he was also the author of bowls, tiles and masks. In 1938 he was appointed artistic director of the ILSA, where he accentuated the old-fashioned tone of the creations and paid particular attention to the glazes. In the forties he was at the CIMA in Deruta, first as a collaborator (his dinner service decorated with female figures ironically inspired by the traditional theme of 'Beautiful Women' won the Faenza Prize in 1942) and from 1945 as artistic director, designing forms and above all decorations. The latter ranged from the figurative (*Frattaglie* – 'Offal' – series with flowers and fruit, *Peacock*, *Leaves*) to the abstract (*Harlequin* decoration), anticipating the style of the fifties, and to reworkings of the classical repertoire. In 1946 he won another prize in the Faenza competition with the panel *The Giving of the Keys to Saint Peter* (Faenza Cathedral).
Bibliography
Domus, April 1932; *Casabella*, January 1933; *Domus*, February, May 1933; 5th Milan Triennale 1933; *Domus*, February 1935; ENAPI 1936; Pagano 1938; Minghetti 1939; Folliero 1957; Frattani, Badas 1976; Crispolti 1982; *Mostra della ceramica italiana* 1982; Rosso 1983; Chilosi, Ughetto 1995.

Günther Stüdemann
(Berlin 1890 – Thurnau 1981)
After studying painting in Hamburg and Secessionist Berlin, Stüdemann arrived in Positano in 1924 and the same year founded the Fontana Limite factory at Vietri, where many foreign artists worked, from the Dutch ceramist Sophia van Stölck to the German painter Elisabeth Schweizer. Considered the precursor of the ceramics produced by the so-called 'German colony' in Vietri, the artist also worked with Richard Dölker (there is a crèche by the pair in the Thurnau Museum) and probably with Margarethe Thewalt Hannasch. The factory mark was initially a muffle and then a small fish that would later be adopted by Melamerson's ICS. The production was sold chiefly at Positano, where ceramic panels with decorative religious and profane subjects typical of the German period (vessel, fish) can still be seen. In 1928 he left Italy and set up a new factory at Velten, near Berlin, only to move to Spain in 1933 and then return to Germany for good in 1939.
Bibliography
Faenza, issue I, 1927; Romito 1994; Romito, *La ceramica vietrese …* 1999; Romito, *La Collezione Camponi* 1999.

Mario Sturani
(Ancona 1906 – Turin 1978)
While still studying at secondary school, in Turin, he started to paint, adhering to the so-called second Futurism. He attended the ISIA in Monza and, in 1928, began to collaborate with Lenci, providing sketches for ceramics. The archives of the factory contain 180 of them, counting only the ones that were actually made into ceramics, for there were many more designs that never went into production. At the exhibition of *Lenci Ceramics* held at the Galleria Pesaro in Milan in 1929, thirty-two of the ninety-five works on display bore Sturani's signature. In 1932 he was in Paris, where, after seeing an exhibition on the work of Picasso, he decided to give up painting. Back in Turin, after working with the publisher Frassinelli, he resumed his collaboration with Lenci, designing dolls, toys and furniture as well, a relationship that would last until 1964. In an unpublished autobiographical novel, *Il maglione rosso*, Sturani, who always nursed the grander ambitions of painting and writing, played down his work at Lenci, dismissing it as a not very demanding way of earning a living. In reality his contribution to the decorative arts of the period, even within the limits of the Futurist current in which it was presented, was far from insignificant, and decisive as far as Lenci was concerned, for he was responsible for many of the most original, ironic and brilliant creations in its catalogue. Worth singling out, among Sturani's most typical inventions, are the *Bowls*, hemispherical containers spanned by bridges of figurines.
Bibliography
Ceramiche di Lenci 1929; *La Casa Bella*, April 1929; *Domus*, April, November, December 1930; Guigoni 1930; *Domus*, June 1936; Minghetti 1939; Proverbio 1979; Bossaglia 1980; *Mostra della ceramica italiana* 1982; *Le ceramiche Lenci* 1983; Rosso 1983; Mimita Lamberti 1990; Panzetta 1992.
(cat. 210-215)

Gigi Supino
(Genoa 1895– ?)
He studied sculpture in Milan, first with Ernesto Bazzaro and then at Adolfo Wildt's School of Marble. At the first Monza Biennale, in 1923, Richard Ginori presented a high-fired earthenware bust made at San Cristoforo in twenty copies, numbered and signed 'Supino scultore'. Over the next three years the sculptor created monuments for the universities of Pisa and Pavia and collaborated on the execution of Attilio Selva's Monument to the Fallen in Trieste. In the thirties he took part in the Venice Biennale on four occasions. The last exhibition at which he showed was the Biennale of 1948.
Bibliography
Panzetta 1994; Sgarbi (ed.) 2000.

Tamburlini & Carbonaro
In 1902 the Triestine sculptor Achille Tamburlini and the painter Raffaele Carbonaro founded a workshop in Venice for the creation of large works in terracotta and decorations for exteriors, some in the Art Nouveau style, others of Renaissance inspiration. They showed works of large and small size at the Venice Biennale of 1903 that stood out for the original process by which the terracotta was coated with copper. In 1906 they met with success at the Simplon Exhibition in Milan, but the stand was destroyed by fire. The workshop ceased its activity in 1911.
Bibliography
5th Venice International Exhibition of Art, 1903; 7th Venice International Exhibition of Art, 1907; Stringa, Venice 1987; Melegati 1988; Stringa 1995.
(cat. 43)

Tato, Guglielmo Sansoni
(Bologna 1896 – Rome 1974)
In 1919 he committed himself enthusiastically to Futurism, without any specific artistic training. He showed paintings at the main Futurist exhibitions and at numerous Venice Biennali. The *Enciclopedia dei Ceramisti* of 1939 said that he developed a passion for ceramics early on and served an apprenticeship at the Minghetti factory in Bologna, reproducing a series of tiles decorated with African subjects presented at the Exhibitions of Colonial Art in Rome and Naples. It also speaks of a production of his own, in 1928, at a factory in Vietri sul Mare. In the thirties he collaborated with Mazzotti in Albisola on the production of panels that were often transpositions into ceramic of his pictures celebrating Fascist rhetoric (*The Assault*, *March on Rome*). The more decorative ceramic wall for the seaside holiday camp of the Burgo Paper Mills at Moneglia was also made at the pottery in Albisola in 1938. He showed ceramics and photographs at the First Futurist National Exhibition held in Rome in 1933.
Bibliography
Mostra di trentatré artisti futuristi 1929; Minghetti 1939; Crispolti 1982.

Luigi Tazzini
(1868– ?)
Born in Lombardy, he was hired by Richard-Ginori of Doccia in 1899, and was soon given the post of artistic director. At the Paris Exhibition of 1900 he was able to study the best European examples of the Art Nouveau style, which allowed the factory to appear at the Turin Exhibition of 1902 with a completely updated repertoire. In 1923 Gio Ponti took over from him as artistic director, and he placed his great experience at the designer's disposal. His long collaboration with the factory ended only with his retirement, at the beginning of the thirties.
Bibliography
3rd Monza Biennale 1927; Ponti 1930; Minghetti 1939; Manna 2000.
(cat. 139)

Aleardo Terzi
(Palermo 1870 – Castelletto Ticino 1943)
Known as a poster designer and illustrator, active in Rome, Milan and London, he was introduced to ceramics by Duilio Cambellotti. He took part with Cambellotti in the first Monza Biennale, winning a silver medal. There are few records of this presence: only *Emporium* published a photograph of ceramics about which Papini wrote: '[...] I find the tableware in white and deep blue produced by the kilns of the SICLA to the designs of Cambellotti himself and of Aleardo Terzi delightful. Especially the ones by Terzi, which to the novelty and elegance of the glazed white forms sparingly add a precious linear decoration in light blue'.
Bibliography
Le Arti Decorative, September, December 1923; 1st Monza Biennale 1923; Carrà 1923; *Emporium*, July 1923; Sapori 1923; Marangoni, *Enciclopedia* 1927; Minghetti 1939; Bossaglia, Quesada 1981; De Guttry, Maino 2003.

Margarethe Thewalt Hannasch
(Germany 1901–1962)
Graduating from the Kunstgewerbeschule in Berlin, she came to Vietri in 1926, after working for a few months at Cantagalli in Florence, in response to an advertisement by Max Melamerson seeking personnel. However, she did not work at his factory, but at the one run by Vincenzo Pinto until 1931, when she went back to Germany. Here, after the war, she began to work with ceramics again, creating for the most part pieces of large size, such as fountains, wall panels and vases, very different from her production of small figures and objects of everyday use decorated with remarkable freedom of expression in Vietri. She returned to Vietri in 1958, but was so disappointed with what she found there that she moved to Scario until 1961, when she went to Germany for medical treatment, but died the following year.
Bibliography
Romito 1994; Romito, Salerno 1999; Romito, La Collezione Camponi 1999.

Sirio Tofanari
Florence 1886 – Milan 1969)
This self-taught sculptor specialized in animals, which were also made in earthenware by the SCI at Laveno toward the end of the thirties. In 1908 he showed at the Promotrice di Belle Arti in Turin and the same year at the first exhibition of the art of Romagna at Faenza. At the Venice Biennale of 1909 one of his works was bought by the Galleria d'Arte Moderna in Florence. In 1911 he exhibited in Barcelona and in 1915 in San Francisco. At the Primaverile Fiorentina of 1922 he showed several bronzes representing animals, and presented more animals at the Venice Biennale of 1934.
Bibliography
8th Venice International Exhibition of Art, 1909; Felice 1942; Morazzoni 1957; Gallina, Sandini 1985; Panzetta 1994.
(cat. 353)

Felice Tosalli
(Turin 1883–1958)
He acquired a familiarity with sculpture in his childhood, from his cabinetmaker father. In the closing years of the 19th century he attended the Accademia Albertina and then got a job with a woodcarver. From 1903 to 1905 he was in Paris, where he worked in a factory specializing in the reproduction of antique furniture. On his return, he tried his hand at graphic art, designing advertising posters and postcards. After the First World War he took up sculpting in wood, but also produced works in bronze and plaster. Between 1928 and 1936 he supplied Lenci with models for ceramics. As in the medium of wood, his favourite subjects were animals represented with great realism and expressive elegance. He showed three figures at the exhibition at the Galleria Pesaro in Milan in 1929: Caracal, Owl with Stoat and Centaur. Following the experience with Lenci, he collaborated with the German Rosenthal factory and, after the war, with the Ceramiche d'Arte Campionesi.
Bibliography
Ceramiche di Lenci 1929; La Casa Bella, April 1930; Buzzi 1930; Domus, May July, September 1930; June 1936; Minghetti 1939; Proverbio 1979; Mostra della ceramica italiana 1982; Le ceramiche Lenci, 1983; Panzetta 1990; Panzetta, Saluzzo 1992; Panzetta 1992.

Tarcisio Tosin
(Cles 1904 – Vicenza 1999)
His father Marco, formerly a printer at Antonibon in Nove, had moved to Cles to take up a job in a workshop located in the town's castle. In 1914 the family went to Verona, where his father opened a small factory with three more ceramists from Nove and Tarcisio attended the School of Arts and Crafts. In 1918 he started work as a ceramist at a factory in Verona, moving to the factory run by the Borromeo family on Isola Bella in 1920. In 1927 he was a modeller at the factory of the Brotto family in Vicenza, which he acquired in 1930, changing its mark to La Freccia and updating its previously traditional production to meet the canons of Art Deco. At the same time he taught applied ceramics at the School of Arts and Crafts in Vicenza.
Bibliography
Stringa 1986.
(cat. 355-361)

Trerè
Factory founded at Faenza in 1878 by Angelo Trerè for the manufacture of cooking pots and crockery for everyday use. Merged with Ferniani and Farina in 1898 to form the Fabbriche Riunite di Ceramiche, it was closed in 1908 because its exclusively handmade production based on traditional models was not a commercial success. Reopened as a cooperative, it carried on making the same type of cheap and traditional products until the twenties, when it found itself in crisis again. In 1927 new partners were brought in, including the ceramist Paolo Zoli. After a year and a half the factory closed again, but reopened shortly afterwards with other partners. One of them was Arnaldo Savioni, formerly the director of a factory at Montelupo Fiorentino, who improved the quality and variety of the decorations while continuing to follow tradition, including that of other regions of Italy. Characteristic was its production of pieces in manganese black, but also the introduction of decorations devised by Savioni himself and the ceramist Giuseppe Fiumi from Faenza. In the thirties the factory made ceramics designed by Bruno La Padula and Gino Pollini for the ENAPI. The factory was destroyed by bombs in 1944.
Bibliography
Arte Decorativa 1931; ENAPI 1933; ENAPI 1936; Domus, July 1938; ENAPI 1938; Domus, September 1940; Frattani, Badas 1976; Dirani, Vitali 1982; Ravanelli Guidotti, in Museo d'Arti Applicate 2002.
(cat. 465)

Manlio Trucco
(Genoa 1884–1974)
From the age of ten to seventeen he was at Balem, in Brazil, where his father ran a rubber factory. Returning to Genoa, he attended the Accademia Ligustica and then studied painting for three years in Florence. In 1906 he went on a honeymoon that lasted for three years, travelling around the world from Africa to Europe to America. Back in Italy, he devoted himself to painting. In 1910 he moved to Paris, where he met Paul Poiret who entrusted him for five years with the technical management of the Martine school and studio of decorations for fabrics, wallpaper and furniture. In 1921 he returned to Italy at the invitation of Angelo Barile, founder of La Casa dell'Arte at Albisola Capo. Here Trucco, in addition to bringing the technique (studied in Mexico) of decoration with glazes applied directly to the biscuit and then covered with a layer of transparent glaze, introduced new decorative motifs, first of plant and marine derivation and then Art Deco. A year later he set up the ceramics factory of La Fenice, which quickly attained a considerable size (in 1924 it employed forty women as painters). In 1925 he took part in the Paris Expo, and in 1930 won the gold medal at the Monza Triennale. In 1926 Mario Labò introduced him to Arturo Martini, who made his first series of figures at the factory, some of them coloured by Trucco himself. The success of the production meant that the factory lost the arts and crafts character that its founder had intended for it, and for this reason Trucco sold it in 1936 and retired to his house-cum-studio (now a museum named after him), devoting himself to painting and the creation of one-off ceramic pieces.
Bibliography
Le Arti Decorative, August 1923; June-July, August 1924; La Cultura Moderna, August 1924; 2nd Monza Biennale 1925; Emporium, July 1925; 3rd Monza Biennale 1927; Domus, December 1932; ENAPI 1932; Domus, May, September 1933; 5th Milan Triennale 1933; Minghetti 1939; 7th Milan Triennale 1940; Mostra della ceramica italiana 1982; Rosso 1983; Chilosi, Ughetto 1995; Ughetto 2000; Chilosi, in Museo d'Arti Applicate 2002.
(cat. 223, 403)

Tullio d'Albisola
(Albisola Marina 1899–1971)
He began to work with ceramics as a boy in the pottery run by his father Giuseppe Mazzotti. In 1922 he was jailed for two years for political reasons. He made his first attempts to produce a different, not imitative kind of ceramics as early as 1925, but his definitive choice of Futurism took place in 1927, when he met Nino Strada, Bruno Munari and Marinetti in Milan, and then came into contact with two Ligurian Futurists, Alf Gaudenzi and Dino Gambetti. In 1928 he took part in the Crèche Exhibition in Savona and, the following year, in the one in Turin, where he took the so-called Strapaese Crèche. In 1929 he showed his creations (crèches, pots, jugs, plates and services of fairly simple form, decorated with geometric, abstract patterns mixed up with letters in broad expanses of dazzling colours) in one room of the Exhibition of Thirty-three Futurist Artists at the Galleria Pesaro in Milan. Subsequently he focused his research on the forms, on the construction of original plastic structures, and on the ceramic material, in the sense of a passage from translucent ceramic to matt majolica, resinate lustres and bucchero. The following year, Mazzotti's Futurist creations were shown at the Monza Triennale and in a new show at the Galleria Pesaro in Milan, Futurist Exhibition Architect Sant'Elia and 22 Painters, marking

his venture into the field of sculpture. In 1931 he showed at the *Futurist Exhibitions* in Florence and Chiavari, in 1932 in Trieste, in 1933 again at the Galleria Pesaro, in the *Homage to Boccioni* exhibition, and in Nice and in 1935 at the *Italian Futurists* exhibition in Paris. At the beginning of the thirties, Tullio established links with some Futurists in Turin, in particular Fillia and Diulgheroff. In the second half of the thirties, at the urging of Prampolini, he also began to work on mural reliefs. Examples of remarkable quality were the wall entitled *The Fascist Forces* at the Milan Triennale of 1936 and the frieze of the corporations at the Paris International Exhibition in 1937 (both with Nino Strada). In 1938 he and Marinetti wrote and published the *Manifesto of Futurist Ceramics*. In 1940 made a mural relief to a design by Prampolini for the Triennale d'Oltremare in Naples. Even after the war, there was no falling off in Tullio's commitment to ceramics: he continued to devote himself to the medium, up until 1959 with his brother Torido and then in the factory he founded with his sister Vittoria, where he would once again work actively with artists.

Bibliography
3rd Monza Biennale 1927; *La Casa Bella*, February 1929; *Domus*, December 1929; *Mostra di trentatré artisti futuristi*, 1929; Ponti 1930; *Domus*, February 1935; Pagano 1938; D'Albisola, Marinetti 1939; Minghetti 1939; Folliero 1957; Bossaglia 1980; Crispolti 1982; *Mostra della ceramica italiana* 1982; Préaud, Gauthier 1982; Rosso 1983; Castagnoli 1989; Chilosi, Ughetto 1995; Morelli 2002; Chilosi, in *Museo d'Arti Applicate* 2002.
(cat. 224-230, 384, 386-393)

Angelo Ungania
(Faenza 1905–1996)
An expert ceramist, he worked in Faenza for Paolo Zoli's La Faïence, Focaccia & Melandri and Emilio Casadio. For Melandri, in the second half of the twenties, he developed a system of casting, a method little used in Faenza. For this he was awarded the technical prize of the municipality of Faenza in 1942. He took part in the third National Competition of Art Ceramics in Faenza, in 1941, with several pieces, ranging from centrepieces to ornamental figures, made at Casadio's pottery. After the war Ungania opened a craft workshop in Milan, later moved to the Ligurian Riviera, where Lucio Fontana made some of his works.

Bibliography
Domus, September 1941; *Stile*, November 1942; 8th Milan Triennale, 1947; Savini 1992; Bojani 1999; Dirani, Vitali 2002.

Sandro Vacchetti
(Carrù, Cuneo 1889 – Turin 1974)
In 1905 he went to Turin to join his brothers Emilio and Pippo, painters by vocation, graphic artists by necessity. He worked with Emilio on the design of film posters. From 1914 until the beginning of the war he was in the United States, where he did the same job and probably worked with ceramics as well. In 1919 he began to collaborate with Lenci, modelling the heads of dolls with Giovanni Riva. He went on to become artistic director of the ceramics factory, designing numerous models of various types, from vases to female figures. Four of his pieces were presented at the exhibition held at the Galleria Pesaro in Milan in 1929, including a delicate *Madonna* and a much more showy and aggressive Art Deco sculpture entitled *The Two Tigers*. In 1934 he left Lenci to set up Essevi, active until 1952. Later he would devote himself exclusively to painting.

Bibliography
Ceramiche di Lenci 1929; *Domus*, November 1932; Minghetti 1939; *Torino tra le due guerre* 1978; Proverbio 1979; *Mostra della ceramica italiana* 1982; *Le ceramiche Lenci* 1983; Panzetta 1992.
(cat. 205, 378-380)

Vasellari Eugubini Mastro Giorgio
The pottery was founded at Gubbio in 1920 by the Neapolitan painter Ilario Ciaurro, Enrico della Torre, Gino Clerici and the Milanese lawyer Cesare Carlo Faravelli. It was located in the Palazzo del Bargello and employed around thirty people. Ciaurro started out from the local tradition, while bringing its forms and decorations up to date. In 1924 Ciaurro moved to Orvieto to run the Arte dei Vasellari and the factory in Gubbio was kept going by Faravelli alone.

Bibliography
Domus, October 1928; May 1929; *Annuario Industrie della Ceramica e del Vetro* 1930; Minghetti 1939; Satolli 1983; Bojani 1992.

Virio da Savona (Vittorio Agamennone)
(Verona 1901 – Savona 1995)
A painter, he started to work with ceramics at Mazzotti, around 1920, and then at Alba Docilia. Returning to Mazzotti in the mid-twenties, he specialized in animal subjects inspired by Art Deco. He was one of the first artists operating in Albisola to pass from the latter style to that of the Novecento. He also made plates and vases decorated in sgraffito with plant and animal motifs influenced by Indian art. From 1929 to 1933 he was in France, and on his return devoted himself almost exclusively to painting.

Bibliography
Minghetti 1939; Bossaglia 1980; Rosso 1983; Chilosi, Ughetto 1995.

Arrigo Visani
(Bologna 1914 – Imola 1987)
He followed the courses in ceramic technique and artistic ceramics at the Scuola di Ceramica in Faenza, along with Gaetano Ballardini, Domenico Rambelli, Anselmo Bucci, Giorgio Morandi and Virgilio Guidi. He went on to take a diploma at the Accademia di Belle Arti in Bologna. After the war, he worked from 1946 to 1950 at the Cooperativa Ceramica in Imola, where he designed and painted ceramics that were admired by Gio Ponti, among others. The factory did not allow its collaborators to sign their pieces, but a series of forms drawn from the repertoire of common household articles can be attributed to him, in particular imaginatively reworked bottles. Later he took up teaching, for a long time at the school in Castelli, where he also carried out an intense productive activity for which he won important awards. He went on to teach at Sesto Fiorentino and, in the sixties, founded and ran the Istituto d'Arte at Oristano.

Bibliography
Mingotti 1991, Ravanelli Guidotti 1994.

Vitali e Missier, Industrie Ceramiche Artistiche, ICAM.
Founded in Venice in 1926 by Achille Missier, previously in partnership with Giacomo Dolcetti, and Luigi Vitali. In 1928, the latter withdrew and the company took the name of ICAM. In style and quality the production was very close to that of the Bottega del Vasaio, especially in the painted decorations of Renaissance inspiration and the recurrent theme of Venetian characters of the Commedia dell'Arte. At the beginning of the thirties the small factory was acquired by Giulio Guerrieri, who for a certain period went on producing Missier's models.

Bibliography
Stringa, *Terre Ferme*...1987.

Giacomo Vivante
(Venice 1877–1969)
A painter who studied, like Guido Cadorin, under Cesare Laurenti at the Scuola Libera del Nudo, he ran a ceramics workshop on Murano with an Art-Nouveau-inspired production of Secessionist derivation from 1902 to 1911. At the Udine Exhibition in 1903 he met Chini, who showed significant appreciation of his work. The following year he was at the Exhibition in Saint Louis, and at the Venice Biennale in 1905 and 1909. In addition to elegant vases and planters with very restrained decoration, he made tiles for Cadorin's furniture that were shown at the Biennale in 1909, the last clear evidence of the workshop's activity. Vivante also made the majolica tiles, now lost, of the Laurenti frieze in the Storione Hotel in Padua.

Bibliography
8th Venice Biennale 1909; Stringa, Milan (da sistemare) 1987; Stringa 1987; Melegati 1988; Stringa 1995; *Venezia e la Biennale* 1995.

Achille Wildi
(Pesaro 1902–1975)
He began to work with ceramics at the age of just ten, in the Molaroni factory at Pesaro where he became an expert on the styles of the Renaissance. In 1919 he left Pesaro and began to move from one centre in Italy to another, including Faenza, where he worked for the Nuova Ca' Pirota in 1922. In 1929 he was in Paris, then Milan and finally San Marino, where he worked with the Masi factory.

Bibliography
Arte e immagine... 1980; Benzi 2001.

Zaccagnini
We know that Ugo Zaccagnini (1868–1937) had been in charge of the moulding and spraying department at Ginori of Doccia and then a founder, with others, of the SIFMA in the last decade of the 19th century, before it was taken over by Fantechi alone in 1906. It is likely that the Manifattura Zaccagnini in Via Monteoliveto in Florence was set up around this date. The first event in which it is recorded to have taken part was the Florence Crafts Exhibition in 1923, where it showed terracottas similar to those of the Manifattura di Signa, only glazed on the inside. In 1936 the injection of capital by the Florentine industrialist Aristide Loria transformed the family firm into a joint-stock company. The factory moved to Piazza Pier Vettori and

was expanded to the point where it employed 130 workers (in 1930 it had had only twelve). The historicist repertoire was abandoned and, thanks to the modern taste of Ugo's son Urbano Zaccagnini (1901–1964), and the collaboration of sculptors like the animal specialist Fosco Martini and Ottorino Palloni, gained a reputation for the originality of its products both in Italy, where it met with success at the Milan Triennali, and on the American market. *Domus* published many of the creations presented at the exhibition in Milan, including a vase and two figures of the seasons in July 1937 and a wide selection of pieces in June 1940 that ranged from a large terracotta vase with cord decorations to rustic objects 'with a sgraffito coating' and pieces in an archaic and African style, all designed by Urbano Zaccagnini, and a number of coloured figures of animals. The following year the same magazine devoted two pages of its July issue to the Florentine factory, reproducing vases decorated with the characteristic cord motif and with wickerwork patterns and large jars adorned with speckles and bubbles. Finally the December issue of the same year presented a series of small animals with a smooth glaze that, 'if it were not for the cracked surface, would resemble the old animals of the Royal Factory in Copenhagen'. In those years the factory established links with some very well-known artists, including Giorgio de Chirico who had the prototypes of three sculptures made in terracotta there. It continued its production at similar standards of quality after the Second World War as well, until shifting to a more commercial approach following Urbano's death.
Bibliography
Annuario Industrie della Ceramica e del Vetro 1930; *Domus*, May 1932; ENAPI 1932; *Domus*, September 1933; ENAPI 1933; 5th Milan Triennale 1933; ENAPI 1936; 6th Milan Triennale 1936; *Domus*, June 1937; July, December 1938; June 1940; 7th Milan Triennale 1940; *Domus*, July, December 1941; *Mostra della ceramica italiana* 1982; Rosso 1983; Conti, Cefariello Grosso 1990; Zaccagnini 1994; Maldini 1999; Pratesi, in *Museo d'Arti Applicate* 2002. (cat. 466)

Aldo Zama
(Faenza 1888–1996)
Working at the Fabbriche Riunite di Ceramiche, he specialized in the decoration of ceramics with figures and landscapes. In 1911 be became artistic director of the decoration department and in 1925 resigned to open a workshop of his own. His production was largely along the same historicist lines as the factory where he had worked, but used vaguely Art Nouveau decorations as well. He also made pieces of very different kinds to order. In the thirties he updated his style, as is apparent from some tiles shown at the Milan Triennale in 1936 and published by the *Enciclopedia dei Ceramisti*, modelled in relief or painted with exotic figures. He also took part in the ENAPI Exhibition at the 1940 Triennale with vases, boxes and a sculpture. His workshop closed in the mid-fifties.
Bibliography
Liverani 1927; ENAPI 1936; Ettorre 1936; ENAPI 1938; Minghetti 1939; 7th Milan Triennale 1940; Dirani, Vitali 1982.

Emilia Zampetti Nava
(Camerino 1883 – Rome 1970)
She went to Rome in 1900 to attend the Accademia di Belle Arti. She was a pupil of Giuseppe Cellini and Camillo Innocenti and a friend of Duilio Cambellotti. Initially she devoted herself chiefly to painting, and portraiture in particular, but went on to practice the applied arts as well, from fabrics for interior decoration to furniture, toys and ceramics. The few examples of the latter that have come down to us are characterized by simple forms and polychrome decorations of animals on stylized floral backgrounds. After her marriage to the painter Hector Nava, she lived in Argentina from 1912 to 1919, continuing to cultivate her artistic interests. On her return to Italy, she illustrated a pioneering book for primary-school education. When, after a long period dedicated to her family, she returned to art in 1934, she devoted herself exclusively to painting.
Bibliography
De Guttry, Maino, Quesada 1985; Quesada 1988.

Adelina Zandrino
(Genoa 1893–1994)
In 1913 she was in Paris with her father, a well-known journalist and theatre critic, and worked in an atelier making costumes for opera and as an illustrator of refined editions, frequenting the leading figures of the Parisian literary and art world, from Rodin to Robert du Montesquieu. During the war she created postcards and posters of patriotic propaganda. Later she began to work with ceramics through Manlio Trucco's La Casa dell'Arte. She took part with the latter in the Genoese Promotrice of 1922, showing mostly plates painted with genre scenes in costume or masquerade. Her works of the twenties – fruit stands, candlesticks, majolica jars, lampshades, wall plates and jugs – were characterized by an exuberance of colour inspired by the Ballets Russes and other Parisian influences. She also made small sculptures, chiefly female figures somewhere between *belle époque* and D'Annunzian decadentism. In 1930 she took part in the First Female Exhibition of Art and Work at the Castello Sforzesco of Milan, designing the poster. Later she chose terracotta as her medium and tackled more engaged themes, such as motherhood and the female condition. She fired her small sculptures in the Tonet kiln at Genoa Sturla and coloured them without firing. She showed at the Triennale of 1936 and the Paris Exhibition of 1937.
Bibliography
Le Arti Decorative, August 1923; 3rd Monza Biennale 1927; 6th Milan Triennale 1936; Minghetti 1939; 7th Milan Triennale 1940; Rosso 1983; Chilosi, Ughetto 1995.

Zanolli, Sebelin & Zarpellon
Factory founded at Nove in 1920 by the ceramists Sebastiano Zanolli (1895–1946), Teodoro Sebelin (1890–1975) and Alessandro Zarpellon (1891–1939). In 1926 it absorbed the workshop of Demetrio Primon, who collaborated on the execution of a large panel in polychrome majolica tiles for the façade of the building that housed the factory. The production was divided into two parts, one defined as artistic and made up of vases, boxes, ornate basins and candlesticks, designed by Zarpellon, and another defined as modern and consisting of figures and groups, designed by Sebelin. In the thirties Giovanni Petucco collaborated with the factory. The *Annuario Industrie della Ceramica e del Vetro* of 1930 assigned it thirty-six workers. Following the deaths of two of the three partners, in 1939 and 1946, it was run by their widows and Sebelin's wife, as he had opened a new workshop. In 1954 the children of the three founders took over. In the sixties the factory, now called Zanolli e Sebelin, began to collaborate with artists, and in particular Pompeo Pianezzola, who transferred the production of his workshop there and also became the designer of its mass-produced articles.
Bibliography
Annuario Industrie della Ceramica e del Vetro 1930; Minghetti 1939; 7th Milan Triennale 1940; *Mostra della ceramica italiana* 1982; Stringa 1986; Stringa, *Omaggio a Bassano e Nove*, 1987.

Antonio Zen
(Nove 1871– ?)
He started to work with ceramics in 1885, while he was following the course of sculpture at the Accademia di Belle Arti in Venice, entering into partnership with Demetrio Primon, owner the previous year of a workshop at Bassano. The production was initially of the so-called 'artistic' kind, i.e. imitating the past. In 1897 Primon withdrew from the partnership and set up a business of his own (he took part in the Paris Exhibition of 1900), only to move, in 1903, to the Società Cooperativa (Agostinelli and Dal Prà) and then to Zanolli, Sebelin & Zarpellon. Antonio Zen carried on alone with a production partly based on the old models, but partly inspired by Art Nouveau and then by Novecento. After the First World War the factory was expanded: by 1930 it had around fifty workers, rising to seventy-five by 1939. Enrico Caccia Guerra collaborated with the factory.
Bibliography
Annuario Industrie della Ceramica e del Vetro 1930; Minghetti 1939; Stringa 1980; *Mostra della ceramica italiana* 1982; Stringa, *Omaggio a Bassano e Nove* 1987; Stringa 1988.

Aldo Zerbi
Jugging by the traces it left in the press of the time, Aldo Zerbi's career as a ceramist was brief and intense. His name appeared with a certain prominence at the Monza Triennale of 1930, and one of his supporters was Tomaso Buzzi, the curator of the Ceramics Gallery, who published some of his vases in *Dedalo*. *La Casa Bella* also devoted two pages to him, and from these images we can get an idea of the characteristics of his production. They are of large cob stoneware vases decorated with astrological themes and vases, plates and bowls that are also in stoneware, but with cracked monochrome or polychrome glazes. The following year Zerbi took part in an exhibition of Italian decorative art in Amsterdam, reported by Ugo Nebbia

in *Emporium*, showing more stoneware vases. In 1933 he was at the Triennale again, where the link with Buzzi was confirmed by the inclusion of two plates he had designed (*Sea of Ulysses* and *The Trojan Horse*) alongside crazed porcelain and other objects in the exhibition of ceramics organized by the architect himself, and a centre for a fountain made up of a sculptural group in glazed terracotta (*Cleaning of the Elephant*, donated by Zerbi to the Civiche Collezioni del Castello Sforzesco in Milan in 1936), shown by the ENAPI. On this occasion Gio Ponti described him, in *Domus*, as a rising star in Italian ceramics. But three years later, in a long article in the same magazine taking stock of the Italian decorative arts ahead of the Paris Exhibition, Ponti was obliged to express regret at his loss: '[...] Zerbi, one of the few master ceramists, has retired [...]'.
Bibliography
Buzzi 1930; *La Casa Bella*, September 1930; 4th Monza Triennale 1930; Nebbia 1931; ENAPI 1933; *Domus*, May, October 1933; 5th Milan Triennale 1933; *Domus*, October 1936; Minghetti 1939; Frattani, Badas 1976; Ausenda, in *Museo d'Arti Applicate* 2002.
(cat. 434)

Umberto Zimelli
(Forlì 1898–1972)
He studied at the Scuola d'Arti e Mestieri and the Accademia di Belle Arti in Ravenna, with Giovanni Guerrini, going on to become a teacher and set designer. From 1921 he worked as a ceramist at the Fabbrica di Ceramiche Artistiche on Isola Bella, in Lake Maggiore. In 1926 he began to teach again, first ceramic decoration in Milan, at the Mantegazza Vocational Schools for Women and, in 1932, at the Umanitaria philanthropic association, and then, from 1933 to 1943, decorative composition for goldsmiths, silversmiths and ceramists at the ISIA in Monza. Here he made small bejewelled and filigreed ceramics in a modern neoclassical style. He exhibited at the Monza Biennali and the Triennali of 1933, 1936 and 1940. In 1932 he won the ENAPI competition for ceramic planters. After the war he ran the Lombard office of the ENAPI. In 1947, and then at intervals of two years up until 1953, he showed his ceramics at the Galleria Gian Ferrari in Milan.
Bibliography
Emporium, September 1925; ENAPI 1936; *Domus*, March 1939; Folliero 1957; Frattani, Badas 1976; Bossaglia 1986.

David Zipirovič
(Kershan, Russia 1855 – Moscow 1946)
A Russian painter in a historicist style, he arrived in Deruta in 1923 at the invitation of Alpinolo Magnini, artistic director of the Società Anonima Maioliche Deruta. For the next four years, he devoted himself with great virtuosity to the reproduction of masterpieces by Raphael, Michelangelo, Mantegna and Botticelli on ceramics. His production consisted of plates, vases and panels, mostly of large size, which were very popular with collectors. After his departure, several decorators in Deruta continued to practice this genre quite unconnected with modernity.
Bibliography
Busti, Cocchi, 'Tradizione e innovazione nella ceramica derutese del Novecento', in Bojani 1992; Ranocchia 1999; *David Zipirovič...*, 2000.
(cat. 277)

Paolo Zoli
(Faenza 1885–1960)
He was one of the workers at Minardi who took over the factory in 1913. In 1919 he opened La Faïence with some partners, producing articles that were in part inspired by the tradition of Faenza and in part modern. Shortly afterwards the other partners withdrew and Zoli joined forces with Melandri, producing among other things Nonni's Art Deco statuettes. In 1921 Melandri opened a workshop of his own, and Zoli kept on running La Faïence by himself. In 1927 he formed a partnership with a financier in Bologna and a dealer in Forlì to reopen the Trerè factory, an attempt that failed after less than two years. Zoli then moved to Switzerland to work as an employee in a ceramics factory.
Bibliography
Sapori 1925; Minghetti 1939; Dirani, Vitali 1982; Rosso 1983; Savini 1992.

Zortea
Factory founded at Bassano in 1921 by Luigi Zortea, formerly a modeller at Passarin and Fabris. It distinguished itself by a basically modern production of one-off pieces, complex compositions of plant elements, animals and figures in ivory majolica that were presented at the Milan Triennale of 1933, the Brussels International Exhibition of 1935, where they won a gold medal, and Paris Exhibition of 1937. Gio Ponti also came into contact with the factory, devoting some attention to it in the pages of *Domus* and having some of his ceramics for passenger ships made there. In the pre-war period the factory employed about twenty workers, a figure that rose to around fifty after the war. On Luigi's death in 1950, his son Francesco stepped into his shoes.
Bibliography
5th Milan Triennale 1933; *Domus*, December 1933; ENAPI 1936; *Domus*, June, October 1937; Minghetti 1939; Stringa 1980; Stringa, *Omaggio a Bassano e Nove* 1987.

Bibliography
edited by Paola Franceschini

1895
'Industrie artistiche. Fabbricazione della porcellana', in *Emporium*, 1895, pp. 93-103.
1897
F. Musso, 'La ceramica all'Esposizione di Torino', in *Natura ed Arte*, 1897-1898, fascicule XVIII, pp. 487-494.
1898
M. Antelling, 'Arte Industriale nella esposizione italiana di Torino. Ceramica', in *Arte Italiana Decorativa e Industriale*, november 1898, pp. 85-87.
M. Antelling, 'Esposizione Nazionale di Torino. I. Le terre cotte di Signa', in *Emporium*, 1898, pp. 295-298.
G. Di Giacomo, 'L'arte ceramica in Italia. Capodimonte – L'Officina Richard Ginori', in *Natura ed Arte*, 1898-99, fascicule XXIV, pp. 1006-1011.
'Esposizione Nazionale di Torino. I. Le ceramiche a gran fuoco di C. Novelli di Roma', in *Emporium*, 1898, pp. 299-301.
1899
Sem Benelli, 'Le ceramiche di Galileo Chini di Firenze', in *Emporium*, 1899, pp. 74-78.
1900
'Saggio delle opere esposte nel Palazzo d'Italia alla gran mostra di Parigi', in *Arte Italiana Decorativa e Industriale*, 1900, May, pp. 41-42; June, pp. 49-50; october, pp. 79-82; December, pp. 90-91.
A. Sandier, 'La Céramique à l'Exposition', in *Art et Décoration*, July-December 1900, pp. 184-196.
1901
E. Aitelli, 'Esposizione internazionale d'arte decorativa a Torino. L'Italia e gli Italiani', in *Natura ed Arte*, 1901-1902, pp. 750-762.
Sem Benelli, 'L'Arte industriale a Parigi', in *Emporium* 1901, pp. 263-288.
1902
I Esposizione Internazionale d'arte decorativa moderna. Catalogo Generale Ufficiale, Turin 1902.
A. Melani, 'L'Esposizione d'arte decorativa odierna in Torino. IV Ceramica italiana', in *Arte Italiana Decorativa e Industriale*, 1902, pp. 55-58.

A. Melani, 'L'arte della Ceramica di Firenze', in *L'Arte Decorativa Moderna*, August 1902, pp. 225-230.
V. Pica, *L'Arte decorativa all'Esposizione di Torino del 1902*, Bergamo 1902.
G. Tesorone, 'L'odierno movimento dell'arte decorativa in Napoli', in *Arte Italiana Decorativa e Industriale*, 1902, pp. 45-49.
M.P. Vermeil, 'L'Exposition d'Art décoratif moderne à Turin', in *Art et Décoration*, XII, July-December 1902.
1903
'L'arte decorativa all'esposizione di Venezia', in *Arte Italiana Decorativa e Industriale*, May 1903, p. 37, July pp. 53-56.
V. Esposizione Internazionale d'Arte della città di Venezia. 1903. Catalogo illustrato, Venice 1903.
1904
Società Ceramica Richard-Ginori 1873-1903. Memorie, Milan 1904.
1905
V. Pica, 'L'arte decorativa all'esposizione di Venezia. Le sale italiane', in *Arte Italiana Decorativa e Industriale*, 1905, pp. 45-47.
VI. Esposizione Internazionale d'Arte della città di Venezia. 1905. Catalogo illustrato, Venice 1905.
1906
E.A. Marescotti, E. Ximenes (edited by), *Milano e l'Esposizione Internazionale del Sempione. Cronaca illustrata*, Milan 1906.
V. Pica, 'Artisti contemporanei: Hans Stoltenbergh Lerche', in *Emporium*, June 1906, pp. 402-423.
V. Pica, 'L'arte decorativa all'Esposizione di Milano. Qua e là per le esposizioni straniere', in *Emporium*, September 1906.
V. Pica, 'L'arte decorativa all'Esposizione di Milano. La sezione italiana', in *Emporium*, October 1906, pp. 243-255; November 1906, pp. 323-340.
1907
VII. Esposizione Internazionale d'Arte della città di Venezia,1907. Catalogo illustrato, Venice 1907.
1908
I Mostra Biennale romagnola d'Arte, catalogue, Faenza 1908.
V. Pica, 'La prima mostra romagnola d'arte a Faenza', in *Emporium*, September 1908, pp. 225-236.
1909
VIII Esposizione Internazionale d'Arte della città di Venezia. 1909. Catalogo illustrato, Venice 1907.
1910
Esposizione Universale e internazionale di Bruxelles, catalogo ufficiale della Sezione Italiana, Bruxelles 1910.
IX Esposizione Internazionale d'Arte della città di Venezia, catalogue, Ca' Pesaro, Venice 1910.
1911
Le Esposizioni di Roma e di Torino nel 1911 descritte e illustrate, Milan 1911.
G. Lavini, 'L'Arte Industriale all'Esposizione in Torino', in *Arte Italiana Decorativa e Industriale*, 1911, November, pp. 85-89.
1912
V. Pica, *Hans St. Lerche*, Bergamo 1912.
1914
U. Ojetti, 'Giovanni Tesorone', in *Faenza*, 1914, fascicule I, pp. 21-22.
Undicesima Esposizione Internazionale d'Arte della città di Venezia, catalogue, Venice 1914.
1916
A. Lancellotti, 'Le esposizioni d'arte a Roma', in *Emporium*, June 1916, pp. 460-480.
1919
R. Calzini, 'L'Esposizione Regionale Lombarda di Arte Decorativa', in *Emporium*, luglio 1919, pp. 150-159.
1920
M. Korach, 'La maiolica di Faenza e il suo rinnovamento', in *Le Vie d'Italia*, March 1920.
V. Pica, *Hans St. Lerche, Alberto Martini, Mario Cavaglieri*, Galleria Pesaro, Milan 1920.
'Hans Stoltenberg Lerche', in *Emporium*, May 1920, pp. 261-262.
1921
R.P., 'Industrie Artistiche Italiane', in *Emporium*, January 1921, pp. 106-112.
F. Sapori, Domenico Baccarini, Turin 1921.

F. Sapori, 'La Prima Mostra Biennale d'Arte in Roma', in *Emporium*, June 1921, pp. 303-319.
1922
V. Costantini, 'L'arte applicata e le Biennali di Monza', in *Arte Pura e Decorativa*, July 1922.
1923
'Attraverso la Mostra di Monza', in *Le Arti Decorative*, August 1923.
'Attraverso la Mostra di Monza', in *Le Arti Decorative*, December 1923.
C. Carrà, *L'arte decorativa contemporanea alla prima Biennale Internazionale di Monza*, Milan 1923.
C. da Faenza, 'Ceramiche d'arte e industriali della "Lombarda" di Milano', in *Arte pura e decorativa*, 1923, n. 5, p. 18.
V. Giglio, 'L'arte in Sardegna', in *Le Arti Decorative*, July 1923, pp. 18-22.
M. Labò, 'La sezione ligure', in *Le Arti Decorative*, August 1923, pp. 23-26.
G. Marangoni, 'Da Monza a Parigi', in *Le Arti Decorative*, October 1923, pp. 7-9.
G. Marangoni, *La Prima Mostra Internazionale delle Arti decorative della Villa Reale di Monza 1923. Notizie, rilievi risultati*, Bergamo 1923.
P. Mezzanotte, 'La prima mostra internazionale delle arti decorative di Monza, I e II', in *Architettura e Arti Decorative*, 1923, pp. 391-404 and pp. 429-457.
R. Papini, 'La Mostra delle arti decorative a Monza. Le arti della terra', in *Emporium*, July 1923, pp. 3-21.
R. Papini, *Le arti a Monza nel MCMXXIII*, Bergamo 1923.
'Premi e distinzioni', in *Le Arti Decorative*, September 1923, pp. 36-39.
Prima Esposizione Internazionale delle Arti Decorative. Monza, Villa Reale, 19 maggio-21 ottobre 1923, exhibition catalogue, Milan- Rome 1923.
F. Sapori, 'La sezione del Lazio', in *Le Arti Decorative*, dicembre 1923, pp. 11-18.
F. Sapori, 'La sezione del Lazio', supplement to *Lidel*, 1923.
M. Sarfatti, 'La prima Biennale d'Arte Decorativa a Monza. Le ceramiche', supplement to *Lidel*, Milan 1923.

P. Sinopico, 'Le ceramiche di Francesco Ciusa', in *Le Arti Decorative*, August 1923, pp. 27-30.
La Società Ceramica Richard-Ginori nel suo primo cinquantenario 1873-1923, Milan 1923.

1924
'Le arti paesane calabresi alla III Mostra alla "Mattia Preti" in Reggio', in *Le Arti Decorative*, November 1924, pp. 34-37.
'Ferruccio Mengaroni', in *Le Arti Decorative*, January 1924, pp. 11-18.
'La mostra delle ceramiche italiane a Pesaro', in *Le Arti Decorative*, June-July 1924, pp. 45-48.
'La mostra delle ceramiche a Pesaro', in *La Cultura Moderna*, August 1924, pp. 598-600.
U. Ortona, 'Duilio Cambellotti', in *Le Arti Decorative*, April 1924, pp. 22-31.
U. Ortona, 'Giovanni Prini', in *Le Arti Decorative*, August-September 1924, pp. 48-56.
L. Serra, 'La Mostra d'Arte di Pesaro', in *Emporium*, August 1924, pp. 517-531.
G. Titta Rosa, 'Michele Cascella', in *Le Arti Decorative*, November 1924, pp. 38-43.

1925
E. Agostinione, 'L'arte della ceramica nella seconda Biennale', in *Le Arti Decorative*, September 1925, pp. 14-23.
R. Buscaroli, 'Le ceramiche di Melandri', in *Le Arti Plastiche*, June 1925.
F. Carnevale, 'Un ceramista: Gian Carlo Polidori', in *Emporium*, November 1925, pp. 314-320.
Catalogo seconda mostra internazionale delle arti decorative, Villa Reale di Monza, maggio-ottobre 1925, Milan 1925.
C.A. Felice, 'Da una Biennale di Monza all'altra', in *Le Arti Decorative*, April-May 1925, pp. 27-34.
A. Frangipane, 'La sezione calabrese alla II Biennale di Monza', in *Le Arti Decorative*, September 1925, pp. 20-23.
G. Marangoni, 'Un ceramista italiano: Ferruccio Mengaroni', in *La Cultura Moderna*, 1925, pp. 1-9.
G. Marangoni, *La seconda Mostra Internazionale delle Arti Decorative nella Villa Reale di Monza. Notizie, rilievi, risultati*, Bergamo 1925.
U. Nebbia, 'L'Italia all'Esposizione Internazionale di Parigi. Le Arti Decorative industriali moderne', in *Emporium*, July 1925, pp. 17-36.
Opere scelte. Seconda mostra internazionale delle arti decorative. Monza 1925, Milan 1925.
R. Papini, 'Le Arti a Monza nel 1925. I. Dagli architetti ai pastori', in *Emporium*, September 1925, 139-160.
R. Papini, 'Le Arti a Monza nel 1925. II. Dalle ceramiche ai cartelloni', in *Emporium*, October 1925, pp. 223-243.
G.F. Rossi, 'Alla Biennale di Arti Decorative di Monza', in *Emporium*, September 1925, pp. 63-64.
F. Sapori, 'La Romagna alla II Mostra di Monza', in *Le Arti Decorative*, August 1925, pp. 25-30.
L. Serra, 'Alcuni aspetti dell'arte di Ferruccio Mengaroni', in *Le Arti Decorative*, June 1925, pp. 17-28.
L. Serra, 'La sezione marchigiana alla Mostra di Monza', in *Le Arti Decorative*, July 1925, pp. 14-21.
R. Strinati, 'Un ceramista: Renato Bassanelli', in *Le Arti Decorative*, February 1925, pp. 33-35.
G. Titta Rosa, 'L'Abruzzo a Monza', in *Le Arti Decorative*, June 1925, pp. 36-41.
P. Torriano, 'La seconda Mostra di arti decorative a Monza', in *L'illustrazione italiana*, October 1925.

1926
R. Buscaroli, 'La Fornace Bubani', in *Le Arti Plastiche*, April 1926.
Gio Ponti, 'Le ceramiche', in *L'Italia alla Esposizione Internazionale di Arti Decorative e Industriali Moderne*, Paris 1926.
F. Sapori, *La II Esposizione Internazionale delle Arti Decorative a Monza*, Rome 1926.

1927
Catalogo ufficiale della III Mostra Internazionale delle Arti Decorative, maggio-ottobre 1927, Milan 1927.
'Le ceramiche di Arturo Martini', in *Problemi d'arte attuale*, November 1927, pp. 19-20.
V. Giunti, *La maiolica italiana*, Milan 1927.
G. Liverani, 'La raccolta delle ceramiche rusticane ed una recente acquisizione', in *Faenza*, 1927, fascicule I, pp. 21-23.
G. Liverani, 'Per la Mostra permanente della moderna ceramica italiana d'arte', in *Faenza*, 1927, fascicule I, p. 24.
G. Liverani,' Per la Mostra permanente della moderna ceramica italiana d'arte', in *Faenza*, 1927, fascicule II-III, pp. 69-72.
G. Liverani, 'Per la Mostra permanente della moderna ceramica italiana d'arte', in *Faenza*, 1927, fascicule IV, pp. 92-93.
G. Marangoni, *Enciclopedia delle moderne arti decorative. Le arti del fuoco: ceramiche, vetri, vetrate*, Bergamo 1927.
G. Marangoni, *La III Mostra Internazionale delle Arti Decorative nella Villa Reale di Monza. Notizie, rilievi, risultati*, Bergamo 1927.
G. Marangoni, 'La III Mostra Biennale di Monza: sezione italiana', in *La Cultura Moderna*, 1927, fascicule X, pp. 577-588.
R. Papini, 'Le arti a Monza nel 1927. Gli Italiani', in *Emporium*, luglio 1927, pp. 14-32.
F. Reggiori, 'La terza Biennale delle Arti Decorative', in *Architettura e Arti Decorative*, 1927, pp. 300-318.

1928
'Le ceramiche Mengaroni all'Esposizione di Torino', in *La Casa Bella*, May 1928.
'Ceramiche Pandolfi', in *La Casa Bella*, July 1928.
'L'Esposizione Ceramica di Pesaro', in *La Casa Bella*, September 1928.
Esposizione Internazionale di Torino, exhibition catalogue, Turin 1928.
'Esposizione di Milano del concorso nazionale per l'ammobiliamento economico indetto dall'Opera Nazionale Dopolavoro', in *Domus*, November 1928.
'L'Esposizione Nazionale della Ceramica di Pesaro', in *Domus*, October 1928.
G. Guerrini, 'Il Padiglione dell'Ente Nazionale delle Piccole Industrie all'Esposizione di Torino', in *La Casa Bella*, October 1928.
A. Parini, 'La mostra piemontese dell'artigianato', in *La Casa Bella*, November 1928.
'Per la Mostra permanente della moderna ceramica italiana d'arte', in *Faenza*, 1928, fascicule VI, p. 144.
F. Sapori, *Domenico Baccarini e il suo cenacolo*, Faenza 1928.
F. Sapori, 'Le ceramiche Polidori', in *La Casa Bella*, November 1928, pp. 31-33.

1929
U. Ammirata, 'Elogio delle ceramiche di Richard-Ginori', in *Problemi d'arte attuale*, January-February 1929, pp. 70-77.
'L'arte della maiolica in Castelli', in *Corriere dei ceramisti*, 1929, pp. 173-181.
G. Ballardini, *Mastro Ferruccio Mengaroni maiolicaro di Pesaro*, Faenza 1929.
F. Bolaffi Kalifa, 'Craquelés della Fabbrica Reale di Copenhagen', in *Domus*, December 1929.
'La ceramica imolese', in *Le Arti Plastiche*, March 1929.
Ceramiche di Lenci, exhibition catalogue (presentation by U. Ojetti), Galleria Pesaro, Milan 1929.
'Le ceramiche di Lenci', in *La Casa Bella*, April 1929, pp. 29-32.
'Le ceramiche di Vietri sul Mare', in *Problemi d'arte attuale*, March 1929, pp. 136-139.
G. Chessa, 'Arturo Martini inventor di ceramiche', in *Domus*, August 1929.
'Concorso O.N. Dopolavoro, Enapi', in *Architettura e Arti Decorative*, July 1929.
C.A. Felice, 'Alcune ceramiche danesi, italiane, russe e tedesche', in *Domus*, July 1929.
R. Giolli, 'Saggi della ricostruzione. L'esempio della Richard-Ginori', in *Emporium*, Septmber 1929, pp. 149-162.
G.M., 'La nuova ceramica', in *La Casa Bella*, June 1929.
Mostra di trentatré artisti futuristi, Galleria Pesaro, Milan 1929.
'II Mostra Nazionale della Ceramica. Pesaro 1928', in *Corriere dei ceramisti*, 1929, pp. 269-275.
E. Paulucci, 'Una mostra d'arte del presepe a Torino', in *La Casa Bella*, February 1929.
E. Paulucci, 'Le nostre arti decorative alla mostra di Barcellona', in *La Casa Bella*, June 1929.
Soccorsa, 'Le ceramiche di Vietri sul Mare', in *Domus*, May 1929.
'Il soprammobile ceramico', in *La Casa Bella*, September 1929, pp. 21-24.

1930
Annuario Industrie della Ceramica e del Vetro, Milan 1930.
A.B., 'Richard Ginori e la nuova ceramica italiana', in *La Casa Bella*, December 1930, pp. 48-51.
A. Balsamo Stella, 'Vetri e ceramiche d'arte all'esposizione di Stoccolma', in *Domus*, November 1930.
T. Buzzi, 'Le ceramiche italiane all'Esposizione di Monza', in *Dedalo*, 1930 (vol.I), pp. 241-260.
A.F. Carto, *Arte decorativa 1930 all'Esposizione di Monza*, Milan 1930.
Catalogo ufficiale della IV Esposizione triennale internazionale delle arti decorative ed industriali moderne, maggio-ottobre 1930, Milan 1930.
'Ceramiche di Martini', in *La Casa Bella*, June 1930, pp. 48-49.
Ceramiche moderne d'arte Richard-Ginori, Milan 1930.
ENAPI, *L'Enapi alla IV Esposizione internazionale d'arte decorativa ed industriale moderna, Villa Reale di Monza*, Rom 1930.
C.A. Felice, *Arte decorativa 1930 all'Esposizione di Monza*, Milan 1930.
A. Guigoni, 'Ceramiche moderne', in *La Cultura Moderna*, September 1930, pp. 531-538.
'A Monza fra breve', in *La Casa Bella*, March 1930.
'Invito all'ornamento', in *La Casa Bella*, September 1930.
R. Pacini, 'La IV Triennale d'arti decorative a Monza', in *Emporium*, November 1930, pp. 259-276.
R. Papini, *Le arti d'oggi: architettura e arti decorative in Europa*, Milan-Rome 1930.
E. Paulucci, 'Monza 1930', in *La Casa Bella*, March 1930, pp. 35-38.
G. Ponti, 'La Biennale di Monza. I ceramisti', in *Le Arti Plastiche*, April 1930.
F. Reggiori, 'La Triennale di Monza. IV Mostra Internazionale delle Arti Decorative', in *Architettura e Arti Decorative*, July 1930.
'La Triennale d'Arte Decorativa', in *Lidel*, June 1930.

1931
Arte Decorativa. Settimana italiana di Atene, exhibition catalogue, 26 April-3 May 1931.
'Ceramiche Lenci', in *La Casa Bella*, November 1931.
C.A. Felice, 'Il Museo e la Scuola della Ceramica a Faenza', in *Domus*, May 1931.

Mostra dell'Istituto Superiore Industrie Artistiche della Villa Reale di Monza, Galleria Milano, Milan 1931.
U. Nebbia, 'Una mostra d'arte decorativa italiana ad Amsterdam', in *Emporium*, July 1931, pp. 54-58.

1932
ENAPI, *Il Fiera Nazionale dell'Artigianato. Catalogo illustrato ad uso dei commercianti*, Florence 1932.
'La Fiera dell'Artigianato in Firenze', in *Domus*, June 1932.
'Moderni rivestimenti di ceramica', in *Domus*, June 1932.
G. Ponti, 'Verso gli artisti', in *Domus*, November 1932.

1933
ENAPI, *Artigianato d'Italia. V Triennale. Sala dei modelli ordinata dall'ENAPI*, Milan 1933.
G. Baroni, 'Appunti sulle ceramiche italiane alla V Triennale di Milano', in *Industria del vetro*, 1933.
'Maioliche d'Albisola', in Domus, September 1933.
'Modelli di ceramiche, stoffe, mobili ed intarsi dell'artigianato', in *Domus*, September 1933.
'Modelli di produzioni artigiane di ceramiche, vetri, cuoi moderni', in *Domus*, October 1933.
'Modern Italian Ceramics. Some Examples from the Lenci Studios', in *The Studio*, October 1929, pp. 719-721.
R. Papini, 'La Quinta Triennale di Milano. Ispezione alle arti', in *Emporium*, December 1933, pp. 331-384.
A. Pica, *V Triennale di Milano. Catalogo ufficiale*, Milan 1933.
G. Ponti, *La casa all'italiana*, Milan 1933.
G. Ponti, 'Le ceramiche alla Triennale', in *Domus*, May 1933, pp. 233-235.
G. Ponti, 'Maioliche d'arte italiane', in *Domus*, June 1933.
G. Ponti, 'Caratteri delle arti decorative', in *Domus*, July 1933.
G. Ponti, 'Industrie italiane d'arte ceramica alla Triennale', in *Domus*, July 1933.
G. Ponti, 'Le ceramiche italiane alla Triennale', in *Domus*, August 1933, pp. 428-435.
'Nino Ernesto Strada: ceramica', in *La Casa Bella*, January 1933, p. 30.

1934
C. Albini, 'La tavola', in *Domus*, June 1934.

1935
T. Bouilhet, 'A proposito della Esposizione d'arte artigiana a Parigi', in *Domus*, July 1935.
'Carattere di ceramiche di oggi', in *Domus*, June 1935, p. 32.
'Ceramiche moderne italiane al Jeu de Paume', in *Domus*, June 1935.
'Wiener Werkstaette e Kunstgewerbeschule', in *Domus*, September 1935.

1936
'Alcune ceramiche d'arte (Tyra Lundgren)', in *Domus*, February 1936.
'Alcune ceramiche di Lenci alla VI Triennale', in *Domus*, June 1936.
'Carattere di alcune ceramiche olandesi', in *Domus*, September 1936, pp. 36-39.
'Un ceramista di Vienna (Powolny)', in *Domus*, May 1936.
ENAPI, *L'artigianato d'Italia alla VI Triennale di Milano*, Milan 1936.
C. Ettorre, *Come si dipinge la ceramica*, Torin 1936 (Il ed. 1954).
C.A. Felice, *Arti industriali d'oggi, Quaderni della Triennale*, Milan 1936.
R. Papini, 'Le arti a Milano nel 1936', in *Emporium*, August 1936, pp. 65-78.
G. Ponti, 'Disciplina delle produzioni d'arte', in *Domus*, August 1936.
A. Pica, *Guida alla VI Triennale,* exhibition catalogue, Milan 1936.
G. Ponti, 'La battaglia di Parigi', in *Domus*, October 1936, pp. 1-25.
G. Ponti, 'La "dimostrazione" della Germania alla Triennale', in *Domus*, September 1936, pp. 15-17.
G. Ponti, 'La sezione francese alla VI Triennale', in *Domus*, August 1936, pp. 30-37.
'La Richard-Ginori alla VI Triennale', in *Domus*, June 1936.
P. Torriano, 'L'arte decorativa alla Triennale milanese', in *L'illustrazione italiana*, June 1936.

1937
M. Albini, 'Arti decorative e della casa alla Esposizione 1937 a Parigi', in *Domus*, October 1937, pp. 10-16.
'Alcune ceramiche d'arte italiane presentate a Parigi', in *Domus*, June 1937, pp. 17-19.
ENAPI, 'Ceramiche liguri (Albisola)', in *Cataloghi dell'Artigianato Italiano*, Rome 1937.
ENAPI, 'Ceramiche delle provincie meridionali', in *Cataloghi dell'Artigianato Italiano*, Rome 1937.
ENAPI, 'Ceramiche venete (Nove e Vicenza)', in *Cataloghi dell'Artigianato Italiano*, Rome 1937.
'VII Mostra-mercato nazionale dell'artigianato di Firenze. Le ceramiche', in *Domus*, July 1937, pp. 10-16.
F. Pasqui, 'Scuole d'arte in Italia', in *Quaderni della Triennale*, Milan 1937.
G. Ponti, 'Tyra Lundgren a Parigi', in *Domus*, June 1937, pp. 21-23.

1938
'L'artigianato alla mostra di Firenze', in *Domus*, July 1938, pp. 1-27.
E. Baumbach, *Le sculpteur Lucio Fontana, un essai analitique*, Campografico 1938.
ENAPI, 'Ceramiche di Faenza', in *Cataloghi dell'Artigianato Italiano*, Rome 1938.
'L'Italia a Buenos Aires', in Domus, December 1938.
'Lundgreen', in *Domus*, September 1938.
G. Pagano, *Arte decorativa italiana, Quaderni della Triennale*, Milan 1938.
E. Robiola, 'Ceramiche di Colette Gueden', in *Domus*, May 1938.

1939
F.T. Marinetti, T. D'Albisola, *La ceramica futurista*, Savona 1939.
A. Minghetti, *Enciclopedia Biografica e Bibliografica Italiana. Ceramisti*, Milan 1939.
G. Ponti, 'L'Artigianato alla IX Mostra nazionale di Firenze', in *Domus* July 1939, pp. 33-41.
G. Ponti, 'Per la VII Triennale', in *Domus*, September 1939.
G. Ponti, 'Collaborazione tra artisti e produzione', in *Domus*, November 1939.

1940
G. Baitello, *La Scuola d'Arte di Castelli*, Castelli 1940.
F. Carnevali, 'L'Enapi alla VII Triennale', in *Domus*, July 1940.
'Ceramiche di Laveno alla Triennale', in *Domus*, May 1940, pp. 38-43.
'Ceramiche di Deruta', in *Domus*, July 1940, pp. 64-65.
'Ceramiche di Leo Ravazzi', in *Domus*, December 1940, pp. 96-98.
'Ceramiche di Zaccagnini alla Triennale', in *Domus*, June 1940, pp. 88-90.
ENAPI, *VII Esposizione Internazionale delle arti decorative e industriali moderne*, exhibition catalogue, Milan 1940.
'Fantasie di Albisola', in *Domus*, May 1940, pp. 34-37.
R. Papini, 'Le arti a Milano nell'anno XVIII', in *Emporium*, May 1940, pp. 211-219
VII Triennale di Milano. Guida, exhibition catalogue, Milan 1940.
G.P., 'Richard-Ginori o della finezza', in *Domus*, June 1940, pp. 46-51.
G. Ponti, 'La VII Triennale: il grande sforzo dell'arte italiana per la riconquista del suo posto nel mondo', in *Domus*, April 1940.
L. Sinisgalli, 'Due giovani ceramisti', in *Domus*, July 1940.

1941
'Ceramiche italiane', in *Domus*, December 1941.
'Ceramiche moderne', in *Domus*, May 1941, pp. 56-59.
'Domus vi offre sempre nuovi suggerimenti', in *Domus*, July 1941.
C.A. Felice, 'Contro la produzione fittizia', in *Domus*, June 1941.
G. Liverani, *Il Regio Istituto per la Ceramica di Faenza*, Florence 1941.
'Scelta da Richard-Ginori', in *Stile*, September 1941.
'Stile della Manifattura Richard-Ginori di Doccia', in *Stile*, April 1941.
G.R., 'Un esempio (Castelli)', in *Domus*, December 1941.
G. Tramonti, 'Rassegna del III Concorso Nazionale della Ceramica d'Arte a Faenza', in *Domus*, September 1941, pp. 28-30.

1942
C.A. Felice, 'Verso il ventennio della Triennale', in *Stile*, March 1942, pp. 38-41.
'Fancello a Brera', in *Stile*, June 1942, p. 42.
'Gusto di Richard-Ginori', in *Stile*, October 1942, pp. 51-57.
M. Labò, 'Le ceramiche di Fancello', in *Domus*, April 1942, pp. 208-216.
Mostra retrospettiva del pittore Giovanni Grande (1887-1937), Turin 1942.
G. Pagano, N. Bertocchi, 'Salvatore Fancello', in *Domus*, March 1942, pp. 122-134.
'I pezzi preziosi di Doccia', in *Stile*, June 1942, pp. 50-58.
G. Ponti, 'La ceramica, un settore dell'avvenire del popolo italiano', in *Stile*, April 1942, pp. 40-41.
'Ricordo di Fancello', in *Stile*, February 1942, pp. 37-39.
G. Ponti, 'Maioliche italiane a Faenza', in *Stile*, November 1942, pp. 27-31.

1945
G. Polidori, 'Ferruccio Mengaroni', in *Faenza*, 1945, fascicule III-IV, pp. 70-73.

1947
Ottava Triennale di Milano. Esposizione internazionale delle arti decorative e industriali moderne e dell'architettura moderna, Catalogo-guida, Milan 1947.

1948
Tullio d'Albisola, 'Conversazione sulla ceramica moderna italiana e francese', in *Faenza*, 1948, fascicule I, pp. 17-19.

1954
Opere di A. Biagini, exhibition catalogue, Rome 1954.
R. Longhi (edited by), *Leoncillo Leonardi*, Rome 1954.

1957
G.C. Bojani, 'Fonti delle ceramiche Minardi a Faenza e l'Aemilia Ars', in F. Solmi, *La società attraente. Cooperazione e cultura in Emilia Romagna*, Bologna 1957.
U. Folliero (edited by), *Cinquanta ceramisti italiani 1952-1957*, Milan 1957.
G. Morazzoni, *La terraglia italiana 1856-1956*, Milan 1957.
A. Pica, *Storia della Triennale di Milano 1918-1957*, Milan 1957.

1960
Otto Maraini, exhibition catalogue, Turin 1960.
G. Morazzoni, *Le porcellane italiane*, Milan 1960.

1963
C. Barile, *Arturo Martini ceramista*, Savona 1963.
L. Ginori Lisci, *La porcellana di Doccia*, Milan 1963.

1964
R. Barilli, *Il Liberty*, Milan 1966.
I. Cremona, *Il tempo dell'Art Nouveau*, Florence 1964.
M. Korach, 'Gaetano Ballardini', in *Faenza*, n. 4-5, 1964.
G. Vianello, *Galileo Chini e il Liberty in Italia*, Florence 1964.

1965
Lino Berzoini, exhibition catalogue, Turin 1965.
1966
G. Perocco (edited by), *Arturo Martini: catalogo delle sculture e delle ceramiche,* Venice 1966.
1967
V. Brosio, *Lo stile Liberty*, Milan 1967.
G. Liverani, *Il Museo delle porcellane di Doccia,* Florence 1967.
G. Mazzotti, *Arturo Martini:* exhibition catalogue, Treviso 1967.
1968
R. Bossaglia, *Il Liberty in Italia*, Milano 1968.
G. Marchiori, G.B. Gardin, *I Cadorin*, Florence 1968.
Mostra di Guido Cadorin: opere dal 1910 al 1968, exhibition catalogue, Venice 1968.
1969
G. Carandente (edited by), *Leoncillo Leonardi. Spoleto 1915 – Roma 1968,* exhibition catalogue, Bologna 1969.
Mostra di Achille Calzi nel cinquantenario della morte, Faenza 1969.
1971
M. Azzolini, *Nonni*, Bologna 1971.
C. Marsan (edited by), *Galileo Chini,* exhibition catalogue, Florence 1971.
Nadir Stringa (edited by), *Giovanni Petucco pittore e ceramista*, Nove 1971.
1972
V. Brosio, *Dortù, Tinelli, Richard, porcellane e maioliche dell'800 a Torino e Milano,* Milano 1972.
Il Liberty italiano, exhibition catalogue, Milan 1972.
M. Korach, 'La porcellana di Castelli', in *Faenza* 1972, n. 2, pp. 44-48.
1973
E. Bairati, R. Bossaglia, M. Rosci, *L'Italia Liberty*, Milan 1973.
U. Baldini, *Marcello Fantoni. Opere dal 1927 al 1973,* Florence 1973.
E. Biavati, 'I Richard, potenziatori di fabbriche ceramiche dal 1822', in *Faenza* 1973, n. 1, pp. 16-22.
1974
R. Bossaglia, *Il Liberty, storia e fortuna del Liberty italiano*, Florence 1974.
C. Marsan, T. Paloscia, C. Cresti, *Galileo Chini,* exhibition catalogue, Salsomaggiore 1974.
Mostra permanente Adolfo De Carolis, exhibition catalogue, Milan 1974.
1975
R. Bossaglia, *Il Déco italiano: fisionomia dello stile 1925 in Italia*, Milan 1975.
G. Massobrio, P. Portoghesi, *Album del Liberty*, Bari 1975.
1976
G.C. Bojani, 'Le ceramiche di Francesco Nonni: una ricognizione negli Anni Venti', in *Faenza,* n. V-VI, pp. 118-123.
P. Frattani, R. Badas, *50 anni di arte decorativa e artigianato in Italia, l'ENAPI dal 1925 al 1975,* Rome 1976.

G. Liverani, 'Ricordo di Maurizio Korach', in *Faenza* 1976, n. 2, pp. 38-40.
L.V. Masini, *Art Nouveau,* Florence 1976.
G. Massobrio, P. Portoghesi, *Album del Liberty*, Bari 1976.
G. Massobrio, P. Portoghesi, *Album degli anni Venti*, Bari 1976.
R. Monti (edited by), *Mostra di Libero Andreotti,* Florence 1976.
M. Rosci, *Arte applicata, arredamento, design, in Torino 1920-1936,* Turin 1976.
1977
G.C. Bojani, *Ceramica Liberty Faentina,* Faenza 1977.
G.C. Bojani, *L'opera di Gio Ponti alla Manifattura di Doccia della Richard-Ginori,* Faenza 1977.
E. Contini (edited by), *Il Liberty a Bologna e nell'Emilia Romagna,* exhibition catalogue, Bologna 1977.
E. Golfieri, *Selezione di opere di Pietro Melandri (1885-1976),* Faenza 1977.
C. Nuzzi, *Galileo Chini,* exhibition catalogue, Florence 1977.
1978
R. Binaghi, *Le ceramiche Lenci, in Torino tra le due guerre,* exhibition catalogue, Turin 1978.
Ceramiche italiane 1920-1950, exhibition catalogue,, Galleria Milano, Milan 1978.
J.V.G. Mallet, 'Storico e storicismo: Fortnum, Cantagalli e Castellani', in *Faenza* 1978, n. 2, pp. 37-41.
A. Pansera, *Storia e cronaca della Triennale,* Milan 1978.
Torino tra le due guerre, exhibition catalogue, Turin 1978.
G. Veronesi, *Stile 1925 ascesa e caduta delle Arts Déco,* Florence 1978.
1979
R. Bossaglia, *Il Novecento italiano*, Milan 1979.
G. Cefariello Grosso (edited by), *La Manifattura Chini: dall'arte della ceramica alle Fornaci di S. Lorenzo,* exhibition catalogue, Florence 1979.
G. Cefariello Grosso, 'La manifattura Chini al Palazzo delle Esposizioni di Faenza', in *Faenza* 1979, n. 5, pp. 156-159.
E. Golfieri, *Pietro Melandri ceramista, pittore, plasticatore,* Faenza 1979.
L. Proverbio, *Lenci-Le ceramiche 1919-1937,* Turin 1979.
1980
Arte e immagine tra Ottocento e Novecento. Pesaro e provincia, Urbino 1980.
Angelo Biancini, mostra antologica, Milan 1980.
R. Bossaglia, *Arti applicate e decorative, in La Metafisica: gli anni Venti,* exhibition catalogue, Bologna 1980.
G. Cefariello Grosso, 'Note su problemi tecnici relativi alla Ceramica Chini: lettere di Bernardino Papi a Galileo Chini', in *Faenza*, 1981, n. 1-6.
Nadir Stringa, 'La ceramica', in *Storia di Bassano,* Bassano del Grappa 1980.

1981
G.C. Bojani, *Golia. Ceramiche degli Anni Venti,* exhibition catalogue, Florence 1981.
R. Bossaglia, M. Quesada (edited by), *A. Terzi,* exhibition catalogue, Rome 1981.
Rodolfo Ceccaroni. Ceramiche degli anni Venti, exhibition catalogue, Florence 1981.
G. Cefariello Grosso, 'Note su problemi tecnici relativi alla Ceramica Chini: lettere di Bernardino Papi a Galileo Chini', in *Faenza*, 1981, n. 1-6.
E. Crispolti (edited by), *La terra, la forma, le cose. La ceramica di Castellamonte,* Turin 1981.
Il Liberty italiano e ticinese, exhibition catalogue, Lugano, Rome 1981.
R. Monti (edited by), *Galileo Chini,* exhibition catalogue, Florence 1981.
1982
Annitrenta. Arte e cultura in Italia, exhibition catalogue, Milan 1982.
F. Benzi, A.M. Damigella, *Galileo Chini. Pittore e decoratore,* exhibition catalogue, Rome 1982.
G.C. Bojani, 'Ceramiche anni Venti: Ceccaroni e Golia', in *Faenza* 1982, n. 1-2, pp. 86-89.
Duilio Cambellotti, exhibition catalogue, Rome 1982.
G. Cefariello Grosso, *Ceramica Chini per l'architettura e l'ebanisteria,* exhibition catalogue, Florence 1982.
E. Crispolti (edited by), *La ceramica futurista da Balla a Tullio D'Albisola,* exhibition catalogue, Florence 1982.
S. Dirani, G. Vitali, Fabbriche di maioliche a Faenza dal 1900 al 1945, Faenza 1982.
Mostra della ceramica italiana 1920-40, exhibition catalogue, Turin 1982.
T. Préaud, S. Gauthier, *La céramique art du XX siècle,* Fribourg 1982.
P. Portoghesi, A. Pansera, *Gio Ponti alla manifattura di Doccia,* exhibition catalogue, Milan 1982.
M. Quesada, *Aleardo Terzi tra liberty e déco,* Palermo 1982.
C. Venturini, *36 incontri. Manifatture e ceramisti italiani 1900-1960,* Milan 1982.
1983
Domenico Baccarini 1882-1907, exhibition catalogue, Faenza 1983.
F. Benzi, 'Alfredo Biagini', in *Gli artisti di Villa Strohl-Fern tra Simbolismo e Novecento,* L. Stefanelli Torossi (edited by), Rome 1983.
Le ceramiche Lenci. Gli artisti-I secessionisti, exhibition catalogue, Milano 1983.
Leoncillo, exhibition catalogue, Casalecchio di Reno 1983.
Il Novecento italiano 1923-1933, exhibition catalogue, Milan 1983.
Gio Ponti. Ceramiche 1923-1930. Le opere del Museo di Doccia, Milan 1983.
F.M. Rosso, *Per virtù del fuoco. Uomi-

ni e ceramiche del Novecento italiano,* Aosta 1983.
Satolli, *La ceramica orvietana degli anni Venti,* exhibition catalogue, Florence 1983.
C. Spadoni, *Leoncillo,* Rome 1983.
Nadir Stringa, *Andrea Parini. Ceramiche 1935-1970,* exhibition catalogue, Nove 1983.
1984
Le Arti a Vienna, Venice 1984.
A. Caròla-Perrotti, G. Donatone, C. Ruju, *Porcellane e terraglie a Napoli dal tardo Barocco al Liberty,* Naples 1984.
G. Cefariello Grosso, R. Monti, *Rinnovando rinnoviamoci. Ceramiche Chini 1896-1925,* exhibition catalogue, Florence 1984.
Chessa, Da Milano, Levi, Menzio, exhibition catalogue, Turin 1984.
G. Cosi, R. Fiorini, Ceramica e riviste italiane dal 1895 al 1930, Faenza 1984.
Teonesto Deabate tra pittura e architettura, exhibition catalogue, Turin 1984.
Vittorio Grassi (1878-1958), exhibition catalogue 1984.
Il sogno del principe, Il Museo Artistico Industriale di Napoli: la ceramica tra otto e novecento, exhibition catalogue, Florence 1984.
1985
G.C. Bojani, V. Fagone (edited by), *Scultura e ceramica nell'arte italiana del XX secolo,* exhibition catalogue, Bologna 1985.
A. Caròla-Perrotti, C. Ruju, *Ceramiche del Museo Artistico Industriale di Napoli. 1920-1950,* exhibition catalogue, Florence 1985.
La ceramica ungherese della Szecessziò, exhibition catalogue, Florence 1985.
I. Cerutti (edited by), *Arti decorative del Novecento,* Novara 1985.
G. Cortenova, *Leoncillo: la metafora della materia,* exhibition catalogue, Milan 1985.
Da Milano, exhibition catalogue, Turin 1985.
V. Fagone, *Ceramica Florio,* Palermo 1985.
I. de Guttry, M.P. Maino, M. Quesada, *Le arti minori d'autore in Italia dal 1900 al 1930,* Bari 1985.
L. Gallina, S. Sandini, *Terraglie di Laveno,* Gavirate 1985.
A. Pansera, 'Il caso Lenci', in *Faenza,* 1985, n. 4-6, pp. 325-337.
A.M. Ruta, *Arredi futuristi. Episodi delle case d'arte futuriste italiane,* Palermo 1985.
G. Vianello (edited by), *Arturo Martini. Terrecotte e Ceramiche,* exhibition catalogue, Milan 1985.
1986
G.C. Bojani (edited by), Francesco Nonni. *Ceramiche degli anni Venti,* Florence 1986.
R. Bossaglia (edited by), *L'ISIA a Mon-

za. Una scuola d'arte europea, Cinisello Balsamo 1986.
G. Cortenova, E. Mascelloni, *Cagli e Leoncillo alle ceramiche Rometti*, exhibition catalogue, Milan 1986.
E. Crispolti, *Fontana*, general catalogue, Milan 1986.
Riccardo Gatti ceramista, scultore, pittore, Faenza 1986.
F. Solmi (edited by), *Momenti del Liberty in Italia*, exhibition catalogue, Correggio 1986.
Nadir e Nico Stringa, *Terre d'arte. Manifatture e opere di ceramisti veneti dal 1930 ad oggi*, Venice 1986.
1987
F. Benzi, G. Cefariello Grosso, G. Cordoni, *Galileo Chini 1873-1956*, exhibition catalogue, Milan 1987.
G.C. Bojani (edited by), *Riccardo Gatti (1886-1972) Ceramiche*, exhibition catalogue, Faenza 1987.
G.C. Bojani (edited by), *Gio Ponti ceramica e architettura*, Florence 1987.
Gigi Chessa 1898-1935, exhibition catalogue, Milan 1987.
L. Marziano (edited by), *Omaggio ad Aldo Ajò*, Gubbio 1987.
Mostra di opere d'arte di Giuseppe Piombanti Ammannati, Grassina 1987.
Gio Ponti. Arte applicata, exhibition catalogue, Milan 1987.
D. Presotto (edited by), *Lettere di Lucio Fontana a Tullio D'Albisola, 1936-1962*, Savona 1987.
M. Quesada, *Domenico Rambelli (1886-1972). Disegni e sculture*, exhibition catalogue, Rome 1987.
L. Stefanelli Torossi, *Pietro Melandri 1885-1976*, exhibition catalogue, Rome 1987.
Nadir Stringa (edited by), *Omaggio a Bassano e Nove*, exhibition catalogue, Monte San Savino 1987.
Nico Stringa, 'L'arte decorativa alle mostre di Ca' Pesaro', in *Venezia, gli anni di Ca' Pesaro*, exhibition catalogue, Milan 1987.
Nico Stringa, *Terre Ferme. Ceramiche del '900 a Venezia e provincia*, exhibition catalogue, Venice 1987.
1988
F. Benzi, G. Cefariello Grosso, *Galileo Chini, Dipinti. Decorazioni. Ceramiche. Opere 1895-1952*, exhibition catalogue, Florence 1988.
Lino Berzoini, exhibition catalogue, Savona 1988.
G.C. Bojani (edited by), *Scultori italiani negli anni Trenta. Forme e miti tra città e provincia*, Faenza 1988.
G. Cefariello Grosso, E. Maggini Catarsi, R. Monti (edited by), *La manifattura Richard-Ginori di Doccia*, Milan-Rome 1988.
M. De Micheli, *Aligi Sassu. Ceramiche*, Florence 1988.
Salvatore Fancello, Nuoro, 1988.
F. Marzinot, *Omaggio a Torido*, Albisola 1988.
A. Pansera, C. Venturini, *Enrico Mazzolani. 26 opere in maiolica e terracotta*, exhibition catalogue, Faenza 1988.
E. Pélichet, *La céramique Art Déco*, Losanna 1988.
M. Quesada (edited by), *Duilio Cambellotti e la ceramica a Roma dal 1900 al 1935*, exhibition catalogue, Firenze 1988.
S. Riolfo Marengo, *Agenore Fabbri: 1929-1988*, Savona 1988.
G. Vecchi, *Maurizio Korach nel centenario della nascita, 1888-1988*, Faenza 1988.
1989
G. Altea, M. Magnani, *Nino Siglienti. Un artista déco e la sua bottega*, exhibition catalogue, Sassari 1989.
G.C. Bojani (edited by), *Piero Ceccaroni: dipinti su ceramica*, Recanati, 1989.
G.C. Bojani, M.G. Morganti, *Domenico Rambelli e la ceramica alla Scuola di Faenza dal 1919 al 1944*, Florence 1989.
R. Bossaglia, *Francesco Ciusa*, Nuoro 1989.
Anselmo Bucci e la ceramica d'atelier, Florence 1989.
P.G. Castagnoli, F. D'Amico, F. Gualdoni (edited by), *Scultura e ceramica in Italia nel Novecento*, exhibition catalogue, Milan 1989.
Le ceramiche di Grottaglie, la cultura delle mani, Taranto 1989.
Ilario Ciaurro 1889-1989, Un secolo d'arte, exhibition catalogue, Terni 1989.
G. Cortenova (edited by), *Corrado Cagli*, exhibition catalogue, Rome 1989.
A. Cuccu, *Studio Artistico Melkiorre Melis*, Bosa 1989.
Il giovane Arturo Martini: opere dal 1905 al 1921, exhibition catalogue, Rome 1989.
G. Mazzotti, *Scritti su Arturo Martini (1931-1980)*, Albisola 1989.
Francesco Messina, (edited by) M. Fagiolo dell'Arco, Milan 1989.
R. Monti (edited by), *La Manifattura Chini*, Rome-Milan 1989.
G. Napolitano, 'Guido Gambone alla Ceramica Avallone di Vietri sul Mare', in *Faenza* 1989, n. 4-6, pp. 254-260.
A. Pansera, C. Venturini, *Enrico Mazzolani. Donne di maiolica e non*, Milan 1989.
Nico Stringa, G. Perocco, *Il giovane Arturo Martini*, Rome 1989.
1990
E. Alamaro (edited by), *Il ritorno del Principe. Aspetti ed oggetti nelle foto delle Scuole-Officine del Museo Artistico Industriale di Napoli (1895-1924)*, Napoli 1990.
E. Bairati, D. Riva, *Il Liberty in Italia*, Rome-Bari 1990.
F. Bertoni, O. Ghetti Baldi, *Giovanni Guerrini 1887-1972*, exhibition catalogue, Faenza 1990.
R. Bossaglia, M.P. Marzocchi, G. Pesci, V. Vandelli, *Il Liberty in Emilia*, Modena 1988.
F. Capetta, G.G. Cefariello Grosso, S. Gentili, M.P. Mannini, *La ceramica sestese*, exhibition catalogue, Firenze 1990.
P.G. Castagnoli, Fabrizio D'Amico, F. Gualdoni, *Duilio Cambellotti. L'officina dell'ambiente*, exhibition catalogue, Milan 1990.
G. Cefariello Grosso, 'Alcune osservazioni sui rapporti tra la ceramica e la scultura italiana del nostro secolo', in *Faenza*, 1990, n. 1-2, pp. 63-68.
G. Cefariello Grosso, *Vetri e ceramiche lungo l'Africo: Chini e Polloni. Arte e arte applicata nel Liberty fiorentino*, exhibition catalogue, Milan 1990.
G. Conti, G. Cefariello Grosso, *La maiolica Cantagalli e le manifatture ceramiche fiorentine*, Rome 1990.
E. Crispolti, *Fontana ceramista in Albisola, gli artisti e la ceramica*, Savona 1990.
E. Crispolti,' La poliedricità di Tullio', in *Albisola. Gli artisti e le ceramiche*, F. Di Tiglio (edited by), Savona 1990.
Domenico Rambelli, Cetona 1990.
Elena (Lenci) König Scavini, *Una bambola e altre creazioni*, Turin 1990.
M.M. Lamberti (a cura di), *Mario Sturani 1906-1978*, Turin 1990.
E. Mascelloni (edited by), *Leoncillo: mostra antologica*, catalogue, Rome 1990.
M. Mimita Lamberti, *Mario Sturani 1906-1978*, Turin 1990.
M. Munari, *Guido Andlovitz. Ceramiche di Laveno 1923-1942*, Rome 1990.
A.M. Nalini, *Futurismo in Emilia Romagna*, exhibition catalogue, Modena 1990.
G. Napolitano, 'Il profilo del periodo tedesco (1925-1947) della ceramica vietrese attraverso la critica del tempo', in *Faenza* 1990, n. 3-4, pp. 126-131.
A. Panzetta, *Felice Tosalli 1883-1958*, Turin 1990.
1991
E. Alamaro, F. Donato, *Gambone. La leggenda della ceramica*, Naples 1991.
G.C. Bojani, *Achille Calzi. Ceramiche 1918-1919*, Faenza 1991.
G.C. Bojani, 'Irene Kowaliska (Varsavia 1905 – Rome 1991)', in *Faenza* 1991, n. 5, pp. 241-244.
G.C. Bojani, *Leonardo Castellani. Ceramiche degli anni Venti*, Faenza 1991.
P.G. Castagnoli (edited by), *Lucio Fontana: la scultura in ceramica*, exhibition catalogue, Milan 1991.
A. Cuccu (edited by), *Irene Kowaliska*, Ilisso, Nuoro 1991.
S. Dirani, *Anselmo Bucci: dall'interpretazione alla reinvenzione*, Faenza 1991.
Leoncillo, exhibition catalogue, Parma 1991.
E. Longo, 'La ceramica di Vietri nella collezione Cambellotti', in *Faenza* 1991, n. 3-4, pp. 188-190.
Fausto Melotti. Opere in ceramica anni '50, exhibition catalogue, Galleria L'Eroica, Milan 1991.
A. Mingotti, 'Arrigo Visani 1914-1987', in *Faenza* 1991, n. 1-2, pp. 42-51.
A. Reggiori, A. Pozzi, *Terra & Terra 5: Agenore Fabbri*, Laveno Mombello 1991.
F.M. Rosso, *Lenci. Ceramiche e disegni*, auction catalogue, Milan 1991.
1992
E. Alamaro, F. Donato, *Irene Kowaliska. Un'artista una donna un mito*, Naples 1992.
G.C. Bojani, *Ceramiche umbre 1900-1940*, exhibition catalogue, Perugia 1992.
G. Cefariello Grosso, *Ceramiche del 'Modern style'*, Florence 1992.
G. Celant, I. Gianelli, A. Soldaini, *Melotti: catalogo generale*, Milan 1992.
'Ceramiche umbre 1900-1940', in *CeramicAntica* 1992, n. 5, pp. 26-28.
A. Contini, *Giovanni Prini*, Genoa 1992.
A. Panzetta, *Le ceramiche Lenci 1928-1964*, Turin 1992.
A. Panzetta, *Felice Tosalli. Legni e ceramiche*, exhibition catalogue, Saluzzo 1992.
M. Quesada, *Forme colori miti. Ceramica a Roma 1912-1932*, exhibition catalogue, Venice 1992.
A.R. Savini, *I faentini ceramisti*, Faenza 1992.
L. Scardino, 'Un enorme fregio ceramico di Cesare Laurenti tra revival e Liberty', in *CeramicAntica* 1992, n. 4, pp. 34-49.
1993
Cesare Andreoni e il futurismo a Milano tra le due guerre, exhibition catalogue, Milan 1993.
E. Biffi Gentili, *Guido Andlovitz. La Commedia Ceramica*, exhibition catalogue, Laveno 1993.
G.C. Bojani (edited by), *Angelo Biancini tra Faenza e Laveno. Ceramiche 1937-1940*, Florence 1993.
O. Casarza, R. Monti, V. Sgarbi, *Libero Andreotti*, Casalecchio di Reno 1993.
G. Cefariello Grosso, 'Alcune osservazioni sui rapporti tra la ceramica e la scultura italiana del nostro secolo', in *Faenza*, 1993, n. 5, pp. 196-200.
G. Cefariello Grosso (edited by), *I. Chini a Borgo San Lorenzo. Storia e produzione di una manifattura mugellana*, Florence 1993.
G. Di Genova, *Giannetto Malmerendi 1893-1968*, exhibition catalogue, Cesena 1993.
C. Gian Ferrari, *Arturo Martini*, exhibition catalogue, Milan 1993.
M. Lipparini, *Remo Fabbri 1890-1977: pittore, affreschista, ceramista*, exhibition catalogue, Cento 1993.
E. Longo, 'Ceramiche popolari siciliane, calabresi e pugliesi nella collezione Cambellotti', in *Faenza*, 1993 n. 3-4, pp. 141-149.
1994
N. Barberini, M. Conti, *Ceramiche Artistiche Minghetti*, Bologna 1994.
R. Bossaglia, E. Godoli, M. Rosci, *Tori-*

no 1902. Le arti decorative internazionali del nuovo secolo, exhibition catalogue, Milan 1994.
P. Campiglio, 'Io sono uno scultore non un ceramista: la ceramica di Lucio Fontana nella seconda metà degli anni Trenta', in Faenza 1994, n. 1-2.
V. Cappelli, N. Soldani, Storia dell'Istituto d'Arte di Firenze (1869-1989), Florence 1994.
C. Caserta, Il Novecento della ceramica a Vietri sul Mare, Salerno 1994.
C. Caserta, 'Il periodo tedesco della ceramica vietrese: appunti da Dölker a Gambone della I.C.A.', in CeramicAntica, 1994, n. 2, p. 28.
G. Celant, Melotti. Catalogo generale delle sculture e dei bassorilievi, Milan 1994.
G. Gardelli, 'La ceramica di Leonardo Castellani', in L'opera artistica e letteraria di Leonardo Castellani, F. e G. De Santi (edited by), Teramo 1994.
Manifattura Egisto Fantechi: modelli, materiali e documenti di un ceramista sestese, 1896-1940, exhibition catalogue, Florence 1994.
M. Massaioli, Arturo Martini a Faenza, Rome 1994.
A. Mingotti, Angelo Biancini. Le forme della scultura, Castel Bolognese 1994.
G. Musumeci, L. Paoli, Laveno e le sue ceramiche: oltre un secolo di storia, Laveno 1994.
A. Panzetta, Dizionario degli scultori italiani dell'Ottocento e del primo Novecento, Turin 1994.
C. Ravanelli Guidotti, La Società Ceramica di Imola. Centovent'anni di opere, Milan 1994.
M. Romito (edited by), Il Museo della Ceramica Raito di Vietri sul Mare, Salerno 1994.
A. Satolli, 'Ricordo di Ilario Ciaurro', in Faenza, 1994, n. 1-2.
Nadir Stringa, 'Un nuovo percorso espositivo ed artistico: il museo della ceramica di Nove', in CeramicAntica, 1994, n. 11.
L. Zaccagnini, 'Gli Zaccagnini e il Museo Stibbert', in Faenza 1994, n. 5-6, pp. 258-262.

1995
Venezia e la Biennale. I percorsi del gusto, Milan 1995.
G. Altea, M. Magnani, Storia dell'arte in Sardegna. Pittura e scultura del primo '900, Nuoro 1995.
M. Amari, 'Le arti decorative a Milano: dall'artista-artigiano all'architetto-designer', in Arte a Milano 1906-1929, Milan 1996.
D. Amoni, 'La rinascita del lustro su maioliche di grande tradizione: la ceramica a riflessi di Gualdo Tadino', in CeramicAntica 1995, n. 1, pp. 50-59.
G.C. Bojani, 'Maestri contemporanei della ceramica: il fiorentino Marcello Fantoni', in Faenza, 1995, n. 1-2, pp. 1-53.
G.C. Bojani, T. Seppilli, La tradizione ceramica in Umbria. Deruta, Gualdo Tadino, Gubbio, Orvieto. Dall'antichità al '900, Perugia 1995.
R. Bossaglia, E. Biffi Gentili, M. De Grassi, Guido Andlovitz, exhibition catalogue, Grado 1995.
C. Chilosi, L. Ughetto, La ceramica del Novecento in Liguria, Genoa 1995.
A. Cimatti, 'Gli inizi: Rambelli e Bucci', in A. Cimatti, C .Fiocco, G. Gherardi, La scuola dei maestri, Faenza 1995.
D. Ferrari, E. Mascelloni, Leoncillo: opere 1938-1952, Milan 1995.
U. La Pietra (edited by), Gio Ponti, Milan 1995.
R. Monti ((edited by), Il divisionismo toscano, exhibition catalogue, Livorno, 1995.
G. Napolitano, 'Ceramica vietrese 1924-1954', in Gli spazi della ceramica, exhibition catalogue, Naples 1995.
A. Pansera (edited by), Novecento da collezione, Milan 1995.
Nico Stringa, 'La presenza della ceramica alle prime Biennali di Venezia', in CeramicAntica 1995, n. 1, pp. 6-13.

1996
E. Alamaro, 'Morte di un ceramista: Andrea D'Arienzo 1911-1995', in Faenza, 1996, n. 1-3, pp. 53-60.
M. Bignardi(edited by), Salvatore Procida. Il racconto delle mani, exhibition catalogue, Napoli 1996.
Riccardo Dölker. Soggiorno italiano, Salerno 1996.
G. Ganzer, Nico Stringa (edited by), La Ceramica Galvani tra le due guerre. Forme e decori di Ruffo C. Giuntini e Angelo Simonetto, exhibition catalogue, Pordenone 1996.
Giardini, Pesaro, Museo delle Ceramiche, Bologna 1996.
E. Longo, 'Ricordo di Mario Quesada e una mostra su Hans Stoltenberg Lerche 1867-1920', in Faenza, 1996, n. 4-6, pp. 291-253.
C. Pirovano, Fausto Melotti: teatrini 1931-1985, exhibition catalogue, Milan 1996.
M. Quesada (edited by), Hans Stoltenbergh Lerche (1865-1920): sculture, disegni, vetri, ceramiche, exhibition catalogue, Venice 1996.
M. Romito, La Collezione Di Marino, Salerno 1996.
M. Tittarelli Rubboli, La maiolica Rubboli a Gualdo Tadino, Perugia 1996.
P. Viscusi, Lo Stile Vietri tra Dölker e Gambone, Salerno 1996.

1997
G.C. Bojani (edited by), Fatti di ceramica nelle Marche. Dal Trecento al Novecento, Milan 1997.
L. Caramel, La ceramica degli artisti, Rome 1997.
A. Carola-Perrotti, 'Le porcellane SI-MAC di Castelli d'Abruzzo 1920-1938', in CeramicAntica 1997, n. 8, pp. 6-9.
M.L. Ferru, M. Marini, Federico Melis. Una vita per la ceramica, Cagliari 1997.
L. Leopardi, Maiolica metaurense 1800-1940, Urbania 1997.
V. Pinto, Giovannino, ceramista vietrese, Salerno 1997.
La porcellana di Castelli. Giovanni Fuschi e la SIMAC, exhibition catalogue, Castelli 1997.
S. Ragionieri, C. Frulli, Enzo Ceccherini, 1894-1971: dipinti, disegni, ceramiche, exhibition catalogue, Sesto Fiorentino 1997.

1998
L. Arbace, Il Museo Artistico Industriale di Napoli, Naples 1998.
R. Ausenda, 'Il risorgimento della ceramica lombarda', in V. Terraroli, Le arti decorative, in Lombardia nell'età moderna 1780-1940, Milan 1998.
R. Ausenda, G.C. Bojani (edited by), La ceramica dell'Ottocento nel Veneto e in Emilia Romagna, Modena 1998.
F. Benzi (edited by), La casa delle vacanze. Galileo Chini opere 1900-1950, exhibition catalogue, Firenze-Siena 1998.
G.C. Bojani, 'Enrico Mazzolani; Senigallia a Faenza, scultura e maiolica', in Faenza, 1998, n. 4-6, pp. 387-389.
G.C. Bojani, Introduzione al XX secolo: una ceramica fra tradizione e creatività, Perugia 1998.
G. Busti, F. Cocchi, La Fabbrica Grande. Ceramiche della Società Maioliche Deruta dal 1920 al 1950, exhibition catalogue, Perugia 1998.
'Ceramica d'artisti', in Faenza, 1998, n. 1-3.
E. Crispolti, R. Silicato, Lucio Fontana, exhibition catalogue, Milan 1998.
L.L. Loreti, I. Loreti, Ceramiche artistiche Molaroni: storia della fabbrica dal 1880 ai giorni nostri, Milan 1998.
Mazzolani, Senigallia/Urbania 1998.
L. Melegati, 'Vicenza', in Ausenda, Bojani 1998.
C. Pagano Conforto, 'Un eclettico artista del Novecento conterraneo di D'Annunzio: Pandolfi, il mago abruzzese del gran fuoco', in CeramicAntica 1998, n. 11, pp. 30-43.
Giovanni Prini dal Simbolismo alla Secessione 1900-1916, F. Rastitti, M. Fagiolo Dell'Arco (edited by), Rome 1998.
Nadir Stringa, 'Bassano', in Ausenda, Bojani 1998.
V. Terraroli (edited by), Le arti decorative in Lombardia nell'età moderna 1780-1940, Milan 1998.
V. Terraroli, 'Milano déco: le arti decorative e industriali tra il 1920 e il 1939', in Milano Déco. La fisionomia della città negli anni Venti, exhibition catalogue, Milan 1998.
G. Vianello, Nico Stringa, C. Gian Ferrari, Arturo Martini: catalogo ragionato delle sculture, Vicenza 1998.

1999
I. Amaduzzi, Io sono uno scultore: Lucio Fontana nella Milano degli anni Trenta, Milan 1999.
D. Amoni, 'Alfredo Santarelli 1874-1957', in CeramicAntica, Genuary 1999, pp. 42-51.
S. Barisione, M. Fochessati, G. Franzone, La visione del prisma, exhibition catalogue, Milan 1999.
G. Bonasegale, A. M. Damigella, B. Mantura, Cambellotti (1876-1960), Rome 1999.
G. Busti, F. Cocchi, Dolce ceramica. Maioliche CIMA per le confezioni di lusso Perugia 1920-1950, exhibition catalogue, Perugia 1999.
E. Crispolti (edited by), Centenario di Lucio Fontana, Milan 1999.
I. Maldini, R. Tacchella, Ceramica Liberty in Italia, exhibition catalogue, Turin 1999.
G. Ranocchia, Deruta. Manifatture e Ceramiche 1920-1960, Perugia 1999.
M. Romito (edited by), La ceramica vietrese nel 'periodo tedesco', Salerno 1999.
M. Romito La Collezione Camponi, Salerno 1999.
J. Ruiz de Infante, 'La scultura ceramica di Lucio Fontana: dal "neobarocco" allo spazialismo', e G.C. Bojani, 'Opere di Lucio Fontana al Museo di Faenza', in Faenza 1999, n. 4-6, pp. 215-226.
E.A. Sannipoli,'Aldo Ajò. Lustri del Novecento', in Vitalità perenne del lustro, G. C. Bojani (edited by), Florence 1999.
M. Tittarelli Rubboli, 'Un lustro degli anni '20 di Aldo Ajò e dei fratelli Rubboli', in CeramicAntica 1999, n. 10.

2000
L. Arbace (edited by), Le ceramiche Cacciapuoti. Da Napoli a Milano 1870-1953, exhibition catalogue, Florence 2000.
G.C. Bojani, Aligi Sassu. L'opera ceramica, Cesena 2000.
G.C. Bojani, G. Busti, F. Cocchi, David Zipirovič a Deruta. Maioliche 1923-1927, exhibition catalogue, Firenze 2000.
G. Busti e F. Cocchi, (edited by), La Salamandra. Arte e industria della ceramica a Perugia (1923-1955), Perugia 2000.
O. Casazza, Ceramica come arte. Marcello Fantoni, exhibition catalogue, Firenze 2000.
G. Cefariello Grosso (edited by), Le ceramiche di Galileo Chini, Florence 2000.
A. Cuccu, 100 anni di ceramica. Le ricerche degli artisti, degli artigiani, delle piccole industrie nella Sardegna del XX secolo, Nuoro 2000.
E. Gaudenzi, Bottiglie in maiolica da collezione prodotte dalle manifatture faentine dal 1900 al 1960, San Marino 2000.
S. Lucchesi, C. Pizzorusso (edited by), La cultura europea di Libero Andreotti. Da Rodin a Martini, Cinisello Bal-

samo 2000.
L. Manna, *Gio Ponti. Le maioliche*, Milan 2000.
M. Picone Petrusa (edited by), *Gli anni difficili. Arte a Napoli dal 1920 al 1945*, exhibition catalogue, Naples 2000.
Francesco Randone. *Il maestro delle Mura (1864-1935)*, G.C. De Feo (edited by), Rome 2000.
G. Salvatori, 'Il "Museo-Scuola-Officina" nel dibattito tra arte e industria a Napoli nelle testimonianze di Giovanni Tesorone ed Enrico Taverna (1877-1912)", in *L'arte nella storia*, Milan 2000.
V. Sgarbi, (edited by), *Wildt a Forlì. La scultura dell'anima*, Venice 2000.
D. Taverna, F. De Caria, I *Colmo. Aldo Besso, Giovanni Colmo, Golia*, Canelli 2000.
L. Ughetto,(edited by), *Manlio Trucco 1884-1974. Ceramiche, mobili, dipinti, disegni*, Albisola Marina 2000.
David Zipirovič, *Deruta maioliche 1923-1927*, exhibition catalogue, Florence 2000.

2001

S. Barisione, M. Fochessati, G. Franzone, *Parole e immagini futuriste dalla collezione Wolfson*, Milan 2001.
F. Benzi (edited by), *Il Liberty in Italia*, exhibition catalogue, Milan 2001.
C. Bernardini, D. Davanzo Poli, O. Ghetti Baldi, *Aemilia Ars. Arts & Crafts a Bologna*, exhibition catalogue, Bologna 2001.
G.C. Bojani, 'Da un giovane Arturo Martini a un inedito Gino Rossi: la donazione Luisa Gregorj', in *Faenza* 2001, n. 4-6, pp. 80-83.
A. Chiostrini Mannini, *Il bello dell'utile. Ceramiche Ginori e Richard-Ginori dal 1750 al 1950*, Florence 2001.
Marcello Fantoni, *Omaggio agli antenati. Opere inedite*, Florence 2001.
E. Gaudenzi, *Ceramica pubblicitaria. Esemplari delle manifatture e dei maestri faentini del Novecento*, San Marino 2001.
L. Miodini, *Gio Ponti: gli anni Trenta*, Milan 2001.
S. Pansini, *Ceramiche pugliesi dal XVII al XX secolo*, Faenza 2001.
O. Perera, *Ceramica in Piemonte*, Turin 2001.
L. Proverbio, *Lenci. Ceramiche da collezione*, Turin 2001.
V. Terraroli, *Skira Dictionary of modern Decorative Arts 1851-1942*, Milan 2001.

2002

Museo d'Arti Applicate. Ceramiche III, Milan 2002.
B. Buscaroli Fabbri (edited by), *Domenico Rambelli*, Ferrara 2002.
S. Dirani, G. Vitali, *Fabbriche di maioliche a Faenza dal 1900 al 1945*, second edition, Faenza 2002.
E. Gaudenzi, *Pietro Melandri (1985-1976)*, Faenza 2002.
Leoncillo. Opere dal 1938 al 1968, exhibition catalogue, Matera 2002.
F.R. Morelli (edited by), *Keramos. Ceramica nell'arte italiana 1910-2002*, Rome 2002.
E. Nesti, *Pietro Melandri. Fede, natura e mito nelle maioliche del maestro faentino (1920-1950)*, exhibition catalogue, Empoli 2002.
J. Ruiz de Infante, 'La scultura di Leoncillo negli anni Trenta: i contatti con la Scuola Romana', in *Faenza* 2002, n. 1-4, pp. 133-150.
F. Tetro, *Il Museo Duilio Cambellotti a Latina*, Rome 2002.

2003

Albisola futurista. La grande stagione degli anni Venti/Trenta, exhibition catalogue, Albisola 2003.
M. Bignardi, Guido Gambone. *Dipinti e ceramiche 1930-1969*, Salerno 2003.
M. Bignardi, *La ceramica di Vietri sul Mare, Figure di una storia sospesa sul Mediterraneo*, Salerno 2003
A. Comellato, M. Melotti, *L'opera in ceramica*, Milan 2003.
I. de Guttry, M.P. Maino, *Artisti e Fornaci: La felice stagione della ceramica a Roma e nel Lazio (1880-1930)*, exhibition catalogue, Rome 2003.
S. Dirani, *Francesco Nonni pittore su maiolica*, Florence 2003.
S. Dirani, 'I più noti ceramisti e le maggiori manifatture', in *Faenza del Novecento*, vol. III, Florence 2003, pp. 781-800.
M. Fochessati, 'Arte e industria', in *Il mito del moderno. La cultura Liberty in Liguria*, Genoa 2003, pp.167-202.
Fausto Melotti. Introduzione all'opera in ceramica, exhibition catalogue, Milan 2003.
G. Napolitano, *La ceramica di Posillipo 1937-1947*, Salerno 2003.
V. Terraroli, *Gio Ponti. Disegni e grafica 1917-1960*, Brescia 2003.

2004

G. Altea, *Francesco Ciusa*, Nuoro 2004.
N. Barberini, *Bologna e le sue ceramiche 1758-1967*, Bologna 2004.
F. Benzi (edited by), *Il Déco in Italia*, exhibition catalogue, Milan 2004.
R. Cassanelli (edited by), *Nivola, Fancello, Pintori*, Milan 2004.
S. Dirani, *Francesco Nonni scultore*, Faenza 2004.
A. Fiz (edited by), *Art Déco in Italia*, Milan 2004.
M. P. Ruffini, *Borgo medievale di Torino. Le ceramiche*, Turin 2004.

2005

F. Bertoni, I. Silvestrini, *Ceramica italiana del Novecento*, Milan 2005
M. Caputo, E. Mascelloni, *Le ceramiche Rometti*, Milan 2005.
E. Gaudenzi, *Novecento ceramiche italiana. Protagonisti e opere del XX secolo*, vol. I *Dal Liberty al Déco*, Faenza 2005.
A. Pansera, (edited by), *Terre d'arte. Da Andlovitz a Zauli, incontro con la ceramica italiana del Novecento*, Turin 2005.

2006

S. Barisione, M. Fochessati, G. Franzone, *La Collezione Wolfson di Genova*, Milan 2006.
F. Benzi, M. Margozzi, *Galileo Chini. Dipinti, decorazioni, ceramica e teatro*, Milan 2006.
E. Crispolti, (edited by), *Lucio Fontana. Catalogo generale*, 2 voll., Milan 2006.
L. Prisco, 'La lunga emozione. Cagli dalla ceramica alla scultura', in *Cagli*, F. Benzi (edited by), Milan 2006, pp. 259-373.

M 0162350145
S 00001681
ITALIAN ART
CERAMICSIED ING)
EDIZIONE 1
a cura d
VALERIO
TERRAROLI
SKIRA
EDITORE srl